LJ v

MAR 27 2002

NEW YORK EXPOSED

EDITED BY SHAWN O'SULLIVAN

INTRODUCTION BY PETE HAMILL

NEW YORK EXPOSED

CAPTIONS BY RICHARD SLOVAK

HARRY N. ABRAMS, INC., PUBLISHERS

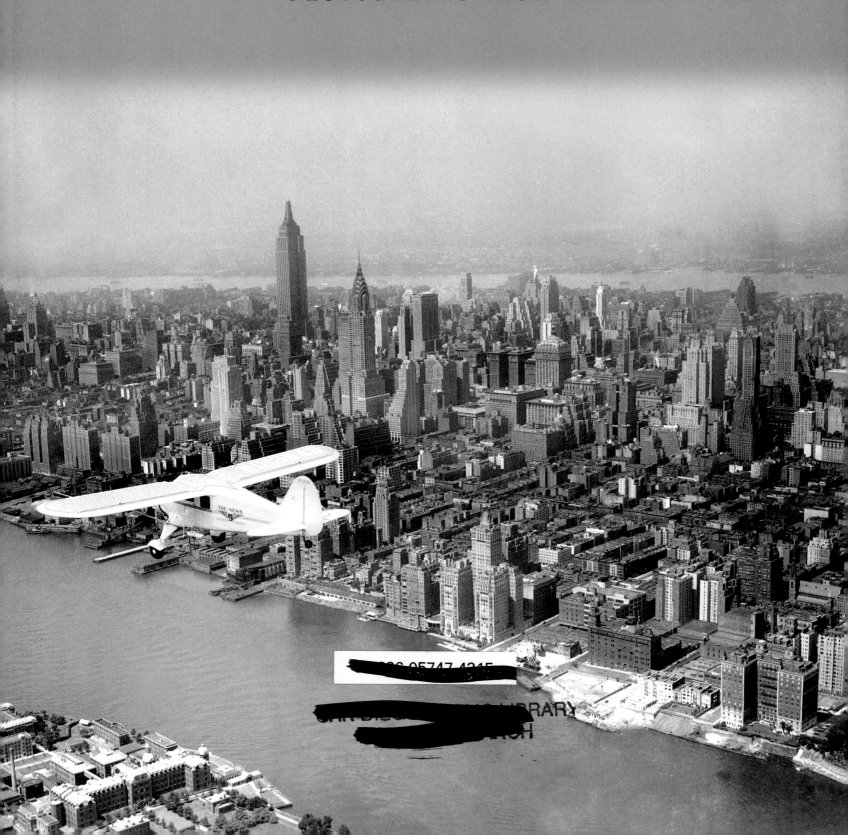

PHOTOGRAPHS FROM THE DAILY NEWS

SAN DIEGO PUBLIC LIBRARY

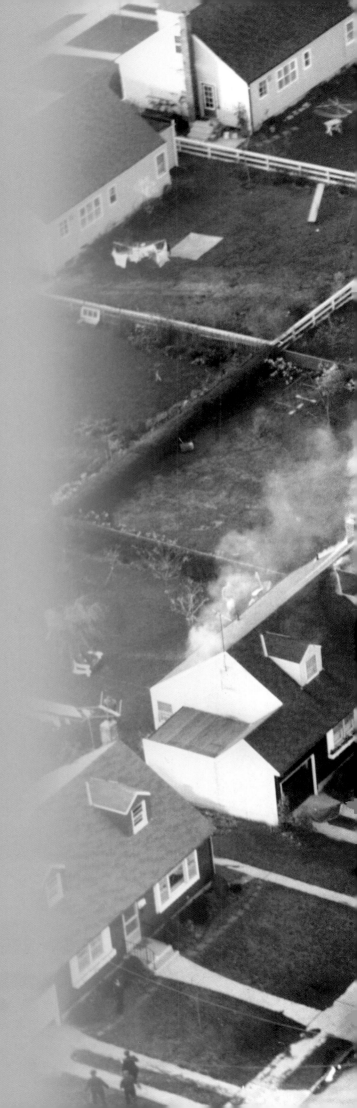

Editor: Eric Himmel
Designer: Robert McKee

Page 1: Legs Diamond, 1930 (see page 76).
Previous spread: A *Daily News* plane
flies over the city
This spread: Plane crash in East
Meadow, Long Island (see page 157).
Overleaf: Frank Sinatra is engulfed
by a crowd in Hoboken, New Jersey,
October 1947. Leonard Detrick

The New York Daily News Photo Archive is
the largest searchable online database of pho-
tographs in the world. Consisting of current
color photographs as well as historic images
edited from more than six million prints and
negatives, the Daily News Photo Archive is
the most comprehensive visual resource for
the history of twentieth-century New York. It
may be accessed on the World Wide Web at
http://www.dailynewspix.com.

Library of Congress Control
Number: 2001090108
ISBN 0-8109-4305-0

Copyright © 2001 Daily News, L.P.
Introduction copyright © 2001 Pete Hamill

Published in 2001 by Harry N. Abrams,
Incorporated, New York
All rights reserved. No part of the contents
of this book may be reproduced without the
written permission of the publisher
Printed and bound in Hong Kong
10 9 8 7 6 5 4 3 2 1

Harry N. Abrams, Inc.
100 Fifth Avenue
New York, N.Y. 10011
www.abramsbooks.com

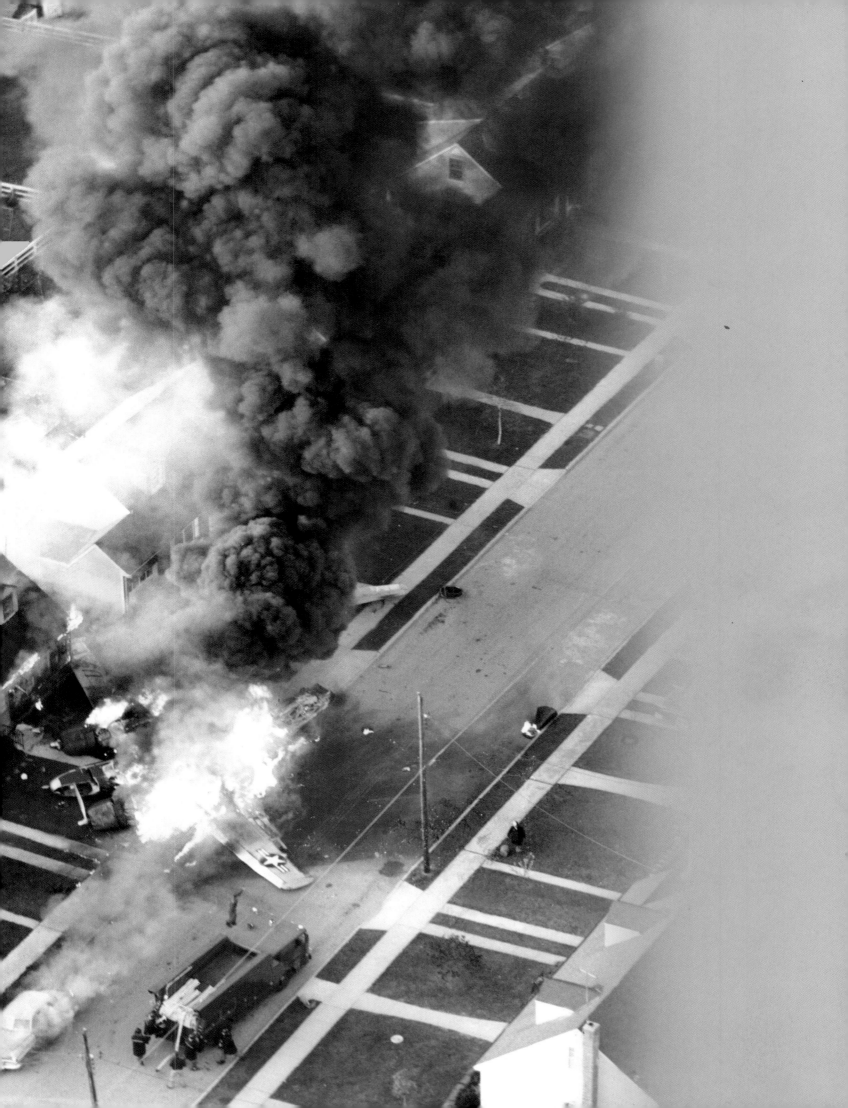

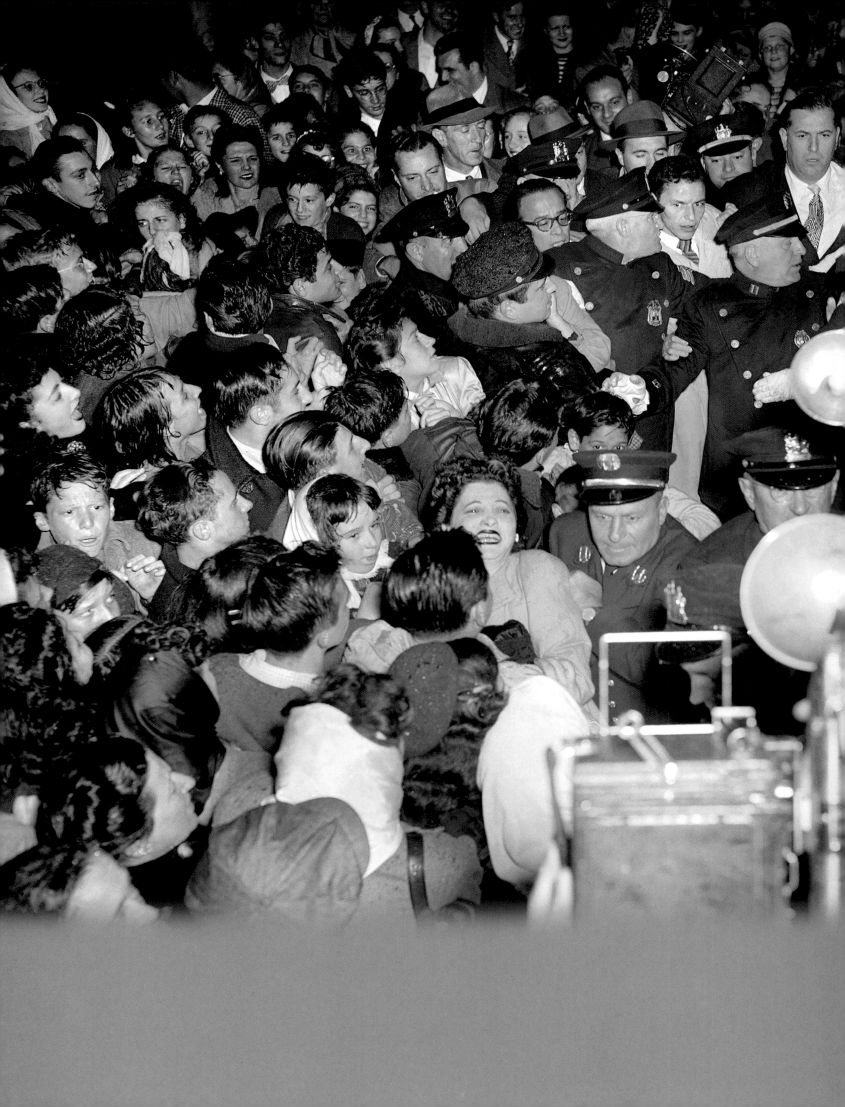

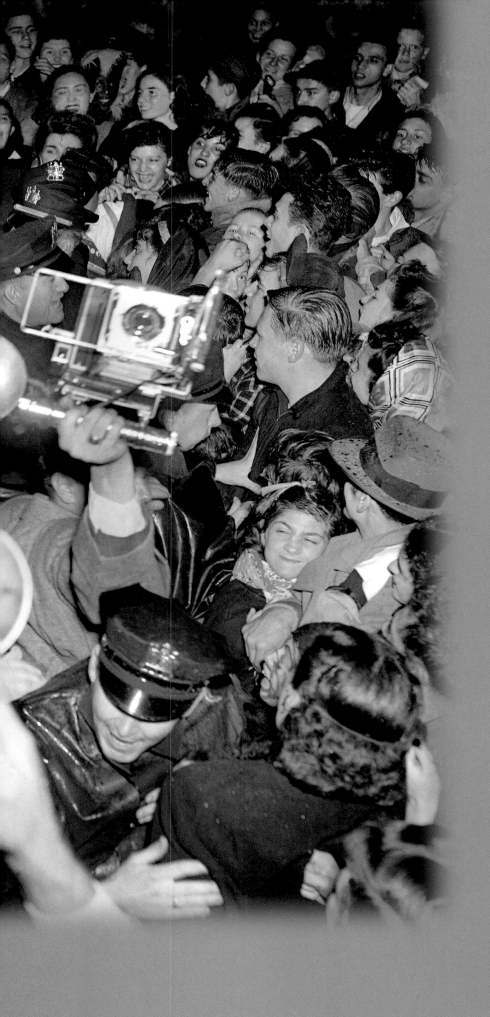

CONTENTS

I.

All photographers freeze time. Amateurs or professionals, hacks or artists, they look at what lies before them, they *see*, and then freeze a moment in the narrative of the world. Their recording instrument is a mechanical device, the camera, but the actual device is marginal to the seeing. The photographer sees and the camera records. No camera creates art. The art lies in the quality of the seeing. And this should be no surprise. The brush and the palette don't give us the painting; the artist does. The piano doesn't write the sonata.

Newspaper photographers must see under special circumstances. They seldom have the luxury of time and few are tortured by the high aspirations of art. They can't wait for hours or days for the exact moment that reveals an enduring image. They have no assistants to perfect the lighting. They work today for tomorrow's newspaper. Their deadlines are rigid because an intricate process of editing, layout, printing, and delivery flows from those deadlines. Photographers are like all daily journalists; they must work as if they are double-parked.

In addition to the remorseless pressure of the clock, staff photographers on newspapers are almost never free to pick and choose the objects of their scrutiny. They are, after all, journalists by profession, and almost every journalist works under the direction of editors. Each morning, editors examine the vast number of possible stories on the daily schedule, decide which must be covered by the limited number of reporters and photographers at their disposal, and hope that something marvelous will come back in a few hours. On a slow news day, the schedule is packed with routine stuff: press conferences, political rallies, museum openings, parades, show business celebrities peddling movies or albums or Broadway shows. These are what historian Daniel Boorstin described in 1961, in *The Image,* as "pseudo-events" and they now seem to dominate American culture. All political campaigns are assemblages of pseudo-events. Most of what passes for civic life is made up of pseudo events. In his defining essay, Boorstin stated that a pseudo event was "not spontaneous, but comes about because someone has planned, planted or incited it." In addition, "it is planted primarily (not always exclusively) for the immediate purpose of being reported or reproduced. Therefore, its occurrence is arranged for the convenience of the reporting or reproducing media."

More than forty years after Boorstin's essay, the pseudo-event is triumphant and the assigned journalist—carrying pen or camera—can only hope to subvert the convention, to see what nobody else sees. The "photo-op" is announced, usually an event staged to create an illusion of compassion, fraternity, or even anger at injustice. The photographer is assigned. The visiting princess or lama or politician poses with AIDS babies or homeless men in a shelter or on the steps of some courthouse. A script is established but the journalist notices other moments: the offered (and accepted) food left uneaten or passed to an assistant, the impatient glance at the wristwatch, the cranky refusal to utter a spontaneous sentence. The superior photographer can even transform the photo-op—a counterfeit of reality—into something incisive, capturing a gesture that reveals character, noting a detail that others don't see, or revealing the essential falsity of the event. The camera freezes the moment of revelation.

At the same time, all editors, photographers, and reporters on a daily newspaper know that routines are established in order to be upset by the real world. Every one of them longs for such upsets because the routine assignments are what you do when nothing is happening. Twenty-seven photographers assemble for the arrival of the Hindenberg—and it explodes before their eyes. The Dallas police guide Lee Harvey Oswald through that form of photo-op called a "perp walk" —and Jack Ruby steps out of the crowd with a gun. The assignment editor stares at a dull schedule, and then a terrorist

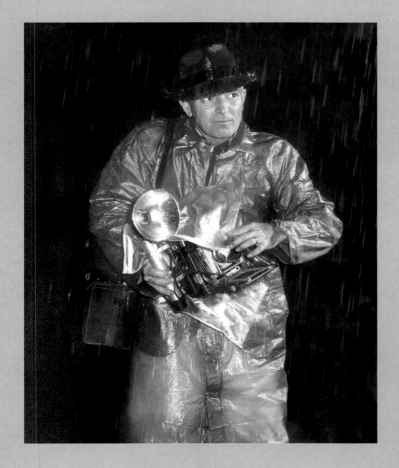

Tom Gallagher at work in the
rain, 1955.

bomb explodes at the World Trade Center. Or a crazed man shoots nine people on the Long Island Railroad. Or a fire kills six children in a tenement. Or a celebrity is shot to death in the entrance to his apartment building. All routine assignments are cancelled. Adrenaline flows. Photographers and reporters rush to the scene of the calamity. They draw on all of their skills, driven by one essential goal: to help the reader see.

In the early Sixties, when I was a young reporter for the *New York Post,* I was told early by a great editor named Paul Sann: "Remember one thing, kiddo. You're not there for yourself. You're not there for me. You're there for the reader. You're going where the reader can't go." And that meant I was there at the scene of calamity or celebration to help the reader share the experience. That is, to help that reader see. And the people who helped *me* see were photographers.

"Look at this guy's socks," a fine photographer named Louis Liotta said to me one morning, as we stared down at the body of a man found in a vacant lot. He was wearing a sport jacket and slacks. "You see? White socks. But what about those white socks?"

"They're dirty," I said. The socks were smeared with an anonymous gray-brown oily substance.

"Exactly," Liotta said. "So he's been out a few days. And that's what the cops'll try to figure out."

Then he pointed me towards a beefy man in a dark-blue overcoat who was watching carefully among the cops and journalists. "That's the guy from homicide," he said. "Ask him about the socks." And so I did. And got a story.

I learned that morning to talk to the photographers before I talked to the cops or my fellow reporters. They were paid to see, and helped me to do the same. I soon learned that photographers also kept other photographers in their sights. At that crime scene long ago (when there were seven newspapers in the city of New York), there would have been a few photographers especially worth watching. They moved like members of an elite corps, with a kind of proprietary swagger. They dressed better than the other photographers. They carried excellent new cameras. They were deferred to by the police, and knew the detectives by their first names. These were the men from the New York *Daily News*.

II.

For a very long time the New York *Daily News* was the greatest of all American tabloids. It had the largest daily circulation in the United States and luxuriant profits. It was part of the dailiness of New York life, more densely meshed with the lives of the city's residents than any newspaper in its history. In those years before television and the evening news shows, the early "bulldog" edition sold hundreds of thousands of copies to people who wanted the latest news and the scores of the ballgames. In the morning, the *Daily News* seemed to bristle in the hands of every other straphangar on the subway cars that carried millions of New Yorkers to work or school. In memory, it was always on our kitchen table when I was a boy, read in detail for the war news and the comic strips and the endless tales of human folly. I'm certain that my immigrant father learned more about America in its sports pages than he ever gleaned from the documents of the Founding Fathers. The *Daily News* was also possessed of a quality derived from the city itself: energy. The tone was brash, sarcastic, irreverent. The writing in the news stories gave the readers some of this sense of New Yorkers talking to New Yorkers, but two graphic elements conveyed the tone even more powerfully: the headlines and the photographs. The headlines were smart and hip, or as blunt as hammers. And the photographs were the best in town. It was not for nothing that the *Daily News* front page logo bragged that it was "New York's Picture Newspaper."

This marvelous newspaper was the creation of one man: Joseph Medill Patterson. He was born wealthy in Chicago in 1879. His father was a newspaperman, one of the top executives of the Chicago *Tribune*. In the tradition of the nineteenth century, Patterson was sent to private schools in Chicago, then packed off for a year in Europe when he was eleven, before being enrolled in Groton in 1891. This was the boys' school that also shaped Franklin D. Roosevelt, who as president would be Patterson's friend and then his bitter enemy. In 1897 Patterson moved on to Yale, but the romance of the newspaper business was already calling. In 1900, young Joe Patterson dropped out of Yale for a year and went off to the Boxer Rebellion in China, to work as an assistant to the Hearst correspondents covering the story. He arrived too late to see any action, but the romantic impulse would not easily vanish.

After Yale, Patterson worked as a reporter for a few years at the staid, dull Chicago *Tribune*. Chicago was then (and remains) a good newspaper town, with a tradition of kick-the-door-down reporting. Patterson acquired some craft, perhaps dreamed of another kind of newspaper, and then dropped out. Bursting with the reform impulse aroused by Teddy Roosevelt and the muckraking journalists led by Lincoln Steffens, he went into politics. In 1903, he was elected as a Republican to the Illinois state legislature, advocated causes that his father opposed, and then—during a father-son quarrel—discovered that his political career was in fact a set-up. He was in the legislature because his father made a secret deal with the state Republican Committee. He resigned immediately and just as swiftly became a Democrat.

His rebellious impulse didn't end easily. As a commissioner of public works under a reform Democratic mayor, he went after Marshal Field & Company for a variety of violations, even though his father-in-law was president. Worse, in his father's view, he tried to force Chicago newspapers to pay higher taxes. Joe Patterson was clearly a young man in opposition to his own moneyed class, and when the Democrats failed to give him support, he again resigned. This time, the logic of his views brought him to socialism.

This was not a casual rich boy's flirtation. Patterson, who enjoyed the raffish working class saloons of the First Ward more than the prim Victorian parlors of his own class, was powerfully attracted by the populist, reformist promise of American socialism. He threw himself into the cause. By 1908, he was serving as campaign manager for Eugene V. Debs in his run for the presidency, helping direct a campaign train called the Red Express. When Debs lost with less than 3 percent of the popular vote, Patterson retired to a farm in Libertyville to become a writer.

His own work—pamphlets, articles, plays, and novels—was addressed directly at an American working class audience. From this experience (and particularly from writing plays), Patterson took what would serve him well as a publisher of a mass-circulation newspaper: an understanding of the structures of drama. To create a sense of drama from the events of a city and the larger world, it was necessary to focus on the essential component of drama, which is conflict.

That was all a decade away when Patterson's life was drastically changed in 1910. That year, his struggle against his father ended when Robert Wilson Patterson committed suicide. Under his stewardship, the Chicago *Tribune* was failing, a prisoner of its own stuffy formulas, unable to compete with its rowdier Hearst competitors. The details of the sui-

cide remain a blur but young Joseph Medill Patterson quickly changed his own life. If his contrarian politics were a rebellion against his father, in some textbook Freudian way, the object of his rebellion was now gone. He and his younger cousin Robert McCormick inherited ownership of the *Tribune*. By 1912, Patterson's involvement with socialism was over.

Actress Evelyn Herbert poses
on board ship, June 1934.
JACK MACMILLAN

He returned to the *Tribune* as co-editor with McCormick and showed a renewed passion for journalism, and a talent for promotion and innovation that drove up circulation. But he was not yet prepared to retreat into an executive office. As a reporter, he covered the U.S. intervention in Vera Cruz in 1914. The following year he spent three months looking at the Great War in Germany, France, and Belgium. He was then—and would be so on the verge of the Second World War—an advocate of American neutrality in the case of foreign wars.

Around this time, for reasons not entirely clear, the self-described neutral joined the Illinois National Guard and was part of the force that futilely pursued Pancho Villa along the Mexican border in 1916. By July of the following year, when the United States entered the Great War, Patterson was a lieutenant of artillery and was sent to France. He proved to be a superb leader of men. His division commander was a brigadier general named Douglas MacArthur, who said of Captain Patterson that he was "the most brilliant natural-born soldier that ever served under me."

Four days after the Armistice, Patterson traveled to London and stayed as an overnight guest with a Dublin-born British newspaper publisher named Alfred Harmsworth, now better known as Lord Northcliffe. He was one of the most successful publishers in the English-speaking world. In 1903, Northcliffe started the modern tabloid newspaper with the *Daily Mirror*, originally aimed at women. The size of the newspaper was not so new; in the nineteenth-century United States, many tabloid-size newspapers came and went. Northcliffe's originality lay in content. He went directly for the

British working-class reader, filling the newspaper with crisp news stories (many of them attacking the bureaucracy), contests, stunts, "exclusives," sports, and a dollop of scandal. Photographs were essential to the formula, dozens of them in every issue. Circulation had risen to 800,000 a day, more than any newspaper in the United States. Northcliffe urged Patterson to start a tabloid somewhere in the United States. Patterson was excited. Back in France, he discussed the possibility with his cousin, Robert McCormick (now a colonel), and they agreed that a modern American tabloid was worth a try. The new newspaper could be financed by the Chicago *Tribune.* And it should be published in New York. And Joe Patterson would run it.

III.

Photography was part of the concept from the beginning, and the original name of the newspaper, when it first appeared on newsstands on June 26, 1919, was the *Illustrated Daily News.* The logo included a camera lens adorned with wings and the first day's editorial stated: "We shall give you every day the best and newest pictures of the interesting things that are happening in the world."

But by common agreement—among the tiny staff and other newspapermen—the sixteen-page newspaper was dreadful. It was very British in typography, featured the Prince of Wales on horseback on page one, and was marked by a tame, uncertain sketchiness in its content (most of which was borrowed from the Chicago *Tribune).* The printing was done on rented presses and the quality was wretched. In mid-summer, two of the original four reporters were fired. There were thirteen other daily newspapers in New York that summer, and three more in Brooklyn, but none felt threatened by the *Illustrated Daily News.* Quick, ignominious failure was in the air.

And then it began to work. Patterson was commuting from Chicago (he would not move permanently to New York until 1925), or firing off telegrams bursting with ideas, and his energy was contagious. "Remember, lay emphasis on romantic happenings and print pictures of girls who are concerned in romances, preferably New York girls," he said in one memo, quoted in Hy Turner's *When Giants Ruled.* "Also, one or more pictures every day with reference to a crime committed the previous day in New York. Please remember particularly, make it snappy, make it local, make it news."

Patterson argued that pictures were themselves journalism, containing much information that could be quickly glimpsed by an audience in a hurry. Much of that audience rode the subways, and the tabloid size fitted their needs perfectly; unlike the eight-column broadsheets, a tabloid could be read with one hand on a rush-hour express train; it could be folded and jammed into a workman's pocket to be finished on a lunch hour. On his trips to New York, Patterson began a lifelong custom of riding those subways himself, watching what readers scrutinized and what they skipped. He saw that they often studied photographs more intently than news stories or canned features.

The first photographer hired by the *Daily News* was a man named Eddie Jackson. He was no amateur. He learned the basics of his craft in a Philadelphia studio at the beginning of the century, became a boardwalk photographer in Atlantic City, and came to New York in 1910 to work for the American Press Association. When the Americans entered the war, he left for France as a lieutenant in the Signal Corps, saw much combat, and was promoted to captain. After the war, he covered the Peace Conference at Versailles, and then was assigned to the White House. He came to New York on July 22, 1919, still in uniform, and was hired on the spot. Among many moments of time frozen by his camera is the aftermath of the explosion on Wall Street on September 16, 1920 (see page 30).

The second staff photographer was Hank Olen, who would become one of the finest of all sports photographers, famous in the craft for capturing the electric moment when Jack Dempsey was knocked out of the ring by Luis Firpo of Argentina (page 48). The third was a friend of Olen's who bore the marvelous name of Marlborough Sylvester Walker. He called himself simply Lou Walker. He had been recently laid off by the *World* and took the job. Lou Walker would develop the Big Bertha, an early version of the telephoto lens, which allowed *Daily News* photographers to lead all New York newspapers in photographing sports and previously inaccessible scenes (including the *Hindenberg* disaster).

A year after its birth, the circulation of the brash young *Daily News* had climbed to 220,000 and the future seemed

without limits (daily circulation passed a million in March 1926). Patterson and his editors tried everything to suck in readers, believing that if they could get them through the door they could keep them there with this new kind of newspaper. So, while covering the city in a fresh, vivid way, they spent money on contests, payments to readers, serials, comic strips, and, above all, photographs. The word "illustrated" was quickly removed from the newspaper's name (too pompous, too British), and on September 17, 1920 the slogan "New York's Picture Newspaper" was added to the logo. By 1921, there were seven staff photographers who developed their own film in four darkrooms. They favored a German camera called the Ica, which took four-by-six-inch glass plates, and had an f/4.5 lens and a leather bellows. The classic Speed Graphic was also being used, but the Ica could be slung on a shoulder strap. All photographers carried flasks of flash powder, fired with a four-inch square flash pan. There were many accidents. In a single year, a *Daily News* photographer named Al Willard suffered extensive burns of his face and arms and almost lost an eye. The photographers didn't seem to care about the hazards. They were young and having the best times of their lives. Years later, John Chapman, who started as a photographer and ended as the drama critic of the *Daily News*, wrote about those days in his memoir, *Tell it to Sweeny*:

"Newspaper photography has improved in quality since 1919—and with the improvement has vanished most of the fun and competitiveness which once made news pictures an adventure."

That sense of adventure among the early tabloid photographers was driven by a belief that they were making something new. Looking back, Chapman clearly yearned for the daily excitements of his own youth and the youth of the craft that he eventually gave up. This was part of the continuing debate about the loss of inventiveness that can sometimes accompany technological advance.

American newspapers had been using the half-tone process to reproduce photographs since 1894, when the Boston *Journal* printed twenty-one halftones in a single edition on its Hoe quadruple press. Three years later, the New York *Tribune* was doing the same. By the end of the century, photographs were part of the formula of almost every daily newspaper in the country. What was new about Patterson's *Daily News* was the way photographs seemed to dominate the

Harry Warnecke braves the catwalk of the George Washington Bridge, September 1929.

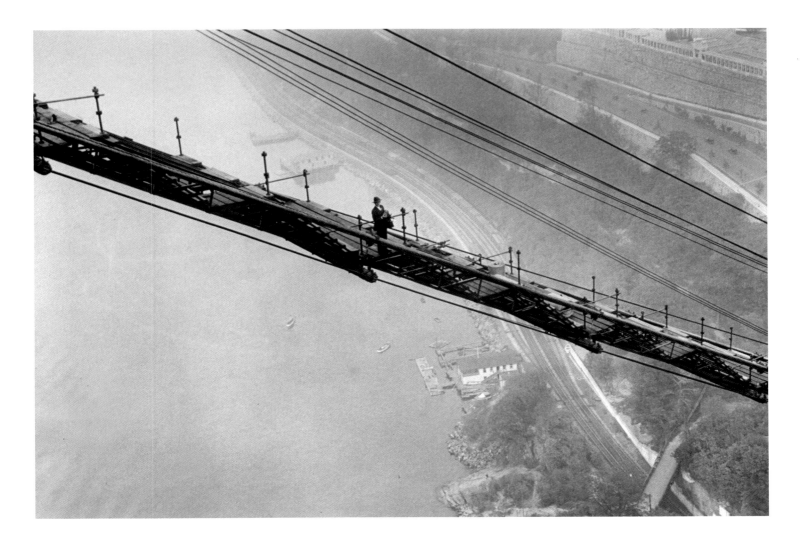

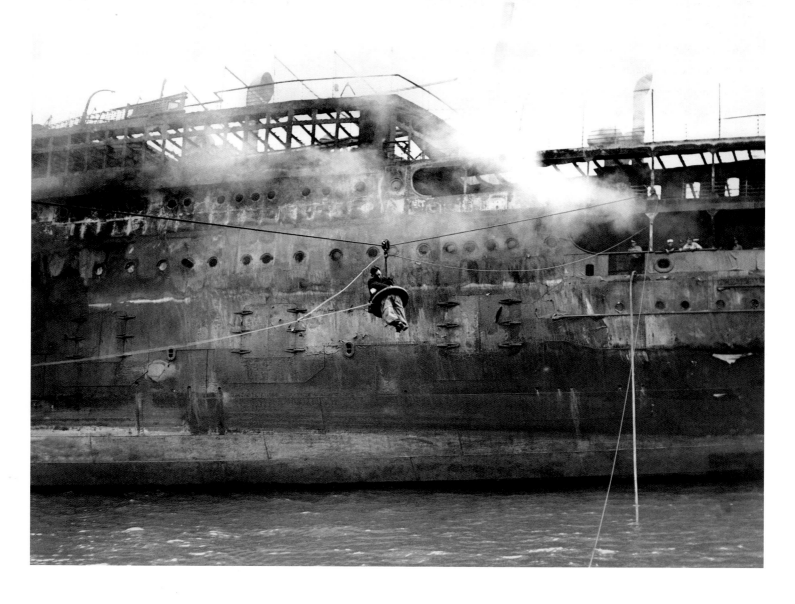

Larry Froeber is rescued from the smoldering SS *Morro Castle* after he had collapsed and burned his hands, September 8, 1934.

content of the paper. Part of the reason for this impression was the tabloid format itself. To be seen, pondered, felt, photographs needed room on the page; they could not resemble postage stamps. Under Patterson's urgings, photographs were given much space in his bright new tabloid. By the late Twenties, they would make up 40 percent of the "news hole"— the non-advertising space. Eventually, the entire centerfold of the *Daily News* would be devoted to photographs.

Patterson also gave photographers status, handing out bonuses for superb work, pushing hard (and spending money) for technical innovation, approving expenses for cars, boats, and airplanes if they were required to get the picture to the newspaper—and then to the reader. The adventures of *Daily News* photographers in that era were later enshrined in journalistic legend: raffish tales of cut-throat competition with other photographers, flights in open-cockpit biplanes, dashes by motorcar to ports where ships were leaving for New York. "It took wile, guile, deceit, and money to get a far-off picture home first," Chapman wrote of his own youth and the young years of the newspaper that employed him.

In the meantime, technical improvements were changing the working style of all newspaper photographers: the development of the 35mm Leica (1925), the replacement of powder with the flash bulb (1930), the light meter (1932). At the *Daily News*, Leicas were not used for many years; photographers continued to prefer the Ica or the cumbersome but dependable Speed Graphic, which gave them sharp contrasty images that looked strong when reproduced in the sixty-five dot-per-square-inch halftone process that was used for the paper's printing plates. (Among the more famous holdouts for the Speed Graphic was Arthur Felig, better known as Weegee, a freelancer who beginning in the Thirties sold his pictures to the *Daily News* and other newspapers). It wasn't until the Sixties that the 35mm reflex camera replaced the larger format cameras; one visual sign of the change is the greater exaggeration of horizontal or vertical framing in the photographs

themselves. The change from letterpress printing to offset (in the Seventies) also allowed more subtle tonal qualities in the photographs. In the Nineties, all *Daily News* photographers began to shoot in color, in anticipation of the day when the newspaper would be mechanically capable of using color on a daily basis. The photographs in this book are printed in black and white, because that is the way they most often still appear in the *Daily News*. Perhaps the greatest technological transformation of all is now in progress: the use of digital technology. All the newspaper's photographers are using digital cameras, allowing them extraordinary flexibility as photojournalists. The days are almost over when a photographer would shoot a roll at a crime scene and rush back to a darkroom to develop film. There is no film. There are no tubs of developer, no chemicals, no racks for drying prints. There is only the eye of the photographer, helping us to see.

IV.

As in so much of life, personal or corporate, timing was everything for the *Daily News*. The Twenties seemed made for the blunt, sassy, irreverent style of a tabloid newspaper. Prohibition took effect on January 17, 1920, and New York resisted this most stupid of American laws with an almost patriotic fervor. Working men—many of them naturalized Irish and Italian immigrants—felt the law was directed at them and thus lived as if it was their duty as new Americans to drink. Returned war veterans justifiably felt that service in France entitled them to as much whiskey as they could afford. Speakeasies flourished. Bootleggers became famous, often treated as a new kind of urban royalty. The vast slaughters of the Great War had left the old Victorian mores in rubble, along with any remaining notions about the superiority of European culture. Women, at last, were full citizens, able to vote, and now pushed closer to the center of the American stage. Social and sexual conventions collapsed. The short-skirted, bare-legged, brandy-swilling, cigarette-smoking flapper came downstage doing the Charleston, her hair cropped short and her painted face defiantly laughing. New Yorkers laughed at the rich. They laughed at blue-nosed puritans. They laughed at the Republican presidents Harding and Coolidge. The *Daily News* collaborated in the laughter.

At the same time, American popular culture exploded. The Victrola, which hit the market in 1915, became the primary source of home entertainment, with jazz bursting forth as the first uniquely American music. The movies swiftly dominated mass entertainment, and Patterson, who wrote a long admiring story on nickelodeons in 1915, was quick to make movie stars and Hollywood itself into essential parts of his daily package. (He remained a lifelong movie fan, and urged his editors to look deeply at movies in order to understand the hopes, fears, and desires of the readers). The radio gave singers and musicians national audiences that would have been impossible in the nineteenth century, while the news bulletins and sports reporting challenged newspapers to be better. Big-time sports—unimaginable before the Great War—became a vivid part of American life. New York was unique in having three major league teams, with the New York Giants established at the Polo Grounds (the Yankees were a paying tenant) and the Brooklyn Dodgers in Ebbets Field. In the winter of 1919–1920 a fine Red Sox pitcher named Babe Ruth was traded to the Yankees and turned into a full-time left fielder and homerun hitter. In 1923, Yankee Stadium—The House that Ruth Built—opened for business. Boxing was legalized in 1920 and Madison Square Garden became the venue for bouts that exploited the city's ethnic rivalries; Jack Dempsey drew 65,000 fans to the Polo Grounds in 1923 for his ferocious brawl with Firpo.

As so many of these photographs show, the *Daily News* covered all of these worlds with flair. Particularly crime. There's a photograph here of six men in the morgue looking at the body of a gangster named Monk Eastman (page 35). He was no routine gunsel. At the turn of the century, Eastman emerged as the first great Jewish gangster, battling and then forging alliances with the already established Irish and the new arrivals from Sicily and Naples. He and his 1,200 tough followers became the infantry for Irish-controlled Tammany Hall, voting early and often in elections, using muscle to discourage some voters and encourage others to vote the straight ticket. After a gun battle with a Pinkerton detective, Eastman was packed off to Sing Sing for a long stretch. The city changed while he was gone, and so did his old gang. When the Americans entered the war, so did forty-four-year-old Monk Eastman. With all that New York basic training, he turned out to be a fine combat soldier. When he returned home, widely proclaimed a war hero, New York had changed once again. Prohi-

bition promised extraordinary riches to a smart, brave gangster, and Eastman thought he could revive the spirit of his old gang. He didn't really have time to get started. On the day after Christmas 1920, a crooked Prohibition agent named Jerry Bohan shot him five times and killed him. Monk Eastman, pioneer gangster and war hero, had found tabloid immortality.

In this photograph in the morgue, three of the six men are holding cloth caps and wearing rumpled street clothes. Their shoes don't carry a high sheen. The older man pointing a finger seems clearly to be from the coroner's office, but there's no way to know the identities of the others. Reporters? Detectives? Friends from the Five Points or the war? The men are all small, each of them surely born in the ferocious nineteenth-century New York slums. But they carry themselves with an oddly elegant sense of street reverence. Chances are, each of them was already a reader of the *Daily News*. They seem to know they are staring at the corpse of a legend. Before them on a slab, his face unseen by the viewer and thus oddly more powerful, lies the famous Monk Eastman. Somebody's quarry. There's a marvelous cartoony quality to the figures of the men, but something deeply serious too; they remind me of campesinos scrutinizing the riddled body of Emiliano Zapata in 1919 or ordinary Bolivian soldiers confronted in 1967 with the dead Che Guevara. This photograph established early one of the continuing themes of Twenties journalism: the gangster as celebrity. Or what the critic Robert Warshow later called "The Gangster as Tragic Hero." Led by the *Daily News*, all New York newspapers learned in the early Twenties that there was only one thing better than a live gangster and that was a dead gangster. Violent death completed the drama of the outlaw, giving the story not simply a beginning and a middle but an appropriate end. The *Daily News* understood the lesson long before Hollywood did.

In the early photographs, the nineteenth century maintains an insistent presence. Most of the kids frantically scooping spilt wine on a Brooklyn street are wearing knickers (page 45). A few wear caps. Their white shirts suggest that they are on a break from school. In the distance are the wine barrels smashed by heroic Prohibition agents. They almost surely contained wine manufactured by immigrants in this Italian neighborhood but the same barrels could have been seen on a New York street in 1823. Even more insistent is the street itself: made of cobblestones perfectly laid by anonymous craftsmen. In the upper left of the photograph there's a ghostly fragment of the steel-rimmed wheel of a horse-drawn wagon. There's not an automobile in sight.

The nineteenth century also lives on in the photograph taken at the Metropolitan Opera by Harry Warnecke, one of the greatest early *Daily News* photographers (page 60). This is October 1929, and the decade is about to end with a crash. And yet here are the New York rich, dressed as if the Gilded Age had never ended. In the boxes, men in white tie hover like court attendants, prepared to flee as soon as the house lights dim. The women—one of them is Mrs. Cornelius Vanderbilt—are out of Edith Wharton, strands of jewels or pearls hanging from their necks, their arms bare, programs open before them, chattering, watching, almost certainly calculating. Below them in the orchestra rows, twenty-four women and two men occupy seats. At least five of the women peer at the audience itself through opera glasses. Many have thick fleshy bodies. One lean young woman sits with arms folded unhappily on her lap. The photograph freezes all of them in this single moment, suggesting dense private lives, brittle talk, the preposterous ambition to create an American aristocracy, various levels of ambiguous envy.

Warnecke also made the famous July 1925 photograph of a cop stopping traffic to allow a mother cat to carry her kittens across Broadway at Walker Street (page 32). The photograph, in a strict sense, is a set-up. Warnecke was tipped about the mother cat moving her kittens across the wide avenue. But when he arrived at the scene, the job was finished. Warnecke promptly picked up one of the kittens, moved it back across the street, and the mother cat seized the moment, doing it all over again. Take two. The policeman has a lanky Irish ease about him and is unable to suppress a grin. The men in straw summer boaters all wear neckties. Most of the other men stare shyly or shamelessly at the camera, not the cat. The large shiny automobile waiting for the cat to pass has right-hand British drive in the hands of what appears to be a chauffeur. The only female in the photograph is the cat. But the photograph has the charm and innocence of the paintings of Norman Rockwell, showing an aspect of the city that seldom found its way into newspapers.

In that first decade, the photo-op established itself for the rest of the century, the pseudo-events arranged by growing numbers of press agents. Ordinary people now routinely posed for newspapermen with cameras. Celebrities did so as part of their work. So here is John D. Rockefeller trying to show a human side outside a church. The photograph,

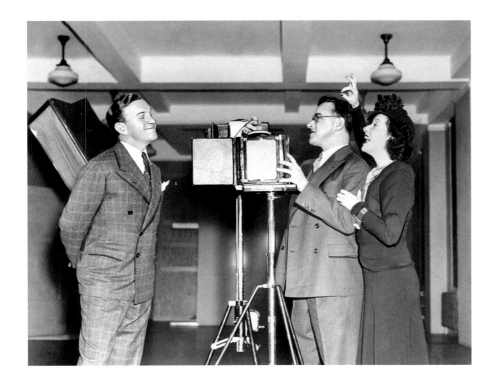

with the multi-millionaire accepting a coin from a child (or having it handed back), instantly demands attention (page 44).
Variations on the old man's drawn bony face and frock coat would appear in dozens of left-wing cartoons by artists as differ-
ent as Art Young and Diego Rivera. The chubby boy is not impressed, either by Rockefeller or the coin. Others on the church
steps wear forced grins while one mustached man stares blankly at the scene with the impassive look of a bodyguard.

In other photo-ops, we see a man fired from a cannon and workers at the Fulton Fish Market displaying a 750-
pound sturgeon (note the man in the center wearing the cocked fedora and tie and know what will happen to the union
movement). These are great dopey fun, artifacts of what columnist Westbrook Pegler dubbed "The Era of Wonderful
Nonsense." The reason for the picture is the making of a picture. Sometimes, as in the photograph of swimmer Stubby
Kruger flying through the air in a striped bathing costume holding a striped umbrella, while the stars and stripes unfurl
below him, the result is a wacky kind of art.

But other photographs come from the real world, and it's no accident that ships are often crucial to the events
recorded; in the Twenties, New York was the busiest port in the United States. In a 1922 photograph, immigrants arrive a
year after new quotas were imposed by the familiar anti-immigration Americans who insisted that future immigrants must
be "Nordic" (page 36). These are almost surely Italian or Greek, and on their faces you can see what can only be described
as joy. Most of them are young. Look at that young woman down in front, holding a straw basket, covering her mouth
shyly, dressed in the best clothes a peasant could afford. She is almost certainly weeping. Look at the other young
women, their beautiful faces beaming, and the men, tipping caps or hats, saying hello to their new country. One man is
even climbing over a rail. They've made it to America. And now they'll go to work.

A ship burns beside a Hoboken pier on the second to last day of 1927, while streams of water soar from fireboats
and five reporters stand together in the foreground (page 53). The casual style of the seasoned reporter is already estab-
lished. One has his hands clasped behind his back. Another has hands on hips. All wear fedoras. They seem to be working
hard at indifference.

Nobody is indifferent on the deck of the British steamer *Vestris* on the afternoon of November 12, 1928 off the coast
of Virginia (page 56). In this astonishing photograph, taken by a crew member named Fred Hanson (and later purchased by
the *Daily News*), men in life jackets grasp thick ropes, while the deck lists at a steep angle and others try desperately to
enter lifeboats. Deck, ropes, crew, passengers form opposing diagonals as vivid as a Baroque painting. The look of alarm
and fear on one young man as he peers toward the approaching sea is the human focus of the image. All other backs are
turned or faces blurred. The man leaning against a bulkhead, apparently a steward, has two broken arms. When the ship
slipped beneath the waves, 110 human beings went with it. Many survivors came to New York some days later on board

George Burns poses for Harry
Warnecke in the Daily News Color
Studio while his wife, Gracie
Allen, looks on, January 1937.
CHARLES HOFF

the *Voltaire,* an event that was also recorded (page 57), and the photograph expresses an exuberant scene of arrival, all

Ed Clarity poses before tak-
ing off on a aerial assign-
ment, October 1962.

the *Voltaire,* an event that was also recorded (page 57), and the photograph expresses an exuberant scene of arrival, all raised hats and waved scarfs and the steam and power of the rescue ship itself.

A different kind of power emerged in the spring of 1927. Two great turbines of tabloid journalism are sex and murder and they came together most powerfully in the case of Ruth Brown Snyder and her lover Henry Judd Gray. Ruth was living the life of a suburban housewife in Queens Village, then a leafy suburb far from the sinful temptations of the big city. She was married to a man named Albert Snyder, who was the art director of *Motor Boating* magazine. Then she met Gray. He was a shy, mild-mannered corset salesman, married, a solid citizen and a father. Ruth went to his office to be fitted for a corset—in a comedy this would be known as "meeting cute"—and just as in a *film noir*, the world tilted drastically for both of them.

A sexual affair started that was later described, of course, as "steamy." The housewife and the corset salesman drank a lot of bootleg hootch. They made love in many hotel rooms. Finally, they decided they could not live without each other. The immediate problem was Mr. Snyder, the art director. Ruth secretly took out a $50,000 life insurance policy on the poor fellow, and then she and Gray set upon him in the Queens Village home. They chloroformed him. They strangled him. They broke his head with a sash weight.

They wanted the police to believe this atrocity was the work of a burglar, so they jerked open drawers, scattered silverware and cushions, spilled clothes on the floor, presumably including a few corsets. Then Gray tied up Ruth, gagged her, stretched her out on the floor and went home. The cops were suspicious from the beginning. No professional burglar would go this far. When the men from homicide learned about the insurance policy, they had a motive that cops always understand (love is simply too vague). They quickly broke the two killers, who were tried, convicted and sentenced to die in the electric chair in Sing Sing. From the death of Mr. Snyder to what reporters in my own time still called "the hot squat," the story unfolded like a splendid hard-boiled novelette right out of *Black Mask*.

Gray and Snyder were scheduled to be electrocuted on the night of January 12, 1928. The *Daily News* editors and staff planned their coverage for weeks. A photographer named Tom Howard was brought up from the Washington bureau and passed off as a reporter. Nobody in the death chamber would know his face. He was outfitted with a small camera strapped to his ankle. A cable release ran up his trousers and through a hole into his pocket. For days, Howard rehearsed in a hotel room. That night, he took a seat in the front row, squirmed around to get a clear view as Ruth Snyder was strapped into the chair, and kept his hand in his pocket.

"The camera shutter was set on bulb," Chapman wrote later. "When the moment for the exposure came Howard hitched up his trousers cuff just far enough to clear the lens, set his leg in a position which he hoped would aim the camera at the chair, push the release—open—and ease it back—close. The bulb exposure had to be made for two reasons; one was that fast lenses and fast emulsions had not been devised for making snapshots in existing artificial light, and the other was that the click of a shutter might betray Howard in the stillness of the awful room."

It worked. Howard got his picture, which is not a photographic masterpiece, but has extraordinary power (page 59). Snyder's hooded head jerks back. In the foreground of the surviving negative, we see the legs of a man, almost casually

watching the woman die in the electric chair. The legs and feet of a woman witness are turned away. A gurney stands against the wall beside the chair, ready to cart the body off. The banality of the postures makes the death of Snyder look ordinary, and thus even more appalling. There's an eerie ghost image behind the chair itself.

The *Daily News* ran an extra edition with a tightly-cropped front page image of Snyder being jolted into tabloid hell beneath the headline DEAD! It sold 400,000 additional copies. The next day, they repeated the photograph for those who had missed it and sold more newspapers. By then, many stuffy sermons were being delivered in print and in pulpits against tabloid sensationalism. These often came from people who believed that the death penalty actually deterred murder but just shouldn't be seen by the people it was supposed to deter. That hypocrisy remains among us today. In 1928, most rival journalists recognized that the brash tabloid had scored an immense "beat" and was there to stay.

In the decades that followed, the templates cut in the Twenties remained essential to the growth and success of the newspaper. The pseudo-event became a constant, with small armies of publicity-mongers setting up photographs, trying to control their content and their display, dictating terms that too many newspaper editors accepted. Patterson, the movie buff, remained convinced that readers had an endless interest in movie stars, even when they weren't doing anything other than posing for cameras. Here we see Mary Pickford and John Wayne, Dorothy Lamour and Alan Ladd: all welcoming the camera, all selling something. Eventually, the freelance paparazzo—named for the photographer in Federico Fellini's *La Dolce Vita* (1961)—would upset the corrupt bargains of the photo-op and start photographing celebrities when they didn't want to be photographed. But for too long a time, the *Daily News* was content to repeat the tired conventions established in the Twenties.

The other constants were often more full of life. The Depression created a whole new set of images for photographers and for citizens. The men waiting in 1932 for admission to a city shelter have already become anonymous (page 69). The high angle, and the slashing human diagonal formed by the jobless, create a mass of men who have lost their individuality. There are a few scattered black faces among them, but in that year most of the New York poor were white. They form a remarkably orderly crowd (perhaps shaped by military service in the Great War only fifteen years earlier), two by two at the front, then thickening to four or five across as the line stretches into the distance, and possibly across the street. They are assembled on East 25th Street in hope of soup and a bed, but they allow room for ordinary pedestrians to go by along the sidewalk apparently glazed by winter ice, or for drivers to get to their snappy roadsters parked at the curb. All seem to have accepted their places on this raw afternoon, in an unwritten armistice with fatalism. All wear hats, ranging from the once-proud fedoras of the broken middle class to the rough caps of busted-out blue collar workers. Some wear neckties, emblems of the failed search for work. Each looks engulfed in isolation, saying nothing to the man beside him. If there are women in their lives—mothers, wives, lovers, daughters—they do not exist on East 25th Street. These men have formed a fraternity of ruined strangers. In the Eighties, similar men—jobless, homeless, womenless—would surge again into the consciousness of New York, put there by photographers.

But even during the Great Depression, some New Yorkers tried to lead ordinary lives, and the photographers from the *Daily News* were present to freeze the small moments. Kids dive off the Grand Street pier into the East River in 1935, looking like extras from the movie *Dead End* (page 93). We know that many such kids contracted terrible diseases in the filthy waters. Some died horrible deaths, heads wedged into sunken milk cans or impaled on spears of scrap metal. But as captured in this frozen moment, they epitomize the carefree pleasures of a summer's day among the city's poorest children. Uptown in Central Park, other kids are "choosing up sides" for a game of softball (page 73). In this ritual (which lasted deep into the Fifties), one kid would toss a bat to another, who gripped it at the barrel. The first kid then would place a hand on top of the hand of the boy gripping the bat, and then they would alternate gripping hands until they reached the top. The boy whose hand filled the last inch would make the first choice of the game: the pick of a player, or the decision to have his team bat last. This was obviously a time before over-organized Little Leagues took the fun out of summer afternoons on ball fields. The kids themselves are clearly "better off" than most. The tallest kid wears a necktie (suggesting that this was a game played after school). At least four of the boys have baseball gloves, a luxury unknown to the kids who are leaping off the Grand Street pier. But both sets of boys seem imbued with joy, in spite of breadlines and Hoovervilles elsewhere in the city.

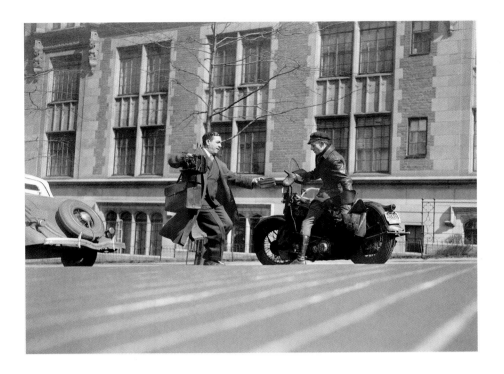

A *Daily News* photographer hands
off film to a motorcycle courier.

Racial tension also became a continuing journalistic theme in the Thirties. The dancing teenagers of the Twenties, who seem uncomfortably stereotypical to contemporary eyes (page 52), were replaced by more sadly familiar images in 1935, when Harlem erupted into violence (page 85). As would happen in 1943, and then more frequently in the Sixties, this was essentially an assault on white-owned property rather than a conflict between blacks and whites. Depression Harlem had been targeted for organization by American Communists (black and white) and Marcus Garvey retained some influence as a prophet of black separation. They were only several of the strands that came together among the black poor on this day of window smashing, looting, and gunshots, all fed by rumor and fear. The nexus of race and class exposed a seething undertow in the city's daily life. And even then—in a time when the income gap between blacks and whites had been narrowed by the economic collapse—symbols had enduring power. One symbol was the white policeman with a gun. The Depression would end, but some New York symbols never do go away.

Throughout the Depression, readers of the *Daily News* could gaze at the reassuring faces of the famous or notorious (the dreadful word celebrity was not then as common as it is now). In an uncertain world, they were people who had triumphed over the leveling force of the economic collapse. There is Amelia Earhart, exuberant with accomplishment; Marlene Dietrich, dancing in a counterfeit of romance with Cornelius Vanderbilt Whitney; a partying J. Edgar Hoover wearing a Mickey Mouse mask, which if removed would have revealed the "tough cop" mask underneath; a young Ronald Reagan posing with Jane Wyman, who would become his first wife. Here, against the background of Depression, Shipwreck Kelly does his act on the top of a skyscraper. A goggled Fiorello LaGuardia, greatest of all New York mayors, races to a fire in a police sidecar. And there is another famous face from the Thirties. He is notorious, not famous, and hasn't triumphed over anything. Still everybody knows his name. He looks oddly regal in a New Jersey prison cell, lean, dressed as sharply as an actor or a gangster, right down to the neat white handkerchief in his breast pocket. This is Bruno Richard Hauptmann, the accused kidnapper and killer of the infant son of Charles and Anne Lindbergh (page 103). He is insisting upon his innocence. But many readers of the *Daily News* must have stared at those hands and wondered whether they had snuffed the life out of a baby.

Across all decades, in bad times and good, the newspaper attempted to create a matrix of normalcy, against which it played its stories and photographs of horror or absurdity. Weather pictures always worked: packed summer beaches, kids romping in water from open fire hydrants, snow-jammed streets, the first days of spring. Sometimes they resembled the paintings of Reginald Marsh (who had begun his career as a sketch artist for the *Daily News);* many were excuses for home-grown cheesecake. On the beach at Coney Island just after World War Two, a young man with a body-builder's physique flexes his pecs for the photographer while his adoring female friend bends away shyly (page 137). A small boy to

the right flexes his own biceps, in a kind of parody, or an act of criticism. In other parts of the newspaper, you could see marvelous cityscapes: downtown street markets after a snow fall, the skyline at night, views from bridges and parkways. There were repeated scenes of firemen tending to victims. Over and over again, there were images of people driven mad by the city or by life or by both: ready to plunge off window ledges or rooftops or bridges. These last were codified by the *Daily News* assignment desk as "jumpers." In the mid-Seventies, a retiring *Daily News* photographer named Tom Gallagher was driving through Elmhurst and saw a familiar building.

"See that fire escape over there?" he said. "I stood there once for an hour in the unbearable heat of a July day, praying that a guy on the roof wouldn't jump. I thought about my wife in the hospital and I prayed for her, and myself, and when he jumped I got six pictures of him going down."

This wasn't callousness; Gallagher was simply doing what he was paid to do: freeze some of those moments of time that make up the long narrative of the city. Almost as common an event as the jumper was the "floater," the swollen body of a human being found in the rivers, canals, or harbor. Usually a floater was a jumper who said farewell without benefit of an audience of neighbors, relatives, cops, or photographers and neighbors. But once in a while, a floater was riddled with bullets or stab wounds and then would be placed into a separate category: the simple murder (usually the consequence of love and jealousy), or the more professional genre of the Mob Hit.

Sports photography was often the best in the newspaper, for one solid reason: there was no script. The sports publicists did arrange pseudo-events: athletes visiting hospitals, managers holding forth in dugouts, newly-signed players donning team caps in winter. But most of the photographers concentrated on the games and contests themselves. Every baseball game was spontaneous; no action and no game was exactly like any other. And the *Daily News* was the essential newspaper for baseball. For a long time, men and women actually read the newspaper in different ways. The men started with the back page, that is, with sports. Women more often started at the front of the newspaper. My father, for example, read Dick Young every day because he was the best baseball writer in the city. My mother read the upfront news first and then went to her favorite comic strip, Milton Caniff's superb *Terry and the Pirates*. There were women sports fans too, of course, and some of them must have started from the back page each morning. But one thing was absolutely certain: the sports section became the most important in the newspaper.

Before World War Two, baseball and boxing were the city's major sports. Kids played ball themselves and rooted passionately for one of the three major league teams. Boxing aroused other passions, some of them ethnic and religious, and the greatest compliment one street kid could utter about another was that "he's good with his hands." There were dozens of small fight clubs in the city, from Coney Island to the Bronx, smoky places where young fighters patiently learned their brutal trade in hopes of making it to the Garden. Every working class neighborhood seemed to have its own

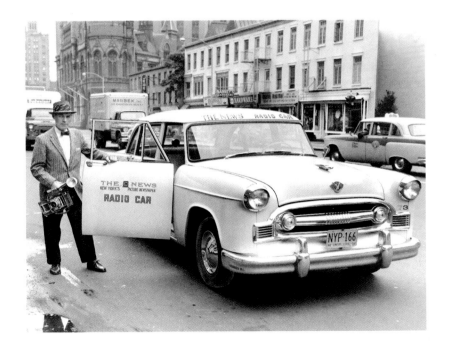

Tom Baffer poses next to one of the *Daily News* Checker Radio Cars, September 1958. At one time, the paper sported ten such cars.

champions, in various weight divisions. It was natural and fitting that the *Daily News* became the sponsor of the Golden Gloves tournaments, featuring amateur fighters. Many went on to professional careers, and one Golden Gloves light-weight champion out of Harlem—Sugar Ray Robinson—would later be welterweight and middleweight champion of the world, and rated by experts as the greatest fighter who ever lived.

There was only minor interest in other sports. Football was played by college boys and basketball hadn't yet blossomed as the city game. In that era before automobiles jammed every street, all New York boys played baseball, or its street variant, stickball. All street kids learned to fight with varying degrees of skill. They dreamed of becoming Babe Ruth or Lou Gehrig, Mickey Walker or Joe Louis, Joe DiMaggio or Mel Ott. They followed the Dodgers, Giants, or Yankees with almost Talmudic intensity, memorizing statistics, acting out plays described in print, heard on radio, or shown in photographs. They always chose sides. Every New Yorker's identity kit included the team for which he or she rooted. It was no accident that the *Daily News* began its long steady slide in circulation and profits around the time in 1957 when the Dodgers and Giants abandoned New York. There were several other reasons (and they afflicted every newspaper in the nation). But baseball was essential to millions of New Yorkers in all boroughs, one of the binding elements of the city; the departure of the Giants and Dodgers helped unravel the bonds.

Long before the circulation and business decline that started in the Fifties, the *Daily News* had begun to tame itself as a newspaper. The major reason was the Depression. In 1930, Patterson, the old socialist, told his staff (quoted in Frank Mott's *American Journalism*): "We're off on the wrong foot. The people's major interest is not in the playboy, Broadway, and divorces, but how they're going to eat; and from this time forward, we'll pay attention to the struggle for existence that's just beginning. All signs point to the prospect of a great economic upheaval, and we'll pay attention to the news of things being done to assure the well-being of the average man and his family."

Another reason was the presence in town after 1924 of Bernarr McFadden's New York *Evening Graphic,* a tabloid that pushed sensationalism to its limit, featuring fraudulent composite photographs (called "cosmographs") and publishing "news" stories that read even then like hilarious parodies of the news. The *Graphic* is the true ancestor of today's supermarket weekly tabloids, but it never made a profit. Advertisers wanted nothing to do with it, for a very simple reason: if the reader doesn't believe the news stories he or she will never believe the advertising. The *Graphic* vanished in 1932. But during its eight years of nutty life, the *Graphic* did accomplish what no Patterson publicity campaign ever could: it made the *Daily News* respectable.

Patterson's other tabloid competitor was Hearst's *Daily Mirror,* founded the same year as the *Graphic,* carried by gossip columnist Walter Winchell (who started his career at the *Graphic).* By the mid-Thirties Winchell was the greatest star in American journalism. In my neighborhood each evening, people went to buy the early editions of the morning papers, laid down a nickel and received a *News,* a *Mirror,* and a one-cent package of Chiclets in return. They read Winchell in the *Mirror.* They read the entire *Daily News.* The kids usually got the gum.

Patterson died in 1947, before the arrival of commercial television in American life, and so he did not witness the way the still photograph slowly began to lose its uniqueness, its existence as the primary source of visual information. The photographs themselves were better than they had ever been, the photographers more resourceful and professional, the technical facilities (particularly at the *Daily News)* more highly-developed. But New York television addicts, like all Americans, were soon drowning in visual images. By the late Sixties, television news was also in "living color," while all New York newspapers were still printed in black and white.

Television eventually killed most afternoon newspapers (and many morning sheets), as the mass audience turned to the easier, more passive medium for news and entertainment. But more subtly, it robbed the still photograph of its monopoly on graphic journalism. Eventually the new medium would help destroy the big swaggering picture magazines such as *Life* and its imitator and competitor, *Look,* both of which had learned valuable lessons from New York's Picture Newspaper. And it eventually forced newspaper editors and photographers to compete in new ways. Above all, they had to *see* better than the television camera did. Moving images on television often missed the revealing detail. In those days before instant replay or VCRs, the images on television could not be played back and studied (and, with the exception of sports, are seldom scrutinized even now). But a great still photograph could be *read.* That is, the person holding the news-

paper could look at the faces, postures, clothing, and hands of the murder suspect, in an attempt to understand character or motive. He or she could examine the surroundings of an event, the scene of the crime or the riot or the disaster, and make the imaginative leap toward being there too. The reader could see the precise moment when Robinson hit Gavilan, or the suicide stepped off the lip of the roof. The moment was frozen forever, not lost in a blur of action. The best photographers rose to the challenge of television. More than ever, they wanted to do more than settle for *a* picture; they wanted to make *the* picture.

V.

The city itself continued to force certain continuities upon the *News* photographers who roamed its streets. There's a marvelous photograph here of a shooting gallery on 42nd Street in 1954 (page 160). The polished floor tells us it is morning, and customers have not yet begun carpeting the place with litter. A young man leans against the door frame, apparently finishing a slice of pizza. He's a masterpiece of the "grease" look: leather jacket, pegged pants, the hair combed and pomaded into baroque streaks and swirls. But it's his face that tells us we are in New York: wary, decoding the evidence of the unseen street, perhaps predatory. The smaller man behind him is dressed in the same style but is oddly detached, as if serving as a bodyguard or an accomplice. A sign offers free sauerkraut. Nobody is shooting in the shooting gallery. But there's a sense of latent menace in the faces of the young men..

The shooting is over in the barbershop of the Park Sheraton Hotel as photographed on a day in October 1957 (page 176). There lies the corpse of Albert Anastasia, better known as the Lord High Executioner of the Mob, shot in his chair while getting a shave. The murderous Anastasia was a crucial link between the Italian hoodlums who controlled the South Brooklyn waterfront and the Jewish hoodlums out of Brownsville who terrified the garment unions (a nice little outfit better known as Murder Incorporated). Albert was believed to have personally killed about twenty-five men. Now it was his turn, and he lies bare-chested on the barbershop floor, waiting for the men from the morgue.

After Anastasia's execution, detectives questioned a young woman named Janice Drake. A classic tabloid blonde, she was married to a comedian named Alan Drake and was friendly with various hoodlums in the world of Mob-controlled

Jacqueline Kennedy Onassis and photographer Mel Finkelstein after a scuffle on 57th Street, November 1969.
ANTHONY CASALE

Susan Watts covers the crash of TWA Flight 800 off Moriches inlet, Long Island, July 1996.
DAVID HANDSCHUH

night clubs (where, in memory, seventy-five percent of the females were as blonde as Janice Drake). At the time of Albert's rubout, she didn't, of course, know nuttin'. Now, in a splendid photograph made two years later Hy Summers, she lies dead in a parked car in Jackson Heights (page 175). Virtually hidden behind the steering wheel is her companion, a hoodlum named Little Augie Pisano. He is also very dead. But I cherish the classic face of the cop, molded by years of observing human folly and unspeakable felonies, and the dainty way he holds his flashlight.

And so, gangsters remained an essential part of the world exposed to the lenses of the *Daily News* photographers. Those who want to follow a narrative line that begins with the death of Monk Eastman can flash forward to the chilling 1979 photograph by Frank Castoral of one Carmine Galante in the backyard of a restaurant in Brooklyn (page 249). For a very brief time, Galante ran the Brooklyn mob. He was clearly a disappointing chieftain and, after a few months in power, was blasted on this day into permanent retirement along with his chief lieutenant. But on the day this photograph ran on the front page, hundreds of thousands of New Yorkers burst into laughter. The cause of their sardonic mirth was a detail lost to television: the cigar jammed in Galante's mouth. Both God and the devil reside in the details.

For a long time, ordinary murder retained its power to disturb. There's a photograph here of a woman named Josephine Senguiz that is a study in human desolation (page 193). She is cradling the head of her lover, James Linares, in the hallway of her apartment, while policemen make notes. Linares has been shot by Josephine's husband. There is blood on the tiled floor. There is blood on the steps. There is blood on her toes and blood on her wedgies. All of it is the blood of her dead lover. Her face has been emptied of almost everything, including grief or horror. She is beyond performing for the cameras. Whatever vision she might have had of a blissful future has drained away with the blood.

The Sixties truly arrived with the murder of John Fitzgerald Kennedy and Dan Farrell, one of the most gifted of the younger *Daily News* photographers, was at the president's funeral to record the small salute of the boy then called John-John (page 198). It was the boy's third birthday. Nobody then could predict the way that boy would himself come to the end of his days. In the coming years, other public men would die, including Martin Luther King and Robert F. Kennedy. The extraordinary was in danger of becoming ordinary.

In New York's Sixties, guns and drugs began to flood the neighborhoods, driving up the murder statistics; it gradually became difficult to get an ordinary crime of passion into the newspaper, or a death in a simple hold-up; by the Eighties, reported killings were almost always multiple homicides. Enormous social and cultural changes were also under way in the country, and New York was part of the larger story. The baby boom of the post-war years was creating what came to be known as a counter-culture. The sound track was provided by rock 'n' roll, which arrived locally in the Fifties on Alan Freed's radio show and at Brooklyn's Fox theater and the St. Nicholas Arena in Manhattan. By 1965, the British invasion was under way, and the Beatles were selling out Shea Stadium, which didn't even exist when Buddy Holly played the Fox a decade earlier, while the Rolling Stones provided their own darker blues-driven counterpoint to the Beatles and their imitators. Hats vanished. Young men wore their hair longer. Clothing merged with costume, marijuana replaced whiskey,

the Pill became a factor in sexual liberation. And behind everything, in demonstrations on the lawns of Central Park, in crowds and draft-card burnings at recruiting stations, bonding the young like cement was the war in Vietnam.

Even celebrities changed. Here is Che Guevara, smoking a cigar while appearing on *Face the Nation* in a Manhattan studio, his movie-star good looks frozen forever (page 210). There is Allen Ginsberg, a Fifties poet who became a Sixties peace advocate, preaching in the shade of a New York tree (page 216). On another page we see Andy Warhol directing one of his avant-garde movies; years later, a crazed woman would give him tabloid immortality trying to kill him with a gunshot (page 217). The Beatles broke up, but John Lennon found Yoko Ono and remained an icon of the counter-culture until he too was murdered in 1985, on the sidewalk outside the Dakota (page 250).

Obviously, not everything in New York life was reduced in the Sixties to sex, drugs, and rock 'n' roll. Millions of citizens got up in the morning, took the subways to work, read the *Daily News,* and went home to their families. Nobody much noticed that factories were closing in Brooklyn and Queens and that the welfare rolls were beginning to expand. Hell, New York was always changing. Buildings were knocked down and others took their place. Hot restaurants opened and closed. And in spite of the growing turmoil, and the long hair, and the use of pot, and the shouts of rock 'n' roll, there were good things happening too.

In sports, the Mets arrived in 1962 to replace the vanished Giants and Dodgers as a National League franchise; they soon moved into their ballpark in Queens, which some of the young called Che Stadium. Professional football became a major sport, with the Giants fielding great fierce teams and the upstart New York Jets playing on the grass at Shea, commanded by a randy, night-clubbing quarterback named Joe Namath. Fewer kids played baseball, and stickball vanished from the crowded streets, but basketball was becoming the city game at last, and the Knicks of Willis Reed, Bill Bradley, Dave DeBusschere, and Walt Frazier started selling out the Garden. And in 1969, a year after the Tet Offensive in Vietnam, various miracles took place in New York: the Mets won the World Series, the Jets won the Super Bowl, and Knicks of the 1969–70 season won the NBA championship. The reporters and photographers covered all of these immense events, and they gave New York a certain amount of emotional immunity from the poisons that were flowing from the distant war.

But even sports could not remain completely separate from the turmoil. The most controversial figure of all was the young man who had become heavyweight boxing champion as Cassius Clay and swiftly changed his name to Muhammad Ali. For a long time, conservative sports writers insisted on calling him Cassius Clay, although they had no problem with the name Sugar Ray Robinson, adapted by the man who was born Walker Smith. But the new name was taken when the kid from Louisville embraced the Black Muslims, influenced by Malcom X, a figure of enormous social controversy. Here is Muhammad Ali in 1964, walking a Harlem street in astonishing anonymity, without bodyguards or hangers-on, whistling some vagrant tune (page 210). Everything else lay before him: his refusal to be drafted on religious grounds (" I got nothing against them Viet Congs"); his three-year exile from boxing as various politically-appointed commissioners (including those in New York) stripped him of his title; the great comeback; the fierce wars with Joe Frazier; the beatings near the end of his career when his skills had eroded; his imprisonment by Parkinson's. In the ring and out, Ali was loved by photographers, and his youth and energy and charm live on in the images they made.

By the late Eighties, New York seemed in irreversible decline, and many photographs gave vivid life to the cold statistics. Murder and other violent crimes soared. The number of welfare cases would pass 1.2 million, while almost a million manufacturing jobs simply disappeared. Homeless men were everywhere, stupid with drugs or alcohol, sleeping in cardboard boxes or under bridges or finding some repose in the expanding network of homeless shelters. Abandoned women and their children were housed in welfare hotels, often run by unscrupulous hustlers. The shopping-bag lady was the female counterpart of the homeless men, usually middle-aged and white, mumbling incessantly to herself, sleeping in doorways.

At the same time, two new plagues made their appearances: AIDS and crack cocaine. Teenagers killed each other over gold chains or the right to control street corners as crack markets. Pregnant crackheads gave birth to crack-addled babies (some of whom also carried the HIV virus). The city's courts and prisons were jammed and so were the wards of public hospitals. The Gay Pride celebrations that rose noisily and triumphantly in the Sixties seemed more like solemn processions by the end of the Eighties, with disco music sounding like a dirge. Poor, ravaged Jose Ramos, photographed by Monica Alemeida in the AIDS ward at Riker's Island prison in 1987, illustrated the fear and pity that was at the heart of

this new plague (page 278). The woman known as Gloria, photographed in a brilliant series by Susan Watts in 1997, fought heroin, peddled her body on Bronx street corners, and still wanted to live (page 307). More and more, the *Daily News* photographers were forced to see beyond the mere surface of events into the true heart of New York darkness.

There were other terrible diversions. Crown Heights exploded into rioting in August 1991, with African-Americans and immigrant blacks blaming Hasidic Jews for a variety of offenses, most specifically the reckless killing of a black child by a Hasidic ambulance. Rocks were thrown, bottles smashed, automobiles burned, some reporters beaten. A visiting Hasidic scholar from Australia named Yankel Rosenbaum was stabbed to death by a black youth from a different neighborhood. John Roca's photograph of a Hasid silhouetted against a fire captured perfectly the sense of an August night careening out of control (page 284).

For readers of the *Daily News,* gangsters began to take on new meanings. Most were simply heroin merchants or colorless old hoodlums like the sparrowlike Carlo Gambino of Brooklyn. In the Seventies, however, the success of *The Godfather* filled some New Yorkers with a certain nostalgia for the days when gangsters supplied only things that were socially acceptable, such as gambling and bootleg whiskey. And the Mob as shown by Francis Coppolla's versions of Mario Puzo's novel did represent power. In a time when all sources of authority seemed to be unraveling, even dark power had its attractions. There was a continued revival of interest in the myth of the Mob, in spite of reality.

This long revival culminated on the night of December 16, 1985, when a colorless businesslike boss named Paulie Castellano lost a Mob primary outside a Manhattan restaurant called Sparks Steak House (page 260). The winner of the primary was a tough, crudely handsome, swashbuckling hoodlum named John Gotti. From the moment he appeared on the public stage, the tabloids and the citizenry loved him. John Gotti looked like a gangster. He dressed like a gangster. He talked like a gangster. In a troubled time, he stood for the eternal verities. The papers started calling him the Dapper Don, and then—after he walked free from several prosecutions—the Teflon Don. Gotti, on the evidence of various tapes, believed in the myth of the Mob as passionately as many citizens wanted to believe it. Yes: a Mob boss must sometimes sanction violence, the myth said, but only as a last resort. And hey, we only kill each other. With dumb street kids killing each other over sneakers and gold chains, John Gotti seemed to be a model of restraint.

Daily News photographers, and television crews, stalked him as a brand new local celebrity, far more important than someone like Princess Di. They photographed him: walking on Mulberry Street, standing in courtrooms, walking down courtroom steps (page 268). But in a crucial way, the camera made Gotti too famous. His acquittals enraged prosecutors and they came at him with sustained attention, and finally nailed him, with the testimony of an informer named Sammy (the Bull) Gravano. At last, Gotti went to jail, and will probably die there. The rat moved to Arizona. Since Gotti's departure, not much attention is paid to the Mob, which is fitting, since it barely exists anymore in its old strutting style. The new Mob is made up of more recent arrivals in New York: Russians, Colombians, Asians, full of fierce immigrant energy, and the newspapers have yet to penetrate their defenses or transform them into myth. We can see here the bodies of dead Vietnamese gangsters, but they don't yet have their own myth (page 290). That mythology will surely emerge, from reporters and novelists and filmmakers, but just as generals always fight the last war, too many editors still look for criminal organizations that resemble the old ones. I suspect that what reporters will eventually discover about the new Mob will be surprising. That is, it will be news. And it will be the subject of some extraordinary photographs.

Today, photographers from the *Daily News* and other newspapers still move out each working day in hope of freezing at least one brilliant moment of the city's narrative. With any luck, that moment will last for a long time, memorializing both the image and the photographer who saw it and recorded it. On some days, they might capture the eerie beauty of an ice-encrusted fire engine, as Tom Monaster did in the Eighties, seeing it as if it were some dim-eyed, unknown arctic animal (page 256). They might see Diana Ross performing in a Central Park rainstorm, with the rain adding an erotic surprise that was not in the script (page 255). They might see the detectives on an early morning examination of the murder of a young woman and know that the photograph will become the first image in a series that will be part of the tale of the Preppie Murder (page 265). Or they might make the visual impact of the photograph of runners on a New York street, at once specific and universal, all flight and desire and speed (page 301).

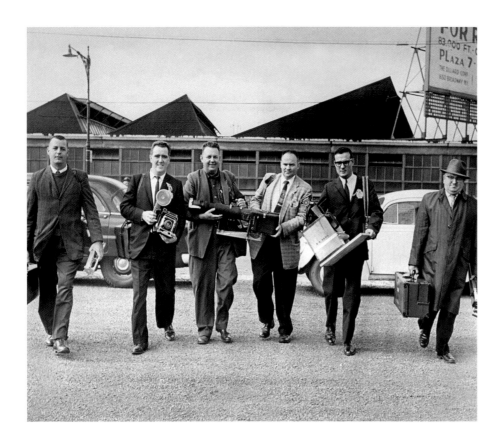

The images in this book are collective proof that the goal of freezing time remains both honorable and immensely valuable. Every city is dynamic, of course, changing by the day and the hour, continually altered by outside forces, or propelled forward by local will and intelligence. New York reversed its long decline in the Nineties with just such an act of collective will (with the help of that great intangible, luck). To be sure, New York at the beginning of the twenty-first century is not the city that it was when Joseph Patterson and the *Daily News* were young. But I suspect that the Captain would smile upon the current version of his great creation, and recognize that photographers are still doing their jobs as he hoped they would, long ago.

For Patterson knew that a great photograph often reveals the city to the people who share its life. Old immigrants see their grandmothers in the faces of young new immigrants. Survivors of hard times recognize the humanity of those trapped in hard times now. The present tense of one man's story can suggest the future of another. Great photographs burn images into memory, and when they are absorbed by hundreds of thousands of people on the same morning, they become part of the dense mesh of community memory. All residents then carry those images as part of their secret urban identity kits, some for a very long time indeed. One immense lesson taught by a dynamic, restless city is that nothing is perfect, utopia is elusive—and even dangerous. Great photographs offer permanent evidence of the endless human capacity for folly. In that sense, they make us all more human. And that is an enterprise that must never end.

The Boys of Autumn: Ed Peters, Dan Farrell, Charles Payne, John Duprey, Jordan Fogel, and William Klein at Yankee Stadium, October 1961.

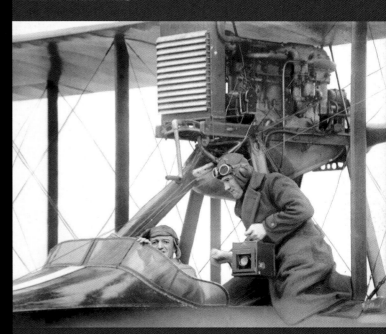

Martin McEvilly prepares to take off to shoot the scene of a disaster from the air, April 1925. From its inception, the *Daily News* used aerial views to give readers a different perspective on the growing city. The paper eventually owned six planes, crashing several along the way. Aerial photography in those days meant landing in cow fields and freezing in open cockpits—this was photography as an adventure.

The country's financial center is shaken by a tremendous explosion—the mangled remains of the unfortunate horse and the wagon carrying the bomb are near the foreground in this photograph (published the following day)—at noon on September 16, 1920, outside the headquarters of J. P. Morgan & Company, the banking giant, at 23 Wall Street. The blast killed about 30 people and injured more than 400, and it left scars in the building that are still visible. This was a period of real and purported anarchist and communist plots—the Bolsheviks had seized power in Russia less than three years earlier—and of a wholesale federal roundup of radicals in response to the "Red Scare." Nevertheless, despite a first-day report in the *Daily News* that "Wall St. Ignored Warning," this explosion remained an unsolved crime.

ED JACKSON

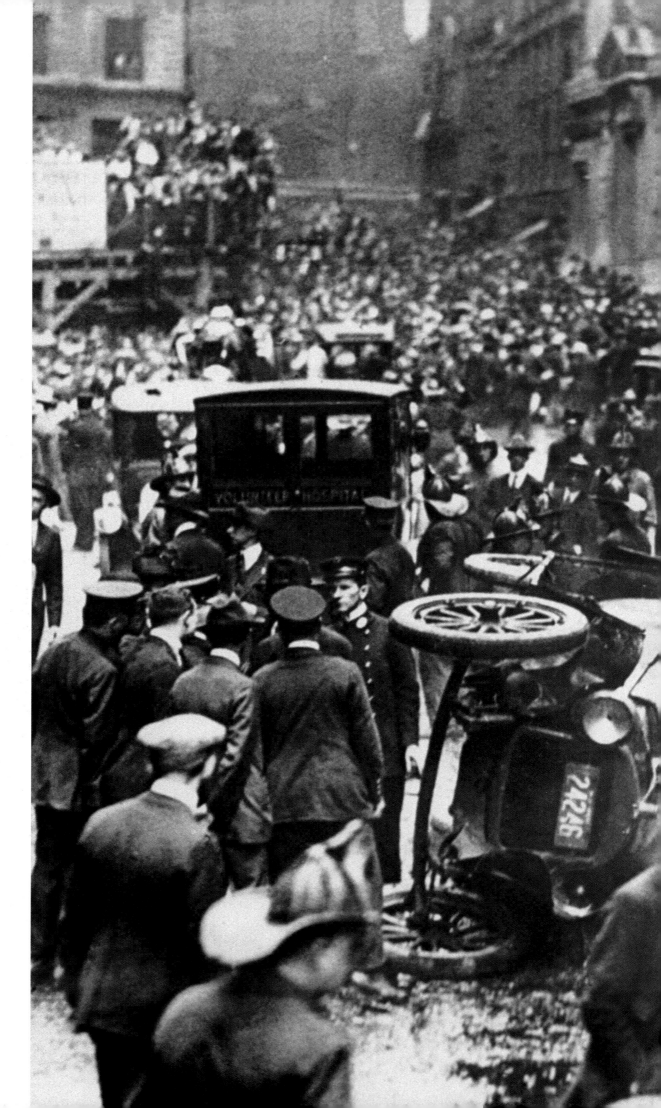

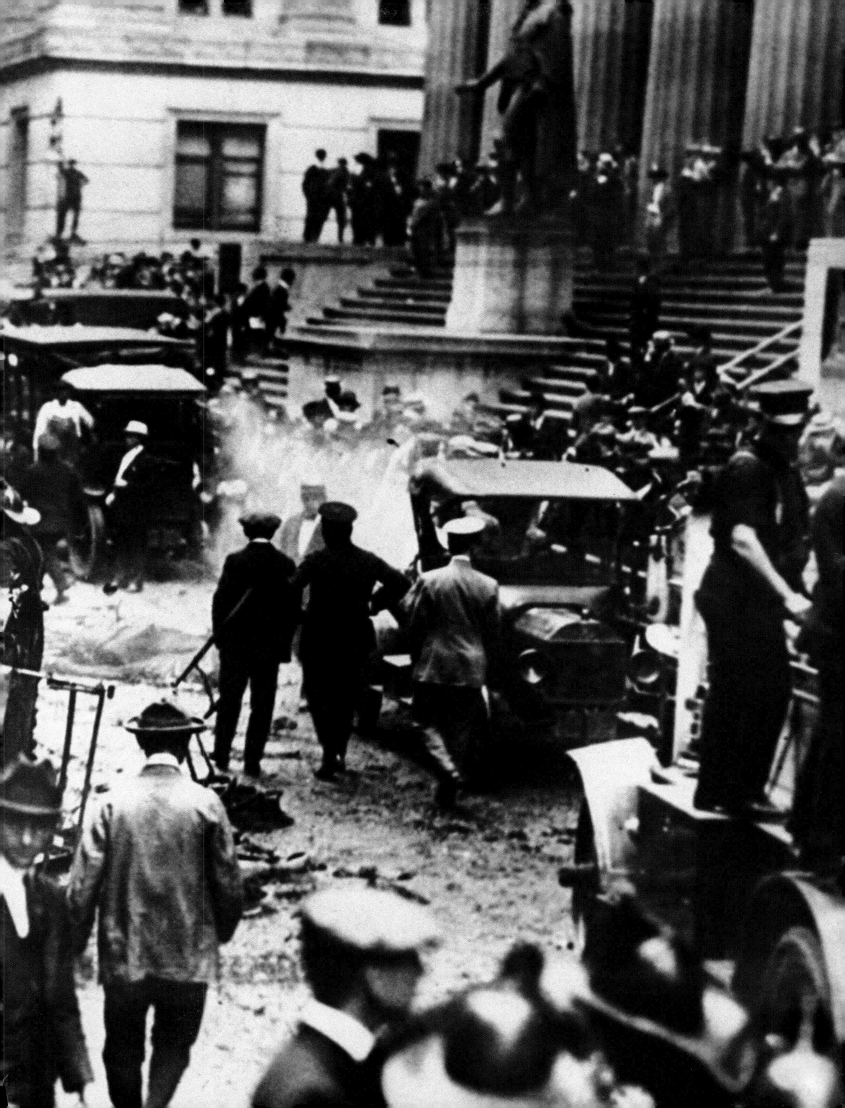

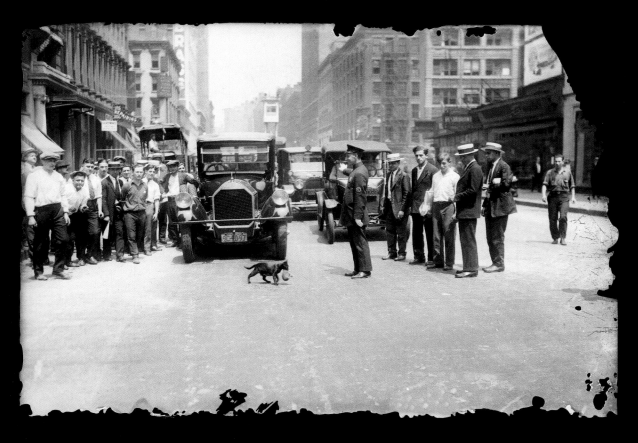

Above:
Blackie halts traffic as she transports her new family of five kittens, one by one, across Lafayette Street at Walker Street (just below Canal Street in lower Manhattan) on July 28, 1925. Police Officer James Cudmore lent a helping hand as the neighborhood mascot, who had mysteriously vanished two weeks earlier, returned from her makeshift maternity ward on the west side of Broadway to "her castle beneath a desk" at the Atwater Company.
HARRY WARNECKE

Opposite:
Shoeless Joe Jackson (right) of the Chicago White Sox and the New York Yankees' Babe Ruth look at one of Babe's home run bats in 1920. The two sluggers' career paths were about to diverge. Ruth, already a star when purchased from the Boston Red Sox over the winter, began his decade-long domination of the game with a .376 season, an .847 slugging average (which no one else has even approached), and a record fifty-four homers—twenty-five more than his 1919 record, and more than all but one other *team*. But 1920 was the last year of Jackson's own decade of glory (his .356 career average was the third highest ever); at the end of the season, he and seven teammates were indicted on charges of having taken money from gamblers to throw the 1919 World Series. Immediately after a jury acquitted them in mid-1921, the high-minded new commissioner of baseball, Judge Kenesaw Mountain Landis, banned them from the game for life. The scandal was a stain on the sport that only the Babe's legendary feats could erase.

34 Customs officials (left to right) E. J. Fitzsimmons, Inspector John Sterling, J. V. Sweeney, and E. J. Starace search four Chinese crew members arrested on October 3, 1928, on charges of smuggling nearly $1.5 million worth of opium— the largest haul in the New York area up to then— aboard the SS *President Harrison*. Sterling, the head of a newly formed drug squad, literally sniffed out the drugs after boarding the ship, docked at Pier 9 in Jersey City, New Jersey. It took the squad two hours, using axes, saws, and crow- bars, to smash through a fake bulkhead and uncover one thousand pounds of opium—"essence of drugged dreams," the reporter called it—stored in six-ounce portions within 2,665 brass containers.
HARRY WARNECKE

Visitors to the city morgue take a look at slain gunman Monk Eastman, once the most notorious gang leader in New York but purportedly a reformed war hero when he was shot five times outside the Blue Bird Café, on East 14th Street near Fourth Avenue, before dawn on December 26, 1920. At the turn of the century, aided for a time by ties to the powerful Tammany Hall political machine, Eastman brutally ran gambling, prostitution, and other rackets on the Lower East Side. During World War I, Eastman unexpectedly enlisted in the Army and served honorably in battle. But speculation that he had reformed seems to have been unfounded: it appears that the corrupt Prohibition agent who later admitted to shooting Eastman was an old rival, feuding with Monk not over a tip to the waiter, as initially claimed, but over bootlegging and drug-dealing operations.

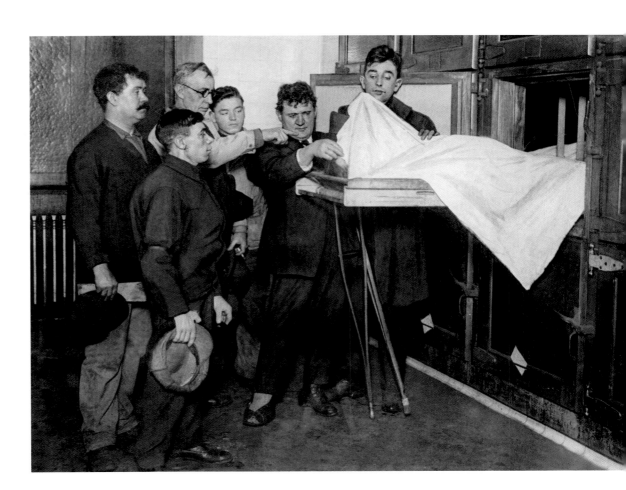

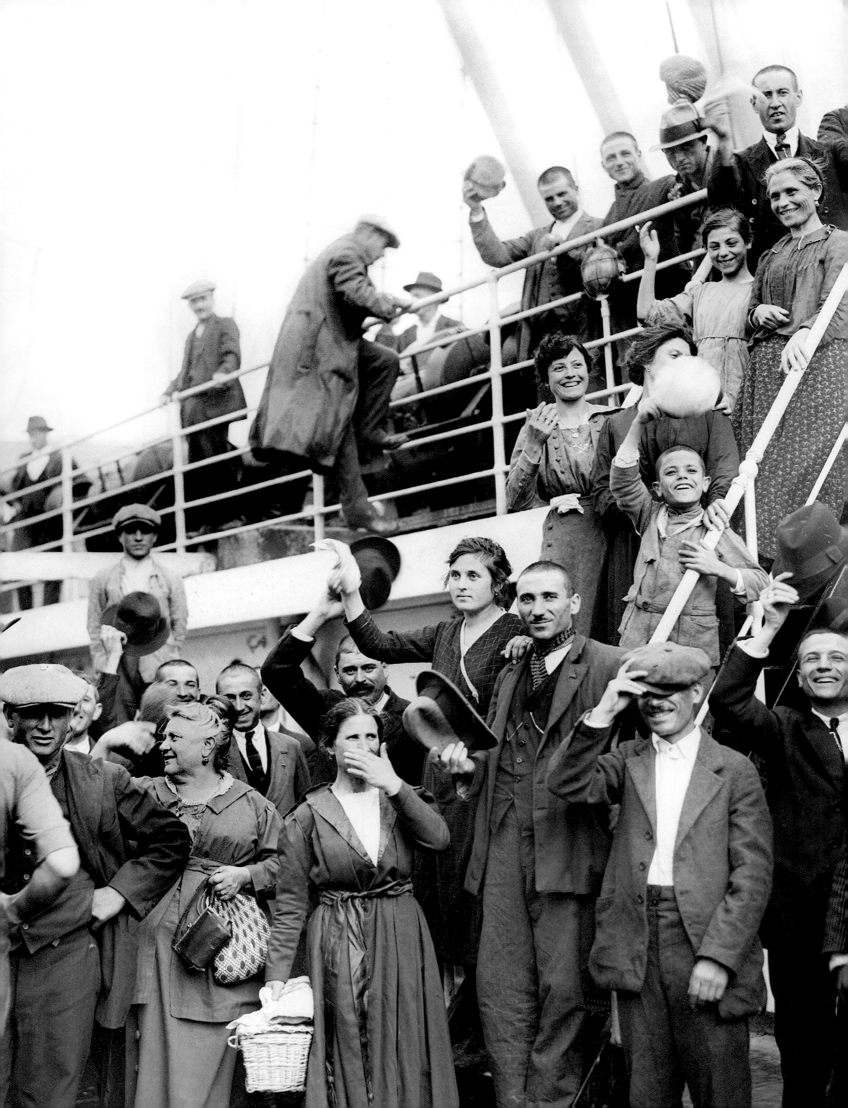

Opposite:
Seven steamships carrying 7,000 immigrants, including these steerage passengers aboard the *Conte Rosso*, arrive at Ellis Island after a race in fog and rain to be the first to land passengers on July 1, 1922, the start of a second fiscal year of sharply reduced immigration quotas. Congressional action in 1921 cut immigration from about 800,000 a year to barely 300,000 (and a 1924 law halved that number), with immigration restricted mostly to people from Great Britain, Ireland, and Germany. The legislation almost completely ended a decades-long flood of ethnically diverse— and therefore, to many Americans, undesirable— arrivals from southern and eastern Europe, most of them through the gates of Ellis Island.

Below:
At the Fulton Fish Market in late May, 1928, workers show off a giant 750-pound sturgeon caught off Virginia. The largest wholesale fish market in the country for well over a century, it is still located just south of the Brooklyn Bridge in lower Manhattan. It is at its busiest in the hours around dawn.
HANK OLEN

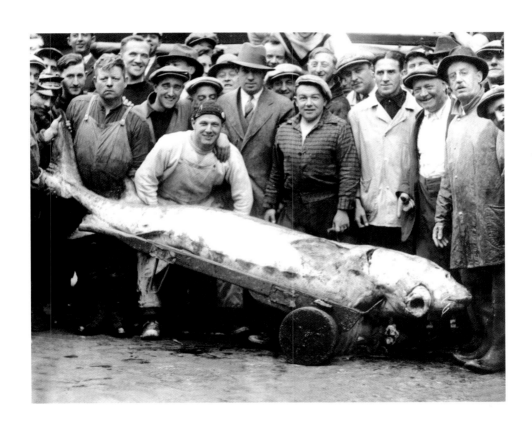

Below:

Olympic swimmer and New York native Gertrude Ederle caused a sensation when she became the first woman to swim the English Channel, in 14 hours and 31 minutes, breaking the previous men's record. Here, the nineteen-year-old athlete is seen coat-ed in grease and wading into the channel on August 6, 1926, to begin the historic crossing from France to England. Her time was sur-passed later that year, but it remained a record for women until 1964. The *Daily News*, her hometown paper, covered the story exhaustively, sparing no expense to get pictures of the feat to its readers as quickly as pos-sible. Upon her return to New York, Ederle was wel-comed with a ticker-tape parade that drew an esti-mated two million people.

Opposite:

Charles A. Lindbergh's fame was based on a single mag-nificent achievement: the first solo nonstop trans-atlantic flight, from Roosevelt Field on Long Island to Le Bourget Field, outside Paris, on May 20–21, 1927. That trip in his monoplane, *Spirit of St. Louis*, lasted a little more than thirty-three hours, but it made him one of the century's most beloved heroes. His ascendancy to the national pantheon of heroes took place virtually overnight: news-papers reporting his feat sold an unprecedented two to five times the number of copies as a normal news day.

40 People wait to get on a crowded trolley on Atlantic Avenue in Brooklyn in the summer of 1926. (Jaywalkers became known as "trolley dodgers," which produced the enduring name for Brooklyn's baseball team.) Brooklyn had become part of New York City only twenty-eight years earlier, about a decade after the Brooklyn Bridge linked the two; however, to many of its approximately two million residents, mostly immigrants, it remained a city separate and apart.

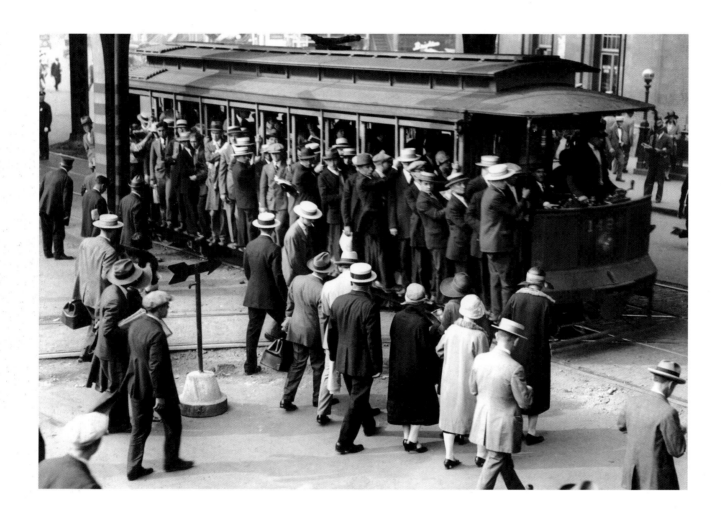

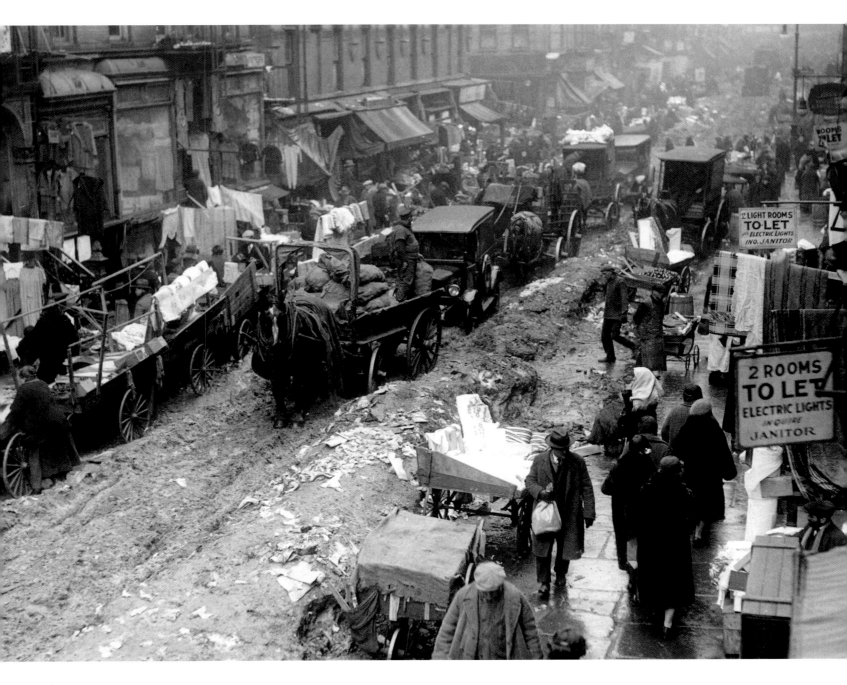

Orchard Street, on the Lower East Side, becomes a dirty quagmire after a heavy snowstorm, in mid-February, 1926. For decades, this area was the heart of the Jewish community from eastern Europe—by 1920, there were 400,000 crowding the neighborhood's tenements, which Jacob Riis had famously depicted in his book *How the Other Half Lives*—and it is still home to a small remnant of that world. As most of the immigrants assimilated and rose out of poverty, however, they also moved away.

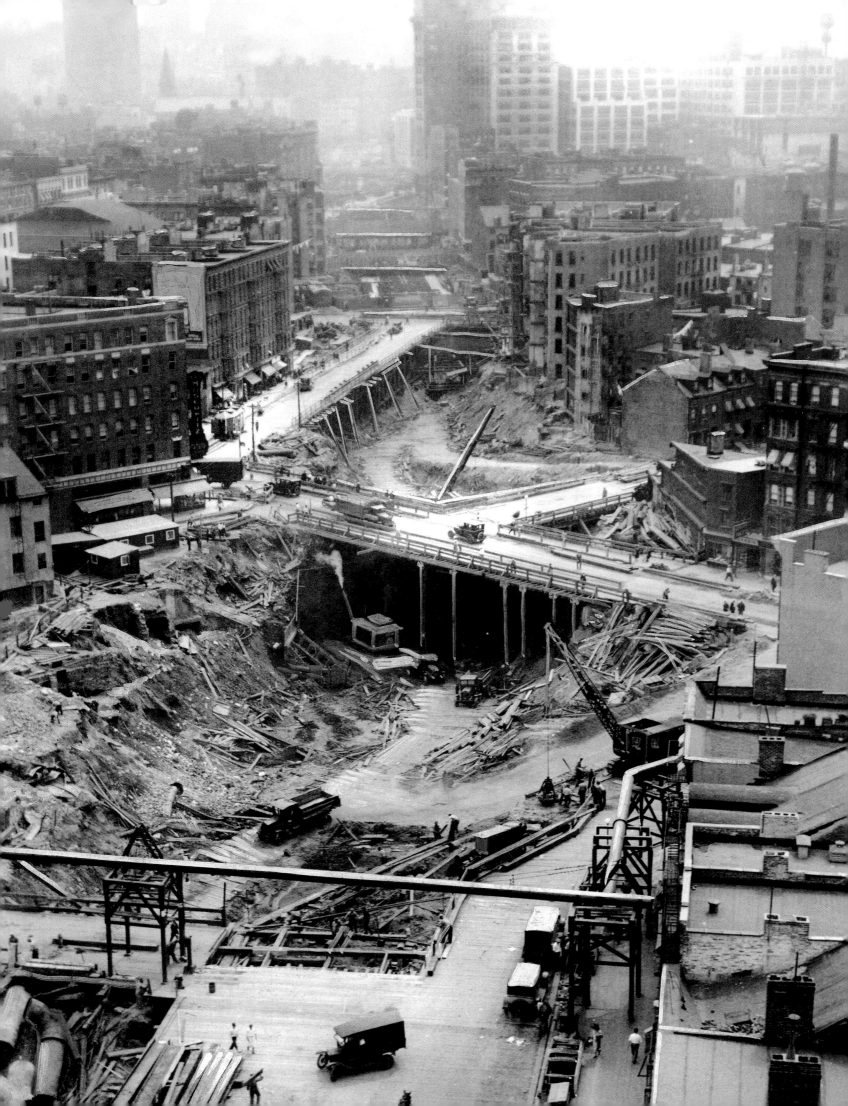

Opposite:
Sixth Avenue (looking south from West 4th Street) in Greenwich Village is a vast excavation for a new subway line in August 1927. The city's rapid-transit system had been born in 1904 with the Interborough Rapid Transit (IRT) line, which initially ran north from the Brooklyn Bridge to Grand Central Station, west to Times Square, and north to West 145th Street. Continued expansion of the system increased dramatically in the late 1920s when the new Independent Subway System (IND) began adding fifty-nine miles of track, including the Sixth Avenue and Eighth Avenue lines.
HERBERT MCCORY

Below:
Joseph V. McKee (left), president of the Board of Aldermen, accompanies Mayor James J. Walker (right) and other officials into a shaft to inspect the new Eighth Avenue subway in late May, 1928. A party of forty assembled nearly 100 feet down, then traveled along the tube from West 53rd Street to West 145th Street, sitting on park benches mounted on a truck. The laying of rails was scheduled to begin the following week. As mayor from 1925 to 1932, the colorful and extremely popular Jimmy Walker oversaw improvements to the city's transit system, hospitals, and sanitation service. Implicated in a massive corruption scandal, he resigned abruptly and moved to Europe for several years.
LARRY FROEBER

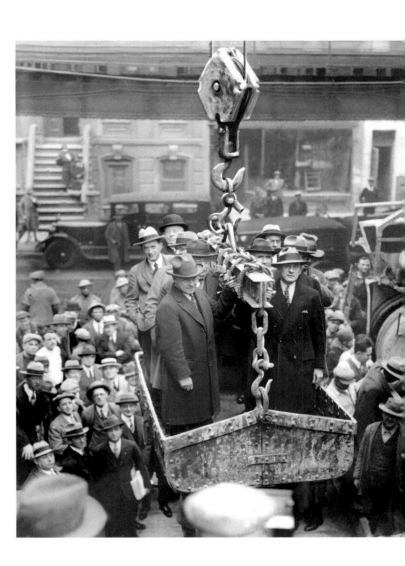

44 On July 8, 1923, John D. Rockefeller marks his eighty-fourth birthday by handing out a nickel to two-year-old Robert Irving Hunter—who politely gives it back at first—after services at New Community Church, near the philanthropist and retired oil tycoon's estate in Pocantico Hills, Westchester County.

Maybe the boy knew that Rockefeller usually gave out dimes in the annual publicity stunt, intended to counter his reputation as a ruthless "robber baron." Either way, the young beneficiaries of his modest cash gifts could only dream of becoming as "rich as Rockefeller."

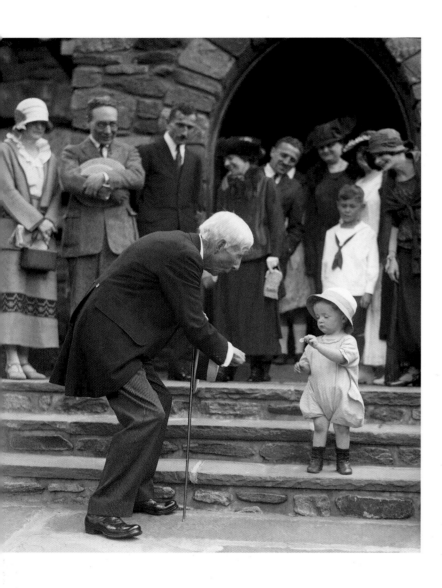

During Prohibition, children scramble to scoop up "soured" wine, dumped at Van Brunt and Sackett streets in the Red Hook section of Brooklyn, before it flows into the sewer. It took Prohibition agents five hours on September 10, 1926, to empty 150 barrels from the A. M. Forni warehouse, and the result was a boisterous block party. The nationwide ban on "the manufacture, sale or transportation of intoxicating liquors" lasted from 1920 to 1933 but was generally considered an overwhelming failure.

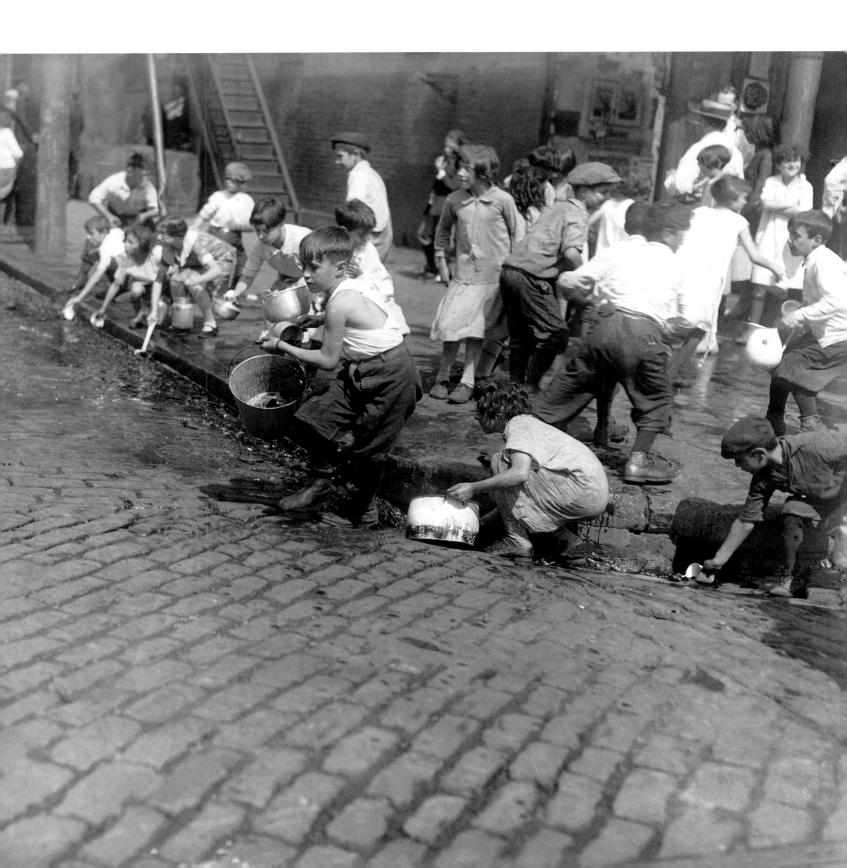

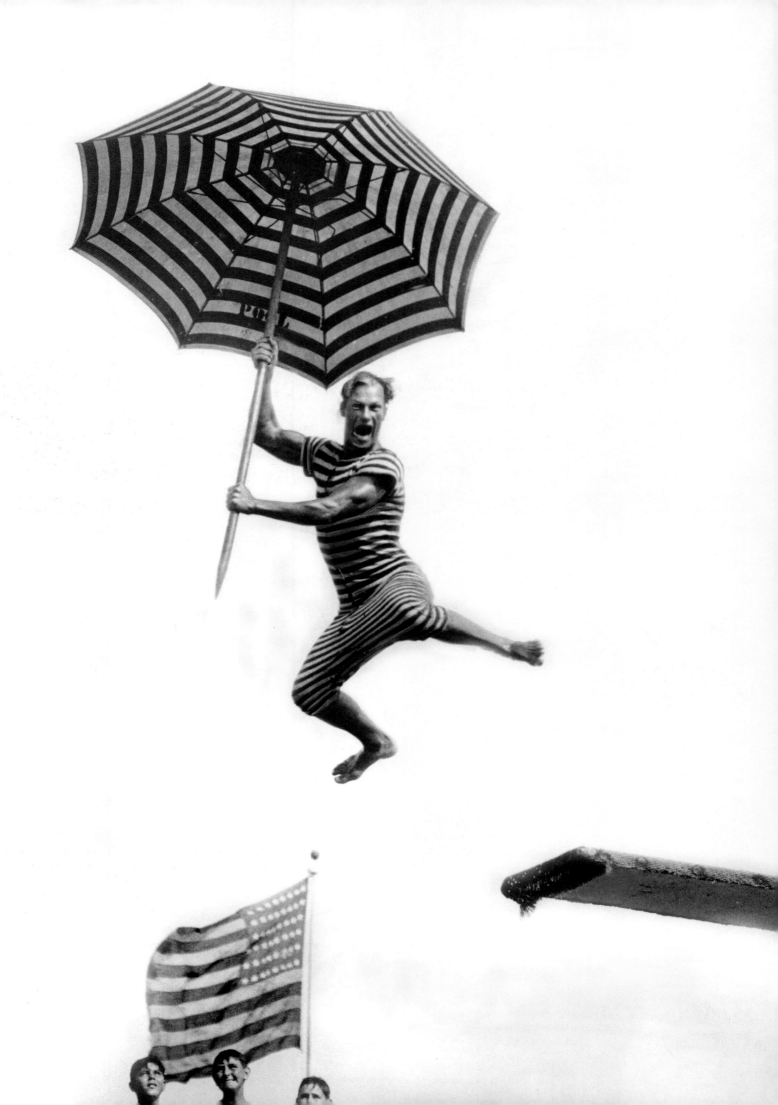

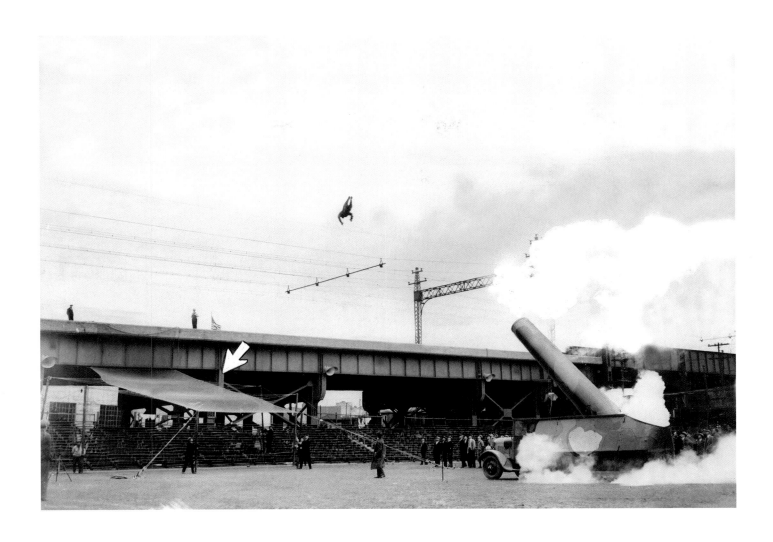

Opposite:
Harold "Stubby" Kruger performs a comic diving stunt at the Olympic Pool in Long Beach in the waning days of summer, 1927. A member of the 1920 and 1924 U.S. Olympic swimming teams, Kruger subsequently found his lifelong niche as a comedian as well as swimming instructor. His straight men in his touring acts included former Olympic competitors Johnny Weissmuller and Larry "Buster" Crabbe, before each in turn moved on to Hollywood. In Billy Rose's Aquacade at the 1939 World's Fair, Kruger was billed as the "salt water daffy comedian."

Above:
Circus performer Hugo Zacchini flies through the air toward his target after being shot from a huge siege gun in late March, 1929. The first "human cannonball," Zacchini, who had served with the Italian artillery during World War I, introduced his act in 1922 with a 200-foot flight into a net on the island of Malta. (The thrust is provided by compressed air, not an explosive charge.) In 1929 he left his father's circus in Europe and signed up with the Ringling Brothers and Barnum & Bailey Circus, which opened each season at Madison Square Garden in New York. Zacchini's son, nephew, and other family members carried on the act long before he died in 1975.
HARRY WARNECKE

Below:

Luis Firpo, boxing hero of Argentina, punches heavyweight champion Jack Dempsey clean out of the ring in the unbelievable first round of their title match on September 14, 1923. A *Daily News* reporter at ringside called it "the greatest slugfest in the history of the ring." Although the entire fight lasted only three minutes and fifty-seven seconds, the 90,000 fans at the Polo Grounds in upper Manhattan got their money's worth. During the first round, Dempsey punched Firpo to the canvas seven times and was himself knocked down—the first time ever—twice, in addition to his flight into the first row (from which, some said, reporters obligingly—if not legally—helped him get back into the fight). In the next round, the savage Manassa Mauler (nicknamed after his Colorado hometown) knocked Firpo down twice more before knocking out the Wild Bull of the Pampas. Dempsey's reign as champ began in 1919 and ended in 1926, when the slugger lost to the more strategic boxer Gene Tunney.

HANK OLEN

Opposite:

Pete Desjardins (left) and John Weissmuller, members of the 1928 U.S. Olympic swimming team, return home from Amsterdam in triumph aboard the liner SS *President Roosevelt*, at the beginning of September, 1928. Desjardins was a champion diver at the Olympics (only the second person to win both the platform and springboard events, a feat not equaled until Greg Louganis did it in 1984), and Weissmuller won a total of five gold medals for swimming in 1924 and 1928—before becoming the most famous Tarzan in Hollywood.

WHITE

Below:

The 240-pound Jim "Tiny" Elliott (also known as Jumbo), the giant of the Robins club and once the biggest man in the major leagues, hops over teammate Babe Herman and reaches first safely on a bunt during the last game of spring training in 1927 before the team's return from Clearwater, Florida, to its home in Brooklyn. Its name—after Wilbert Robinson, the manager from 1914 to 1931—was one of several given to the team, but eventually it became known by just one: the Brooklyn Dodgers.

Right:

The bleachers at Yankee Stadium—and the then unobstructed rooftops behind it—are packed solid with a crowd estimated at 90,000. The New York Yankees beat the Philadelphia Athletics in both games of the double-header on September 9, 1928, to retake the lead in a tight pennant race. The Yankees went on to win a close race for their third straight pennant by late September, then swept the St. Louis Cardinals in the World Series, giving them their first back-to-back championships.

JOE COSTA

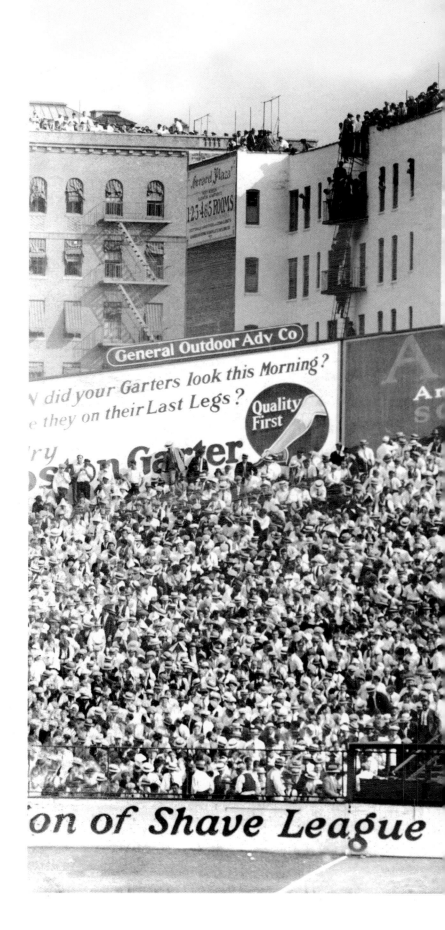

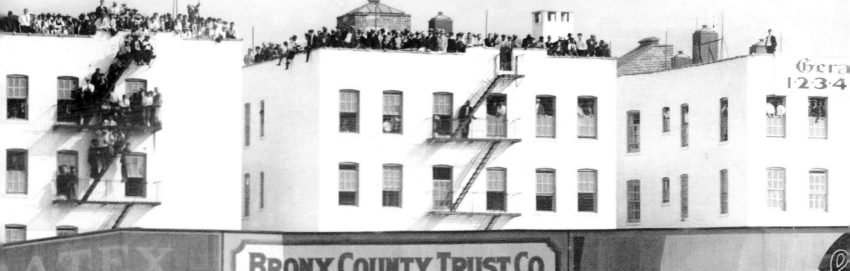

The Charleston is thought to have been invented by blacks working on the docks of Charleston, South Carolina, about 1900, but it didn't become a national dance craze until 1923, when it was featured in the all-black Broadway revue *Runnin' Wild*, accompanying a James P. Johnson and Cecil Mack song of the same name. This photograph, of children doing the Charleston on a street in Harlem in early November, 1920, captures the dance on its journey to Broadway and immortality. After the new subway system connected upper Manhattan to the rest of the island (and real-estate speculation created an excess of vacant apartments), the population of this area soared, with a rapid influx of blacks from the South and elsewhere displacing the nearly 200,000 Jews who had moved up from the tenements of the Lower East Side. By the 1920s, there were some 200,000 African-Americans in Harlem (and only 5,000 Jews there by 1930).

Charleston champions from larger cities all over the United States invade New York, early June, 1926. Like the carefree flappers who performed it and the hidden flasks of Prohibition gin that they imbibed, the fast-paced dance—a wild syncopation of bent knees, heel kicks, and outflung arms—became an enduring symbol of the Roaring Twenties.

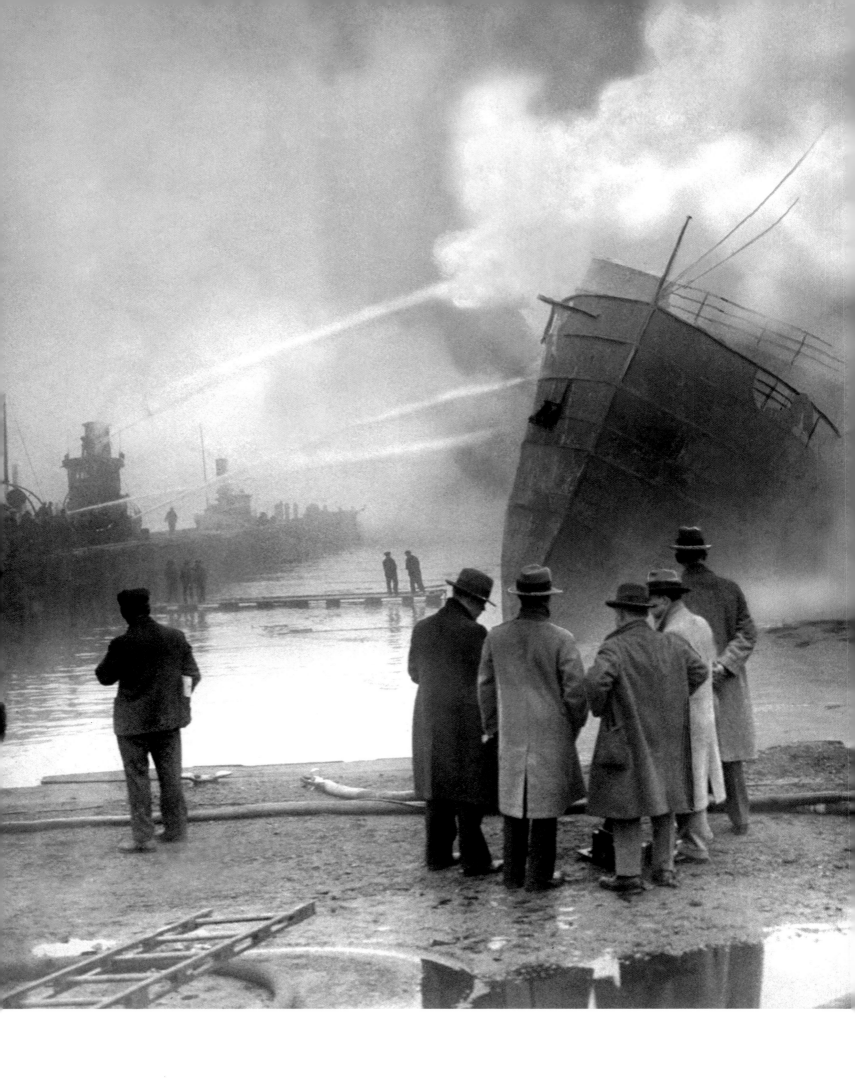

Fireboats attend to the burning SS *Seneca* in Hoboken, New Jersey, on the morning of December 30, 1927, as reporters watch. The ship, out of service for months but still containing 600 barrels of oil, was tied to Pier 12 when fire broke out in the oil and gasoline slicks on the water. The blaze, between 11th and 13th streets, destroyed the 300-foot liner, three barges, two piers, and a derrick; nine firefighters were injured.

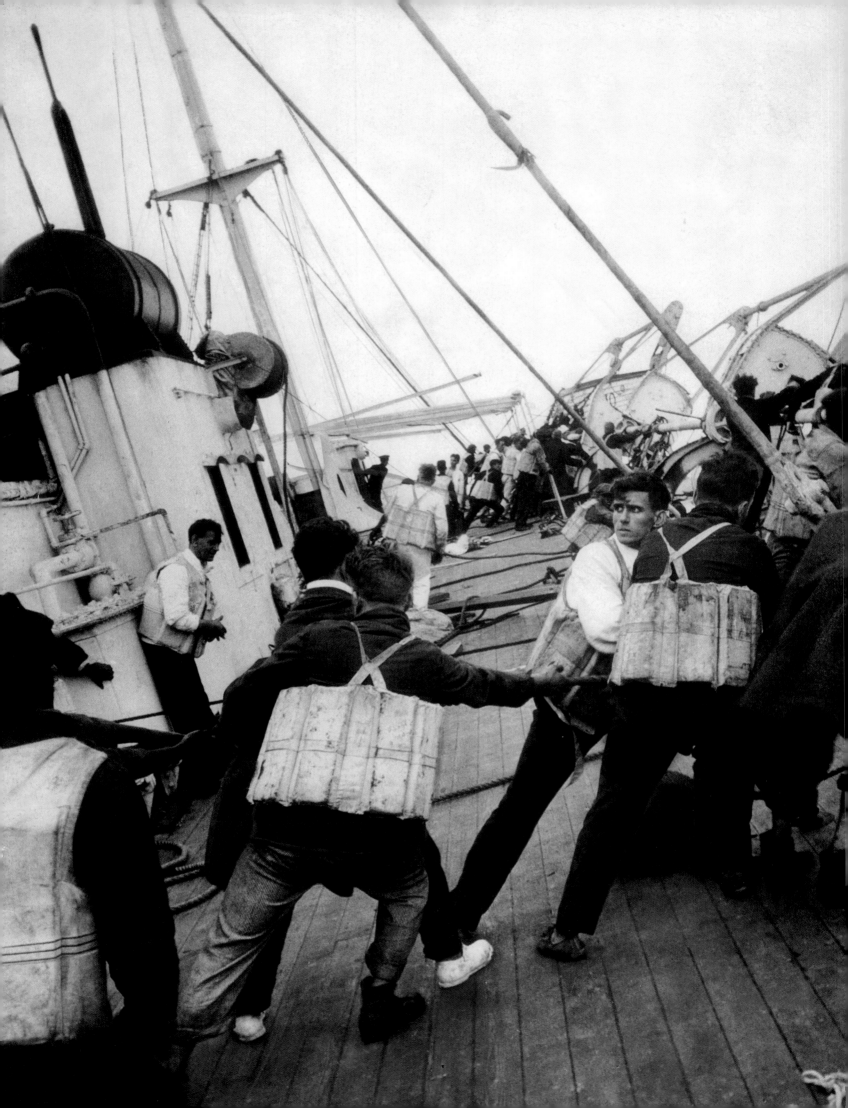

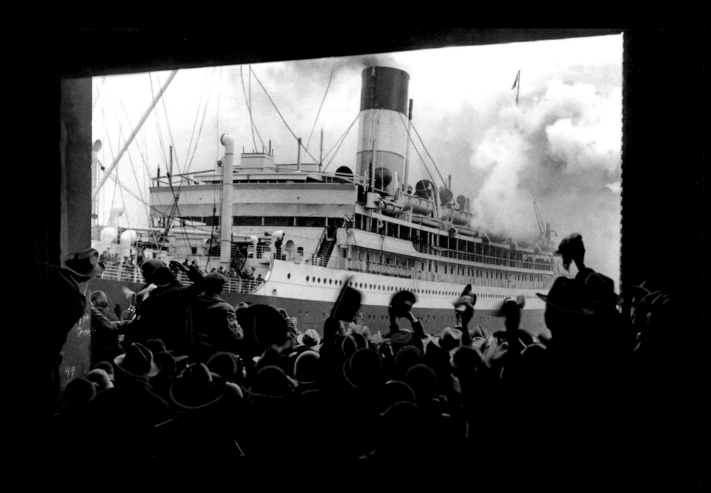

Opposite:

An anxious steward (right) helps to load lifeboats on the ill-fated SS *Vestris*, which sank about 240 miles off Virginia on the afternoon of November 12, 1928, with a loss of more than 100 (including about half of the 129 passengers—and "not a child was saved"—but less than 50 of the 200 in the crew). The headline was "Call Vestris Horror 'Murder!'" The *Daily News* reporter cited "embittered survivors" who, after reaching port, described a chaotic scene of "craven cowardice, imbecile blundering and ruthless inhumanity unique to history." They chiefly blamed Captain William Carey (wearing a long black coat at the right in the background), who went down with the ship, for delaying an SOS call (to save his company the expense of a rescue) for about twelve hours after the ship took on water. The *Vestris*, en route to Barbados and South America, had been allowed to leave port in Hoboken, New Jersey, on November 10 despite a lapsed certificate of seaworthiness and a noticeable list from poorly loaded cargo. During the rush to abandon her after hours of unsuccessful bailing, according to survivors, the crew damaged some of the life boats, and stokers seized others and rowed them away half-empty, ignoring the cries of swimmers in the water. Photos aboard the *Vestris* were taken by crew member Fred Hanson, a pantryman, with an $8.50 camera.

FRED HANSON

Above:

Bound for Barbados, the SS *Voltaire* leaves port in Hoboken, New Jersey, carrying some of the sixty passengers who survived the sinking of the SS *Vestris* twelve days earlier, on November 12, 1928. Four members of the crew who also tried to sail to British territory were taken off the *Voltaire* by court order, obtained by surviving passenger Orrin Stevens. The Boston banker filed the first lawsuit in the case, seeking $30,000 because of the death of his bride of three months and $2,000 for the loss of possessions.

LEONARD DETRICK

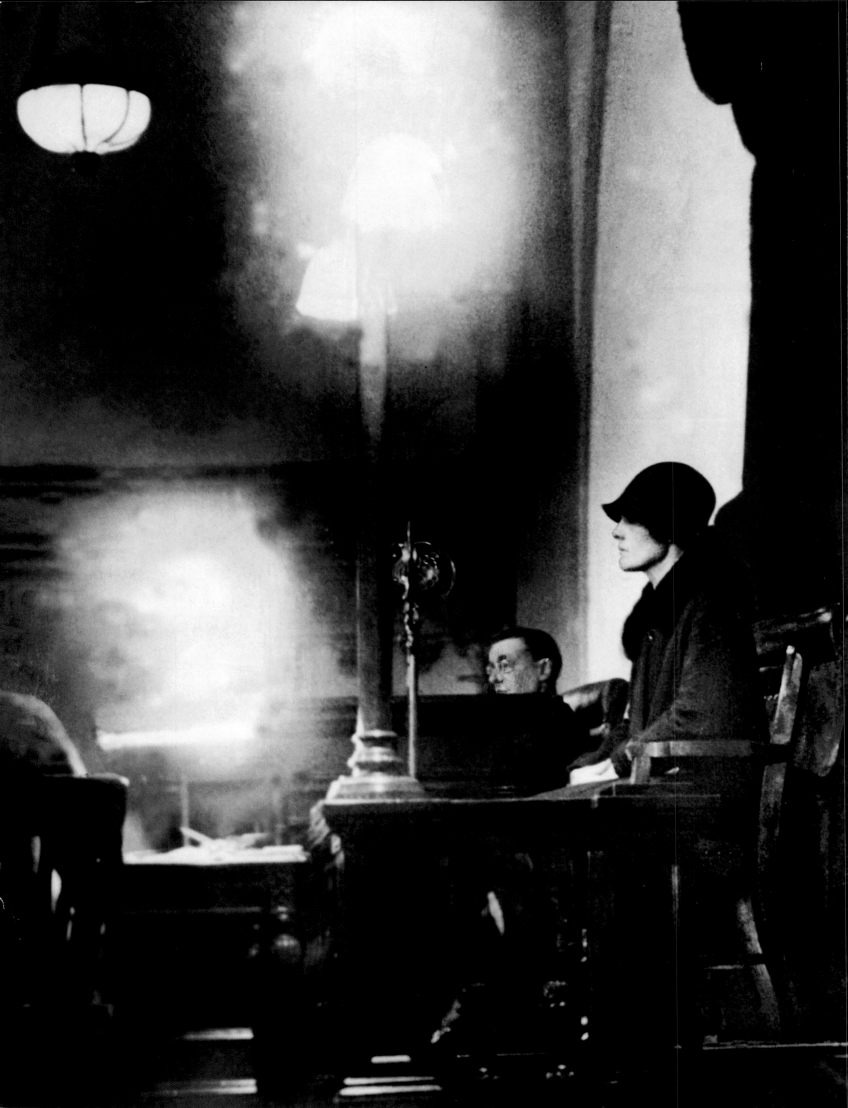

Opposite:
It is late April, 1927, and Ruth Snyder sits in the witness stand as her confession is read to the court. In one of the most sensational crimes of the period, Snyder and her lover, traveling corset salesman Judd Gray, were convicted and sentenced to death for killing her husband, Albert Snyder, the art editor of a boating magazine, on March 20, 1927, in Queens Village. It turned out that she had apparently tried seven times to kill him, by such means as gas and poison, for his $95,000 life-insurance policy. Finally, with Gray's help, she clubbed him with a sash weight and finished him off with chloroform and wire for hanging pictures. The suspects were quick to blame each other when police suggested to each that the other one had told all.

Below:
"DEAD!" Under the blunt headline, this sensational photo showed Ruth Snyder in the electric chair on January 12, 1928, for the murder of her husband—the first such picture ever taken. Because photography was not permitted in the execution chamber, Tom Howard, the "reporter" whom the *Daily News* sent to witness the electrocution at Sing Sing, the state prison in Ossining, New York, used a hidden camera strapped to his leg (seen in the photo at bottom right) and triggered by a bulb in his pocket. The result, one of the most famous photographs of the century, helped to turn many people against the death penalty. Her execution and that of her lover, Judd Gray, took place about five minutes apart. Snyder was about thirty-three.

TOM HOWARD

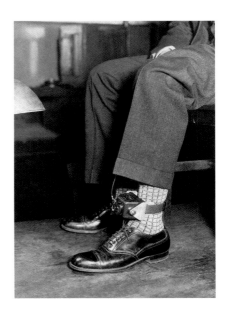

The night before the "Black Tuesday" stock market crash on October 29, 1929, "the dowager Mrs. Cornelius Vanderbilt" (as she was always described, at center above the aisle) and guests sit in the famous Diamond Horseshoe tiers of boxes for the opening night of the Metropolitan Opera (then at Broadway and West 39th Street)—and of the season for high society. Even as the nation's economy began to crumble, life went on as usual for many of the country's richest families. Pages of articles focused on the "Diamond Dust" of the Four Hundred, New York society's elite, but remembered to note that the opera was *Manon Lascaut*, featuring the Met's perennial star Lucrezia Bori.

HARRY WARNECKE

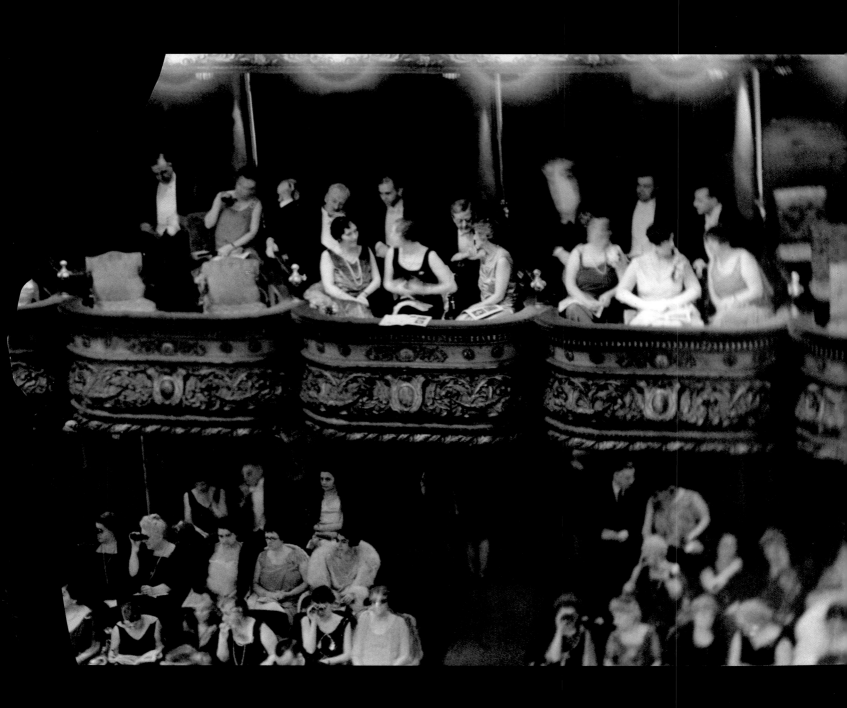

first collapse of the specula-
tive bubble that had been
building through most of the
1920s; after a brief lull,
thanks to a rush of buying
backed by the powerful J. P.
Morgan banking empire (the
headline above this photo

the nation on a continual
decline into the Great
Depression of the 1930s.
ED JACKSON

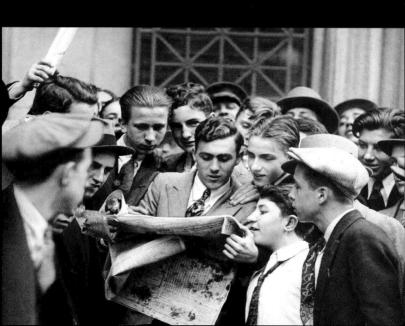

Apprentice photographer George Torrie examines a negative in one of the *Daily News*'s nine darkrooms. In the *News* photo culture, most photographers began as office boys, advanced to couriers, next moved to the darkroom, and finally became shooters. This was an education in every aspect of their art.

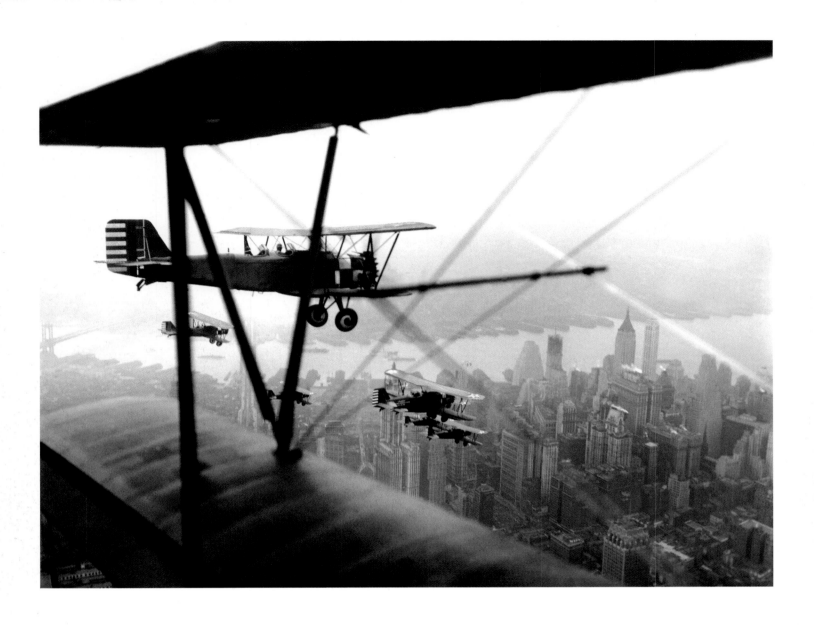

Above:

U.S. Army Air Corps planes fly over New York City as part of spectacular aerial war games on May 23, 1931, described the next day as the "greatest air maneuvers ever held in peace time." It was an era of scaled-back military forces, international disarmament treaties, and American isolationism—not to mention a deepening economic depression. Still, the U.S. government spent $3 million to send up nearly 600 aircraft—the entire American air force, except for 75 support planes—to protect New York City (as well as Chicago, New England, and Washington, D.C., during the same week) against imaginary attack. Millions of New Yorkers watched the 1,400 aviators of the "First Provisional Air Division" fly their planes south over the Hudson River to the southern tip of Manhattan. Poor weather forced the cancellation of the actual mock "Battle over the Battery."

Opposite:

A roving searchlight illuminates the upper reaches of the Empire State Building in this shot of New York City after dark, taken about a month after the May 1, 1931, opening of the tallest building in the world (until the World Trade Center was completed in 1973). The skyscraper, which quickly became the best-known element of the New York skyline, went up fast: work had begun in October 1929— the month that the stock market crashed. (During the Great Depression, some people mocked the mostly unoccupied structure as the "Empty State Building.") In the background at right is the Metropolitan Life Insurance Company Tower. To its right, Broadway is literally the Great White Way.

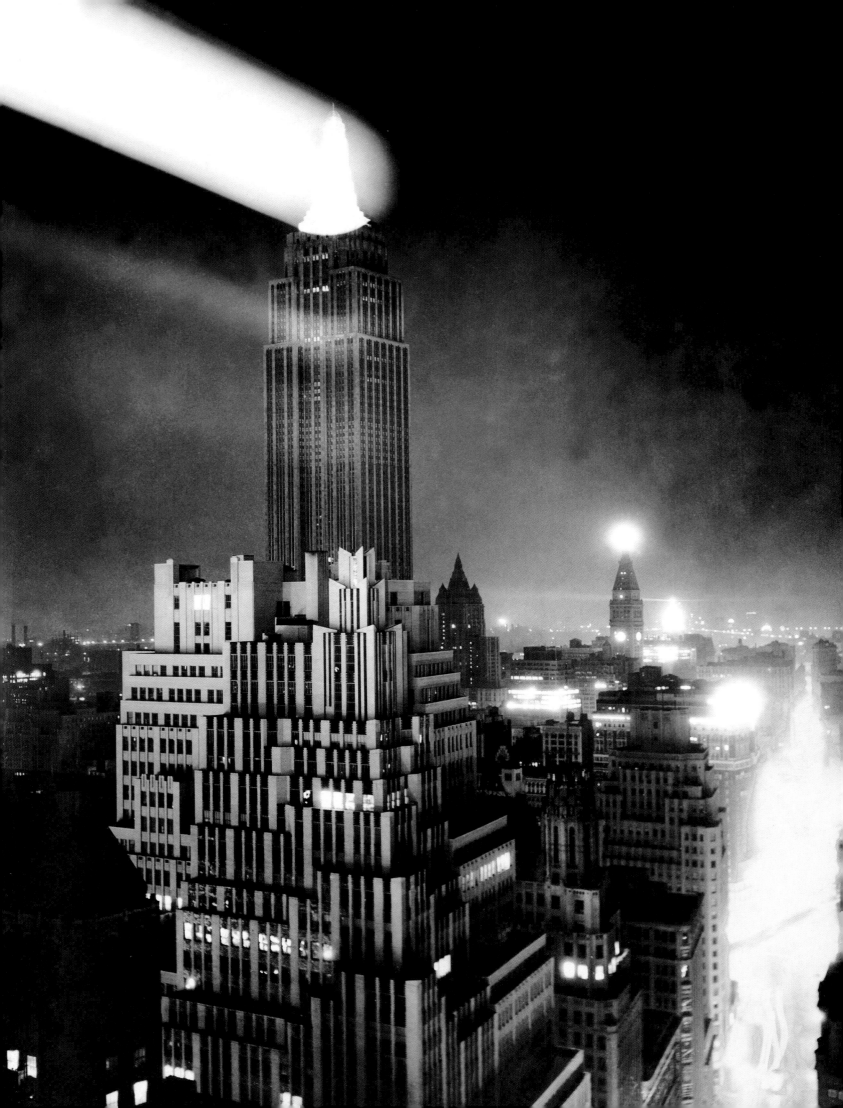

Below:

Joseph C. Brownstone of the failed Bank of the United States is led away by police, February 2, 1931. Brownstone "defiantly refused" to answer a question during an investigation of the bank's failure in December 1930—the biggest in U.S. history up to then (and one of 1,300 in the depression year of 1930), affecting about 400,000 depositors at a time when most savings were not feder-

ally insured. Brownstone was taken to a courthouse and placed in a prisoner's cage with "a motley crew of vagrants"; after a half hour, he relented and admitted borrowing a quarter-million dollars from the bank to gamble in the stock market.
LEROY JACOB

Opposite:

Exhausted contestants try to keep moving, at least a little, on May 9, 1932, during a grueling dance marathon that began March 31—more than 900 hours earlier—at the Fordham Palace, 2505 Jerome Avenue in the Bronx. By this point, only 31 "dancers," 14 couples and 3 individuals, remained out of the original 123 participants. Meanwhile, a Bronx grand jury was condemning what it called an "unhealthful and degrading exhibition," and county prosecutors were

seeking warrants against the five organizers to stop it. Dance marathons began about 1923 as one of many crazes of the Jazz Age; by the depths of the Great Depression, they were luring desperate people in search of modest fame and fortune.

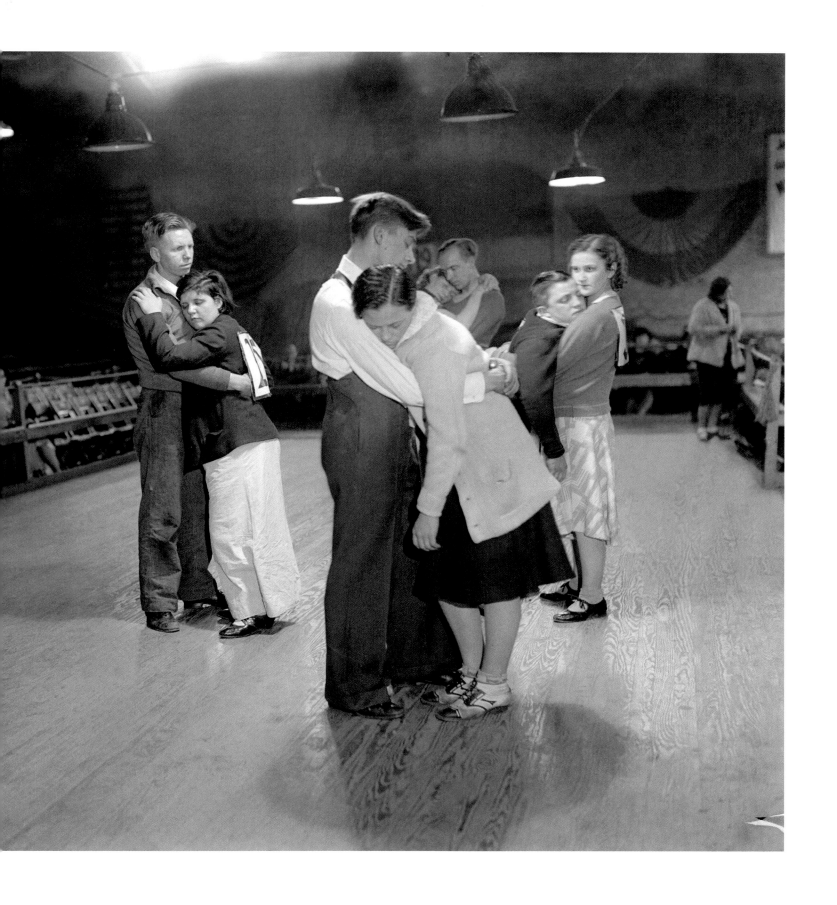

Opposite:

Stretching down the street as far as the eye can see, jobless men wait in line for hours in a gray fog and slow drizzle to be served Christmas dinner at the Municipal Lodging House. The facility, at the east end of 25th Street, provided beds for up to 2,500 homeless men ever since 1908. On Christmas in 1932, the Great Depression was in full swing, and the facility fed 10,500 homeless men in shifts of 250, while a police band and glee club performed carols and other songs. But hope was really "just around the corner": during the previous month, President Herbert Hoover—staunch advocate of faith-based charities rather than extensive government intervention—had failed in his reelection bid, losing to Democratic candidate Franklin Delano Roosevelt.

Right:

President Franklin D. Roosevelt leaves his home at 49 East 65th Street on September 27, 1933, for a short visit to his family estate at Hyde Park, north of New York City. The president traveled to Dutchess County accompanied by four secretaries and an escort of sixty police on motorcycles; his wife, Eleanor, seen behind him here, joined him shortly afterward. This photograph is unusual in that FDR's leg braces are clearly visible; the photos that were actually published in the *Daily News* showed a more formal pose, in which those signs of his paralysis from polio could not be seen.

MARTIN MCEVILLY

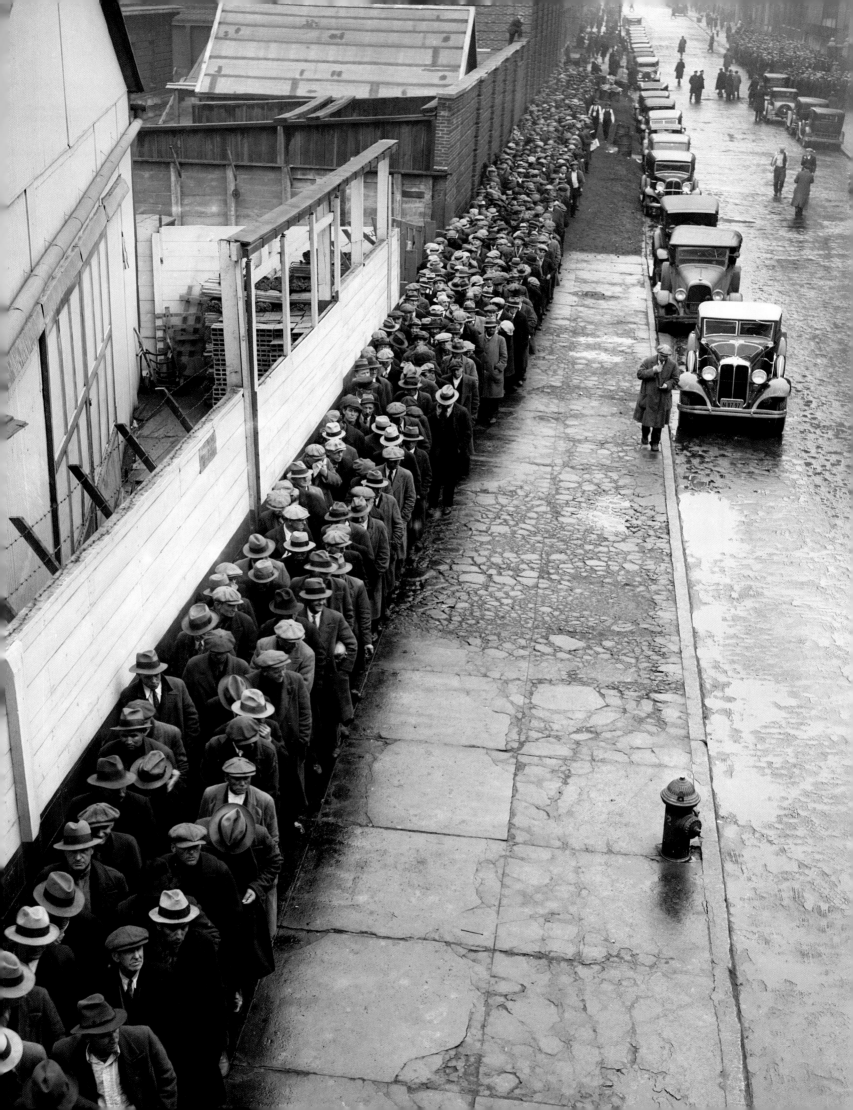

tour a small Hooverville, built on the site of the mostly drained old Central Park Lower Reservoir by unemployed workers, in early January, 1933. Named for President Herbert Hoover, whom many blamed for the state of the economy, these shantytowns which sprang 1930s housed citizens who had lost everything during the Great Depression. Given its proximity to glamorous apartment buildings on either side of the park, this one seemed to many commentators to symbolize the disastrous impact of bad times. **LEROY JACOB**

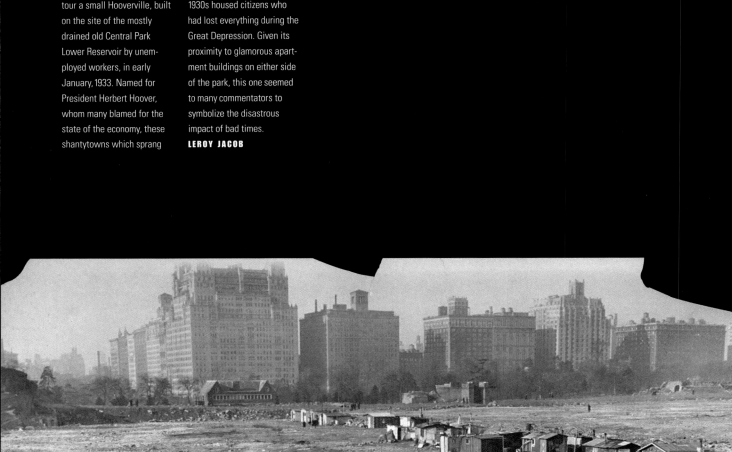

and winter is not far off as Dorothy Muller, twenty-eight, helps her thirty-year-old husband, James, unemployed for two years, add a roof to the home he has built of discarded lumber and other materials at the foot of East 37th Street in Brooklyn, in the swamplands off Jamaica looking on. The Mullers were just one of many homeless families putting up their own rough homes here and in similar places. Most of the victims of the Great Depression, then at its nadir, were essentially left to fend for themselves during the presidency of Herbert Hoover.

72 Men work on finally filling in the site of the old Central Park Lower Reservoir in mid-April, 1933, when the city found money to truck in dirt and pay workers to remove the makeshift dwellings of the Hooverville and fill in and landscape the basin. A large oval created out of the area, stretching roughly from 80th to 84th streets, was renamed the Great Lawn—later the site of concerts, political rallies, and various recreational activities.

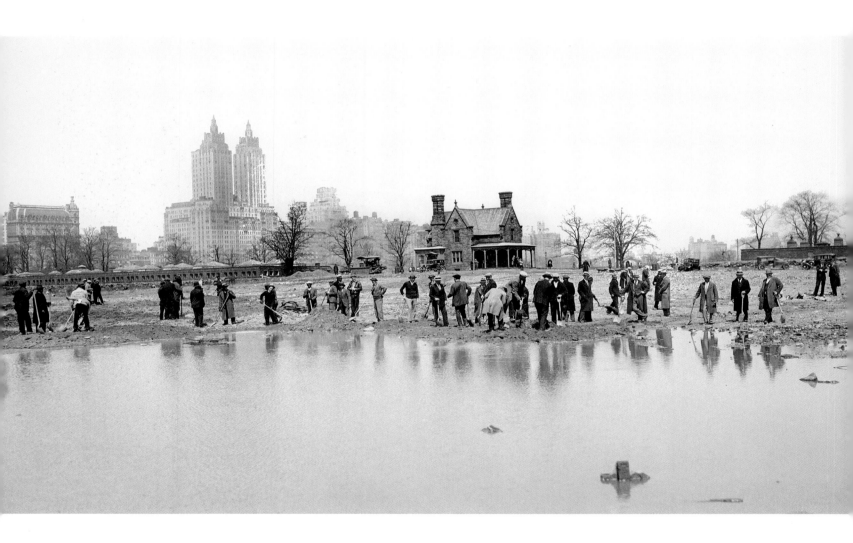

Youngsters (a few in long pants but most clad in knickers, or knickerbockers) gather in Central Park on May 2, 1933, for the first unofficial game of baseball in the filled-in former Lower Reservoir—though they still had to play on dirt and use concrete blocks as bases. It was part of a slightly premature celebration by several dozen mothers and their families to thank Park Commissioner John Sheehy for acting to install playgrounds there, a hotly contested topic then and long afterward. Over the years, playgrounds came and went in the Great Lawn.

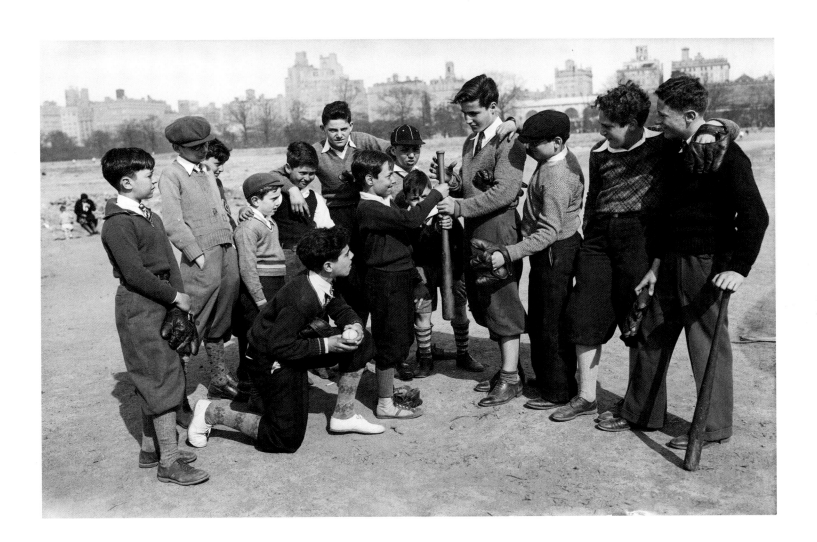

After helping to extinguish an apartment house blaze at 417 West 44th Street, between Ninth and Tenth avenues, on March 18, 1930, firefighter Arthur McCarthy plays nurse for little Edna Lee Gabel. Her mother, May Gabel, twenty-two years old, was severely burned when gasoline used for cleaning suddenly exploded in her second-floor apartment. With her clothes on fire, she scooped up her baby and dashed down the fire escape before collapsing. Firefighters rescued two brothers from third-floor window ledges, and tenants fled a neighboring building as well.

Opposite:
A star is born: actor John Wayne arrives fully costumed aboard the luxury train Twentieth Century for a brief publicity appearance in New York in early October, 1930. Just twenty-three years old, the former bit player had just finished his first lead role, in the big-budget western *The Big Trail*, which opened later in the month. Then he sank into the obscurity of minor westerns—until he achieved stardom for good with *Stagecoach* in 1939.

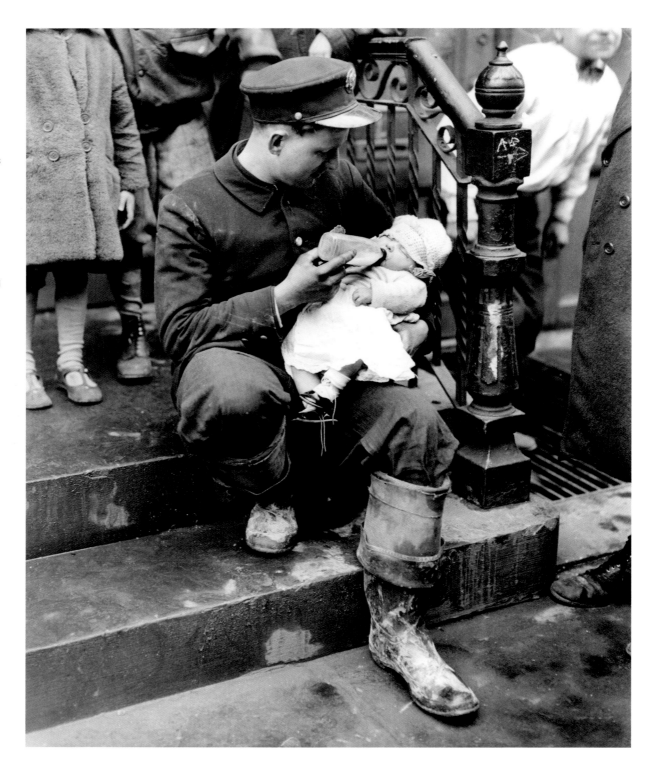

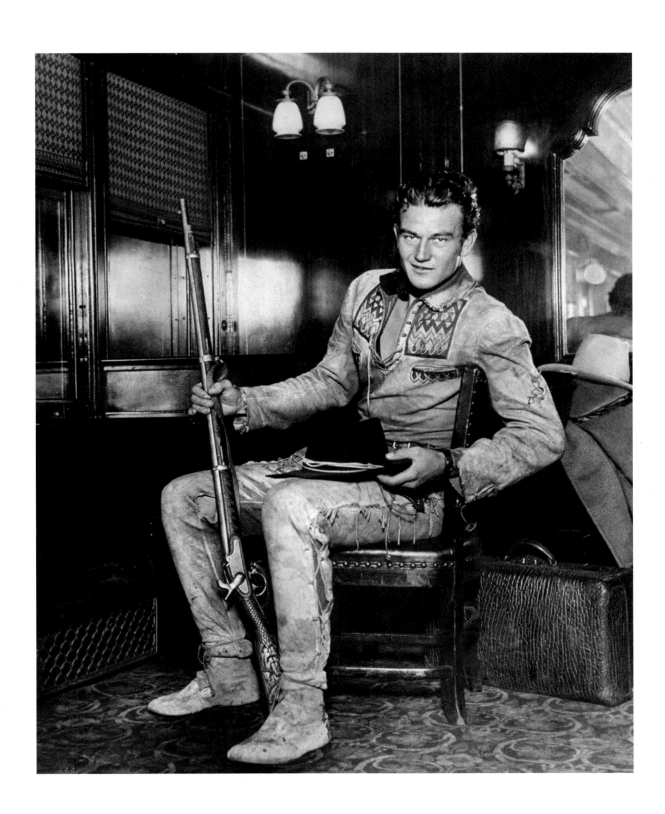

On the last day of 1930, Jack "Legs" Diamond stands behind a police officer on 125th Street in Manhattan, one of several escorting the notorious bootlegger and racketeer—who claimed to be just a nightclub owner— to the train station there after his release from City Hospital on Welfare Island. Diamond was going to his home in the Catskills to recuperate further after being shot four times on October 12 in the hotel room of his girlfriend (who said she was splashing in the bathtub at the time and didn't hear a thing). Diamond survived several shootings during a long-running turf war with mobster Dutch Schultz, and he boasted that no bullet could kill him. In December 1931, unknown assailants proved him wrong.
PHIL LEVINE

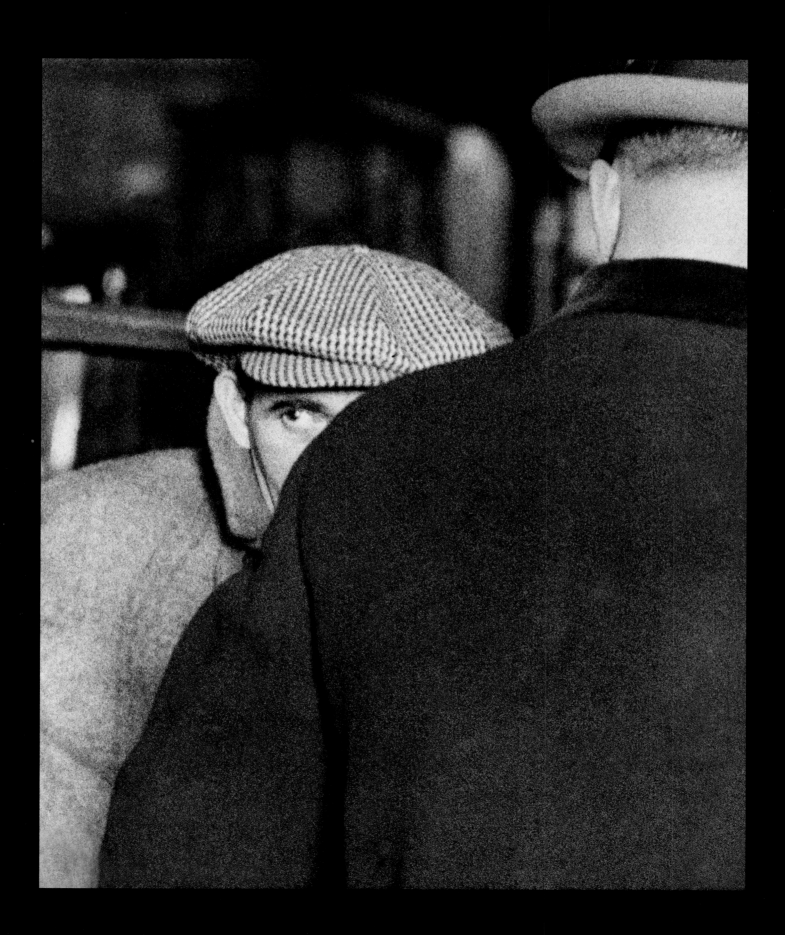

Arm" De Lucca (left to right)
sit in police headquarters in
Brooklyn after a three-mile
police chase ended in arrest

were overtaken
Highway. The tri
out and tried to
it was reported,

78 Jersey City police enforce Prohibition at 252 Paterson Plankroad, where a raid in early January, 1932, turns up vats containing 5,800 gallons each of mash. Nevertheless, the speakeasies throughout the United States never ran dry. In New York City alone, estimates of the number of illegal saloons during Prohibition ranged as high as 32,000—twice the number of bars that existed when drinking was legal.
LEONARD DETRICK

Detectives pile aboard a police car on October 22, 1932, to rush to the scene of a riot at the notoriously overcrowded, scandal-ridden penitentiary on Welfare Island (formerly Blackwell's Island and now Roosevelt Island), in the East River off Manhattan's Upper East Side. About 400 rioters—out of a prison population of about 1,700—went after one another with knives, chairs, brickbats, and fists, leaving one inmate dead and scores wounded in an apparent struggle over control of the inmates' drug trade. About 250 police stood by at first, but after more than an hour they stopped the riot by firing shots into the air. In 1934, Austin H. MacCormick became the commissioner of correction in the LaGuardia administration, and by the following year he had razed the ancient structures and moved the inmates to a new penitentiary on Riker's Island. Today, Roosevelt Island is a residential community, connected to Manhattan by an aerial tramway at Second Avenue and East 60th Street.

Vincent Coll—also known as "Mad Dog" and "Baby Killer"—is laid to rest a few days after he was murdered on February 7, 1932. Coll was a bootlegger who had violently turned against his boss, Dutch Schultz. On July 28, 1931, while aiming at Schultz's top lieutenant, Coll and his gang sprayed East 207th Street in East Harlem with about sixty machine-gun and shotgun bullets—missing their target but killing two-year-old Michael Vengalli and wounding four other children. (Newspaper accounts called the drive-by shooting unprecedented.) Coll was finally captured in early October, but the star witness had credibility problems and the Baby Killer went free—but only until Schultz's men caught up to him at a drugstore phone booth.

OSSIE LEVINESS

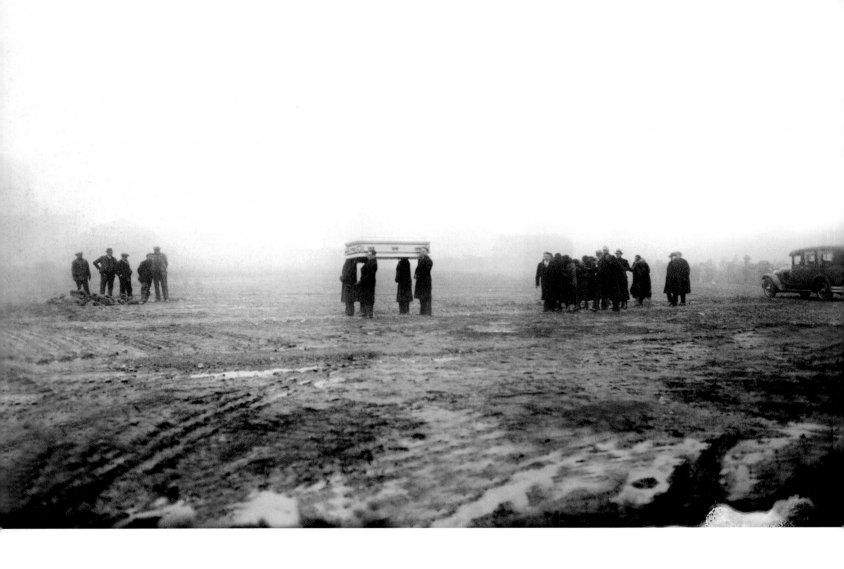

Irving Ashkenas lies sprawled outside a car after being shot sixteen times in Hurleyville, in upstate Sullivan County, on September 5, 1936. A strong-arm man for labor groups, he once served time for knocking down a wealthy dress manufacturer, who suffered a fatal head injury when he fell. After Ashkenas was killed, it came out that he had been a witness for Thomas E. Dewey, then a special prosecutor investigating organized crime (which led Dewey to three terms as governor of New York and two failed bids for the presidency, in 1944 and 1948). Ashkenas's murder was one of at least seven in upstate New York committed during the 1930s by the notorious Murder, Inc., which as the enforcement arm of organized crime was hired to fulfill its ultimate "contracts."
BILL WALLACE

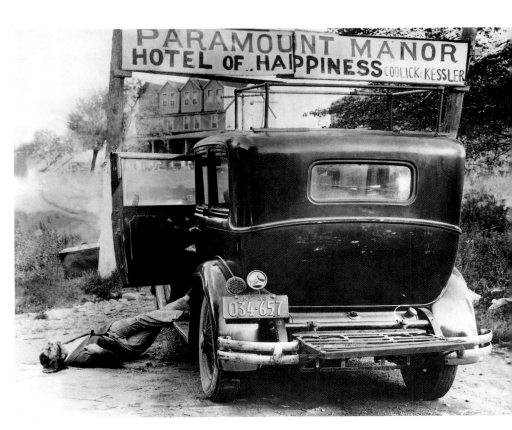

About 20,000 supporters attend a Nazi rally at Madison Square Garden on the night of May 17, 1934, as 1,000 police keep 600 Communist protesters outside. The rally's organizers were called Friends of the New Germany, better known by 1936 as the German-American Bund, which sought to promote the policies of the National Socialist German Workers' Party—the Nazis. The American organization had its national headquarters at 178 East 85th Street, in the heart of Yorkville. Anti-Nazi German groups also had offices in that German-American community on the Upper East Side of Manhattan. American Nazis occasionally paraded through the neighborhood in uniform, complete with swastikas on their armbands, and there were sometimes confrontations, such as a bloody fight with members of the American Legion in the spring of 1938. The German-American Bund held another big rally at Madison Square Garden in February 1939, but it suffered a public-relations blow in September when Germany invaded Poland, starting World War II in Europe.

HANK OLEN

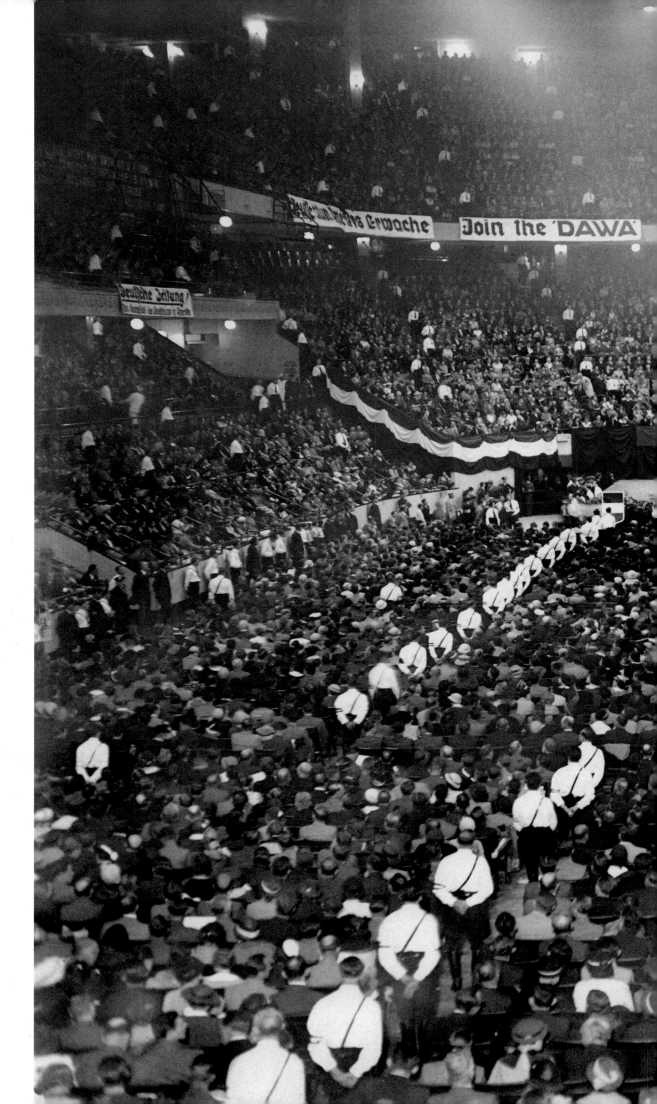

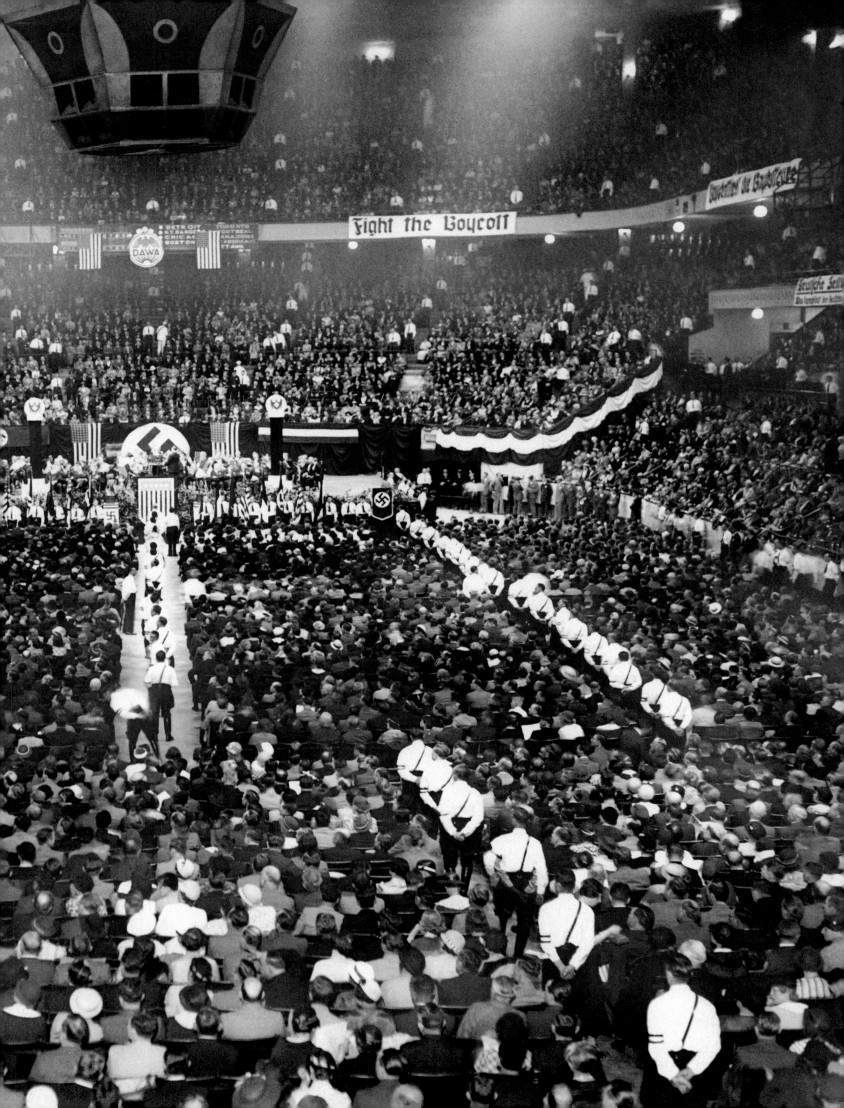

84

A view of Chinatown, much smaller in 1935 than it is today. Only about 4,000 Chinese lived on Mott Street and a few other narrow ones between Canal and Worth streets at the time. Railroad and other workers from the West had come to New York starting in the mid-1870s, but the 1882 Chinese Exclusion Act and later laws essentially cut off immigration from Asia for nearly a century. At this bend in Doyers Street near the Bowery was the famous mission run for two decades by Tom Noonan, a former convict, until his death in 1935. In this vicinity was also the "Bloody Angle," called that because of a notorious battle in the early 1900s between rival tongs, or ganglike fraternal societies, for control of gambling and opium rackets.

ED JACKSON

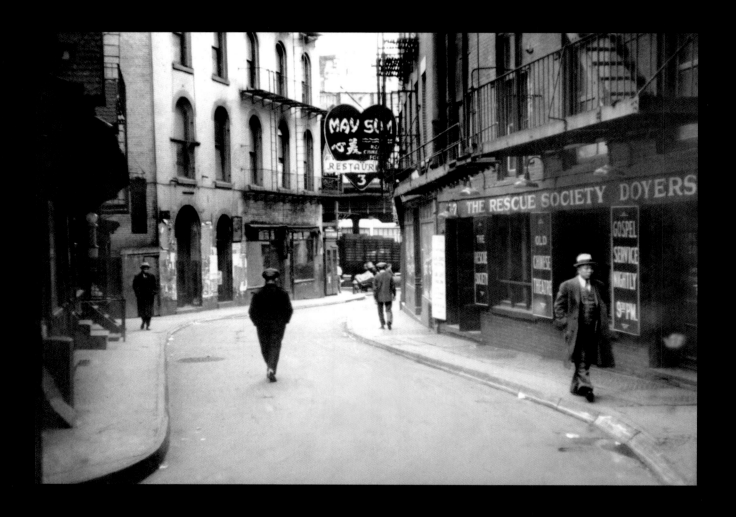

Ominously raising his weapon during rioting in Harlem, this policeman is guarding a drugstore at West 125th Street and Seventh Avenue. The riot on the night of March 19, 1935, began after a minor incident in one of the mostly white-owned stores on 125th Street was blown out of proportion as a result of continuing tensions over Harlem's devastated economy during the Great Depression. A Puerto Rican teenager was thrown out of an S. H. Kress store for shoplifting a ten-cent penknife; within two hours, the rumor spread that Kress employees had beaten a black youth to death and dumped his body out the back door. Protests outside the store turned violent, and overnight hundreds of windows were broken on 125th Street and Seventh and Lenox avenues, dozens of stores were looted, snipers were firing from rooftops, more than one hundred people were shot, stabbed, clubbed, or stoned, and at least one black was killed by police, reportedly for looting. By the next day, hundreds of police had restored calm, though tensions remained high. A subsequent investigation into the causes of the riot noted the overcrowded area's high rates of disease and inadequate medical care, as well as the economic deprivations and discrimination in local hiring

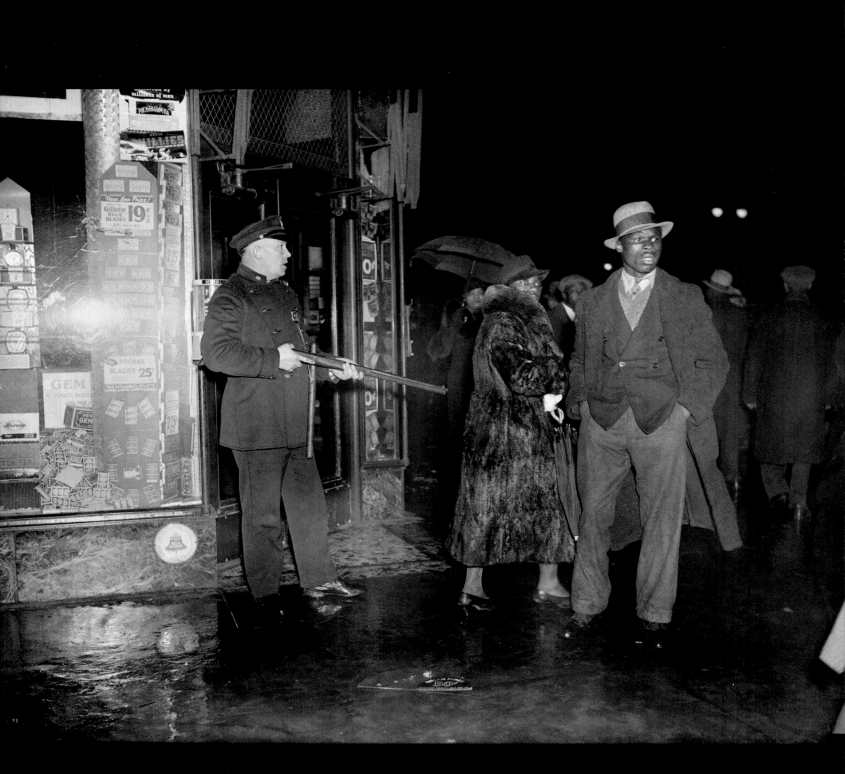

Below:

Ray Olivo, 118-pound sub-novice champ, talks to his family about his victory over Philip Siriani as part of the Eighth Annual Golden Gloves Finals, New York's top amateur boxing show, at Madison Square Garden on March 12, 1934. With the Golden Glover are his father, Samuel (left), brother William (holding six-year-old Leona), and family members Billy, nine; Leonard, eight; and Mable, eleven.

LEWIS

Right:

Harlem residents at a bar on 135th Street raise a jubilant toast after world heavyweight champion Joe Louis's first-round knockout of Max Schmeling on June 22, 1938, in Yankee Stadium—sweet revenge for the German boxer's defeat of the Brown Bomber two years earlier. The 124-second pummeling of Schmeling touched off wild celebrations in African-American communities across the United States—

including an estimated 100,000 people in New York—and Jews also hailed the defeat of the ardent Nazi. Louis, who had become champion by beating James J. Braddock exactly one year before this fight, lost only two other matches in his seventy-one-fight career (during which he successfully defended his title a record twenty-five times, including twenty-one KOs)—and both of those were after he came out of retirement in 1950.

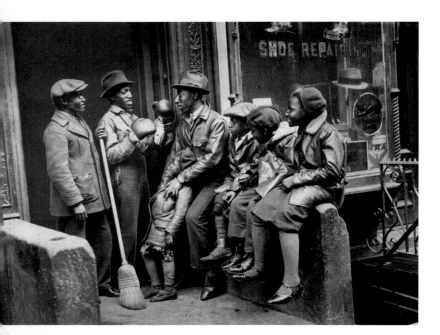

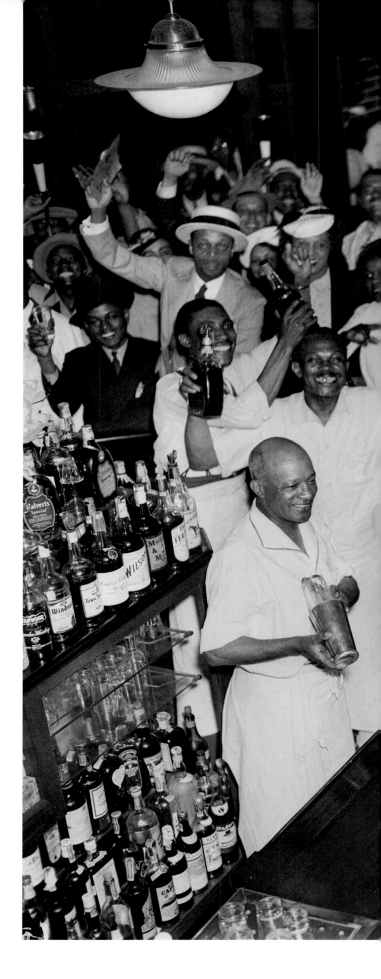

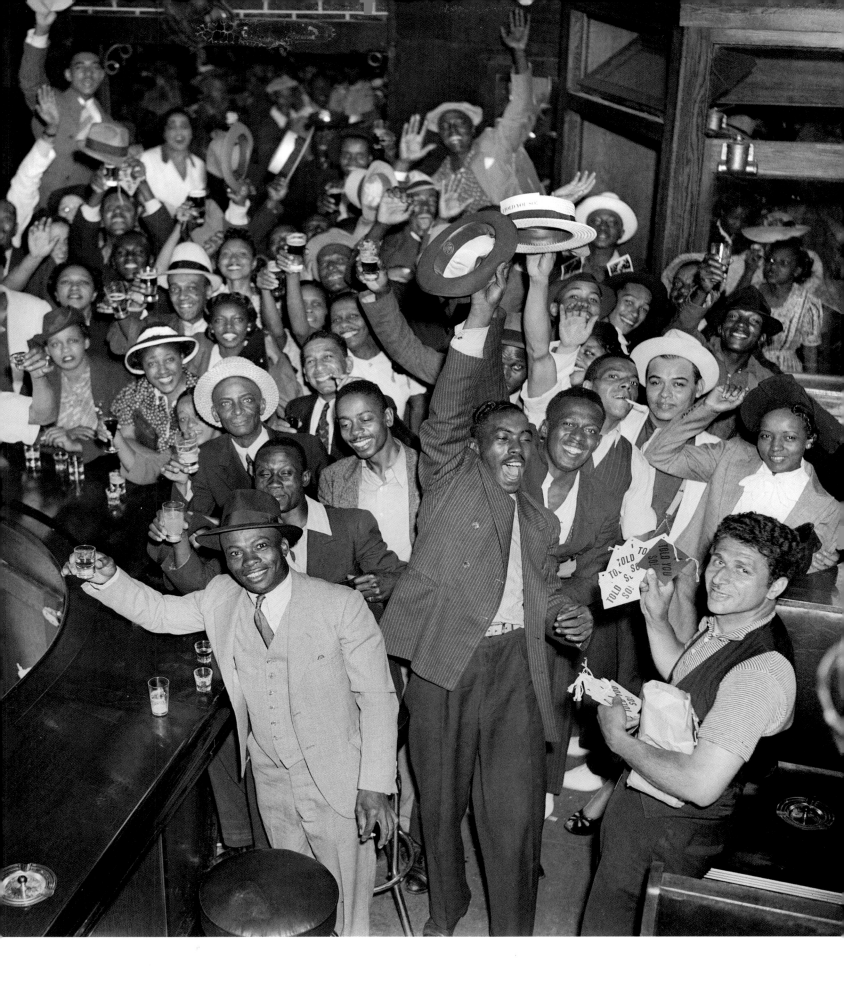

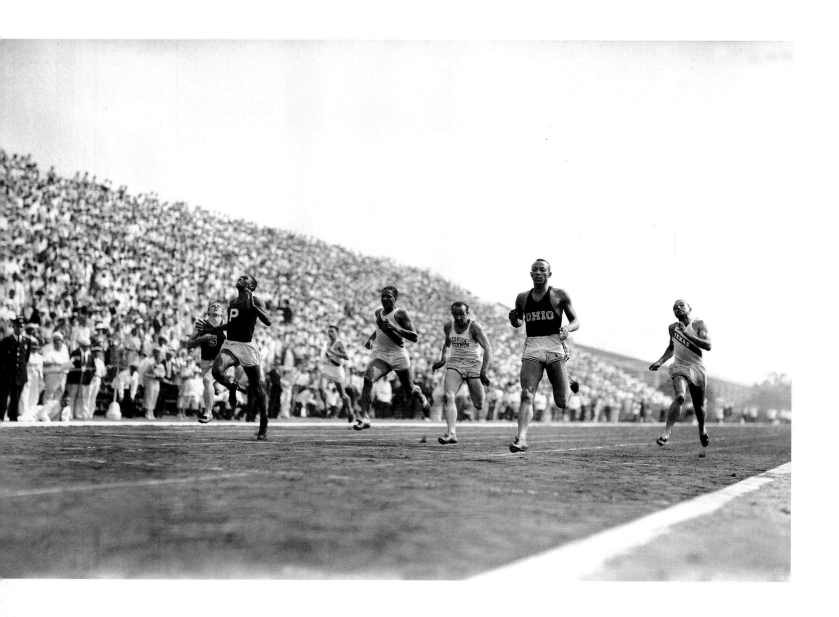

Setting a new record, Jesse Owens wins the 200-meter in twenty-one seconds flat on July 12, 1936, the last day of Olympic trials at the municipal Triborough (now Downing) Stadium on Randalls Island, in the East River. In a blow to Nazi theories of Aryan superiority, the black track-and-field star went on to earn four gold medals at the 1936 Olympics in Berlin. Owens repeatedly set long-lasting records— at a single meet on May 25, 1935, he broke three world records and tied a fourth— and was often called "the Fastest Man Alive." (He even outran racehorses.)

HANK OLEN

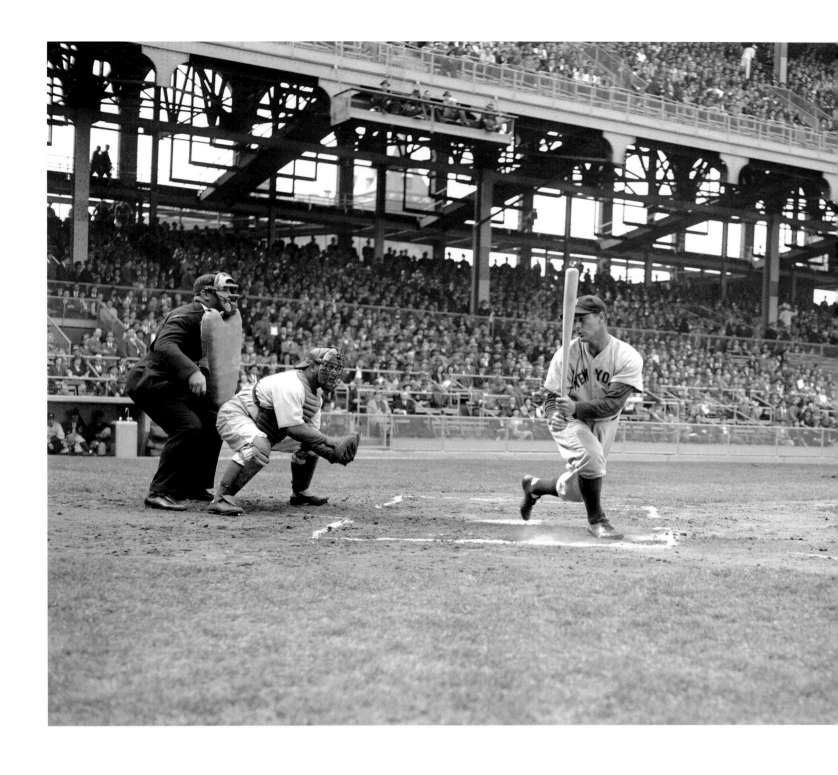

The New York Yankees' Lou Gehrig tries to knock one out of Ebbets Field—but misses—during an exhibition game with the Brooklyn Dodgers on April 15, 1938. It was just before the start of his fourteenth—and final—season at first base. Over the following winter he fell often while ice-skating, and he had a terrible spring training in 1939. After getting only four hits in twenty-eight at bats during the first eight games of 1939, the Iron Horse took himself out of the lineup on May 2. From June 1, 1925, to April 30, 1939, he had played in 2,130 consecutive games—a record that stood until the Baltimore Orioles' Cal Ripken Jr. broke it on September 6, 1995. The reason for Gehrig's sudden deterioration, of course, was tragic: he was diagnosed with amyotrophic lateral sclerosis—known thereafter as Lou Gehrig's disease—on June 20. On July 4, Lou Gehrig Appreciation Day; his uniform number became the first ever retired from the game, and he told the more than 61,000 fans present and the rest of his admirers listening on the radio that he considered himself "the luckiest man on the face of the earth." Gehrig died on June 2, 1941, the sixteenth anniversary of the day he became the Yankees' regular first baseman and seventeen days before he would have turned thirty-eight.

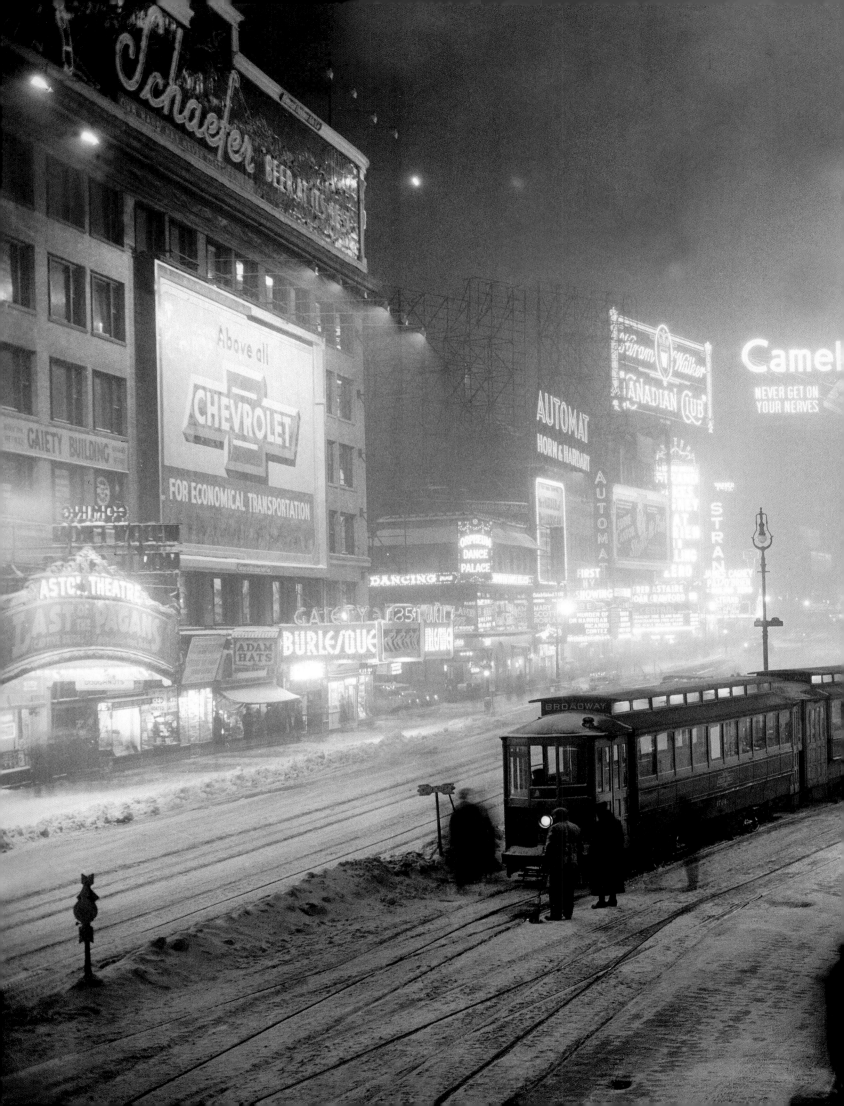

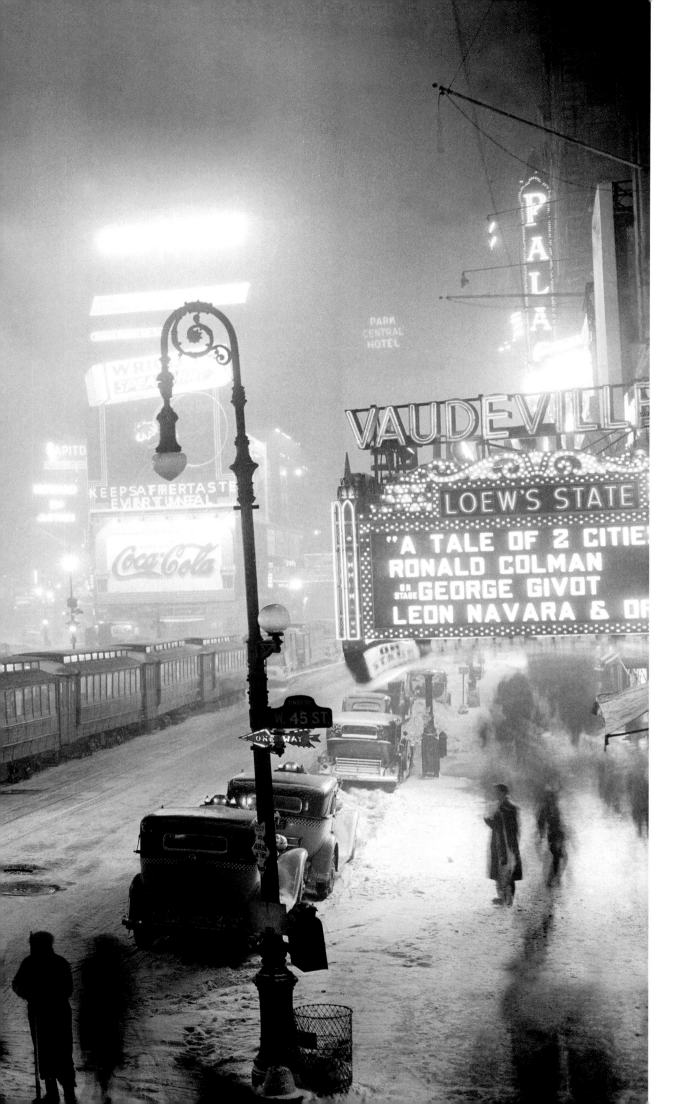

Streetcars are stuck at West 45th Street in Times Square, thanks to a frozen switch during a freak snowstorm on January 19, 1936. Five deaths resulting from heart attacks or accidents were attributed to the storm, which included record sleet and snow, winds gusting up to 100 miles per hour, and even thunder and lightning.

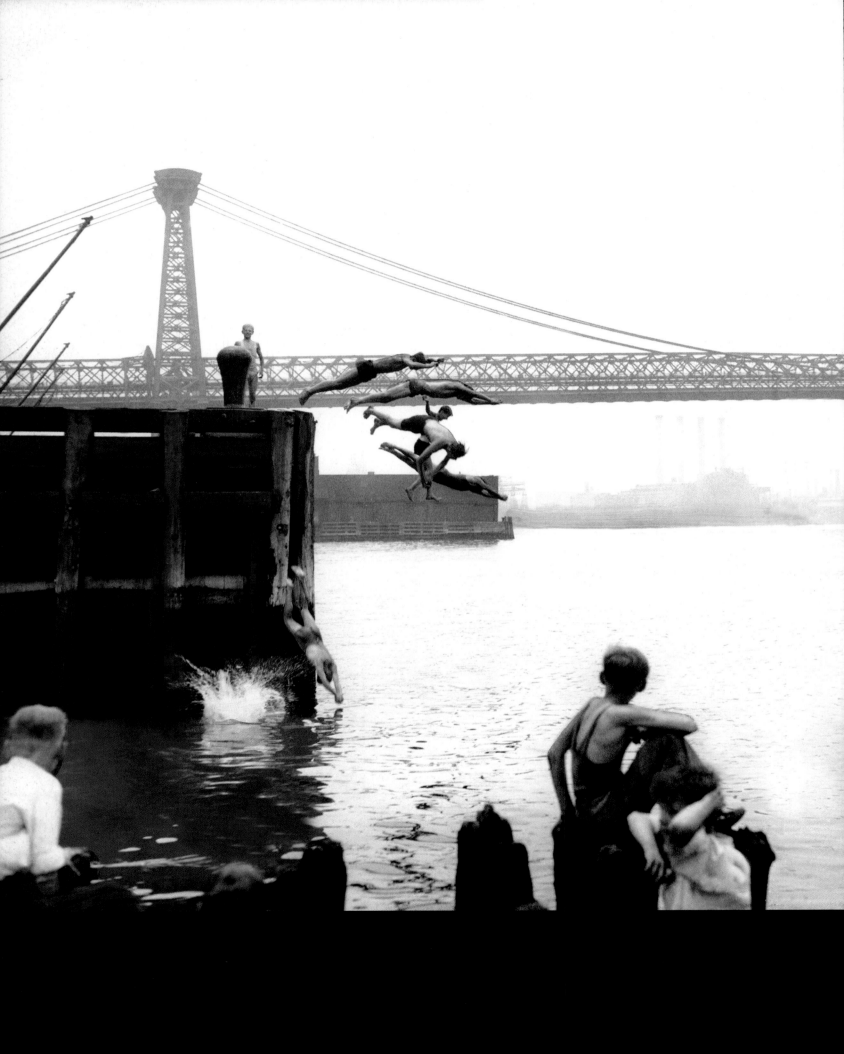

Left:
It's almost the Fourth of July,
1935, and youngsters cool
off by diving into the East
River off a pier at Grand
Street, on the Lower East
Side. The Williamsburg
Bridge is in the background.
GORDON RYNDERS

Below:
The minister of the Colored
Church of Hempstead, New
York, baptizes a member of
his congregation in the old
Belmont Pond, mid-June, 1938.
PLATNICK

Patrolman Charles Glasco
hands a telephone to John
Warde as the emotionally
disturbed twenty-six-year-
old man remains on the
ledge outside Room 1714 of
the Hotel Gotham, at Fifth
Avenue and 55th Street, on
July 26, 1938. Thousands of
spectators on the streets
below anxiously followed the
ordeal, which lasted eleven
hours. Glasco, a traffic cop
whose shift nearby had just
ended when he was called
in, spent the day trying
to calm and save Warde,
while friends, relatives, and
imposters telephoned. At
10:38 P.M., at least one per-
son on the ground called out,
"There he goes!" as Warde
suddenly fell seventeen
floors to his death. The sen-
sational suicide inspired a
long article eleven years
later in the *New Yorker* mag-
azine, which in turn led to
the fictionalized 1951 movie
Fourteen Hours, starring
Richard Basehart as the
young man and Paul Douglas
as the cop (with a cameo by
Grace Kelly, in her film debut).
BOB COSTA

Opposite:
This man has just learned
that the victim of a street
accident is his own wife,
mid-December, 1935.
R. F. CRANSTON

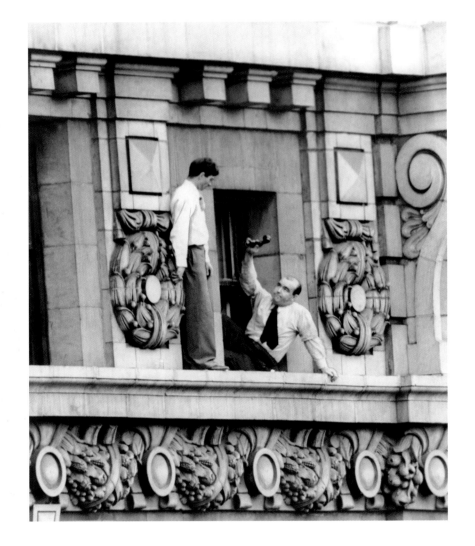

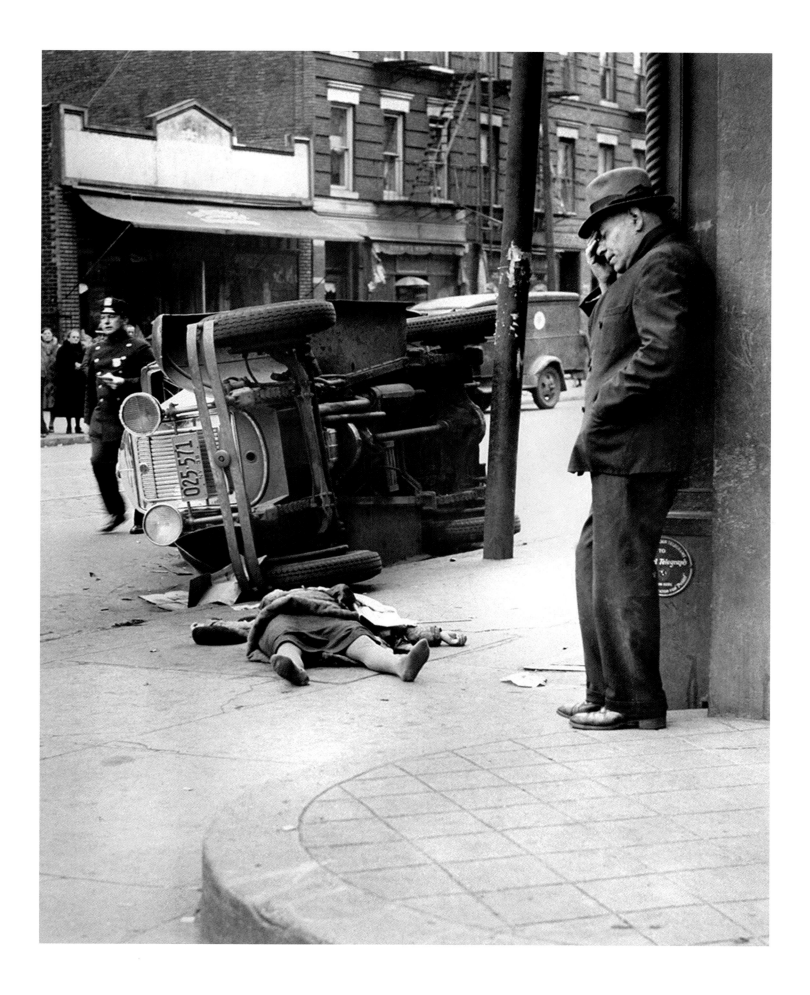

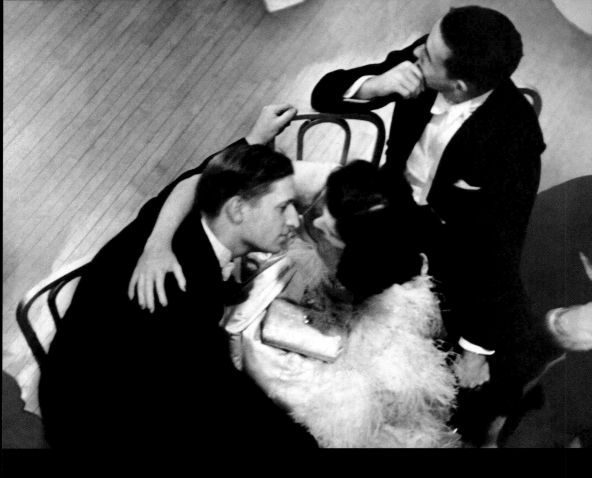

Above:
Brenda Frazier, the debutante of the year in 1938, steals a kiss at her coming-out party at the Ritz-Carlton Hotel, Madison Avenue and East 46th Street, which was attended by about 1,400 of her closest friends. To call her a favorite of photographers would be the understatement of any year; the glamorous heiress showed up, usually in a strapless gown, in some 5,000 articles during one six-month period alone and, of course, graced the cover of *Life* magazine. Her later years were not so kind: two failed marriages, bouts with alcohol and pills, extreme diets, and suicide attempts. She died, a virtual recluse, in 1982, five years before a biography revived memories of her heyday.
JOSEPH COSTA

Opposite, top:
Marlene Dietrich, Hollywood's most alluring femme fatale of the 1930s, and Cornelius Vanderbilt Whitney, scion of two prominent families (his mother, Gertrude Vanderbilt Whitney, created the Whitney Museum of American Art), dance together at the fashionable New York nightclub El Morocco, then at 154 East 54th Street, in late April, 1938.

Opposite bottom:
That's J. Edgar Hoover behind the Mickey Mouse mask at a New Year's Eve party in the elegant Stork Club at the end of 1937. The director of the Federal Bureau of Investigation from 1924 (when it was just the Justice Department's Bureau of Investigation) until his death in 1972, Hoover was much more likely to be depicted in the 1930s standing with FBI agents over the body of a gangster.

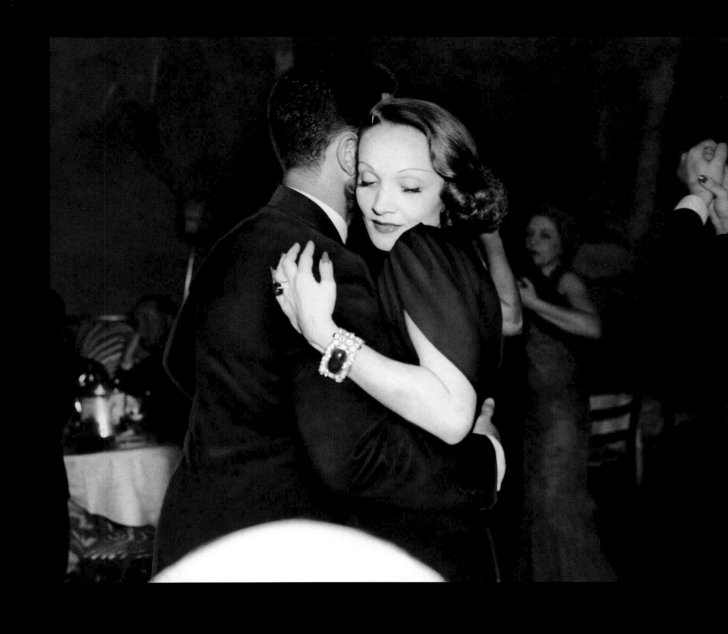

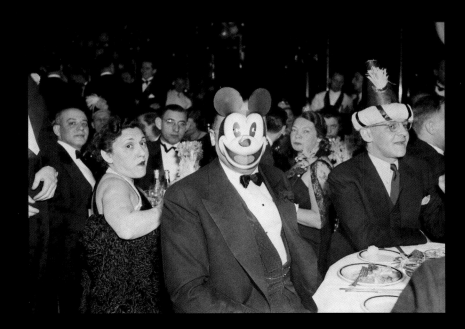

Above:

The always cheerful silent-movie star Mary Pickford shows off a new hat at the Sherry-Netherland Hotel after her arrival in New York, early November, 1934. "America's Sweetheart" was not only the most popular movie actress until the arrival of talkies in 1927, but also a cofounder of the United Artists Corporation, along with fellow filmmakers Douglas Fairbanks (whom she married in 1920), Charlie Chaplin, and D. W. Griffith. But Pickford—already twenty-seven when she starred in *Pollyanna* (1920)—was aging, and tastes had changed. She retired from movies in 1933, the same year she and Fairbanks separated; the fabled Hollywood marriage came to an end in 1936. Meanwhile, America had a new sweetheart, a real little girl with golden curls: Shirley Temple, the number one box-office star from 1935 to 1938.

JOSEPH COSTA

Opposite:

Ronald Reagan, a contract player and occasional movie star, escorts Jane Wyman, still years away from her mid-1940s stardom, at Pennsylvania Station, mid-December, 1939. The two married in 1940, the same year Reagan played the Gipper—ill-fated football star George Gipp—in *Knute Rockne, All-American*. They divorced in 1948, the year of Wyman's Oscar-winning title role in *Johnny Belinda*, and four years before Reagan married actress Nancy Davis.

PHIL GREITZER

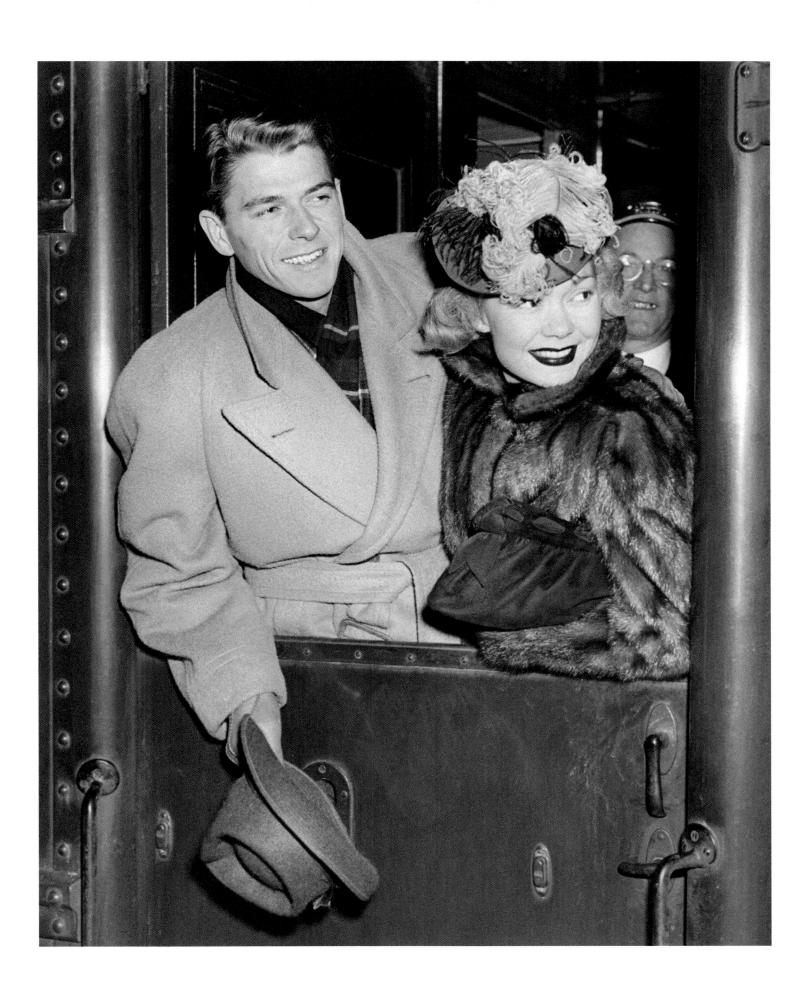

100 Amelia Earhart arrives fatigued and thirsty at Newark Airport on August 25, 1932, after becoming the first woman to fly nonstop across the continent, as well as setting a new distance mark for female pilots. Her flight from Los Angeles in her red-and-gold monoplane, which took just over nineteen hours, occurred only three months after she became the first woman to fly solo across the Atlantic. Probably the most famous American aviator of the period after Charles A. Lindbergh, Earhart vanished five years later without a definite trace while crossing the Pacific on a round-the-world flight.

BROWN

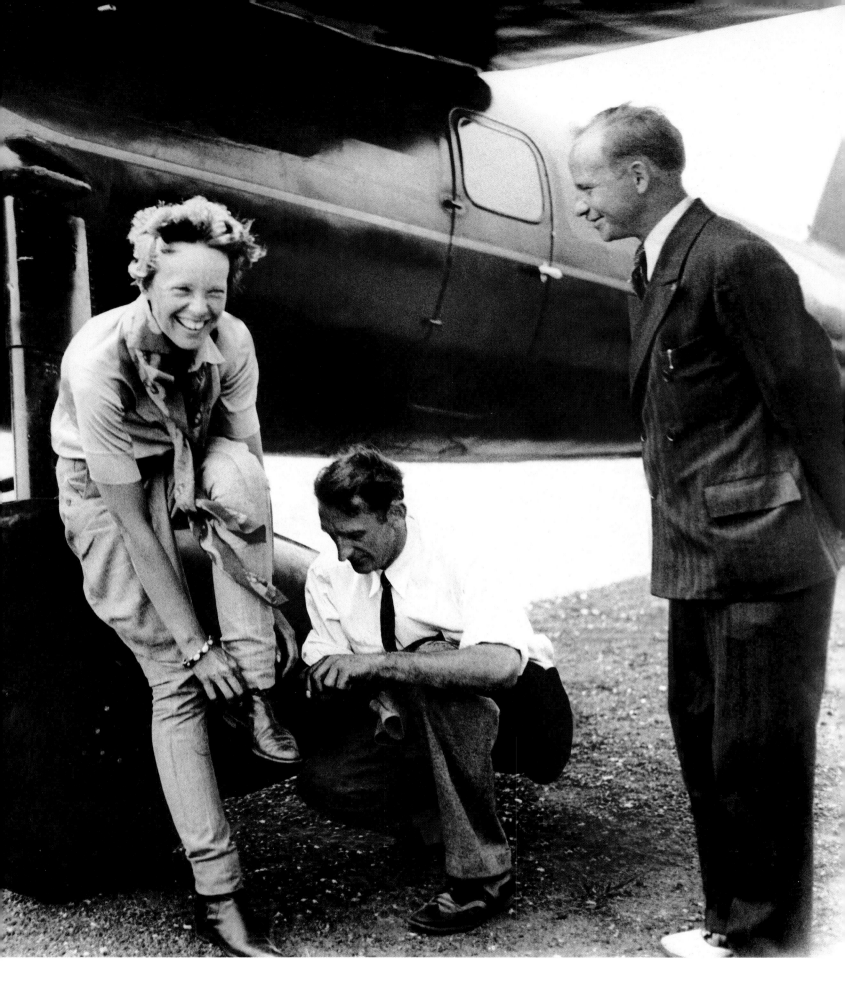

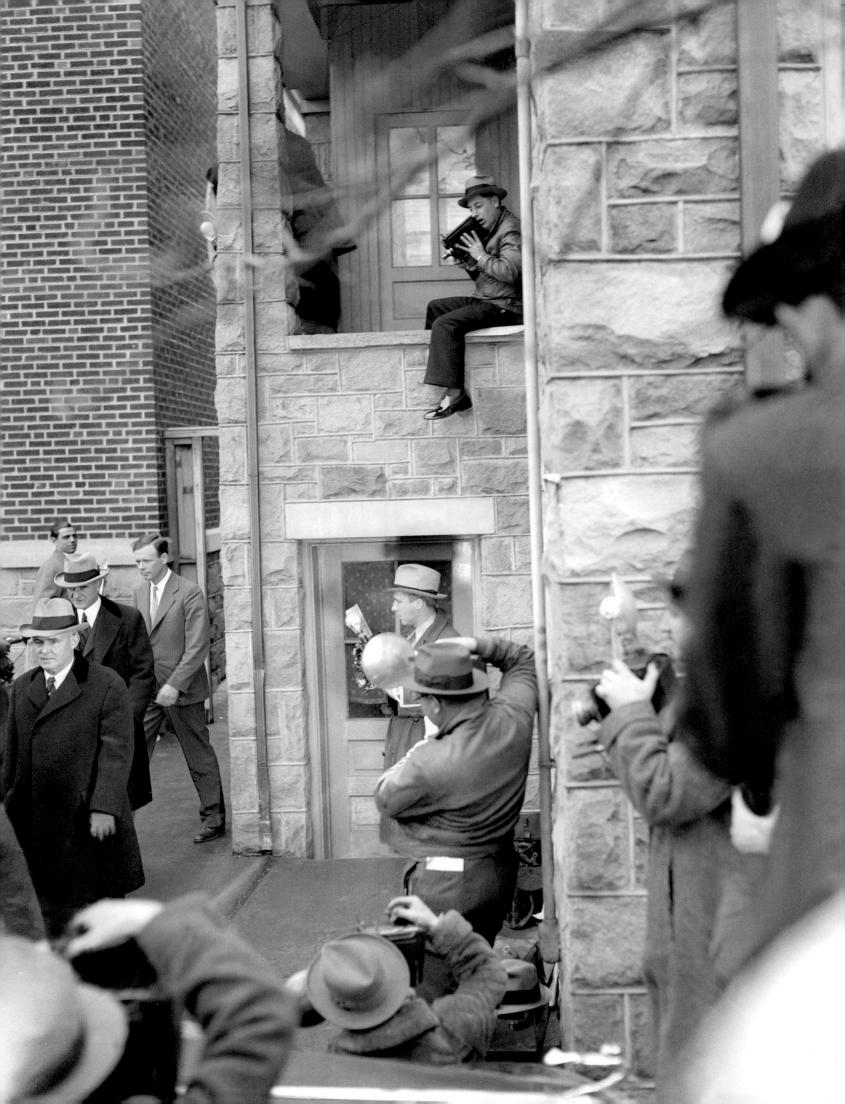

Opposite:
Photographers take pictures of Charles A. Lindbergh during a break in the trial of Bruno Richard Hauptmann in Flemington, New Jersey, early January, 1935, for the kidnap and murder of legendary aviator Charles A. Lindbergh's infant son three years earlier. A week after "the trial of the century" began on January 2, Lindbergh identified Hauptmann as the man he heard briefly call out to him in a Bronx cemetery on an April night in 1932, before a go-between paid the man $50,000 for the safe return of Lindbergh's kidnapped infant son. The baby was found dead in mid-May. The jurors did not buy Hauptmann's claim that he had simply found some of the ransom money among the possessions of an acquaintance who had died, and they found Hauptmann guilty on February 13; he was immediately sentenced to death. A crowd of 5,000 outside the courthouse cheered when the sentence was imposed at 10:47 P.M.

Below:
Hauptmann sits in his cell in Flemington, New Jersey, on February 14, 1935, the day after he was convicted. Maintaining his innocence to the end (and his widow continued to fight for decades to clear his name), he was executed on April 3, 1936.

MARTIN MCEVILLY

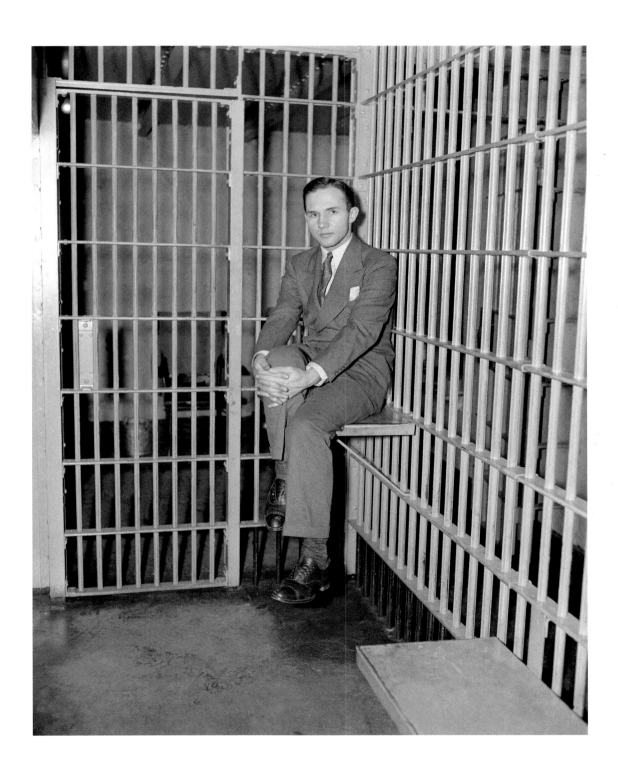

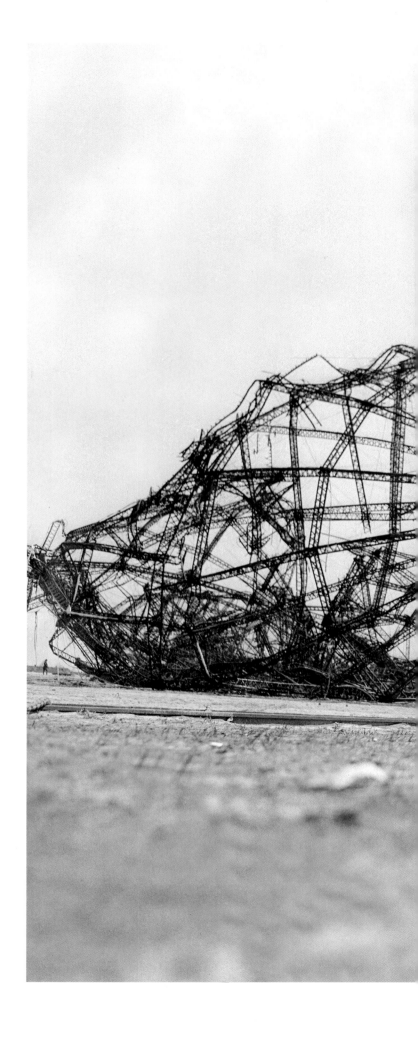

The German zeppelin *Hindenburg* explodes at the mooring tower at Lakehurst, New Jersey, upon its arrival on a commercial flight from Germany on May 6, 1937. The ball of flame rapidly consumed the hydrogen-filled airship, killing thirty-six people. Miraculously, more than sixty others, including people on the ground below, managed to escape the fireball. The year-old German rigid airship was probably destroyed when a discharge of static electricity touched off the highly flammable hydrogen powering it. However, rumors quickly spread that the disaster was a case of sabotage against the Nazi regime in Germany. A radio reporter present for the landing emotionally described the carnage in one of the most famous live broadcasts of the century.
CHARLES HOFF

A soldier stands guard next to the burned-out 800-foot-long skeleton of the *Hindenburg* at the Lakehurst, New Jersey, airfield.

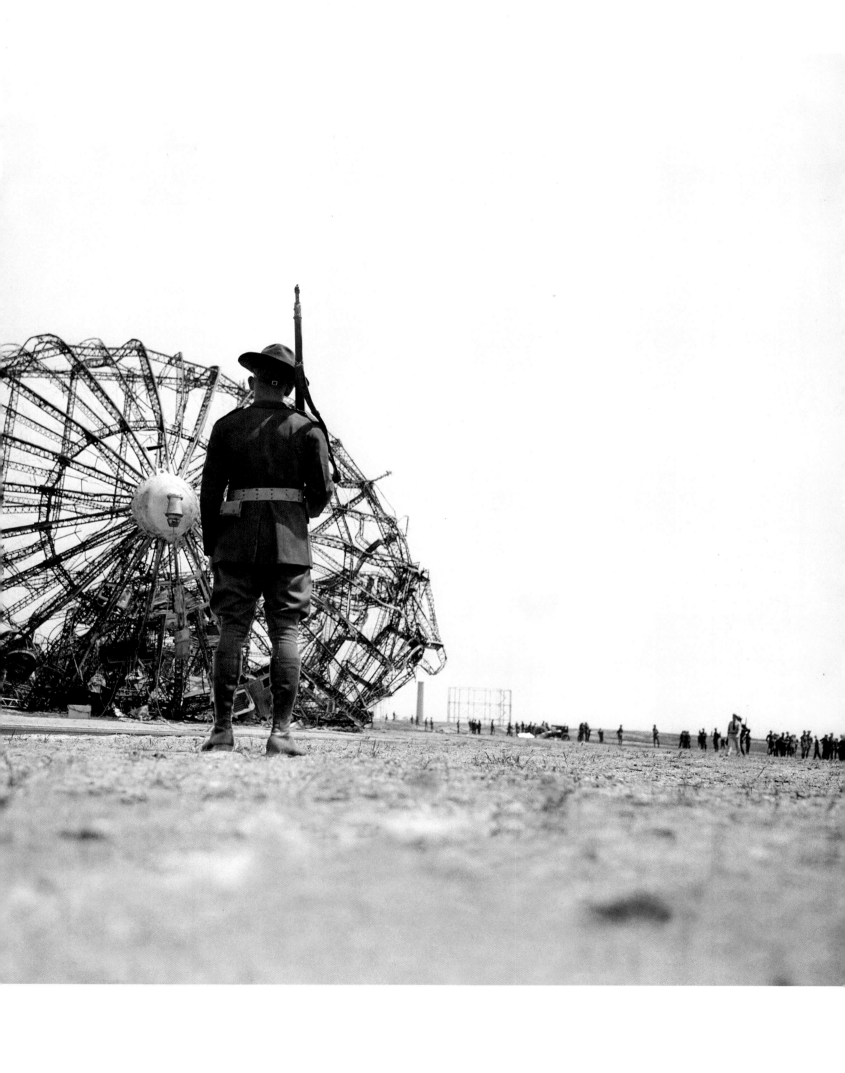

Dorothy Bird jumps for the ball as the umpire, known as Prince Leon, calls a sliding Violet West safe. The game, at Brooklyn's Prospect Park in mid-April, 1938, was played for relaxation and publicity by showgirls in the cast of *Hooray for What?*, a Broadway musical starring Ed Wynn and featuring songs by lyricist E. Y. "Yip" Harburg and composer Harold Arlen (though none became standards like their later "Over the Rainbow" and many others).

SANDHAUS

Opposite:
Alvin "Shipwreck" Kelly, famed flagpole sitter, manages to eat thirteen doughnuts while positioned in a headstand on a board sticking out of the fifty-fourth story of the Chanin Building, at East 42nd Street and Lexington Avenue, on Friday the 13th of October, 1939. He was apparently promoting National Doughnut Dunking Week. Flagpole sitting was another one of those frivolous publicity stunts that dotted the years between the two world wars, and Kelly was undoubtedly the champ. He claimed to have spent a total of 20,613 hours aloft during his lifetime, beginning in 1924, including 1,400 hours in the rain and sleet. During one paid stint promoting the Steel Pier in Atlantic City in the summer of 1930, he spent 1,177 hours—more than forty-nine straight days— atop a flagpole; he slept with his thumbs in holes in the shafts for the platform, to wake up if he started to sway too much. The onetime shipyard worker, who died in 1952, also claimed to have survived five shipwrecks, two airplane crashes, three of automobiles, and one of a train—without a scratch.

CHARLES HOFF

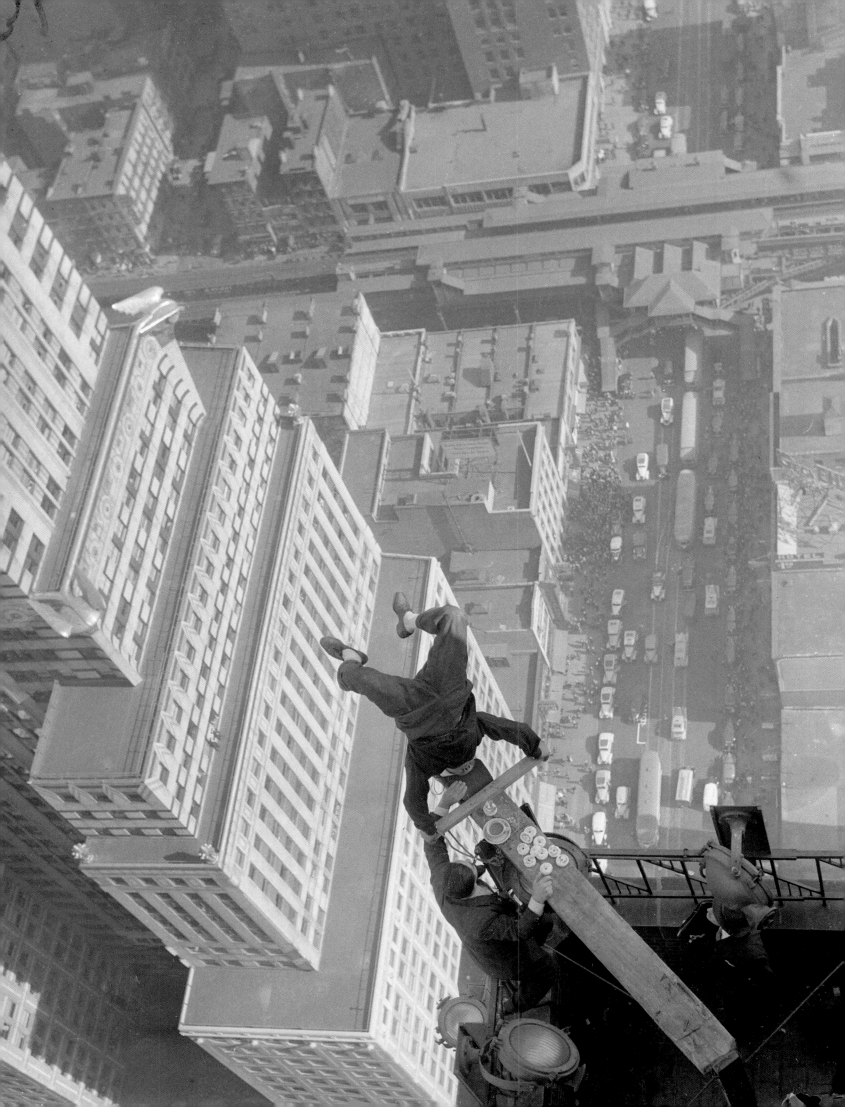

A workman caulks joints with
lead to make them water-
proof during construction of
the Sixth Avenue subway
tunnel in June, 1939.
SEELIG

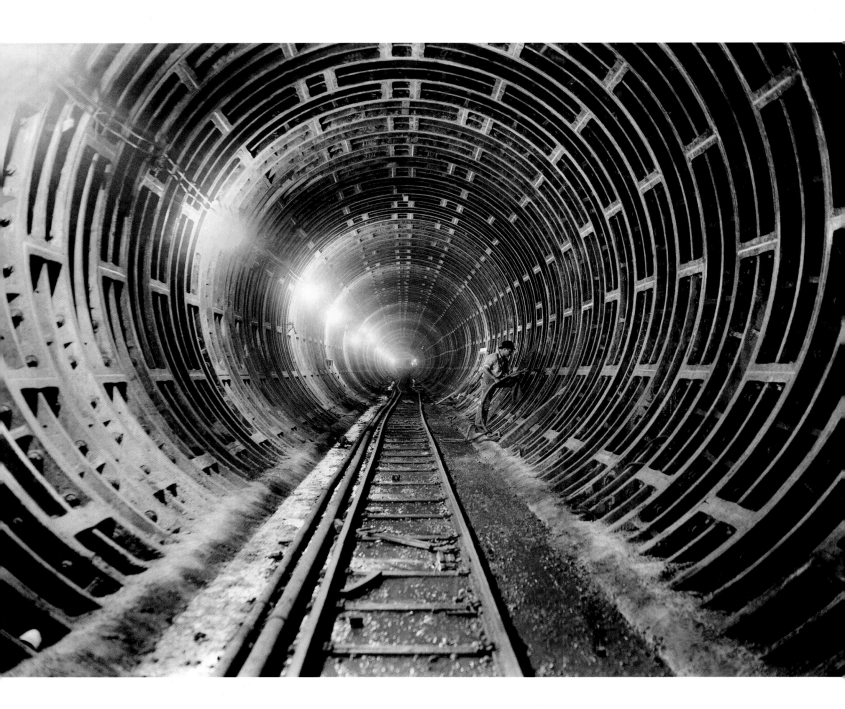

Mayor Fiorello LaGuardia settles into a police officer's motorcycle sidecar—his usual means of transportation in such situations—as he prepares for a ride to a fire on Snediker Avenue in Brooklyn in early June, 1939. The popular reform mayor served an unprecedented three terms, from 1934 to the end of 1945; it was a period of unequaled modernization in New York City, thanks in part to federal New Deal funds. LaGuardia also attacked corruption, cleared slums, improved health and sanitary conditions, smashed gangster-controlled slot machines, and read the comics to youngsters over the radio during a newspaper strike.
MORTIMER

Two dancers at the 1939 World's Fair, Dolores Irwin (left) and Marge Berk, sit in a patrol wagon after their arrest on the night of May 31, 1939—the fourth day of a heat wave—for competing too enthusiastically for the title of Miss Nude of 1939, one of many similar promotional stunts by the concessions in the fair's Amusement Area. Berk usually performed in the Frozen Alive show, while the stripper who called herself just Dolores did a topless "voodoo dance" in the Cuban Village, where the nude contest took place. The two women were only topless when Queens County Sheriff Maurice A. Fitzgerald rose from the audience of 300 and stopped the event, but he reportedly insisted, "It's indecent, I tell you—indecent!"
J. CONDON

THE FORTIES

Charles Hoff uses the Big
Bertha camera to shoot at
Yankee Stadium, July 1948.
This camera, invented by Lou
Walker in the 1920s, was the
precursor to the telephoto
lens and only one of a num-
ber of technological innova-
tions that kept the *Daily
News* photographers
at the top of their game.

Below:

Albert Einstein, widely regarded as the leading scientist of the twentieth century and certainly the most famous one, is sworn in as an American citizen at the federal courthouse in Trenton, New Jersey, near his last professional home at Princeton University, on October 1, 1940. Flanking the father of the theory of relativity were two other new U.S. citizens: his daughter Margot (right) and Helene Dukas, his secretary.

JOHN TRESILIAN

Opposite:

New York Yankees star Joe DiMaggio wears a blanket to keep warm while signing his autograph for some kids at Ebbets Field (just east of Prospect Park), home of the Brooklyn Dodgers, during an exhibition game on April 14, 1940, one day before the start of the season. Later that day, however, the Yankee Clipper injured his knee sliding into second, and he was out until mid-May. DiMaggio went on to hit .352, his third-best year but—after four straight World Series crowns—it was the only time between 1936 and 1943 when the Yankees did not win the American League pennant.

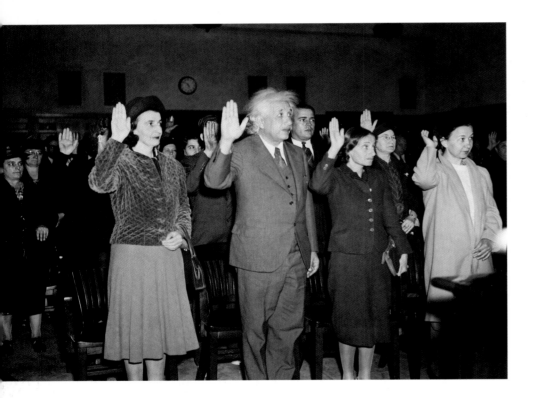

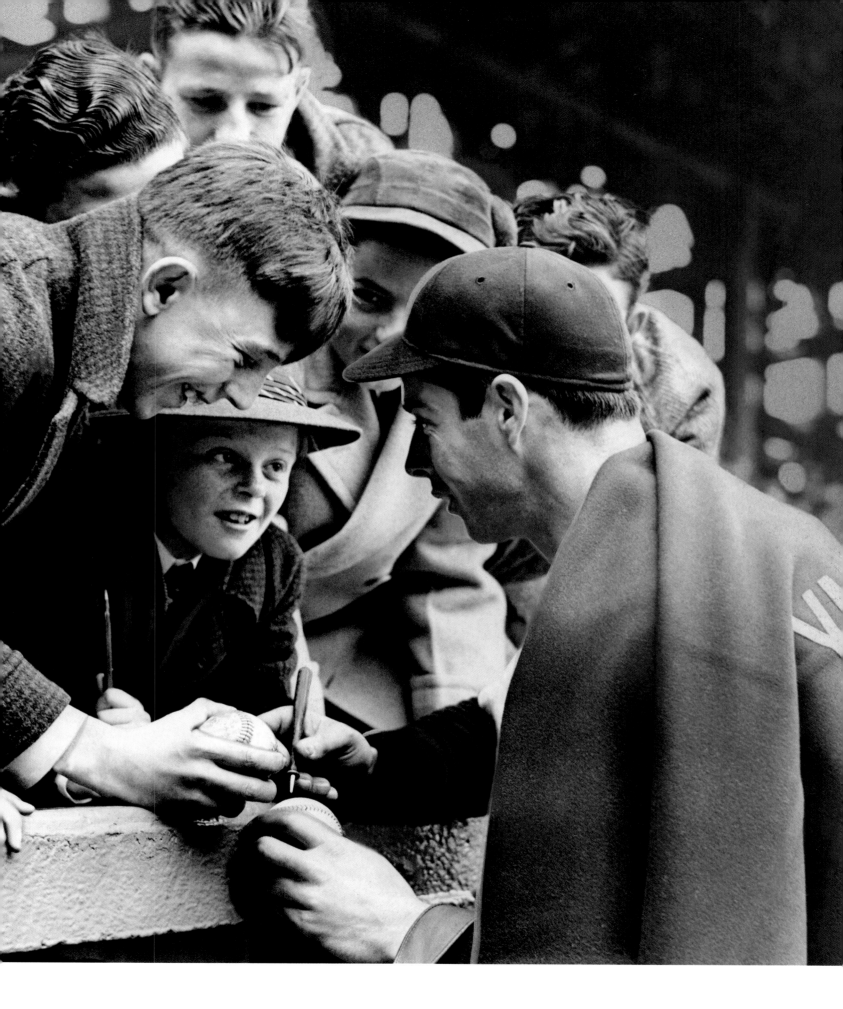

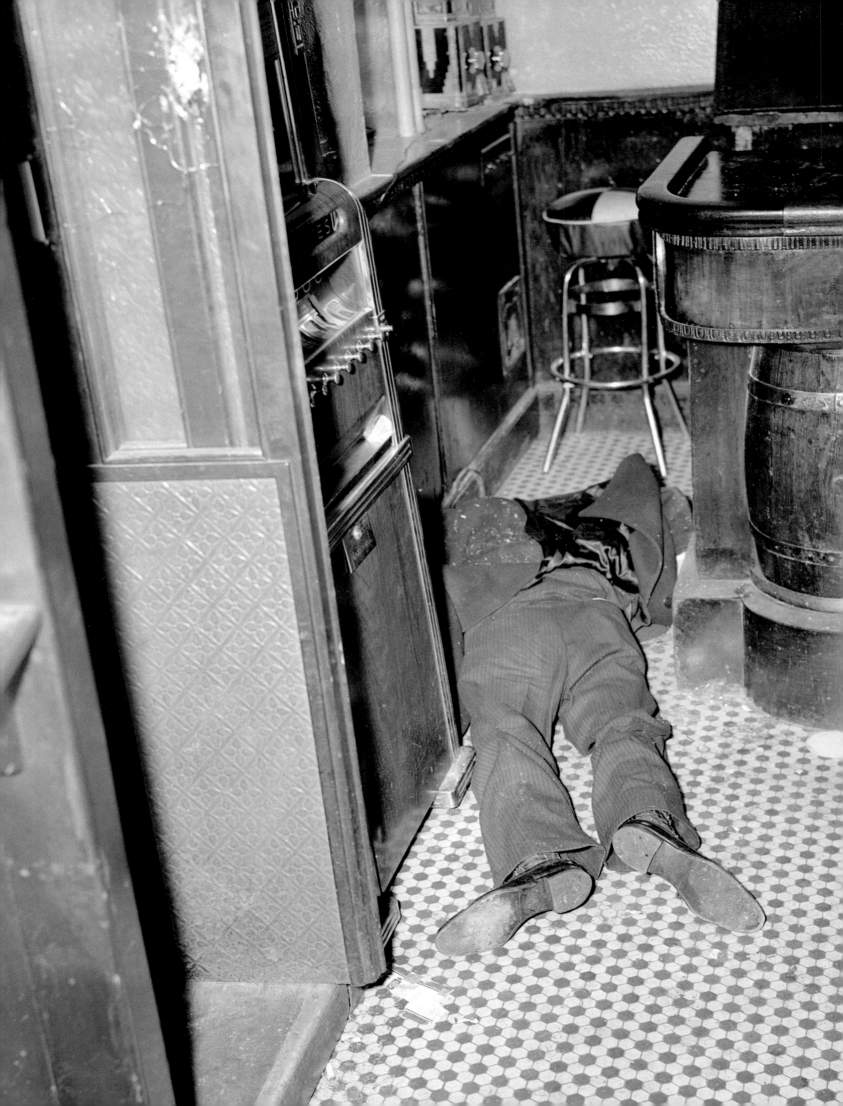

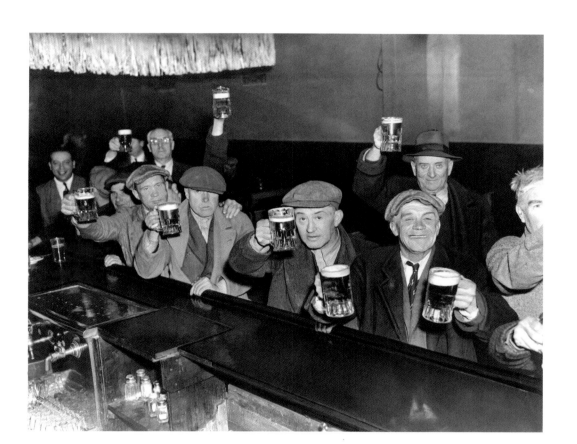

Opposite:
"Thief Trapped by Kiss, Dies Fighting Cops": Murray Fershing lies at the end of the bar on the night of November 14, 1940. He had picked the wrong woman to rob of a diamond ring at knifepoint after dating her for a while; when he subsequently telephoned Dorothy Mori to get together again at the Manhattan Tavern, Amsterdam Avenue and West 75th Street, she had the police waiting for her to identify him with a kiss. As the three detectives moved in on Fershing, he fired five shots wildly, wounding a waiter, before they killed him with seven bullets of their own.
KLEIN

Left:
The gang in a bar at East 1st Street and the Bowery celebrate New Year's Eve, 1941, in their own way. It was only twenty-four days after the Japanese attack on the U.S. naval base at Pearl Harbor, Hawaii, plunging the nation into World War II.
WALTER ENGELS

National Guardsmen of the 245th Coast Artillery undergo physical examinations in their armory at Sumner and Jefferson avenues in Brooklyn before being inducted into the U.S. Army on September 16, 1940. About 60,500 Guardsmen were "summoned to the colors" across the United States that day, under a bill signed August 27 to help safeguard U.S. possessions and territories as war raged in Europe; another 35,700 would be called up the following month. On the same September day, President Franklin D. Roosevelt signed the Selective Training and Service Act—the first peacetime draft in U.S. history, designating October 16 as the date when about 16.5 million American men between twenty-one and thirty-six years old were required to register. His accompanying proclamation stated, "We must and we will marshal our great potential strength to fend off war from our shores." On October 29, the first numbers were drawn, deciding which men would be drafted for one year of training. Little more than a year later, the United States was in the war.

J. CONDON

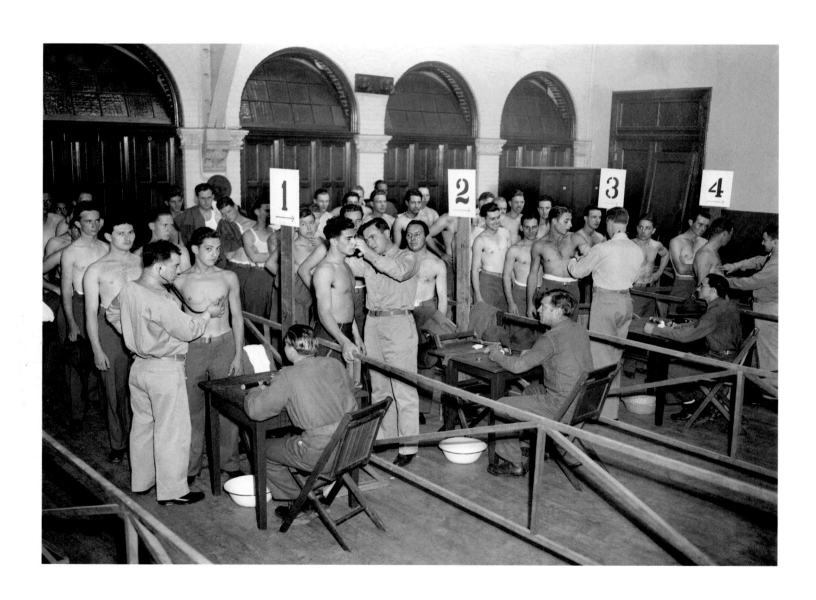

Young athletes who belong to a newly formed "commando unit" practice at the outdoor field of Flushing High School, in northern Queens, in mid-July, 1942.
JOSEPH COSTA

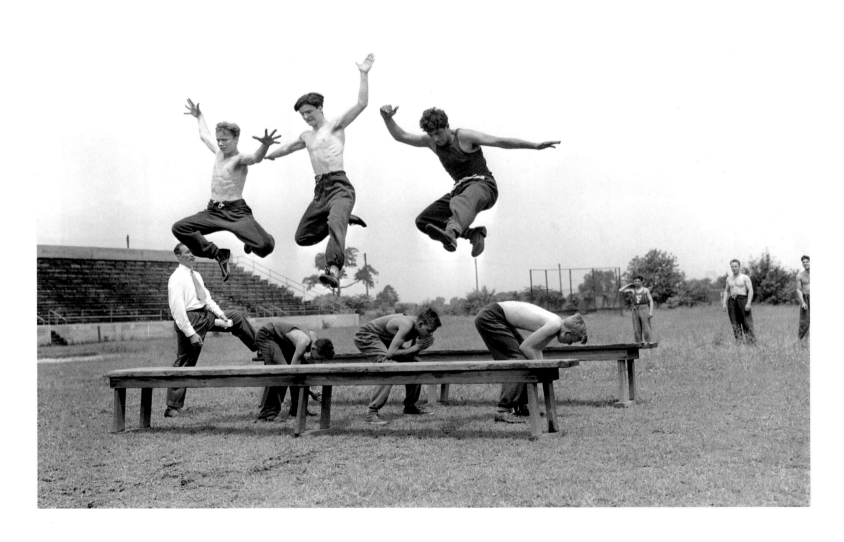

Below:
Members of the U.S. Army Nurses staff stationed at the Post Hospital in Fort Jay on Governor's Island undergo a tear-gas drill. It is the end of November, 1941, a few days before the Japanese attack on Pearl Harbor.
ED JACKSON

Opposite:
Many New Yorkers associated the beginning of the war with the burning of the USS *Lafayette*, formerly the glamorous liner SS *Normandie*, in her berth at West 49th Street on February 9, 1942. Seized from the French Line by the U.S. Navy on December 7, 1941, the vessel had been stripped of her splendid trappings and was in the process of being converted into a troopship when the fire broke out. Inevitably, rumors of sabotage were rife, but the conflagration was purely an accident, which was compounded when firefighters poured so much water on her decks that she became top-heavy and capsized. While boards of inquiry plodded to their soggy conclusions, the ship lay on her side for eighteen months.

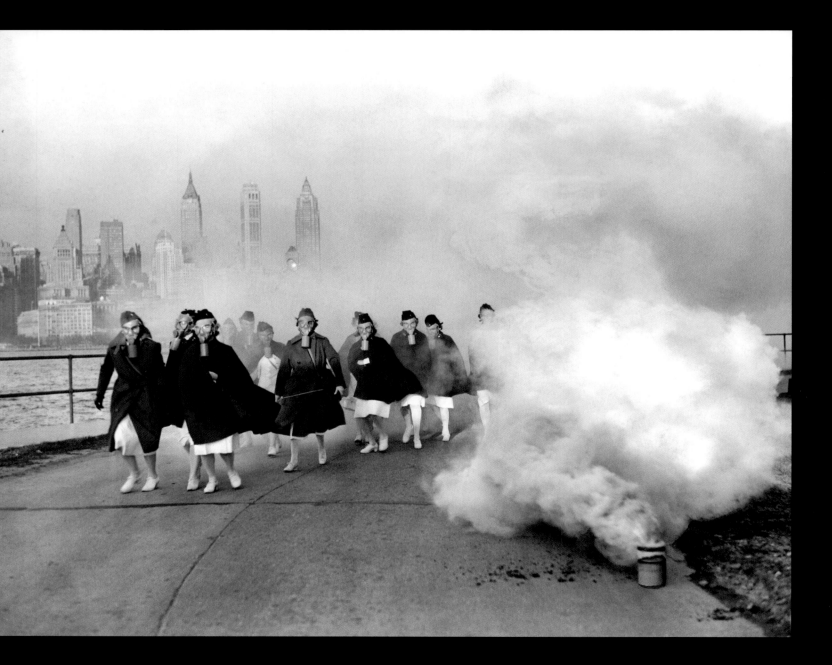

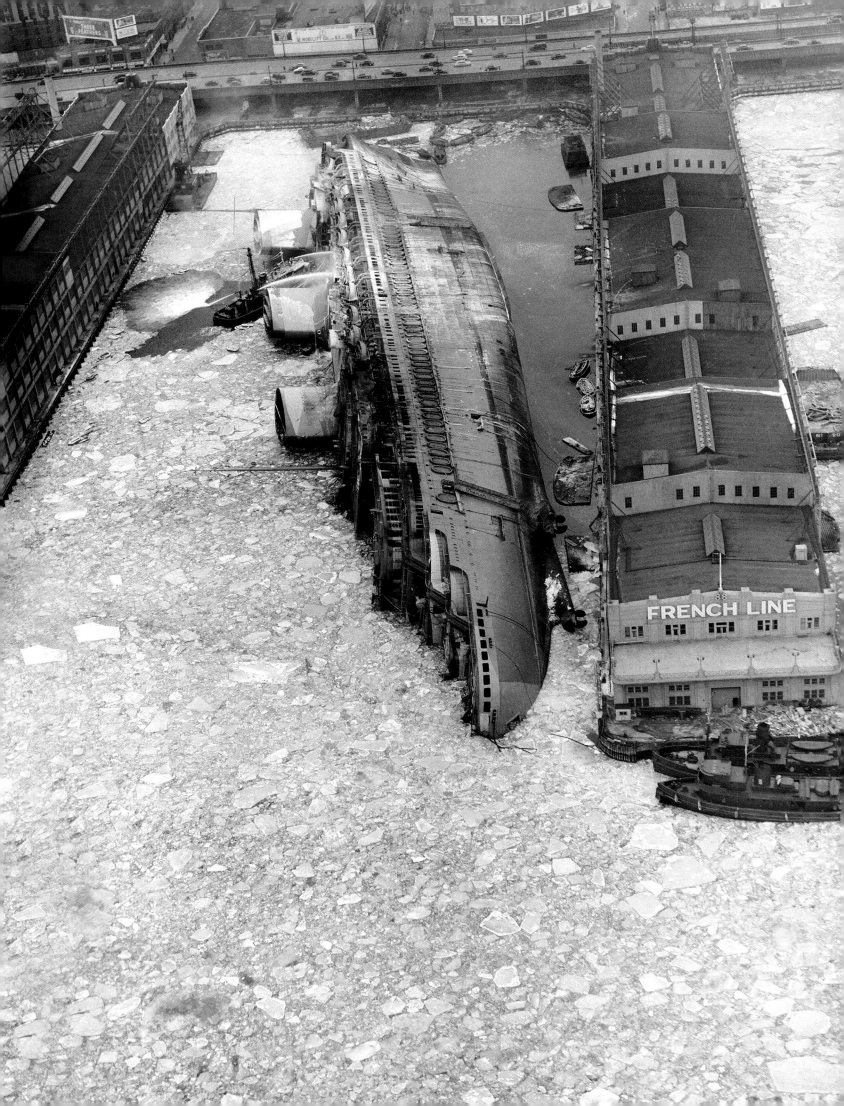

120 Edna Egbert battles with the police as they try to prevent her from jumping off a second-story ledge at her home, 497 Dean Street in Brooklyn, on March 19, 1942. Patrolmen Edward Murphy (left) and George Munday managed to distract her while other officers set up a safety net; then they pushed her into it. The fifty-year-old woman, reportedly distraught because her soldier son hadn't been in touch ever since he joined up a year earlier, was taken to Bellevue Hospital, and the crowd of about 600 onlookers, mostly school children, dispersed.

CHARLES PAYNE

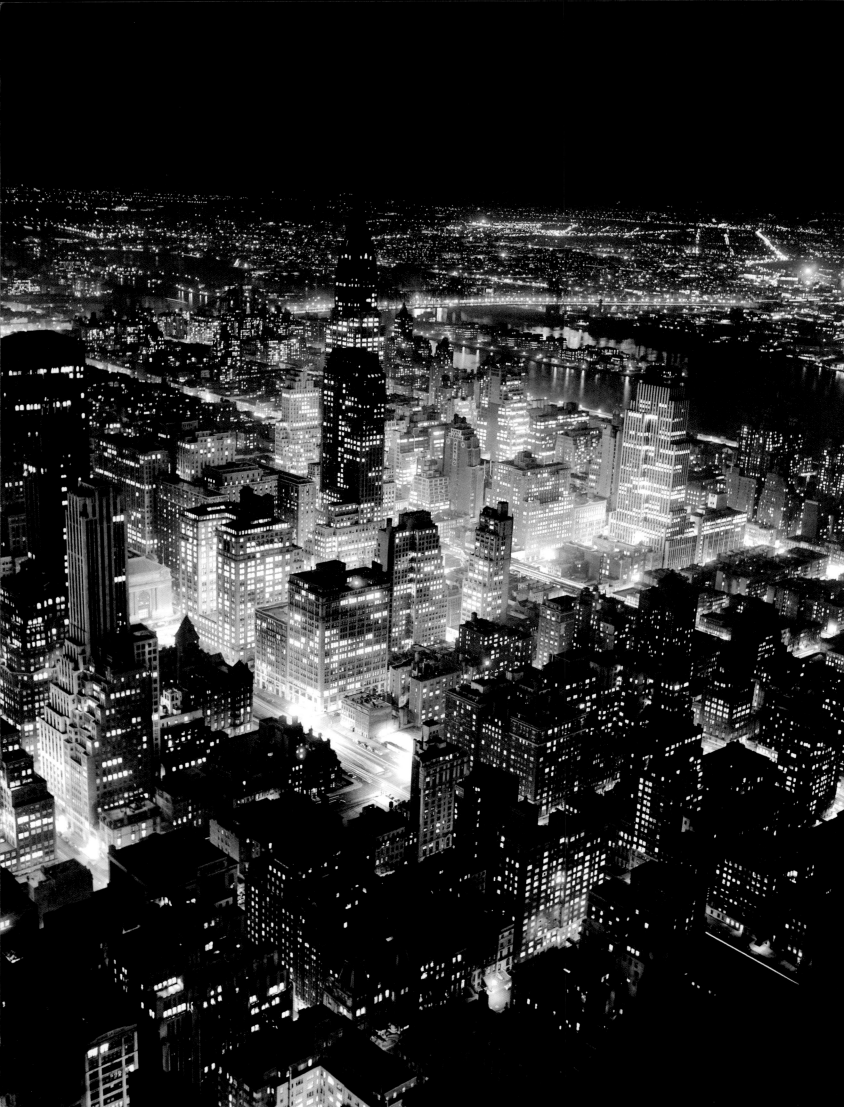

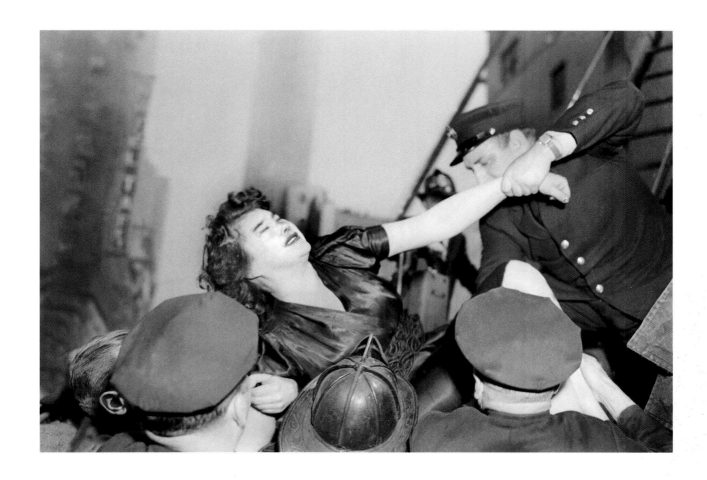

Opposite:
There's a war on, but Midtown Manhattan sparkles on a crisp December night, 1943, in this view probably taken from the Empire State Building looking northeast toward the Chrysler Building.
BILL MEURER

Above:
Illiana Laurel, a Russian opera singer and former wife of Stan Laurel (the skinny, simpering half of the extremely popular movie comedy team of Laurel and Hardy), is helped to safety from the burning Radio Center Hotel, at Seventh Avenue and West 50th Street, on April 17, 1942. The 125 residents of the six-story hotel were mostly women working in Broadway theaters at night, who were roused from their sleep when the daytime fire broke out. As a crowd estimated at 10,000 people gathered, Laurel, who was alone in the penthouse apartment of a friend when smoke began pouring in, reportedly "dashed to a roof ledge, kicked off her shoes, and screamed that she was going to jump" before firefighters used an extension ladder to rescue her. She later explained that she had been reading an exciting detective story at the time, "and I'm sure that's what made me lose my head."
MEL WEISS

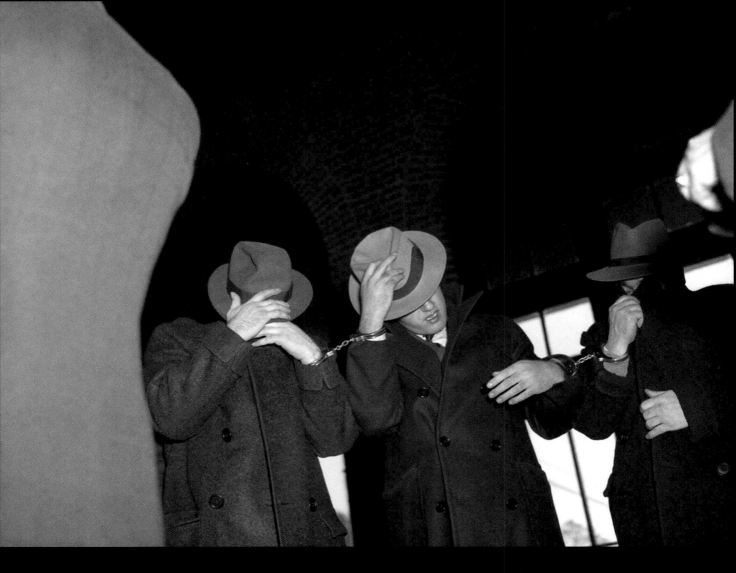

Above:
Frank "The Dasher" Abbandando, Frank Davino, and Harry "Happy" Maione (left to right) hide their faces from photographers on January 13, 1941, as they head to the train taking them from Ossining, New York, back to Brooklyn and new trials for their lives. Davino had merely killed a fireman during a $3,000 payroll holdup; the other two were leading members of Murder, Inc., a group of mostly Brooklyn Sicilians and Jews responsible for hundreds of murders during the 1930s on the orders of organized crime. Maione worked directly under Albert Anastasia, the gang's Lord High Executioner, and Abbandando—who is believed to have killed at least forty people, and who even whispered a death threat against the judge while testifying at his murder trial—was Maione's chief lieutenant. The pair were convicted again of killing a mobster named George "Whitey" Rudnick (who was stabbed sixty-three times with an ice pick and given a final blow to the head with a meat cleaver). Both men were returned to Sing Sing and executed at that prison in 1942.
WALTER ENGELS

Opposite:
Alan Ladd strikes a dramatic pose at the Daily News Studio in late May, 1942, just after the release of the movie tough guy's first major break, in *This Gun for Hire*. He remained a star well into the 1950s and is best remembered today as the mysterious gunman in the western *Shane*.
SEYMOUR WALLY

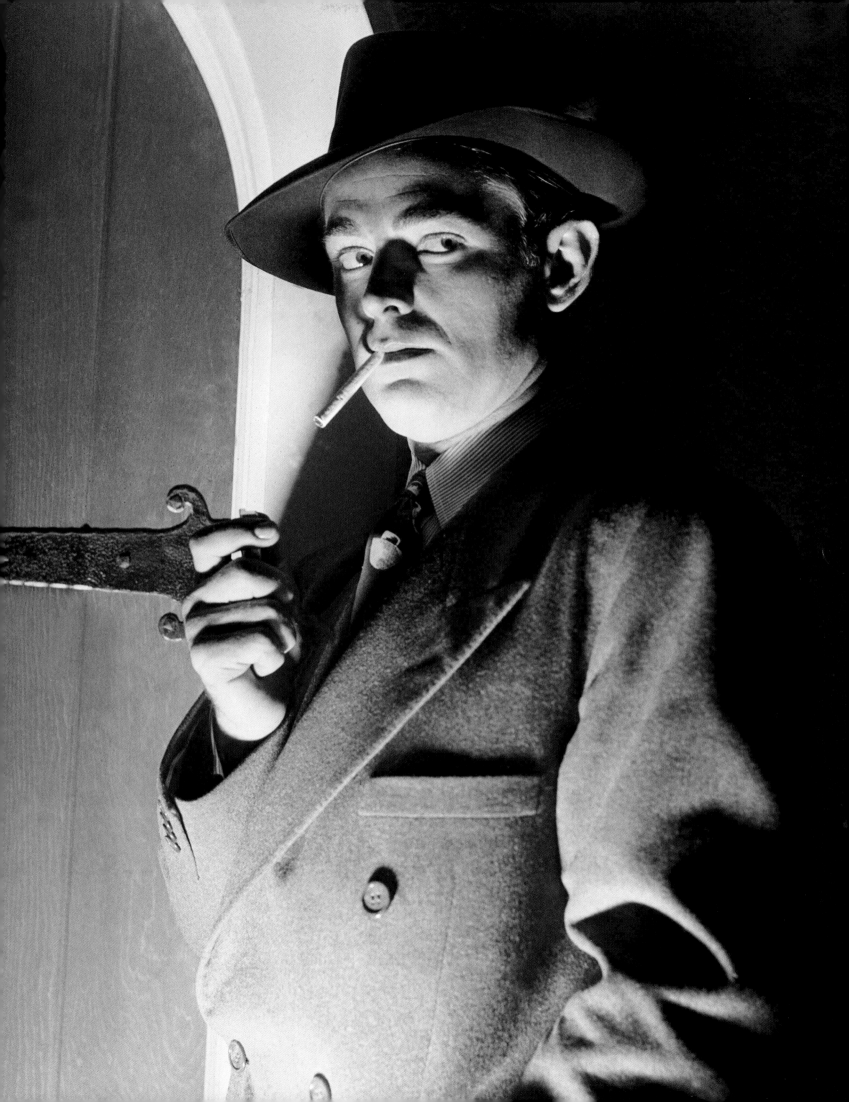

Dancers enjoy an evening
out on the Mall in Central
Park, early June, 1940.
Summer dances and
classical concerts were
popular at the park's
grand promenade, near
Bethesda Fountain.
WALTER ENGELS

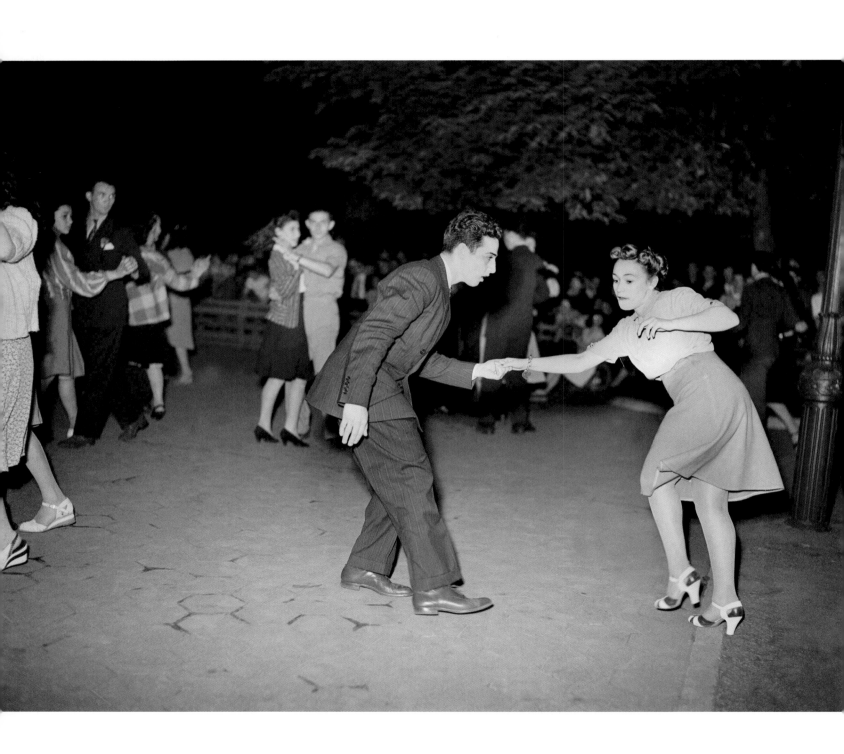

The Harry James Orchestra inspires jitterbugging all over the Paramount Theatre in Times Square, April 21, 1943. Even James himself snagged a partner, whose boyfriend looked on while she swung with the star. Billed as "The World's Number One Trumpeter," Harry James led one of the era's most popular swing bands after leaving Benny Goodman's band in 1939. (His popularity didn't suffer when he married the movie star and pinup favorite Betty Grable in 1943.) When he and his "Music Makers," including singer Helen Forrest, showed up at the Paramount, some 7,000 "hepcats" started lining up outside the theater at 4:00 A.M., and the surging crowd ended up breaking a plate-glass window —along with two ribs of a patrolman caught in the crush. And when the band played "Two O'Clock Jump," eight couples eluded the forty harried ushers and leaped onstage to dance, while other frenzied fans jitterbugged in the aisles and the lobby.

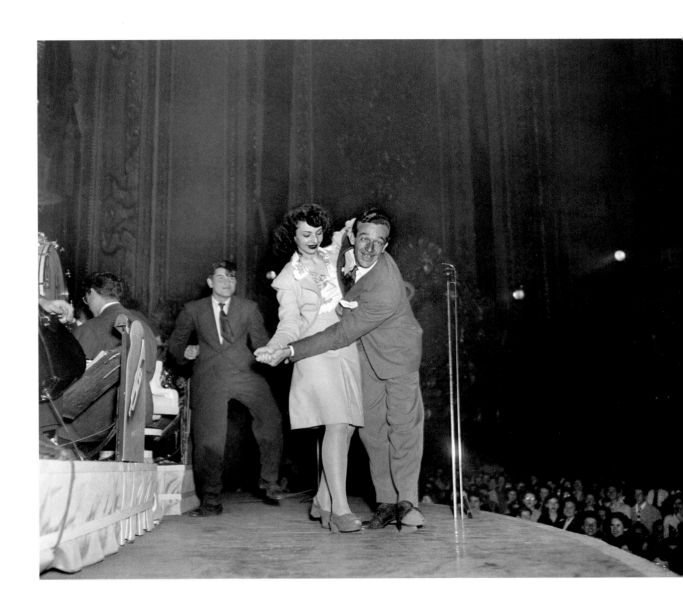

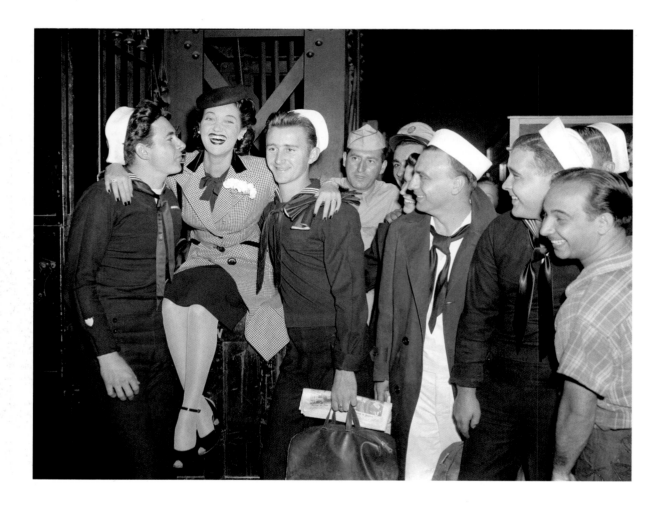

Movie star Dorothy Lamour—
almost unrecognizable not
garbed in her usual sarong—
poses in the arms of service-
men A. J. Patterson (left)
and Michael Kuney after her
arrival at Pennsylvania
Station from Hollywood, mid-
September, 1944. The star of
The Hurricane (1937) and
other South Seas romances,
as well as the "Road" series
of comedies with Bob Hope
and Bing Crosby, Lamour was
in New York to meet and
vacation with her husband,
Major Ross Howard 3rd.
BILL WALLACE

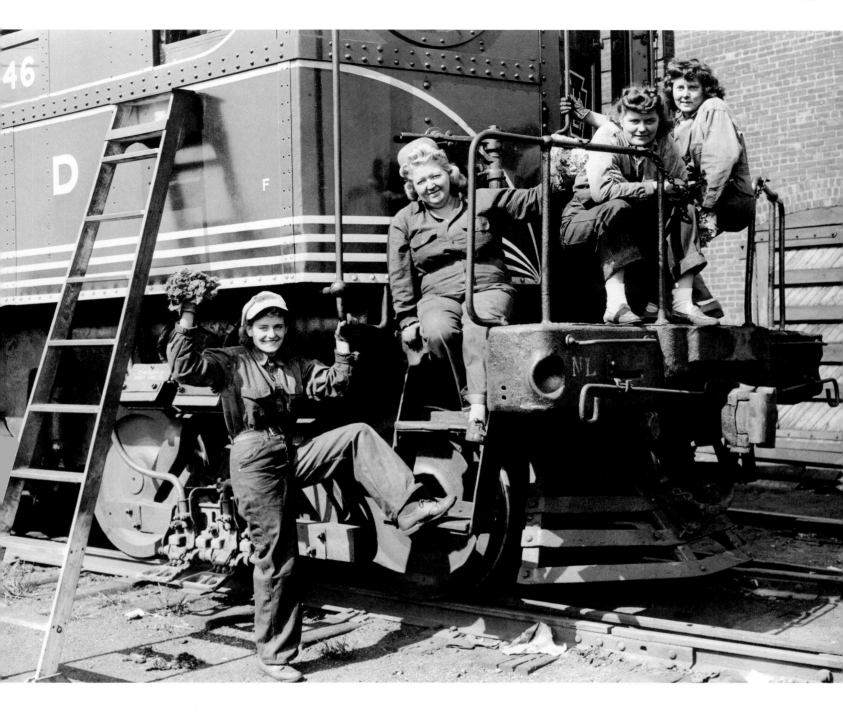

It's almost a year since the United States entered World War II, and women take a lunch break before going back to work for the Long Island Railroad at the Morris Park train yards in southeastern Queens, early October, 1942. When the men went off to fight, women suddenly found employment in all kinds of industries previously closed to them—including nine women whom the LIRR hired to clean engines, at fifty-six cents an hour for a forty-eight-hour work week. After the war ended in 1945, Rosie the Riveter and her sisters began to resist the common notion—among men—that "a woman's place is in the home," foreshadowing the earliest rumblings of the modern feminist movement that erupted in the 1960s.

NICK PETERSEN

130 Below and opposite:
Long before the Beatles, rail-thin singing sensation Frank Sinatra, also known simply as The Voice, has the bobby-soxers shrieking and swooning at the renowned Paramount Theatre, on Broadway between West 44th and West 45th streets. But October 14, 1944, was not a night like every other: as Sinatra began singing "I Don't Know Why I Love You But I Do," a young man moving down the aisle hurled three eggs at him. Struck between the eyes and on the chest, the silenced Voice walked offstage while adolescent females began hitting the troublemaker with handbags, binoculars, and other objects. Rescued by ushers, Alexander J. Dorogokupetz was said to have told the manager, "I don't why I did it but I did." A day later, the lanky, bow-tie-wearing eighteen-year-old, who was not charged, told the *Daily News* he was tired of being teased as a supposed Sinatra look-alike and forced to take dates to the singer's concerts. (He wasn't alone; the next day a group of sympathetic sailors threw tomatoes at the Sinatra poster outside the Paramount.) As for The Voice, he returned for the second show that night (after a movie), was presented with three freshly purchased bouquets of roses, and said, "Things like this are apt to happen in show business."

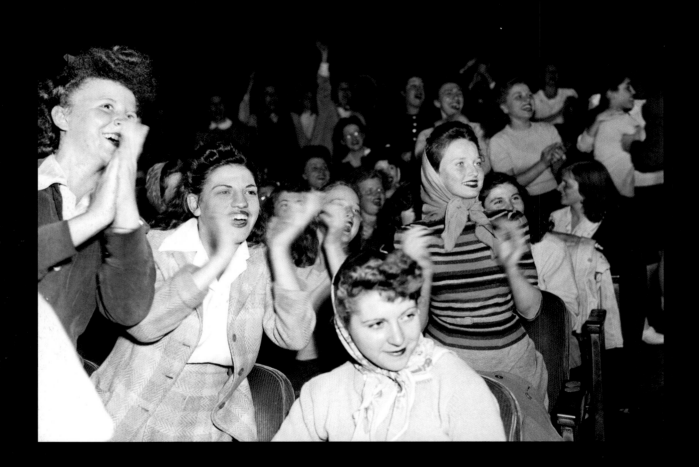

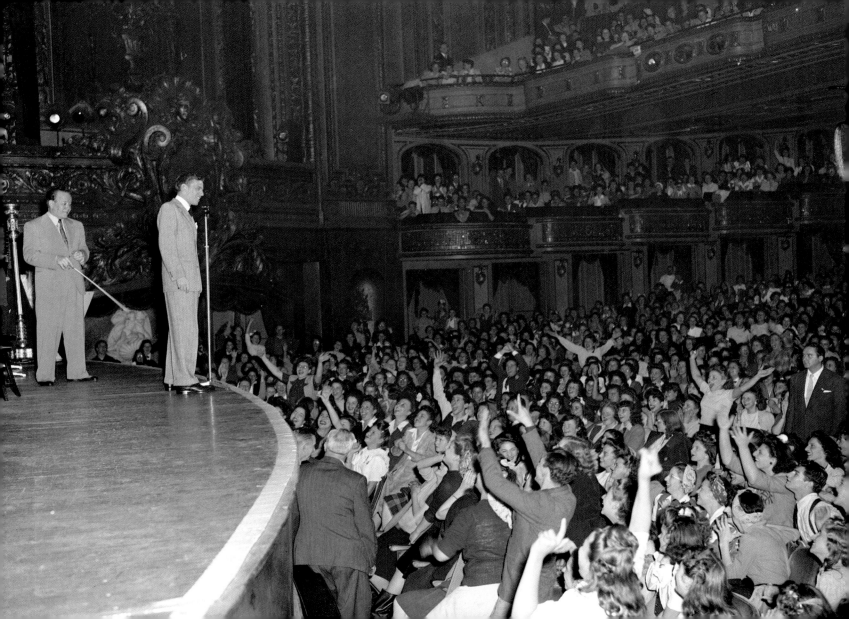

People in Times Square
listen to a broadcast of
President Roosevelt's dec-
laration of war against
Japan, December 8, 1941.
WALTER ENGELS

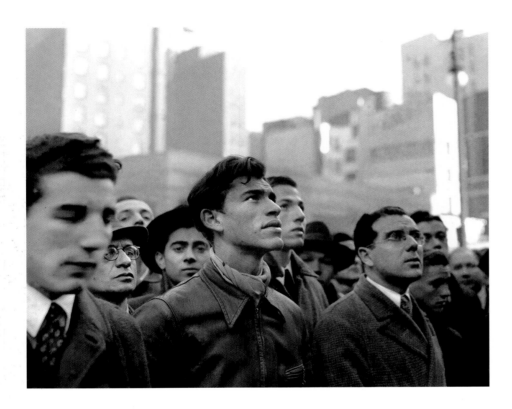

The USS *Kearsarge*, a 27,000-ton aircraft carrier, is launched from the Brooklyn Navy Yard on May 5, 1945, less than a week after the birth of another carrier. The war in Europe was about to end, but no one knew how much longer the fighting in the Pacific would continue, so workers kept churning out warships.

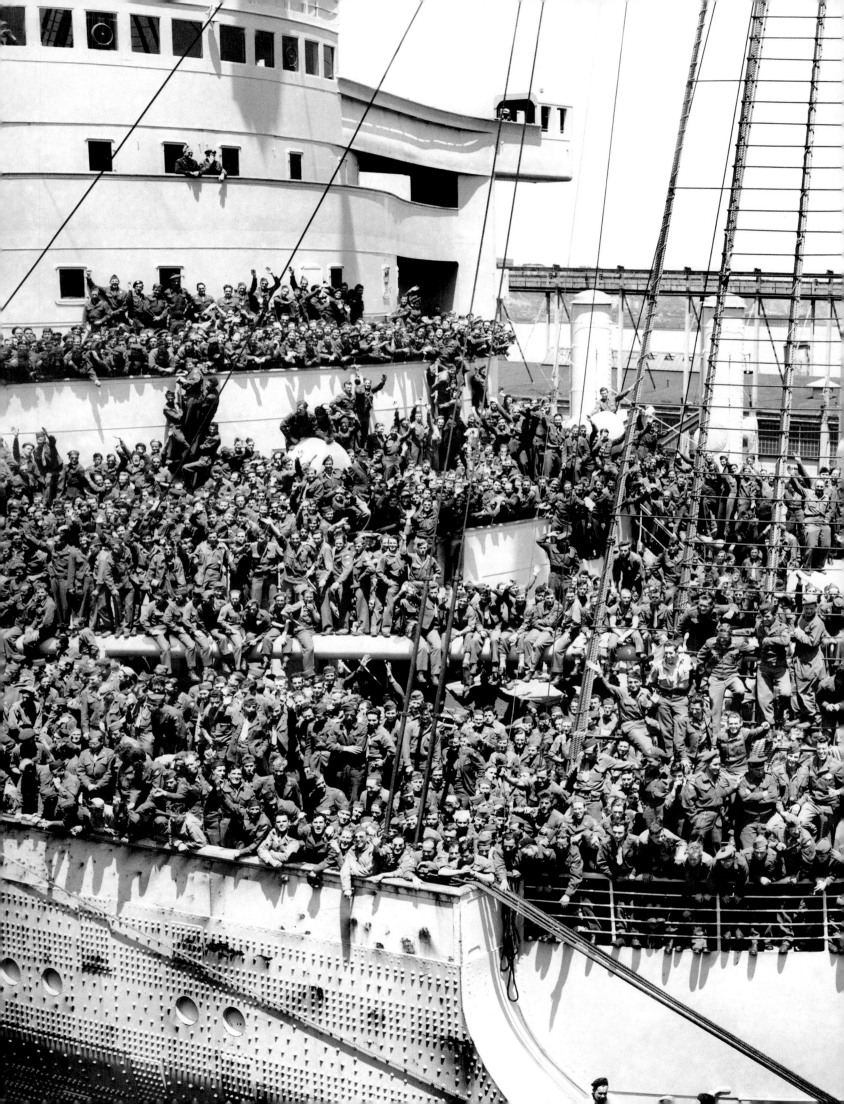

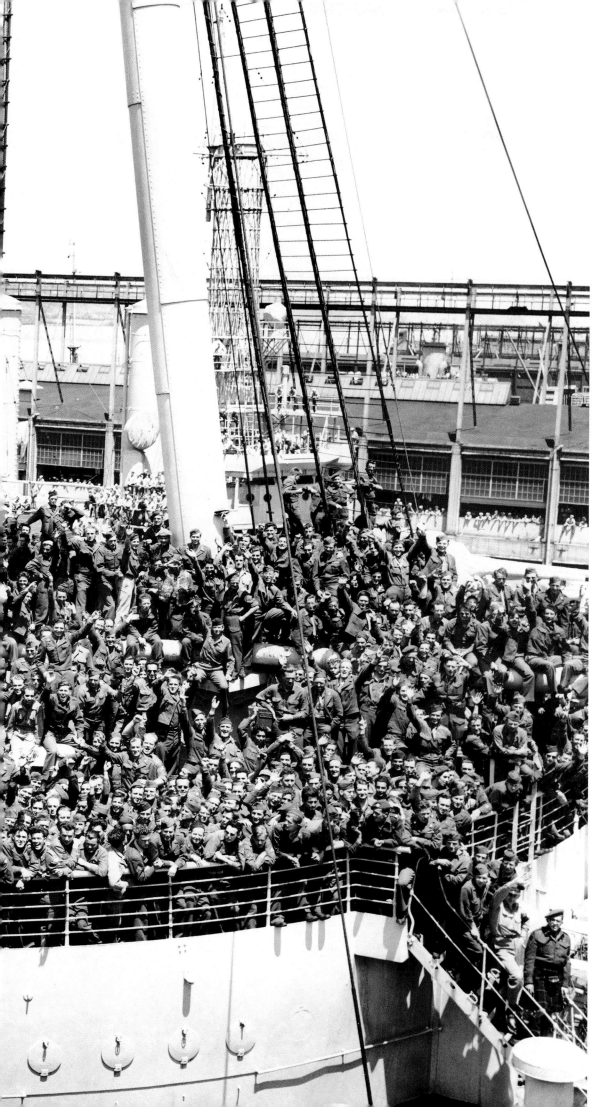

Left:
Nearly 15,000 soldiers, almost half of them Canadians, jam the deck of the *Queen Mary* as the liner docks at Pier 90, at West 50th Street and the Hudson River, on July 11, 1945. In all, some 35,000 soldiers arrived in New York aboard eight troop transports on that date. The long conflict in Europe was finally over, and the famous liner and her sister ship, the *Queen Elizabeth*, along with many others, were repeatedly crossing the Atlantic to bring home the troops. The Japanese surrender did not come for another month, however, and other soldiers were boarding ships to get ready for a planned autumn invasion of Japan.
GORDON RYNDERS

Below:
War bride Pamela Fortier and her young son, Paul, both from England, look out at Pier 95 from the SS *Marine Falcon*. It was October 21, 1947, and the two were en route to Malden, Massachusetts, to join Mrs. Fortier's husband. As happens in every war, many American members of the armed forces got married while stationed abroad during World War II.
JOHN TRESILIAN

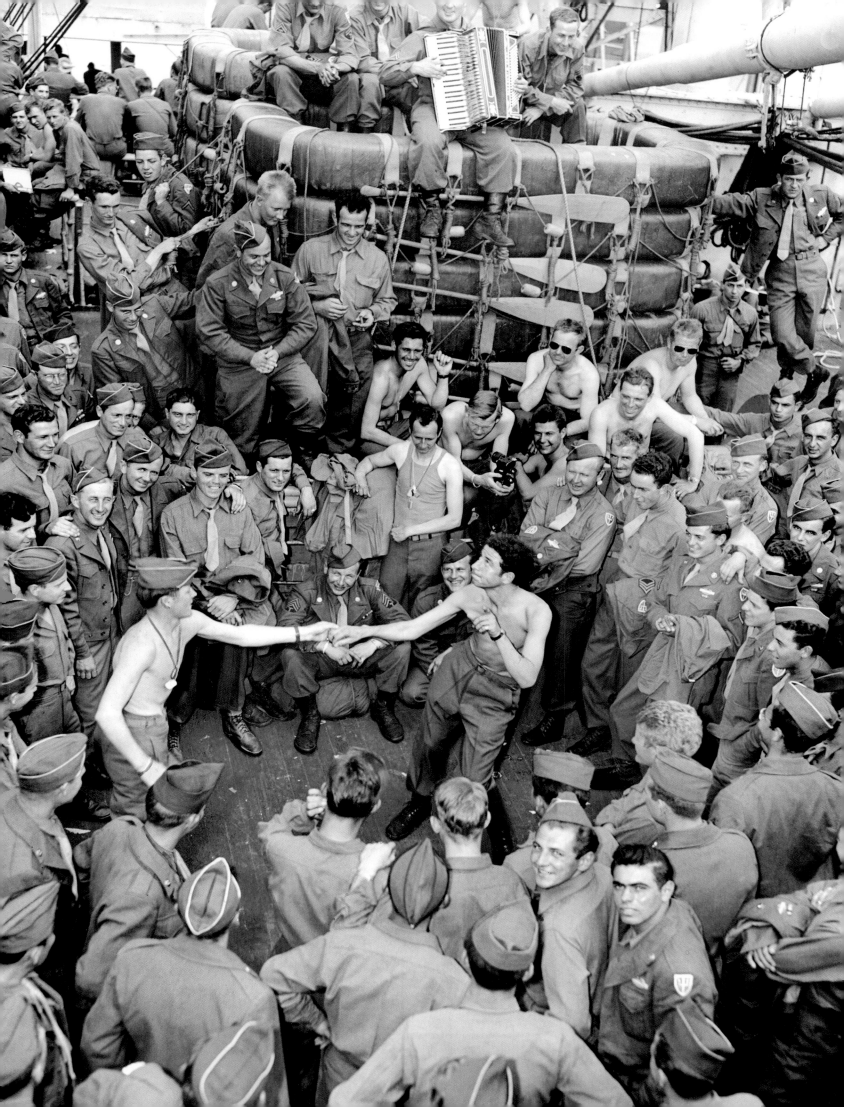

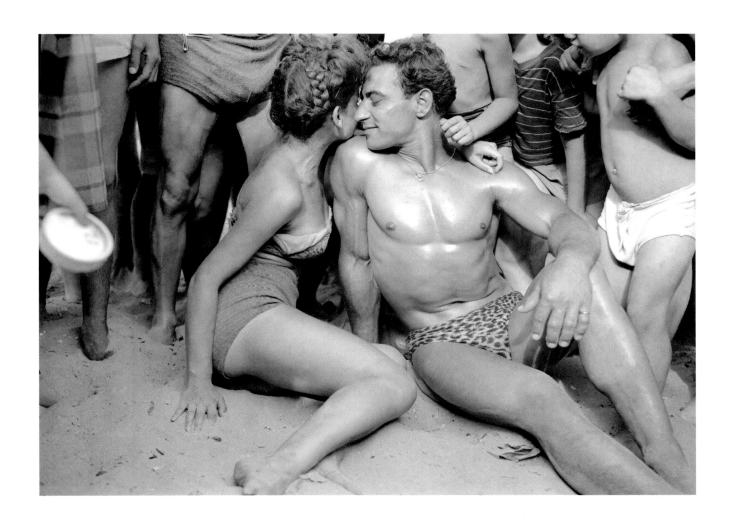

Opposite:
Private Howie Gerhartz
(left) and Private Tony
Martelloni do the jitterbug
while Corporal Joe Separdi
plays his accordion aboard
the U.S. Army transport
Brazil at Pier 84 in the
Hudson River, June 24, 1945.
CHARLES HOFF

Above:
It's August 5, 1945, the eve of
peacetime (the day after this
photo was published, the
front-page headline was
"Atom Bomb Rocks Japs.
More on Way, Truman
Warns; Biggest War Secret
Revealed"), and Mildred
Jacobs and Fred Massaro
only have eyes for each other
amid the crowds at Coney
Island—estimated at 1.5
million people—during the
first Sunday without rain
since July 8. Steeplechase
Park, the boardwalk, and the
beaches typically drew at
least a million people
on summer weekends.
PAUL BERNIUS

138 Soldiers of the 82nd Airborne Division pass under the Washington Arch in Manhattan's Washington Square Park at the start of the Victory Parade, a four-mile march up Fifth Avenue on January 12, 1946, to formally mark the end of World War II five months earlier. It was called the "greatest Army parade America has ever seen": some 13,000 of the "fightingest soldiers in all the world—the smashing, hell-for-leather 82nd Airborne," which fought in Sicily, Italy, Normandy, and the Battle of the Bulge—represented all Allied troops as they followed Major General James Gavin, at thirty-eight the youngest division commander in the Army, up Fifth Avenue to the reviewing stand at 82nd Street under a "blizzard" of ticker tape.

PAUL BERNIUS

Opposite:
Lieutenant John W. Evans of the 82nd Airborne Division is joined by Nurse Lieutenant Barbara Dupray (seated at the window) and his daughter Catherine as he and other wounded veterans from Halloran Hospital follow the Victory Parade as it goes past their windows at 711 Fifth Avenue.

SEYMOUR WALLY

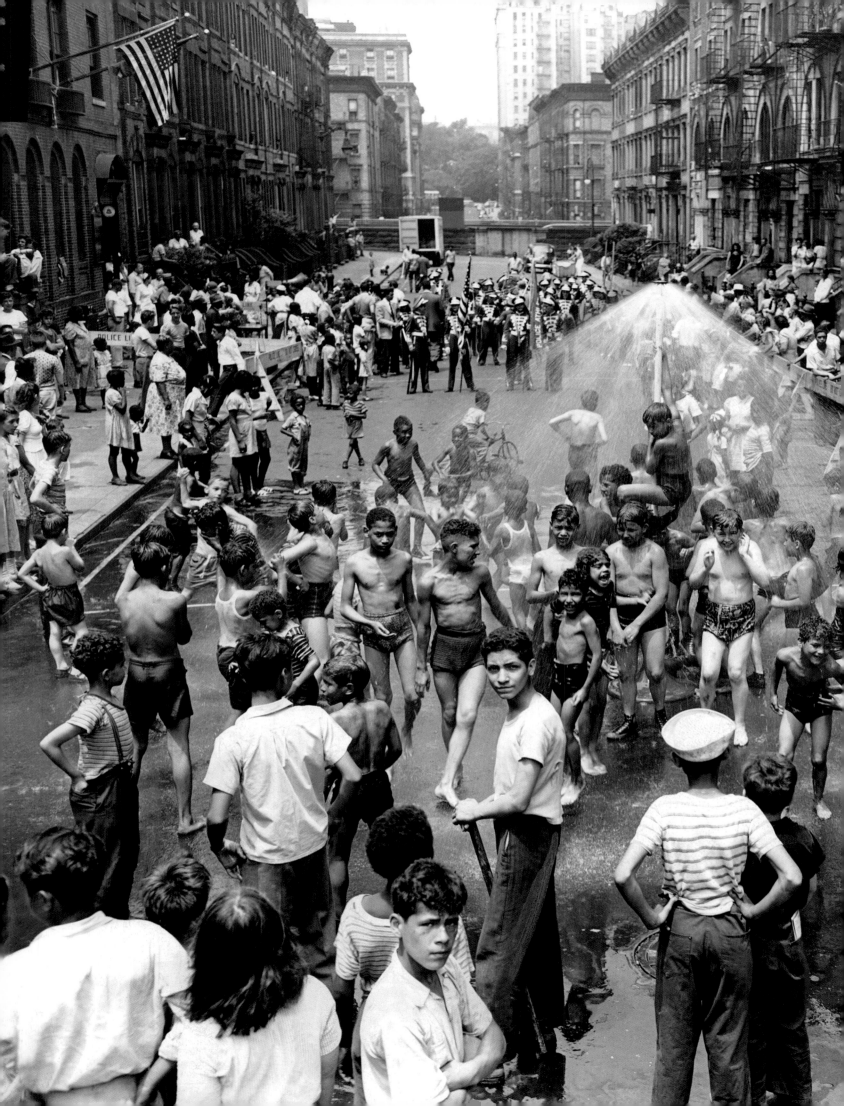

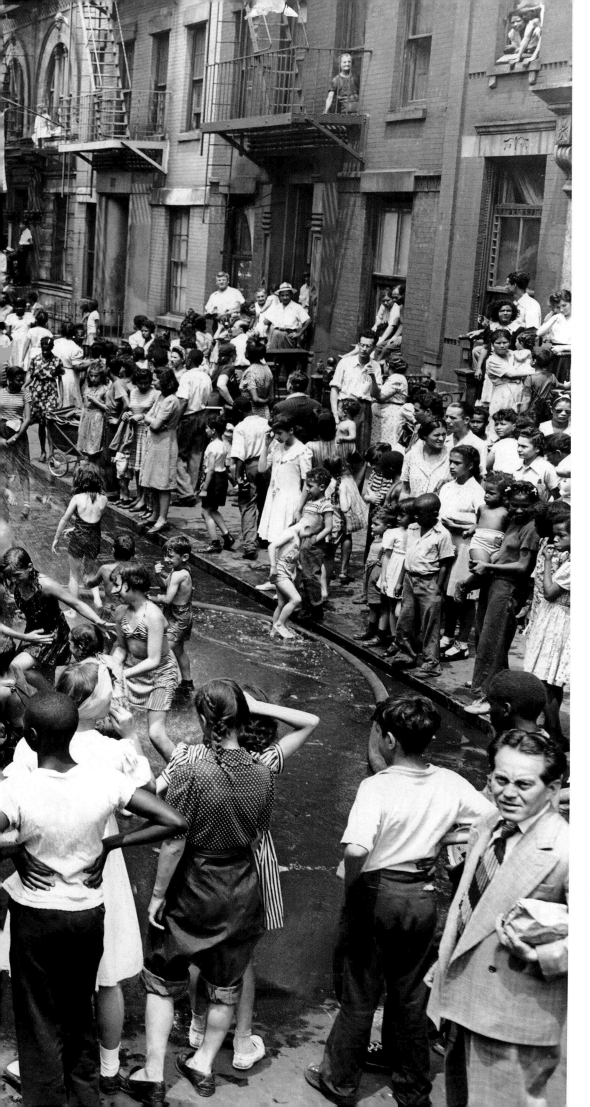

Children enjoy a sprinkler on July 1, 1947, as East 101st Street between Park and Lexington avenues is turned into a traffic-free playground. It was the first of sixty-one play streets designated by the mayor that summer, and supervised by the Police Athletic League. Still, recreational facilities for the city's youth were doled out carefully. Robert Moses—who held a variety of deceptively insignificant-sounding municipal and state posts from 1924 to 1968, but probably reshaped New York City and its environs more than any other individual—was responsible for a startling number of bridges, highways, parks, and other structures, including 255 playgrounds in New York City. Only two of them, however, were built in predominantly African-American neighborhoods. And while white neighborhoods had beautiful municipal swimming pools, minority kids had to rely on opened fire hydrants and other makeshift devices.

GEORGE MATTSON

Hoboken, New Jersey, turns out for its favorite son, singing idol Frank Sinatra, as he rides a fire truck with his father, Captain Martin Sinatra of Engine Company 5, on October 30, 1947—Frank Sinatra Day in that town. That year found the singer—already under some criticism for not serving during World War II (he had been declared 4-F because of a punctured eardrum)—parrying reports that he was associated with organized-crime figures, on account of a trip to Cuba to party with deported mobster Charles "Lucky" Luciano. "Any report that I fraternized with goons and racketeers is a vicious lie," he said. "I was brought up to shake a man's hand when I am introduced to him without first investigating his past."

LEONARD DETRICK

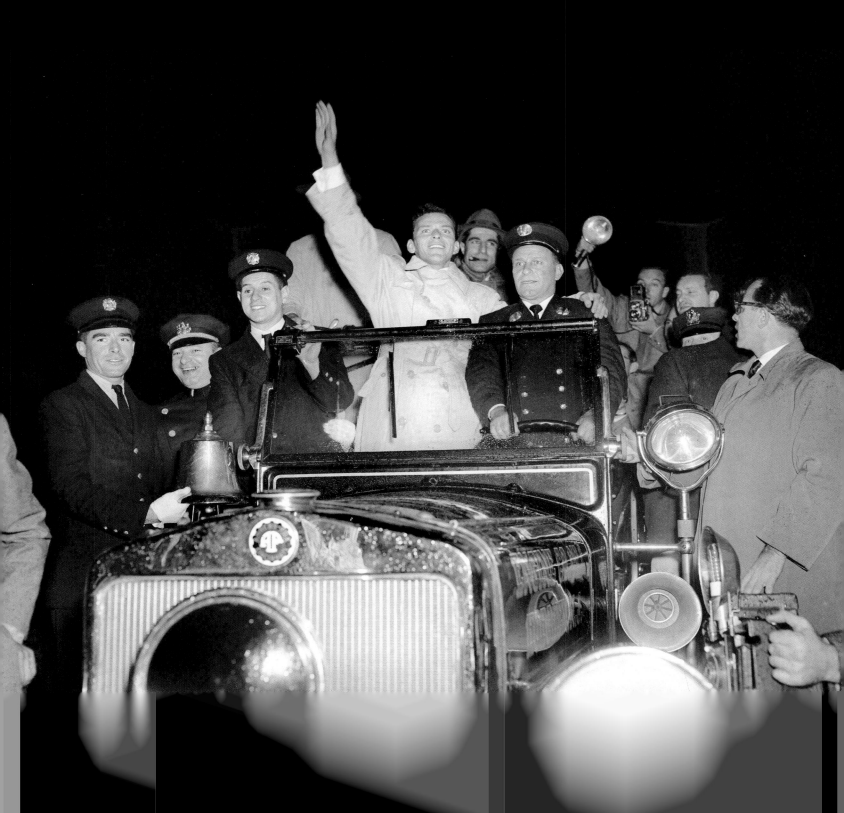

Sugar Ray Robinson, one of the all-time champs of the boxing ring, defeats Kid Gavilan to retain the welter-weight title in a bout at Philadelphia's Municipal Stadium on July 12, 1949. The welterweight champion since 1946, Robinson moved up to the middleweight title in 1951. He temporarily retired in 1952 with a record of only three losses in 137 bouts, before returning to the ring a few years later and regaining his title. **CHARLES HOFF**

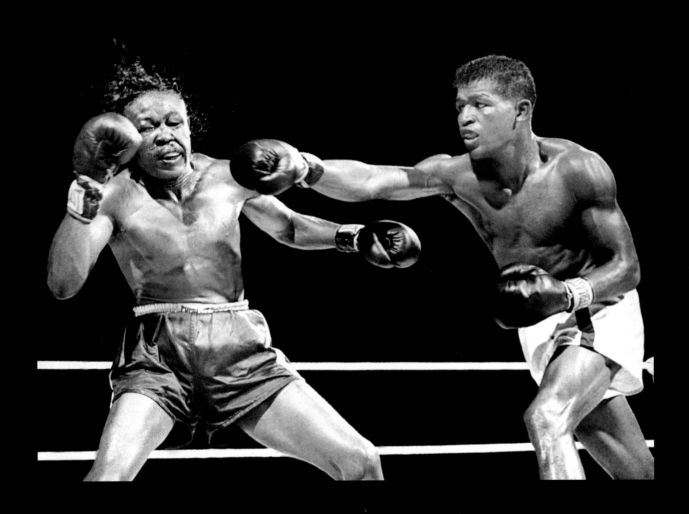

Above:

Richard Nixon is flanked by fellow members of the House Un-American Activities Committee (HUAC), Richard Vail (left) and Herbert Bonner, at the federal courthouse in Manhattan in early March, 1947. The special subcommittee was investigating Leon Josephson, an attorney and admitted Communist, who was accused of obtaining a false passport for an alleged Soviet agent. On March 5, Josephson said the inquiry was unconstitutional and he refused to cooperate. He was later cited for contempt of Congress and jailed for ten months. HUAC's investigations of alleged subversion in and out of government— especially in Hollywood— sparked the post–World War II era of witch hunts and helped launch Nixon's meteoric rise to political power.
ED JACKSON

Opposite:

Humphrey Bogart and Lauren Bacall lead a Hollywood contingent landing at LaGuardia Airport on October 29, 1947, after a well-publicized but mild protest in Washington, D.C., against HUAC investigations into charges of Communist infiltration of the movie industry. Other members of the Committee for the First Amendment included Richard Conte, Paul Henreid, Gene Kelly, Danny Kaye, Sterling Hayden, and director John Huston. Bogart and some others had been dismayed, however, by the confrontational tactics of the ten so-called unfriendly witnesses at the hearing. The day after this photo was taken, HUAC cited the ten screenwriters and directors for contempt of Congress; the Hollywood Ten were fined, jailed, and placed on what became a long blacklist, keeping large numbers of real and purported political leftists out of work for several years. As for Bogart, he saved his own career by writing two open letters, in December 1947 and March 1948, stating that he had been duped by the Committee for the First Amendment—which by then had been declared a Communist-front organization, a common smear tactic in that era.
ART EDGER

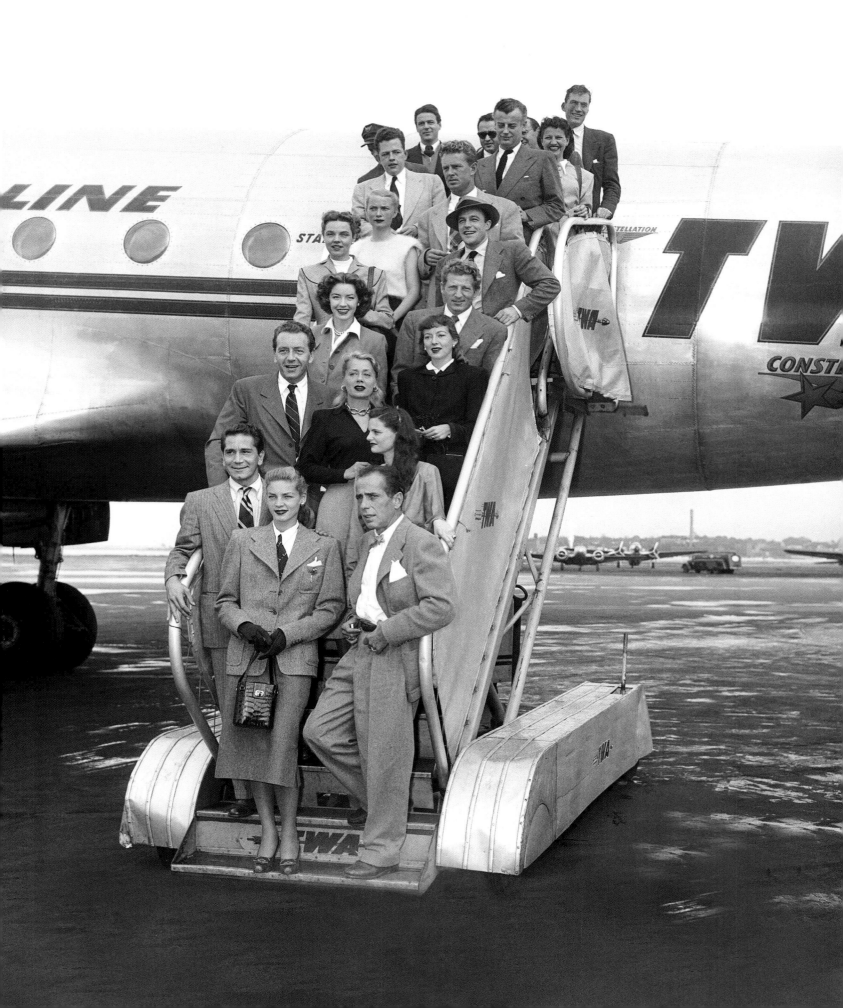

John Kerr and Peter Mahon,
booked for assault and rob-
bery, and angry that their
picture was taken, chase
Daily News photographer
Phil Greitzer through the
68th Street Police Station,
January 1955.

A manacled Julius Rosenberg and his wife, Ethel, embrace in a van taking them to federal prison, where they were ordered held on $100,000 bail each, after they entered not-guilty pleas to espionage charges at the federal courthouse in Foley Square, downtown Manhattan, on August 23, 1950. The court appearance was the first time they had seen each other since Mrs. Rosenberg's arrest on August 11. Based largely on testimony by Ethel's brother, David Greenglass, an employee at the Los Alamos, New Mexico, laboratory where the first atomic bombs were produced during World War II, the couple were convicted in March 1951 of transmitting secrets about the atomic bomb to the Soviet Union in the mid-1940s. Despite widespread protests about an unfair trial, and appeals for mercy at least for the mother of two young children, both of the Rosenbergs were executed on June 19, 1953. Information released from Soviet files appears to support the charges against Julius Rosenberg, but his wife may not have been an active participant in the spy ring. **ED JACKSON**

Mounted police disperse student strikers at Centre and Walker streets in lower Manhattan, April 28, 1950. It was the fourth day of demonstrations by thousands of high school students, in all of the city's boroughs except Staten Island, in support of teachers' demands for $600 more per year; the teachers refused to take part in extracurricular activities, such as chaperoning proms and coaching sports, until their demands were met. The worst day of the student walkout was April 27, when many of them rioted at City Hall and nearby Foley Square, overturning cars, and eight students were arrested. Then, on April 28, some students threw vegetables, garbage, and soda bottles at police while shouting "Gestapo!" and "the foulest obscenities" at the officers; young strikers also knocked over garbage cans and display stands, and the skirt of a female passerby was torn off. City officials took a hard line against the students and what they called radical agitators among the teachers, and the strike soon petered out.
BILL WALLACE

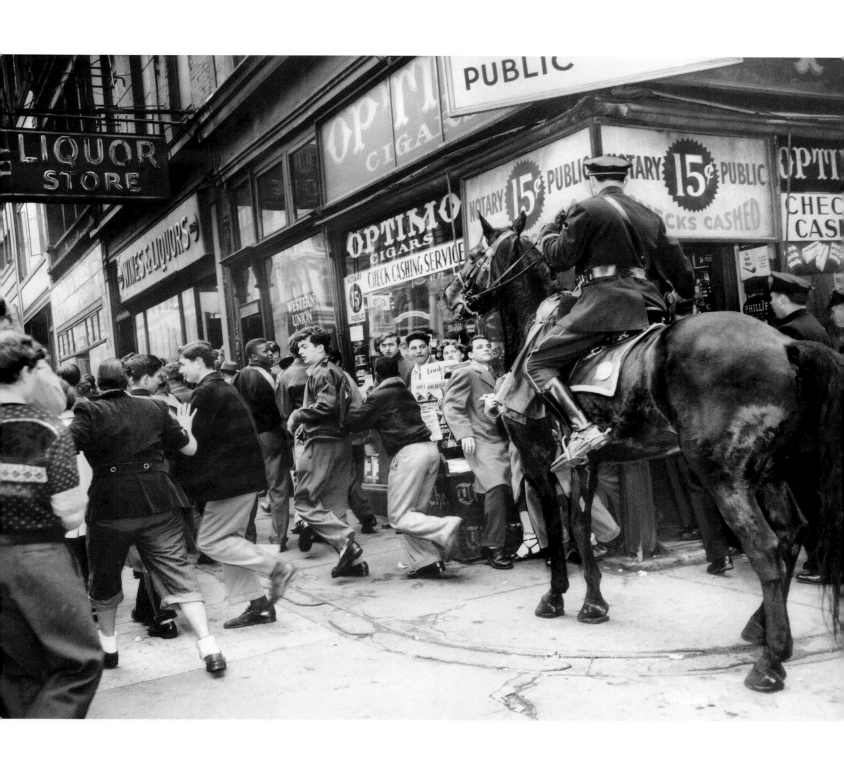

Preparing for his role as a
crusading newspaper editor,
Humphrey Bogart (center)
pays a visit to the *Daily
News* composing room
during filming of *Deadline
U.S.A.*, early November,1951.

John F. Kennedy, in his first year in the U.S. Senate, and the former Jacqueline Lee Bouvier, described as a "socialite career girl," are flanked by their twenty attendants, page boy, and flower girl on their wedding day, September 12, 1953, at Newport, Rhode Island. Jackie wore an ivory silk taffeta gown and her grandmother's rose-point lace veil, and she carried pink and white orchids and gardenias. Five hundred guests jammed St. Mary's Church for the wedding; Archbishop Richard J. Cushing of Boston performed the ceremony, and Robert F. Kennedy was his brother's best man. The reception, for 1,200 guests, took place at the 300-acre Hammersmith Farm, home of Jackie's mother and stepfather. Even a little more than seven years before they moved into the White House, the Kennedys were one of the most glamorous couples in Washington, D.C. **PAT CANDIDO**

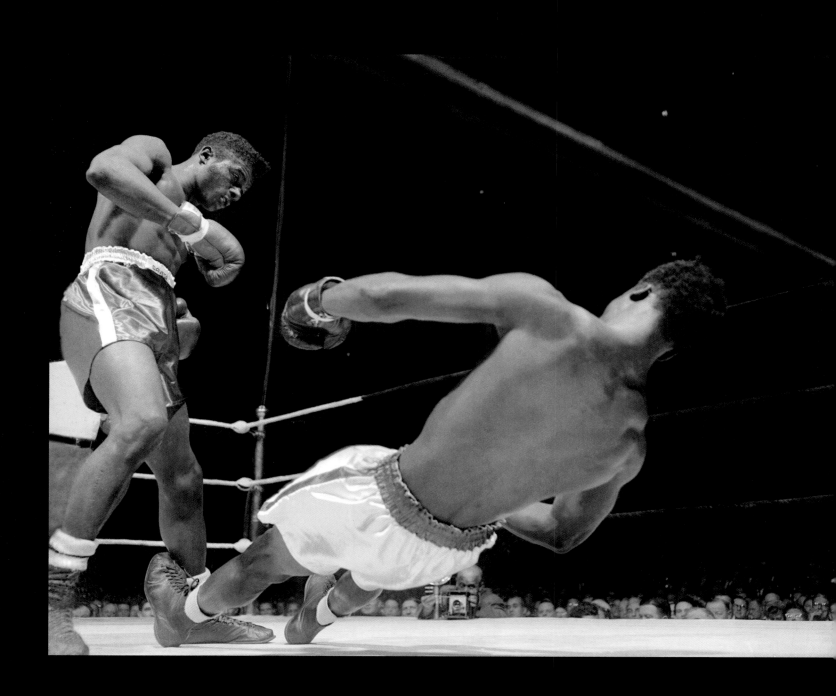

Teenage light heavyweight Floyd Patterson knocks out Clayton Jones with a single punch to the chin just forty seconds into the first round of the New York Golden Gloves Finals on February 18, 1952. He went on to win his second Eastern Golden Gloves title in a row the following month. (His first had been as a middleweight.) Patterson turned professional in September after becoming the Olympic middleweight champion, and four years later he became the youngest man to win the heavyweight boxing title. He lost it in 1959; became the first person to regain the heavyweight crown, in 1960; and then lost it again, to Sonny Liston in 1962.
FRED MORGAN

Refined Sugar? After retiring from the boxing ring for a time, former middleweight champion Sugar Ray Robinson works on a new routine at the French Casino nightclub in late October, 1952, as he makes one of the biggest transitions in the entertainment business. He returned to the ring and regained his title in 1955, holding it on and off until 1960.

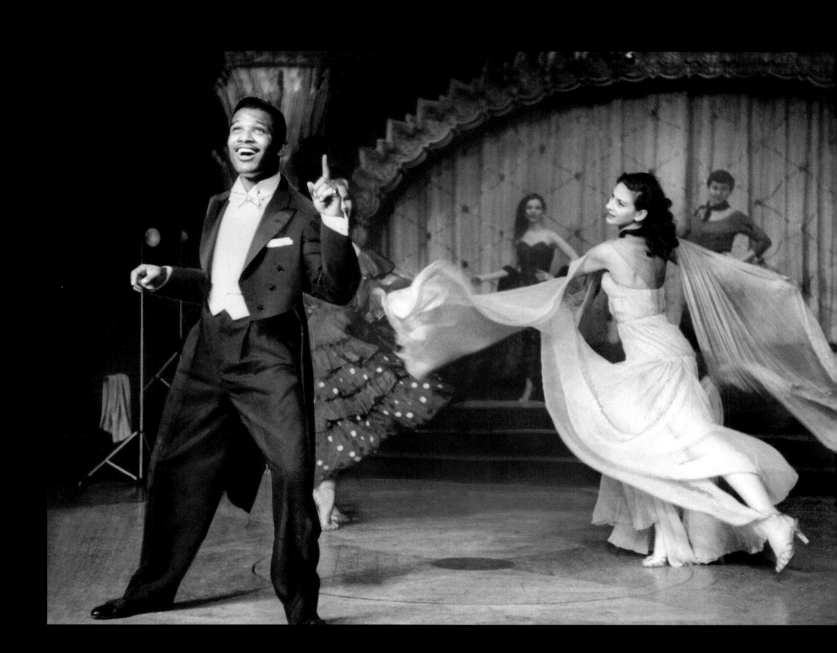

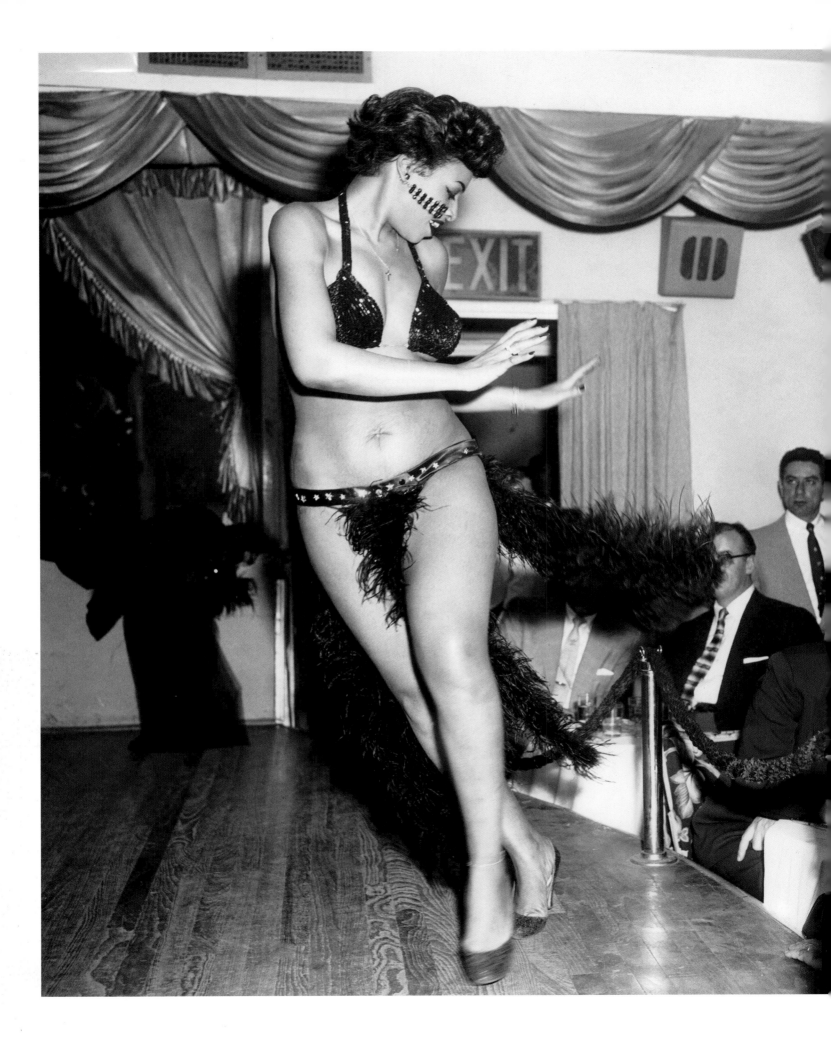

Stripper Venus LaDoll performs
at Club Savannah, 68 West 3rd
Street, April 22, 1954.
JOHN PEODINCUK

Below:
Porfirio Rubirosa and Zsa Zsa
Gabor toast each other while
musicians serenade them at
Czardas Restaurant, 307 East
79th Street, in late June, 1954.
The table was set for the
very public romance between
the notorious playboy (and
ostensible diplomat from the
Dominican Republic) and the
glamorous actress when she
supposedly vowed revenge
for an affair between her hus-
band, George Sanders, and
Rubirosa's ex-wife Doris Duke.
The courtship, masterminded
from his hotel suite in the
Plaza, was ostentatious, and
the relationship tempestuous.
Taken together, the two were
married thirteen times, but
never to each other.
BOB COSTELLO

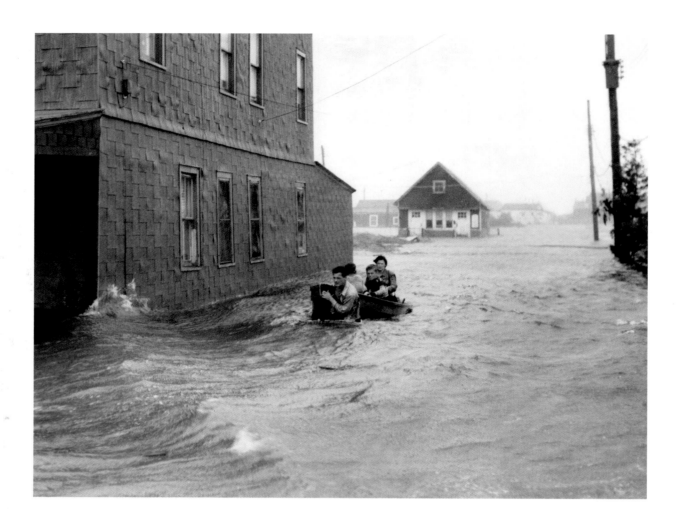

Above:

A rescue worker brings Mrs. Ed Stephens and her three sons to safety along flooded Broad Street, in the marshy Hook Creek section of south-eastern Queens off Jamaica Bay, during Hurricane Carol on August 31, 1954. The fierce storm, with 105-mile-per-hour winds and gusts of up to 125 miles per hour, raked the Northeast from eastern Long Island to cen-tral New Hampshire. It creat-ed fourteen-foot storm tides, caused about a half-billion dollars in damage, left 150,000 people without power, injured about 1,000 people, and killed about 60. And it was only the first of three major tropical storms to hit the Northeast that year.
TOM GALLAGHER

Opposite:

On the afternoon of November 2, 1955, Captain Clayton S. Elwood, piloting an Air Force B-26, lost power in his left propeller during a routine training flight from Mitchell Field on Long Island. The plane crashed into a front yard in East Meadow, setting fire to the house at 61 Barbara Drive and a car. Elwood and Staff Sergeant Charles Slater were killed, but the owner of the house, Paul Koroluck, and his wife and daughter were not home at the time. A *Daily News* plane happened to be nearby, and the photographer cap-tured the scene before the fire engines showed up. This picture was part of the portfolio that garnered the *Daily News* photo staff a Pulitzer Prize in 1956.
GEORGE MATTSON

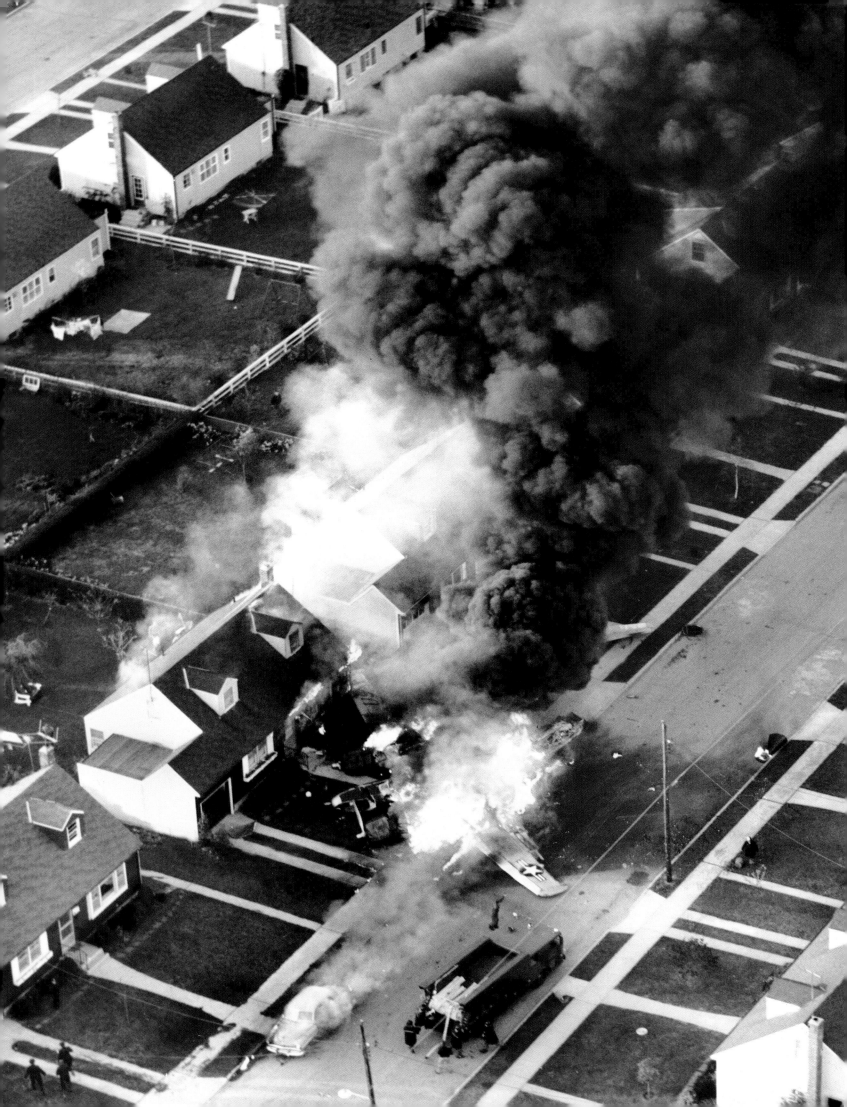

Right:

James Donovan whines as he is booked at the stationhouse in Astoria for felonious assault, May 31, 1955. The seventeen-year-old, who was awaiting sentence for auto theft, and some friends punched a doctor who complained that Donovan was leaning on his car; then they hit the police officers who showed up, and also kicked the *Daily News* photographer. **JACK CLARITY**

Below:

Detectives examine the body of Vincent Macri, the victim of a gang slaying, who was found on April 25, 1954, with two bullets in his head when a retiree living across the street became curious about the unlocked car parked for more than a day in front of 2931 Wickham Avenue in the Bronx, found keys inside it, and opened the trunk. A close associate—and onetime bodyguard—of mob executioner Albert Anastasia, the forty-eight-year-old Macri was a potential witness against him in a tax-evasion case and had also been questioned about two gangrelated killings. Macri's younger brother also disappeared; only his bloodstained car turned up. A couple who also might have testified against Anastasia vanished before the trial, and the mobster ended up with a plea bargain and a light sentence. **TOM CUNNINGHAM**

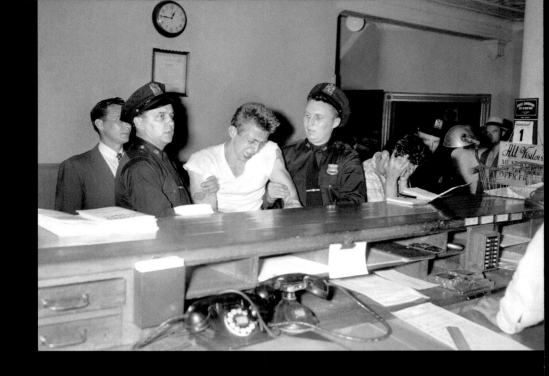

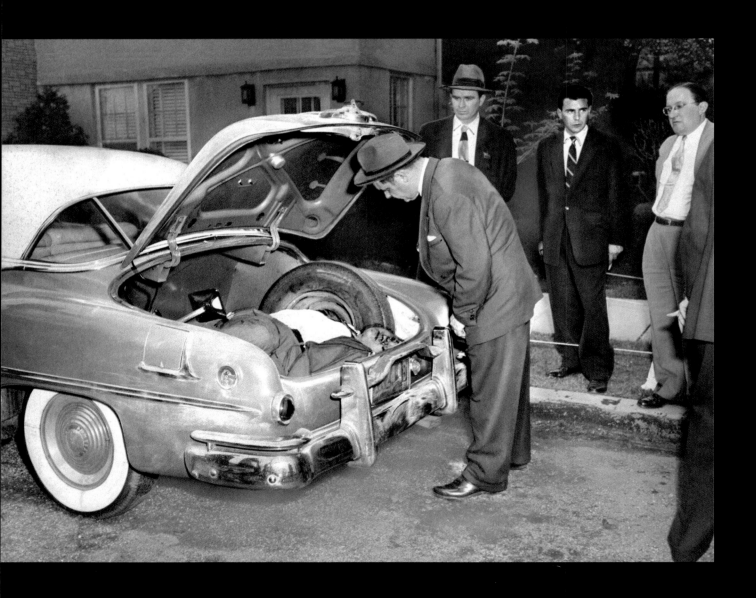

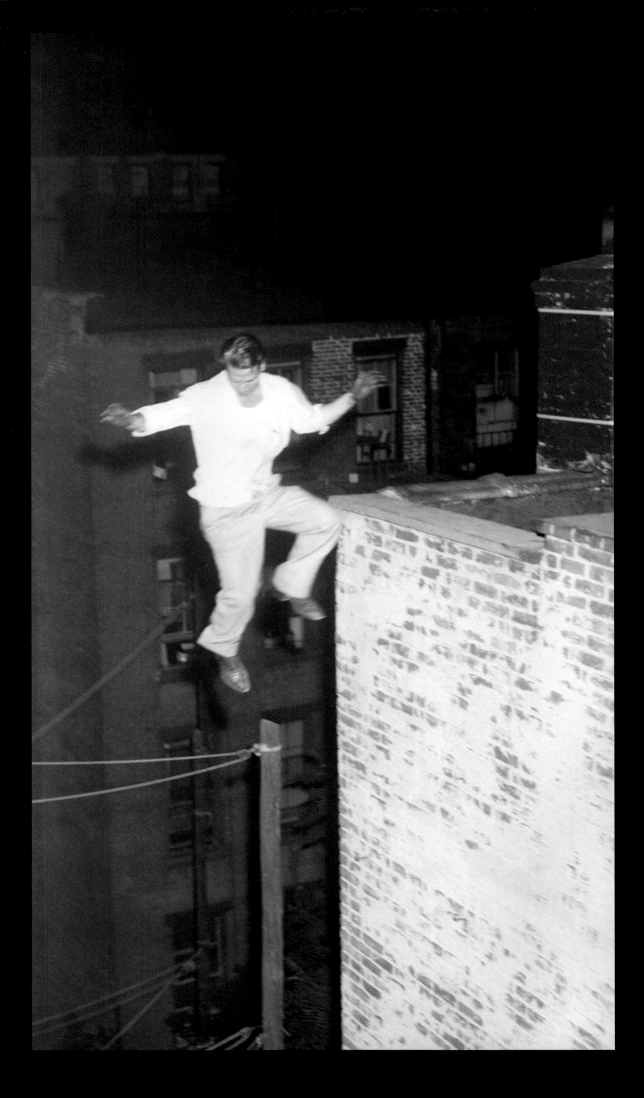

Arthur Bretton falls from a
five-story building at 403
East 83rd Street on July 29,
1954. He had paced the roof
for an hour after a family
quarrel and ignored the
pleas of his wife, two
priests, and other would-be
rescuers. According to wit-
nesses, however, in the end
he did not jump; his foot
slipped. The father of three
was taken to a nearby
hospital and initially listed
in critical condition, but one
of the priests at the scene
administered last rites as
Bretton lay in the yard.
JOHN PEODINCUK

160 A slice of life at Times Square in the 1950s: the entrance to a shooting gallery on West 42nd Street, between Seventh and Eighth avenues, in late February, 1954. Times Square was the city's vibrant theater district ever since World War I— peaking at 264 shows playing at seventy-six theaters during the 1927–28 season— but as early as the Great Depression of the 1930s, the area had already begun a long downslide with the opening of cheap restaurants, tawdry movie houses open almost all night, penny arcades, flea circuses, and the like. Civic leaders and groups such as the Broadway Association crusaded for new laws to crack down on the "honky-tonk influence" damaging the reputation (and real-estate values) of the "busiest corner in the world." It was a crusade that went on with little success until the mid-1990s.

DAVID MCLANE

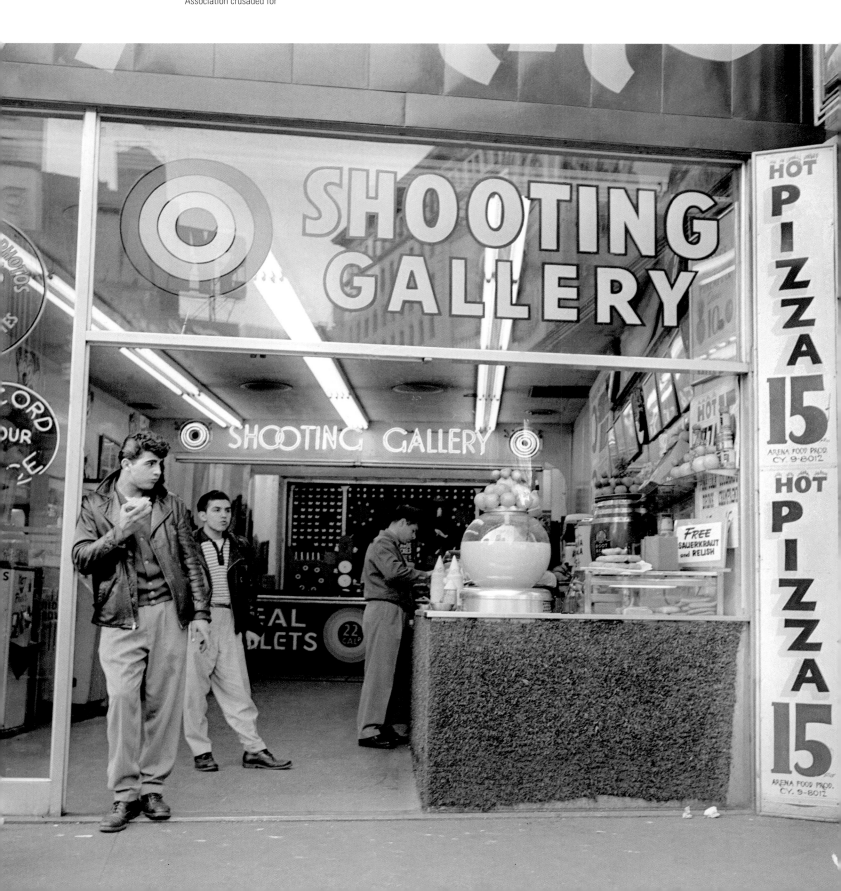

In this beauty parlor, customers spurn the usual women's magazines. Instead, they read racing forms and exchange tips while under their hair dryers.

162 Willie Mays's famous eighth-inning catch going away from home plate in the first game of the 1954 World Series between the New York Giants and the Cleveland Indians on September 29, 1954, was forever etched in the memories of thousands of fans. The venue was the Polo Grounds, the batter was Vic Wertz, and Mays's lightening-fast throw to second base kept the lead runner from advancing beyond third base and breaking a tie. The underdog Giants went on to win the game and the Series. With millions of people watching the game on their new TV sets, Mays was instantly catapulted to the annals of greatness.

FRANK HURLEY

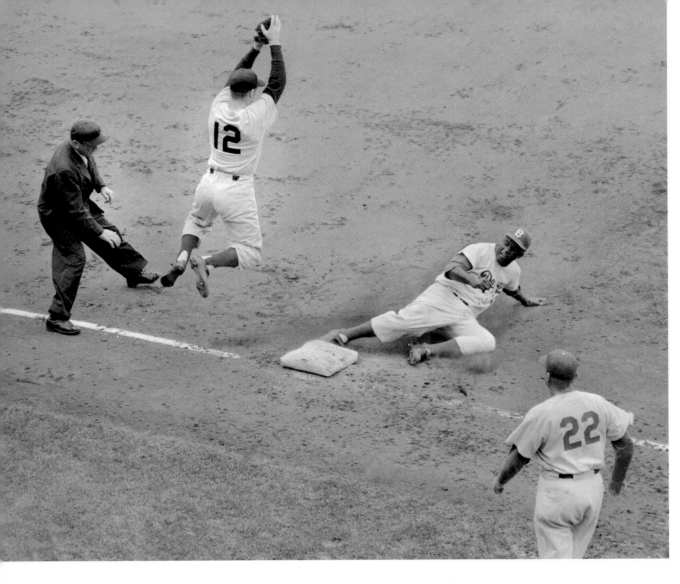

The Brooklyn Dodgers' Jackie Robinson steams into third base after hitting a double to left field and decoying the Yankees' Elston Howard (the first black on the New York team, completing his rookie year) into throwing behind Robinson from left field; third baseman Gil McDougald leaps for the relay throw from second, but it's too late. From the moment he broke the decades-long color barrier in major-league baseball in 1947, Robinson constantly rattled his opponents—even now, when he was described as an aging, "slipping star" who was usually booed more often than cheered by the intense Dodgers fans. Here, however, he helped the Dodgers win the third game in the 1955 World Series, at Ebbets Field on September 30.
FRANK HURLEY

Below:
Umpire Frank Dascoli emphatically signals that the Brooklyn Dodgers' Sandy Amoros is safe at home on Junior Gilliam's third-inning double, in the fourth game of the 1955 Series. We're still at Ebbets Field, and it's October 1. The Dodgers won 8–5, on home runs by Duke Snider, Roy Campanella, and Gil Hodges. During the game, a foul ball conked Yankees president Del Webb on the head.
BILL MEUER

Bottom:
Two days later at Yankee Stadium, Dodger Pee Wee Reese takes to the air over a sliding Billy Martin to fire to first in a vain attempt for a double play on a bouncer by Yogi Berra in the seventh inning of game six. The Yankees took the game 5–1, but on the following day the Dodgers took the game and the Series—finally beating the Yankees in their sixth World Series together in fifteen years. The *Daily News* headline read: "This Is Next Year!"
FRED MORGAN

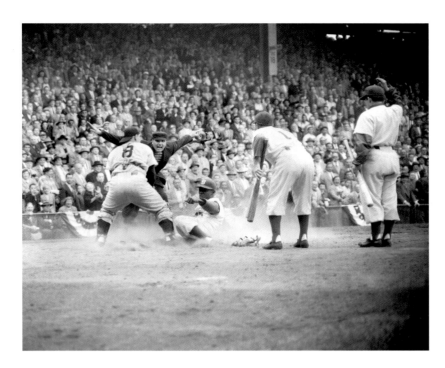

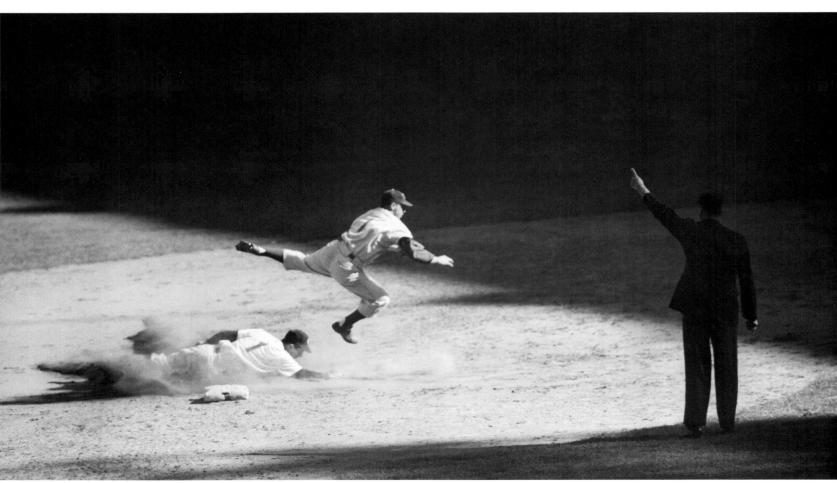

166 New York at night: a couple pause for a cigarette in snowy Central Park in mid-February, 1956. This picture, taken using a three-second exposure and a flash bulb, was described in a *Daily News* photography column called "Camera College."
PHIL GREITZER

Sailors aboard the Navy tug *Cochise* welcome the USS *Nautilus*, the first nuclear-powered submarine, to New York in mid-May, 1956. The sub, built in Groton, Connecticut, had made her first dive at the beginning of 1955 and had already traveled about 36,000 miles around the Atlantic Ocean, but this was her first visit to New York. She sailed into New York Harbor and up the Hudson River to the George Washington Bridge before turning around, accompanied all the while by police helicopters and various salutes from seaborne vessels.
BOB COSTELLO

President Dwight D. Eisenhower waves at a crowd and reporters through the Plexiglas shield on his car as he leaves Washington, D.C., on June 19, 1955, to mark the tenth anniversary of the United Nations. Addressing the world organization the next day in San Francisco, where the UN charter had been drafted and ratified, Eisenhower issued a warning to the Soviet Union about domination of other countries and downplayed an upcoming big-power summit.
FRED MORGAN

Marilyn Monroe and Arthur Miller are a happy couple posing with his dog, Hugo, at his home in Roxbury, Connecticut, June 26, 1956. They married three days later in a secret ceremony at Westchester County Court-house in White Plains, New York. Monroe (thirty) and Miller (forty) made an odd couple: Hollywood's top sex symbol (formerly married to baseball great Joe DiMaggio), riddled with neuroses and self-doubt, and one of the country's leading playwrights, at the height of his career after *Death of a Salesman* and *The Crucible*. The troubled marriage lasted until January, 1961. On August 5 of the following year, Monroe died; she was thirty-six years old. Two years later, Miller drama-tized their failed marriage in a play, *After the Fall*.

HAL MATHEWSON

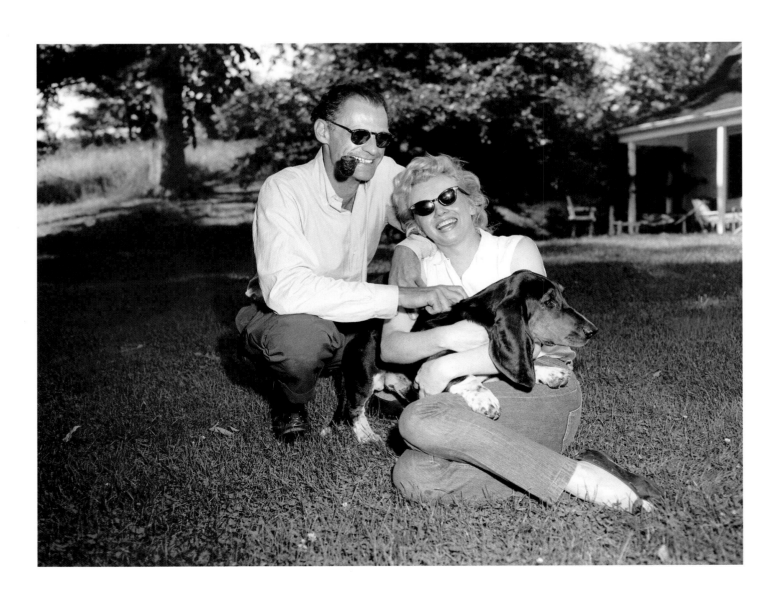

Enduring pop singer Tony Bennett performs in mid-March, 1957, for just a one-woman audience: his wife, Sandy, in their home in Tenafly, New Jersey. A brief look at Bennett and his family, including two young children, ran in a Sunday magazine feature called "At Home with." Bennett went "from rags to riches" during the 1950s; recorded his biggest hit, "I Left My Heart in San Francisco," in 1962; and found a new audience among young rock fans in the late 1990s.
DAVID MCLANE

172

Below:

Elvis Presley leads some of the other members of the Third Armored Division onto the transport *General Randall* at the Brooklyn Army Terminal on September 22, 1958. The King of Rock 'n' Roll was now just a private, on his way to an eighteen-month tour of duty in Europe. (Sergeant Presley was discharged in March 1960.) **ED CLARITY**

Opposite:

The Reverend Martin Luther King Jr. and his wife, Coretta, appear cheerful during a press conference on September 30, 1958, in Harlem Hospital, at Lenox Avenue and 136th Street. But the smiles were misleading. The twenty-nine-year-old leader of the growing civil rights movement was recovering from a near-fatal stab wound inflicted by a mentally ill black woman ten days earlier while he was autographing copies of his book *Stride Toward Freedom* at Bloomstein's department store in Harlem; the blade just missed puncturing his aorta. After lengthy surgery, and a bout with pneumonia, King left the hospital on October 3 to recuperate at the home of family friend in Brooklyn. Then he returned to the helm of the movement for another decade, until his assassination on April 4, 1968. **AL PUCCI**

Alleged call girls Joan
Martin (left) and Maria
Martinez end their night in a
police station, November 7,
1958. Police investigating the
Executive Suite, an East Side
bar that was said to be a
popular "assignation base"
for the garment district,
followed the two women and
a pair of salesmen to the
Warwick Hotel, at 65 West
54th Street. When the police
entered the women's hotel
suite, Martin reportedly said
only, "Happy days are here
again." Police also arrested
the manager of the bar,
Alberta Miles, for allegedly
arranging fifty- to one-
hundred-dollar "dates" for
eight "cuties-for-hire."
BOB KOLLER

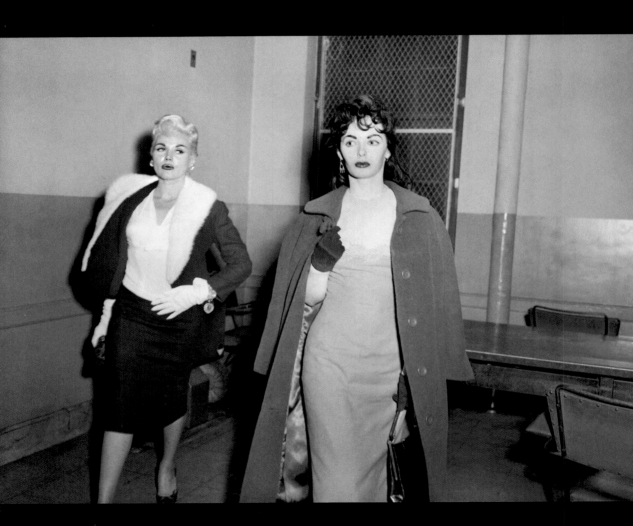

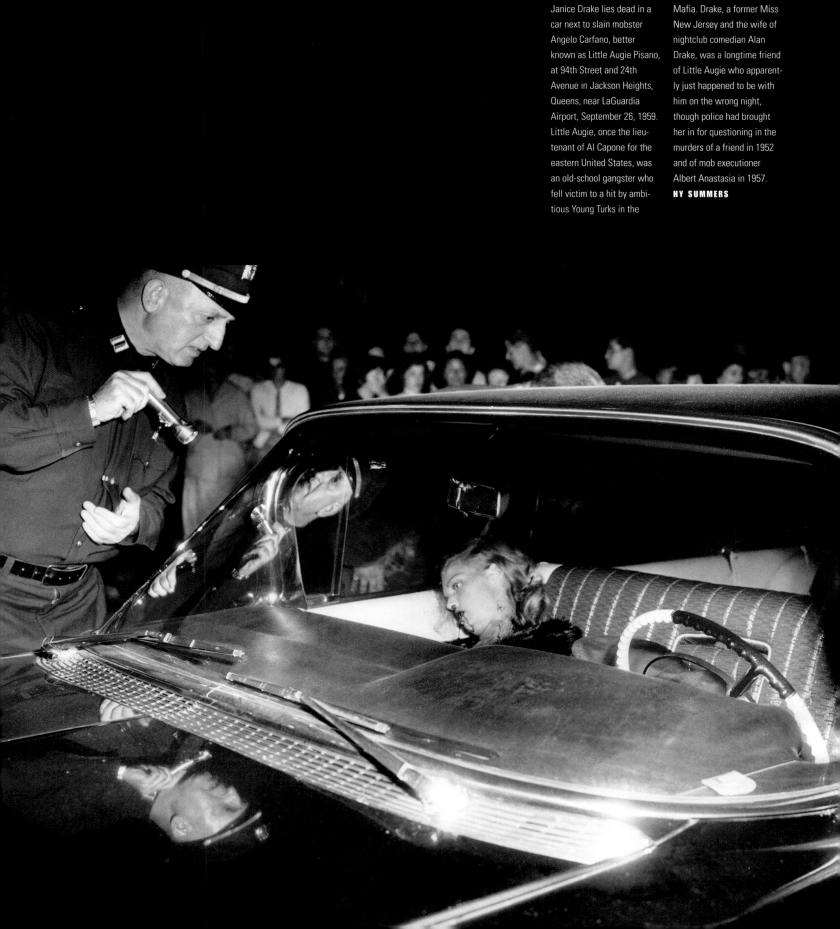

Janice Drake lies dead in a car next to slain mobster Angelo Carfano, better known as Little Augie Pisano, at 94th Street and 24th Avenue in Jackson Heights, Queens, near LaGuardia Airport, September 26, 1959. Little Augie, once the lieutenant of Al Capone for the eastern United States, was an old-school gangster who fell victim to a hit by ambitious Young Turks in the Mafia. Drake, a former Miss New Jersey and the wife of nightclub comedian Alan Drake, was a longtime friend of Little Augie who apparently just happened to be with him on the wrong night, though police had brought her in for questioning in the murders of a friend in 1952 and of mob executioner Albert Anastasia in 1957. **HY SUMMERS**

176 Below:
The body of Albert
Anastasia—who ran Murder,
Inc., a gang of hired killers
for organized crime, in the
late 1930s—lies on the bar-
bershop floor at the Park
Sheraton Hotel, Seventh
Avenue and West 55th
Street, soon after his murder
by two gunmen at 10:20 A.M.

on October 25, 1957. The
gangland rubout of the
ambitious Anastasia,
believed to be in revenge for
his attempted killing of rival
Frank Costello, was ordered
by an even more ambitious
gangster: Vito Genovese, the
boss of all bosses until his
death in 1969.

Opposite:
Anthony Krzesinski lies dead
of a stab wound in the apart-
ment doorway of Frank
Zorovich (left) at 445 West
46th Street, in the Hell's
Kitchen section of midtown
Manhattan, in the early
hours of August 30, 1959.
Krzesinski and another
sixteen-year-old, Robert
Young, were fatally stabbed—
each staggering to a differ-

ent nearby apartment for
help before dying—and two
other teens were wounded in
what became known as the
Capeman murders, because
the killer wore a red-lined
black satin cape. On Sep-
tember 2, police arrested a
defiant sixteen-year-old
Salvador Agron—who said,
"I don't care if I burn; my
mother could watch me"—

and teenage accomplice
Antonio Luis Hernandez
(called the Umbrella Man).
Agron's Puerto Rican gang,
the Vampires, had been
looking for an Irish-Italian
gang, the Nordics, when
they happened upon the
teenagers hanging out at the
playground between Ninth
and Tenth avenues in the
mid-40s. Agron became the

youngest New Yorker to
receive a death sentence,
but it was commuted to
life in 1962, and he was
released in 1979, declared
completely rehabilitated.
Singer-songwriter Paul
Simon turned the story into
a 1998 musical, Capeman.
TOM CUNNINGHAM

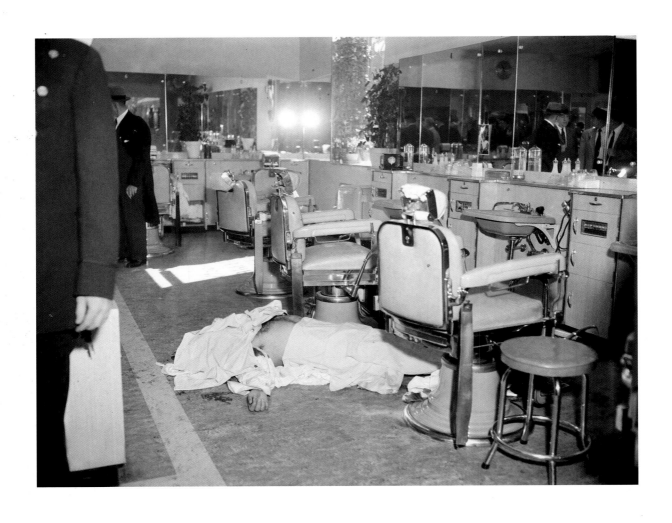

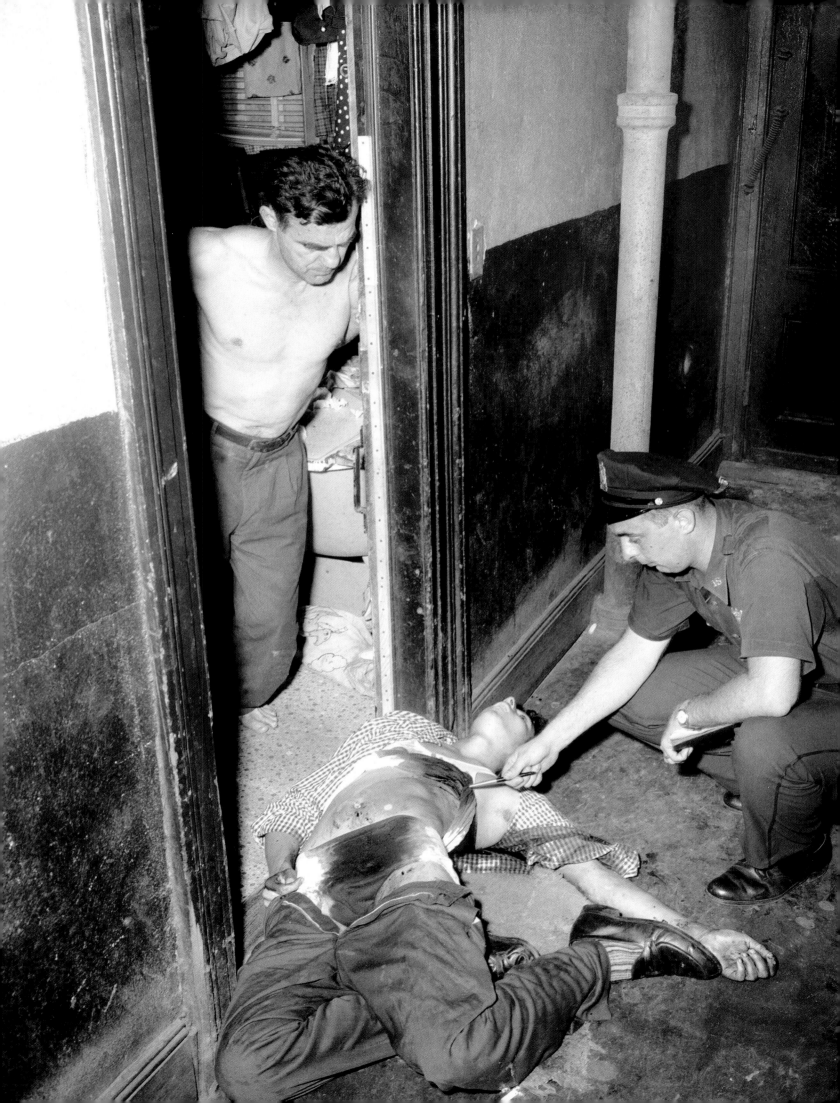

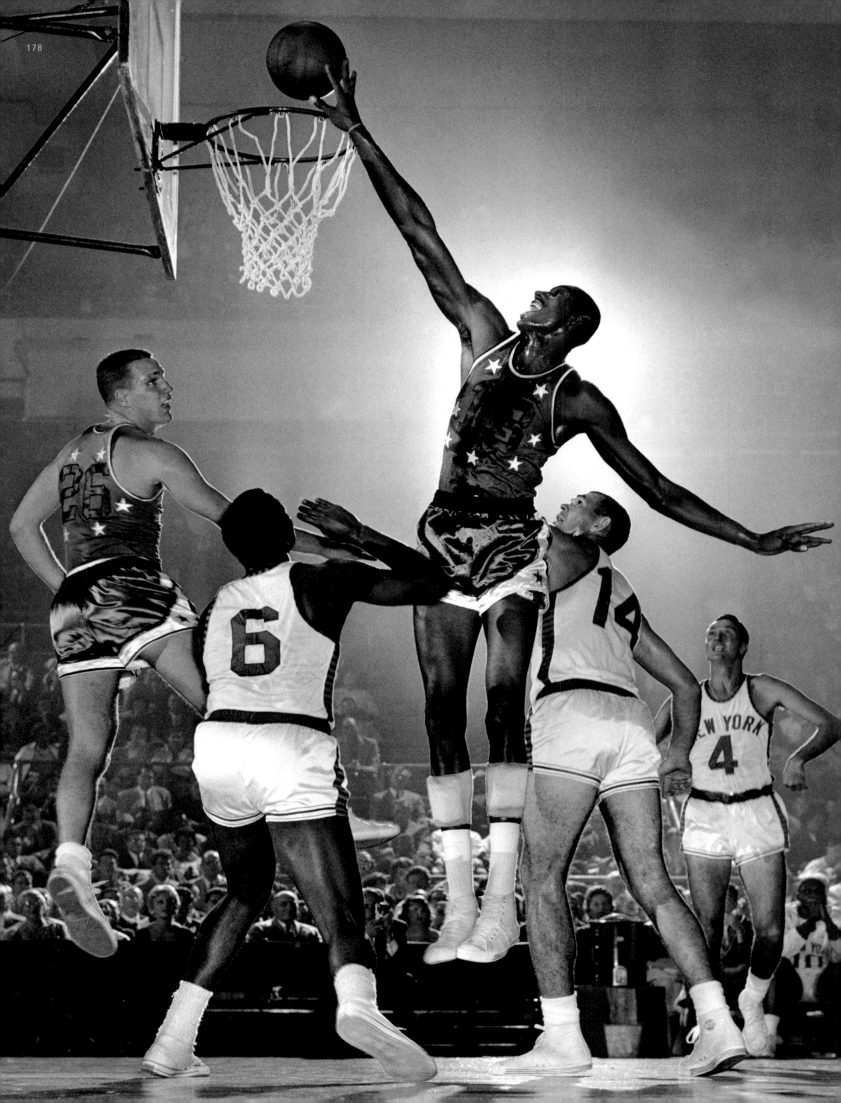

Opposite:
Wilt Chamberlain taps in a rebound for the All-Stars against the New York Knicks at Madison Square Garden in 1959. It was Chamberlain's last appearance before beginning a sterling fourteen-season professional career in the National Basketball Association. Playing for the Philadelphia Warriors and 76ers and the Los Angeles Lakers, Wilt the Stilt led the NBA in scoring for seven consecutive seasons (1959–65), was the Most Valuable Player four times (1960 and 1966–68), and finished his career first in rebounds and second in points and scoring average. In one 1962 game against the Knicks, Chamberlain scored 100 points, still the most by any player.
CHARLIE HOFF

Below:
It's all over but the shouting for students of P.S. 116, at 210 East 33rd Street, as they leave school to start summer vacation on June 27, 1958. Some things never change.
JOHN DUPREY

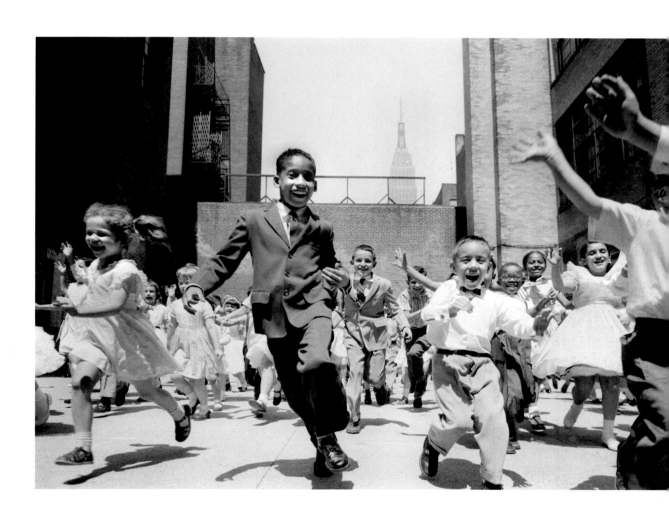

180 Harry and Claire Lischnoff
 show how they were bound by
 a robber in their Bronx apart-
 ment, September 6, 1959.
 PAT CANDIDO

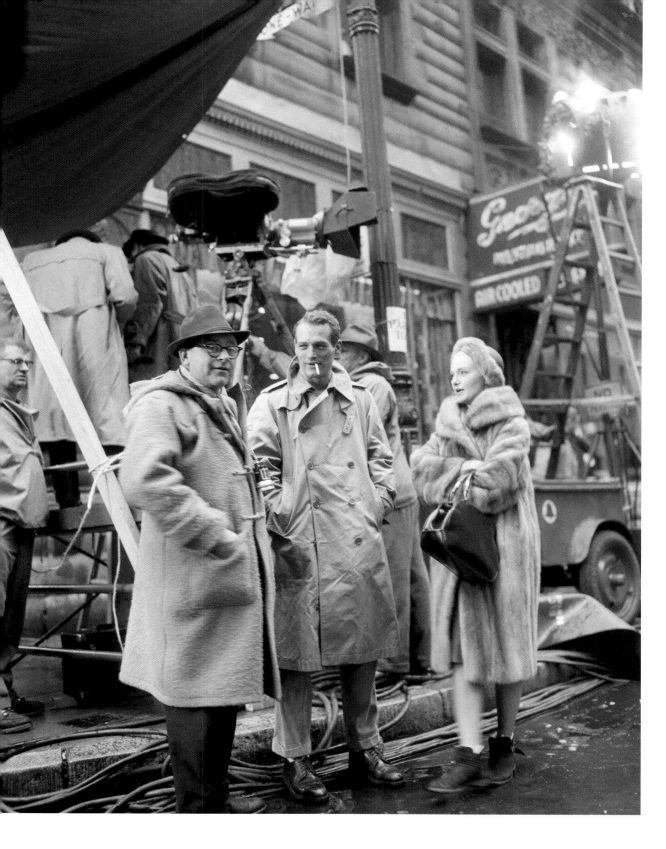

Paul Newman and Joanne Woodward talk with director-producer Mark Robson during filming on location—something that was still uncommon in the late 1950s—for the movie *From the Terrace* at Beaver and Broad streets, in the Financial District, December 13, 1959. Newman was also appearing six nights a week on Broadway in Tennessee Williams's *Sweet Bird of Youth.* Newman, a star ever since his second movie in 1956, and Woodward, his frequent leading lady and the winner of the Academy Award for Best Actress in 1957, had married in 1958.
DAN FARRELL

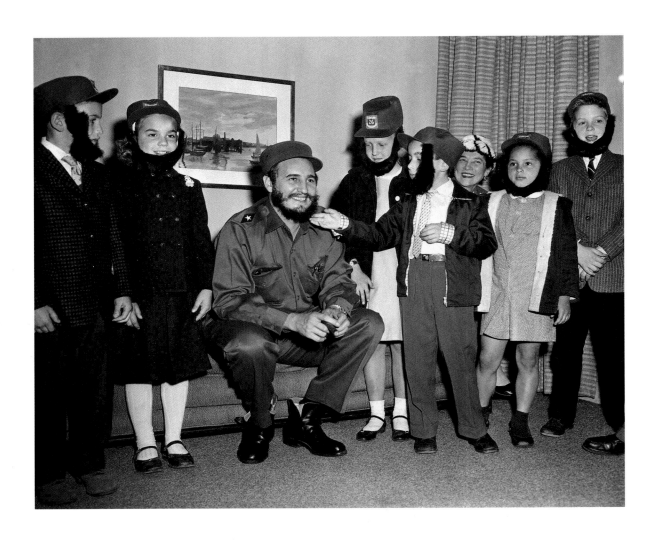

Above:
In his suite at the Statler Hotel, Cuban leader Fidel Castro greets appropriately costumed children from a Queens elementary school on April 24, 1959, during the former rebel's first visit to the United States after seizing power on January 1. The accompanying article said the children were classmates of a son of Castro, who had been secretly sent to the States for safety during the revolution in Cuba. The visit came at a time when relations between the two governments were still uncertain, before Castro openly declared himself a Soviet-style Communist.
GEORGE MATTSON

Opposite:
Children from P.S. 80, on West 17th Street in Brooklyn, are among the first to view the eighty-foot Atlas Intercontinental Ballistic Missile, on display for about a week in mid-May, 1959, at the Aquarium grounds at West 8th Street and Surf Avenue in Coney Island, as part of Armed Forces Week observances. A potent symbol of the nuclear arms race that was developing between the world's two superpowers, the first operational U.S. ICBM was guided by radio and could rapidly travel thousands of miles. So, of course, could the Soviet ICBMs.
C. O. MAMAY

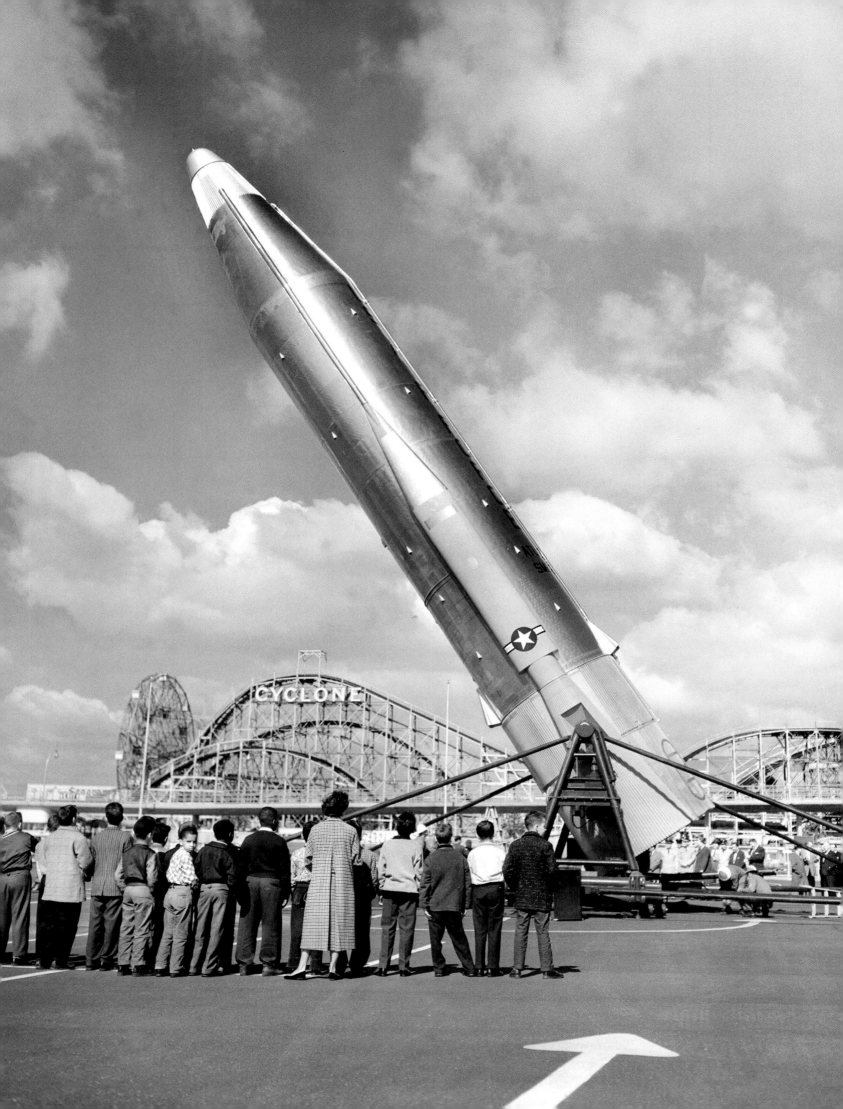

Daily News photographers could often outdo the stunts of their best subjects. Here Jim Mooney shoots circus performers at Madison Square Garden, April 1965.

Democratic presidential nominee John F. Kennedy and his wife, Jacqueline, ride up Broadway in a ticker-tape parade on October 19, 1960. Crowds estimated at a million people, including large numbers at brief rallies first at Broadway and Wall Street and then at City Hall, cheered the Kennedys in what was reportedly the city's "noisiest turnout" since the parade for General Douglas MacArthur in 1951. JFK said it was "the most enthusiastic crowd I've ever seen," while Jackie said she was "thrilled and touched" but also "frightened when the sides of the car seemed to be buckling in." It was, incidentally, the expectant mother's last public campaign appearance; John Jr. was born on November 25. Republican nominee Richard Nixon had his own parade a few days after this one, but it was Kennedy who won New York, along with the election, on November 8.

FRANK HURLEY

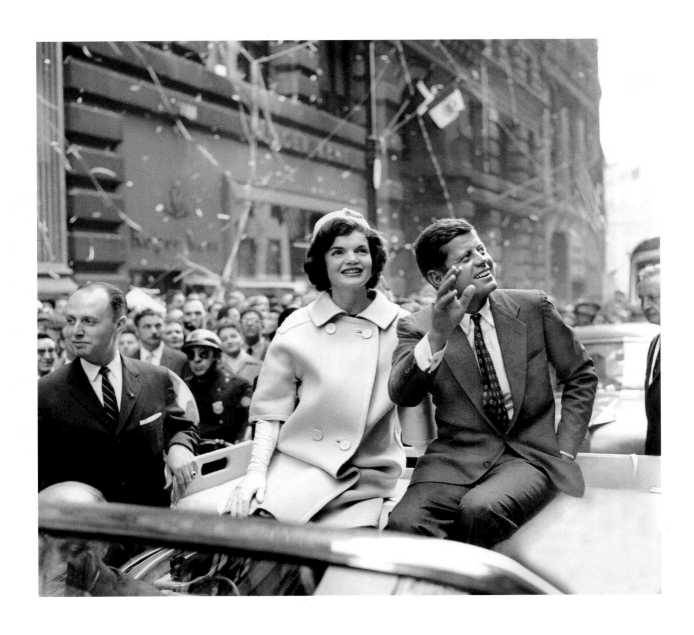

Duck and cover! School-children take part in an air-raid drill at P.S. 58, at Smith Street and First Place in Brooklyn, late October, 1962. Officials tried to reassure Americans that this action would protect them in case of a nuclear attack. This photo was taken during the darkest moment of the entire Cold War: the 1962 Cuban missile crisis, when President John F. Kennedy imposed a "quarantine"—a naval block-ade—on Cuba after discov-ering that the Soviet Union had secretly placed nuclear missiles on that island only ninety miles from Florida. The "eyeball to eyeball" confrontation amid the threat of full-scale nuclear war ended when the Soviets blinked on October 28 and agreed to remove the mis-siles (partly in exchange for a secret promise involving U.S. missiles in Turkey, near the Soviet border).

PAUL BERNIUS

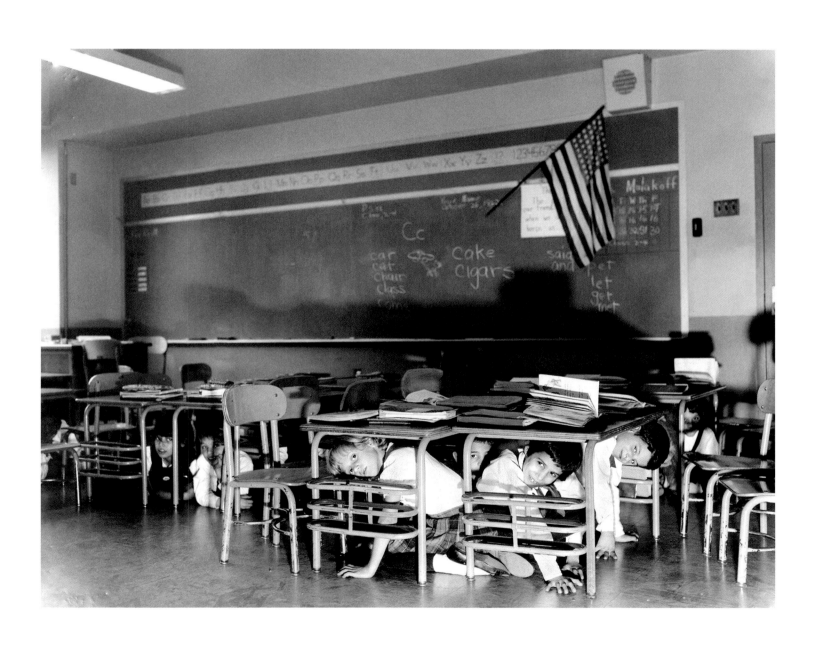

The collision of a United Air Lines DC-8 and a Trans World Airlines Super Constellation over New York City in a snowstorm at 10:34 A.M., December 16, 1960, was the world's worst aviation disaster up to then. The two planes' 116 passengers and 12 crew members all died, as did a half-dozen people on the ground. Yet the total could have been so much higher: the exploding wreckage of the DC-8, which had been coming in to Idlewild (now Kennedy) International Airport from Chicago with 84 on board, scored a direct hit on the Pillar of Fire Church in Park Slope, Brooklyn, creating a twenty-five-foot-deep crater, fifty feet in diameter; wrecked eleven other buildings (leaving more than 200 people homeless); and started a seven-alarm fire in a square-block area—while only narrowly missing two nearby schools. The Super Constellation, coming in to LaGuardia Airport from Ohio with 44 on board, plummeted straight down onto a runway at Miller Army Air Field in Staten Island. The planes should have been five miles apart while approaching the two airports, but investigators concluded that the United plane—the first jet ever to crash with passengers on board—had strayed twelve miles beyond its assigned circling area, into airspace inadequately handled by the two groups of air traffic controllers.

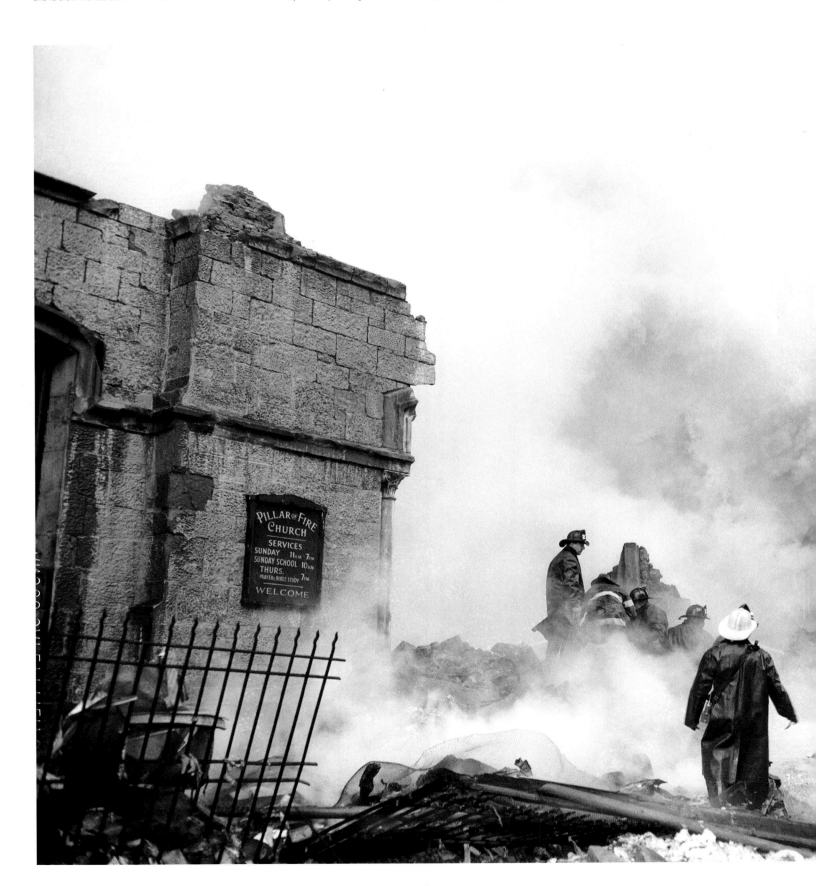

Below:
Eleven-year-old Stephen Baltz of Wilmette, Illinois, seen here receiving aid at Seventh Avenue near Sterling Place, was the only passenger to make it to a hospital. The boy, who was traveling on his own, was flung out of the wreckage into a snowbank, which put out the fire consuming his clothes. Several first-day articles hailed the miracle of his survival. But he had been burned over 80 percent of his body, and his lungs were seared. Stephen clung to life for twenty-six hours at Methodist Hospital, then died on December 17.
ED PETERS

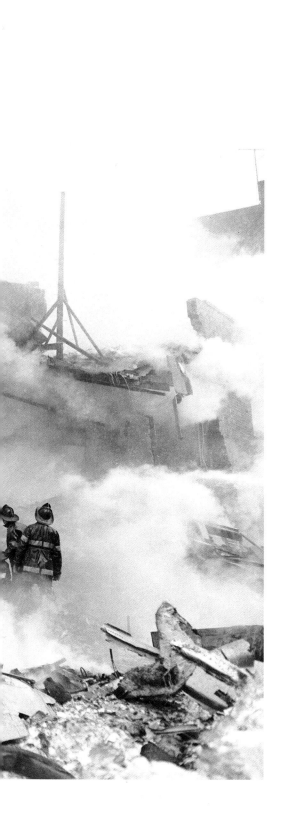

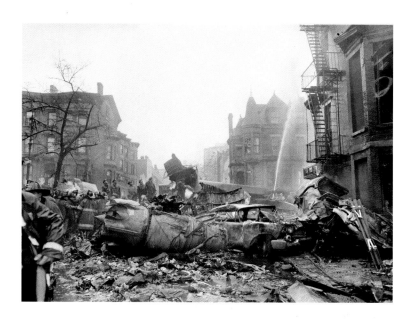

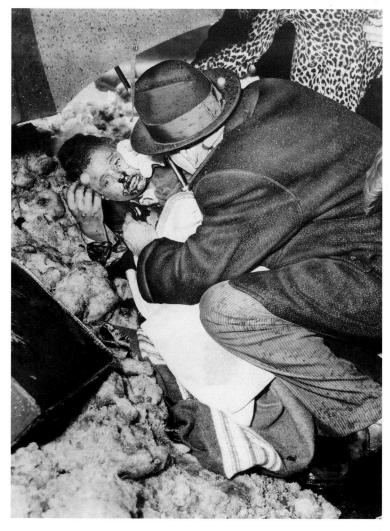

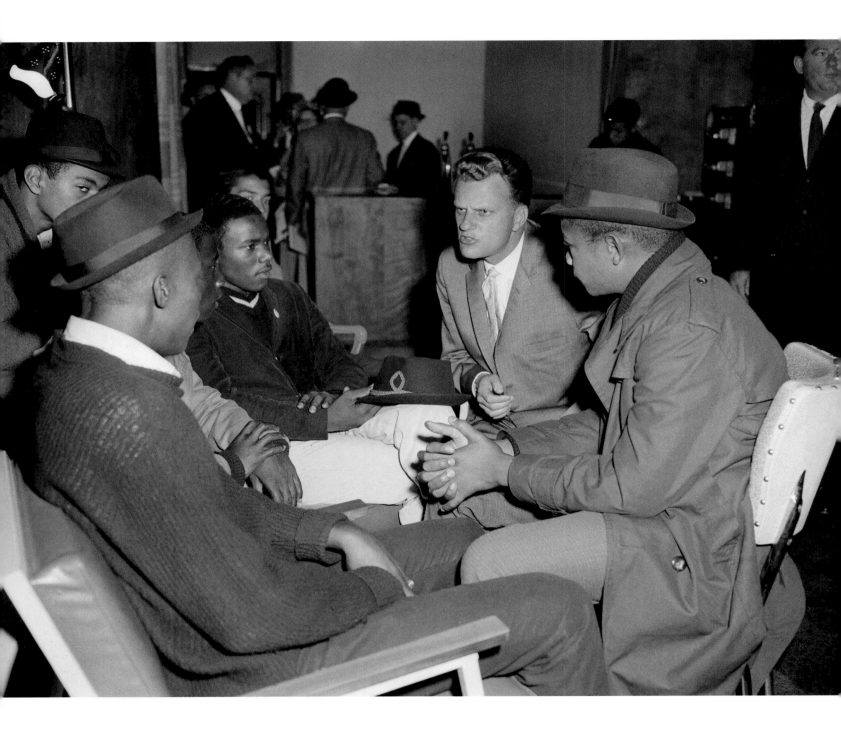

Investigating juvenile delinquency, evangelist Billy Graham tries to straighten out leaders and members of East Harlem street gangs at his Youth Development Inc., Second Avenue near East 109th Street, in early October, 1960. About twenty-five of the seventy present raised their hands when he asked if any would "receive Christ." Graham also took a tour of housing developments in the neighborhood and asked, "Why should we be the richest nation in the world and still have slums?"
JUDD MEHLMAN

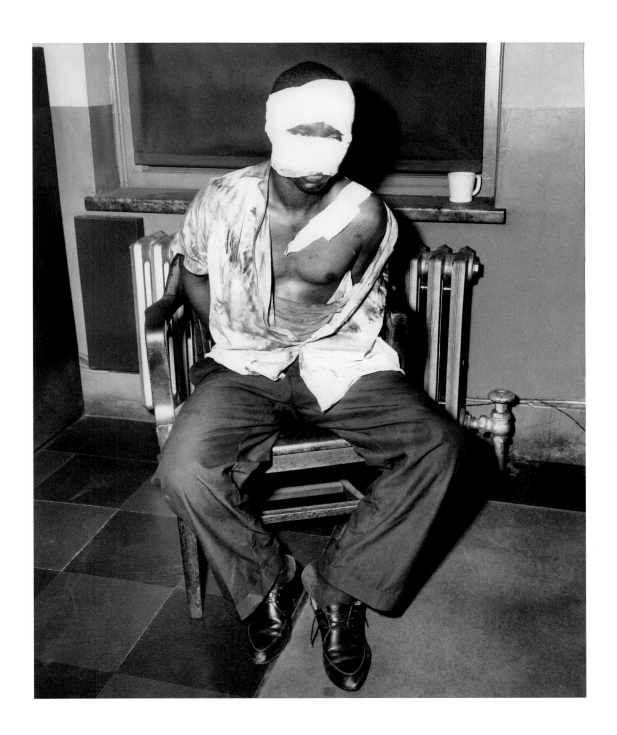

Frank Lott sits in the 32nd Precinct after police beat him for the murder of Officer Francis X. Walsh on September 4, 1961. The officer and his partner were pursuing Lott for a $50 holdup in a grocery store on Eighth Avenue in Harlem. He suddenly turned and shot Walsh while reportedly shouting, "I'm a four-time loser. You won't take me alive." The second officer then captured Lott after a struggle. Lott later pleaded guilty to second-degree murder and was sentenced in 1962 to fifty years to life.
TOM CUNNINGHAM

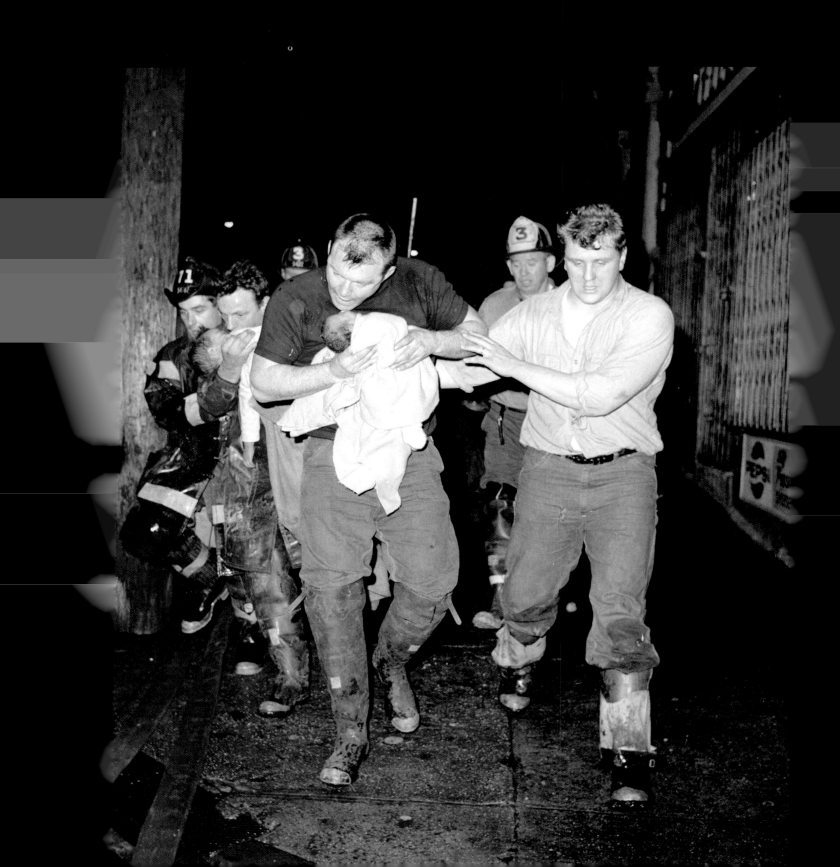

er Maye (a ... apartment fire at 940 East
... oves cham- ... 165th Street in the Bronx,
... ears later, a ... November 28, 1964. Her two-
... Uniformed ... year-old brother, Carlos,
... ciation) tries ... being carried by Jack Mayne,
... wo-month- ... also died in the fire.
... ado after an ... **ALAN AARONSON**

Critically injured, James Linares lies in the arms of Josephine Senquiz on the stairs inside her apartment building at 992 Southern Boulevard in the Bronx, September 26, 1961. Her husband, Henry Senquiz, admitted shooting Linares in a jealous rage.
ALAN AARONSON

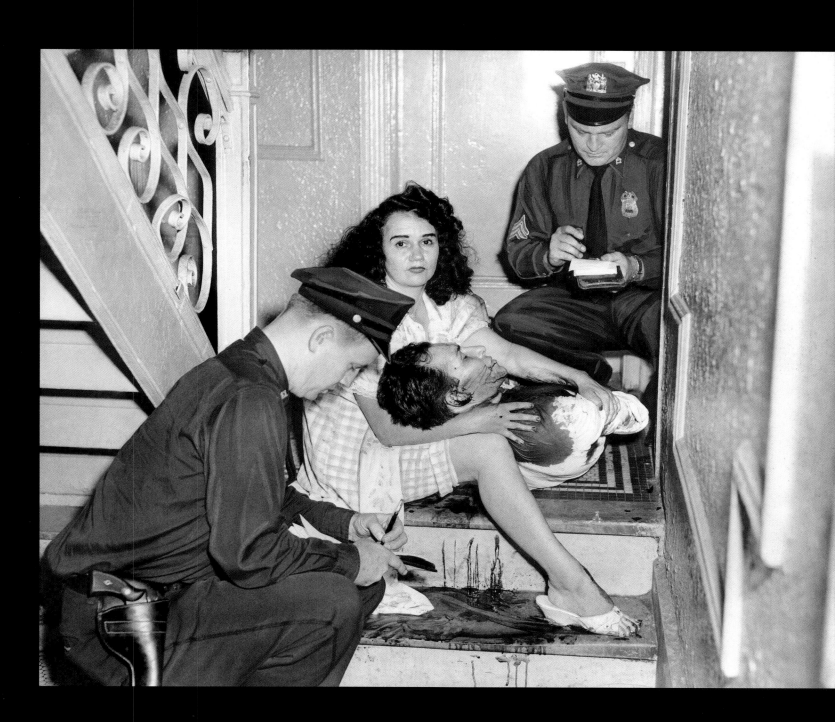

194 Louis Armstrong (foreground)—who reshaped jazz in the 1920s and was still picking up new fans into the 1960s, with his renditions of pop songs such as "Hello, Dolly" and "Mack the Knife"—plays the trumpet at a rehearsal for a recording date in early 1960 with the Dukes of Dixieland. Trumpeter Frank Assunto (background, second from right) and his brother Fred (far left) put that band together in the late 1940s to help revive the earliest form of traditional jazz, born in their (and Armstrong's) native New Orleans. That's another jazz legend, Gene Krupa, sitting at the drums; the Assuntos' father, Pap Jac, is the trombonist behind Krupa. The others in the band are (left to right) Jerry Fuller, on clarinet; Stanley Mendelson, at the piano; Owen Mahoney, the band's regular drummer; and Richmond Matteson, handling bass.

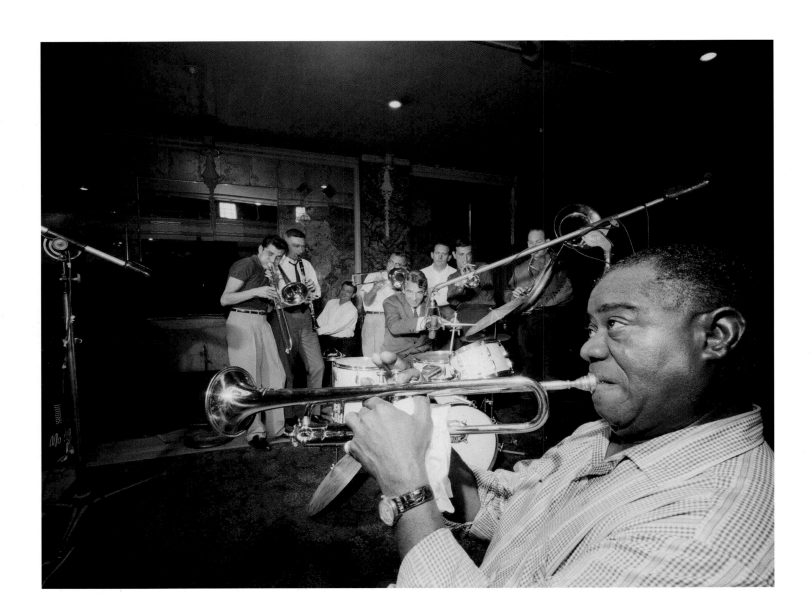

A surreal moment: flamboyant Spanish artist Salvador Dalí is photographed by Girl Scouts before he departs New York aboard the SS *United States* on April 14, 1960.
HAL MATHEWSON

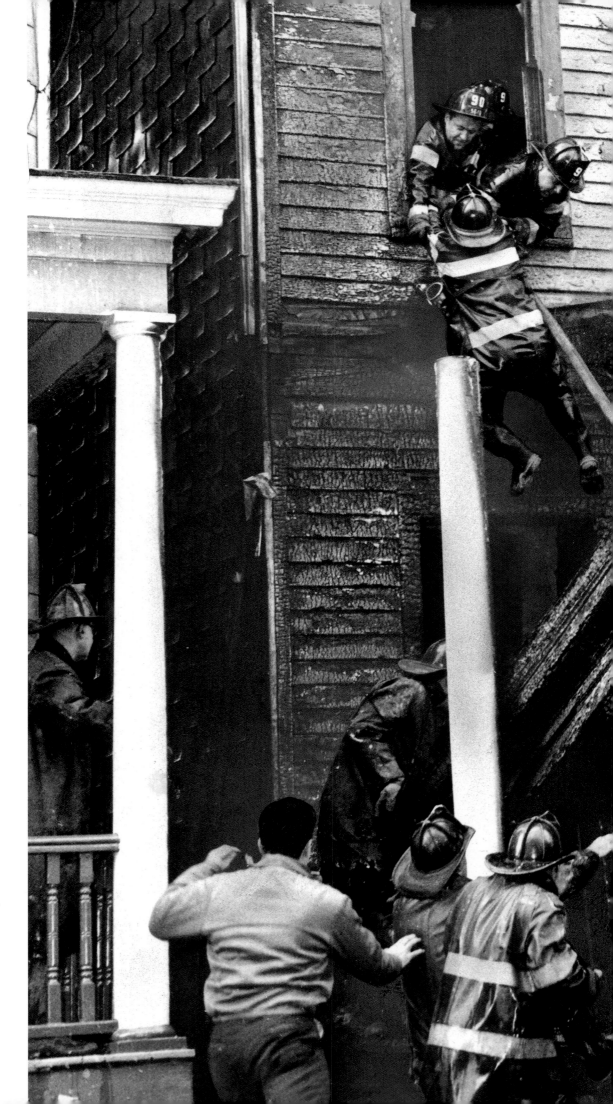

196 Firefighter Anthony Tavolacci clings to a window ledge and two other firemen start to pull him to safety moments after a porch roof collapsed under him, late September, 1962.
OSSIE LEVINESS

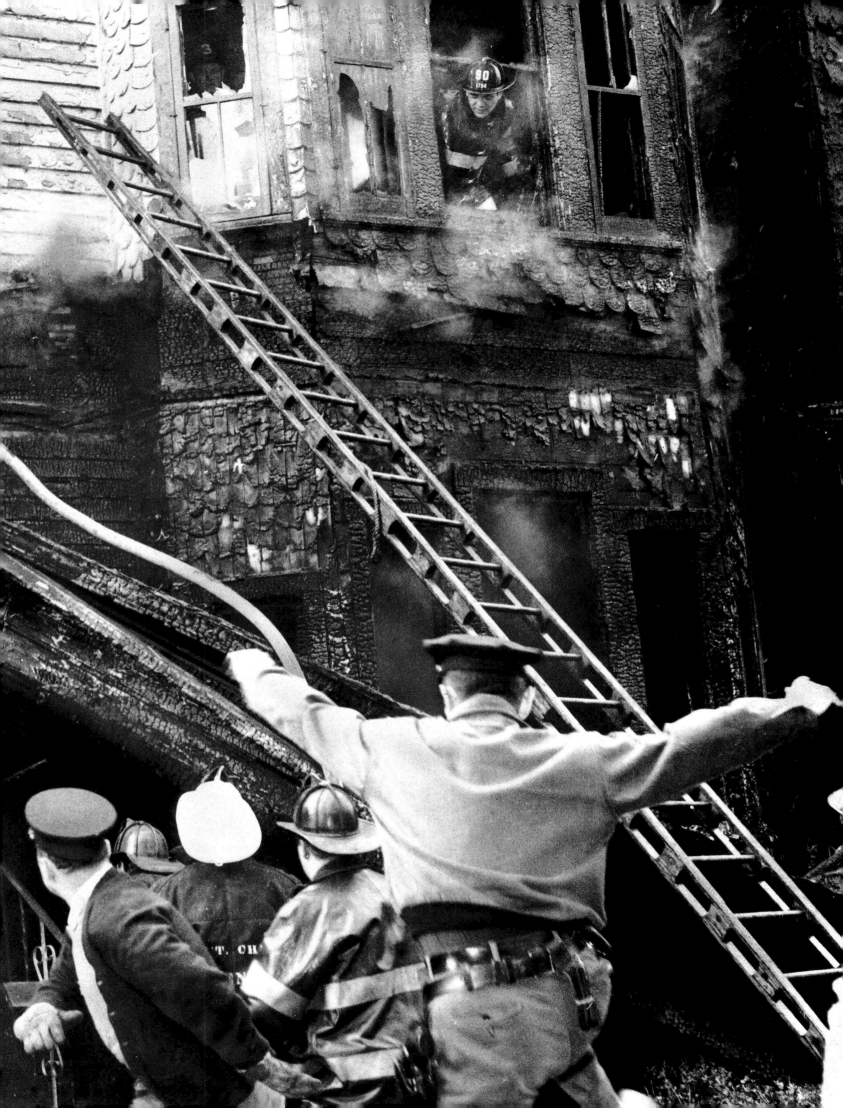

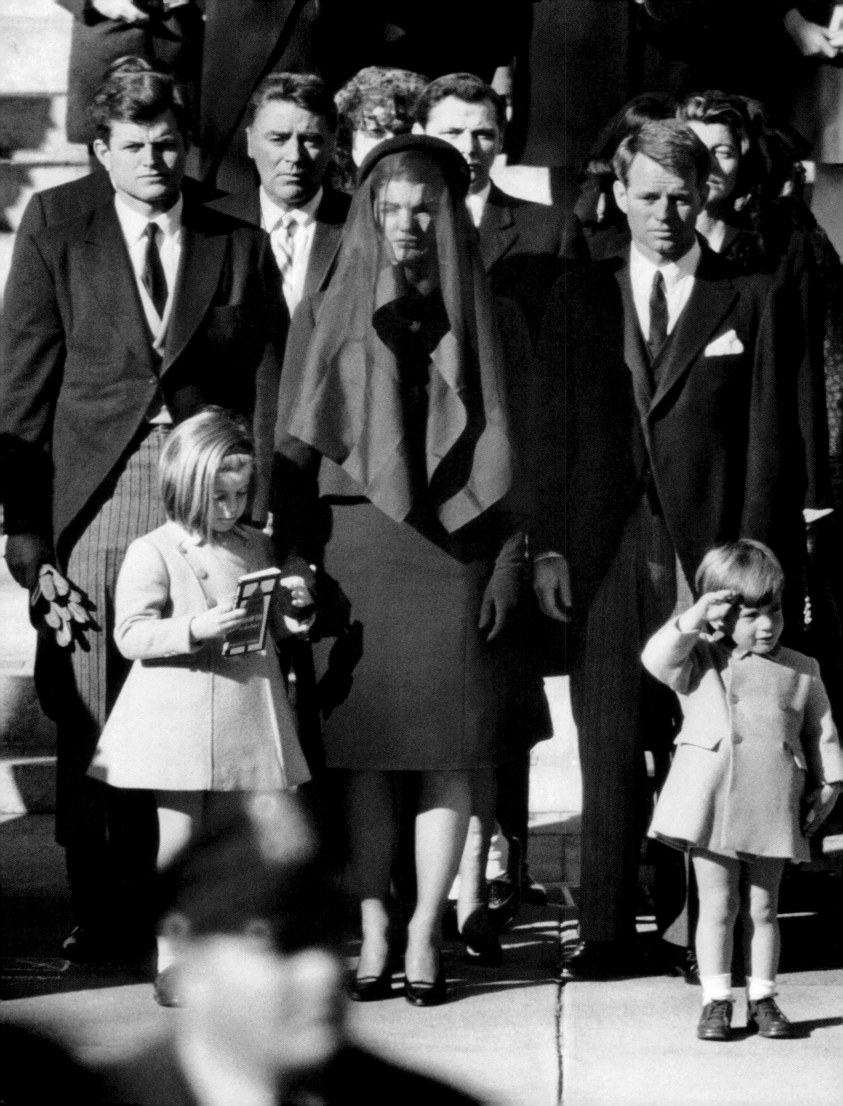

Opposite:
Letting go of his mother's
hand, John F. Kennedy Jr. (he
did not like the nickname
John-John, a media inven-
tion) salutes his father's
flag-draped casket as it pass-
es on November 25, 1963—

the boy's third birthday.
Behind JFK's son is Robert
Kennedy; Ted Kennedy is
on the other side of Jackie,
behind young Caroline, who
was about to turn six.
DAN FARRELL

Below:
Bothered by the ninety-one-
degree midday weather on
May 26, 1965, Caroline
Kennedy breaks away from
her mother and makes a bee-
line for their air-conditioned
limousine at Kennedy Inter-

national Airport (renamed in
tribute to Caroline's father
after his assassination).
Walking with Jacqueline
Kennedy and John Jr. is
Nancy Tuckerman, Jackie's
aide. The Kennedys were

coming from England, where
they had attended the dedica-
tion of a memorial to the slain
president two weeks earlier.
TOM GALLAGHER

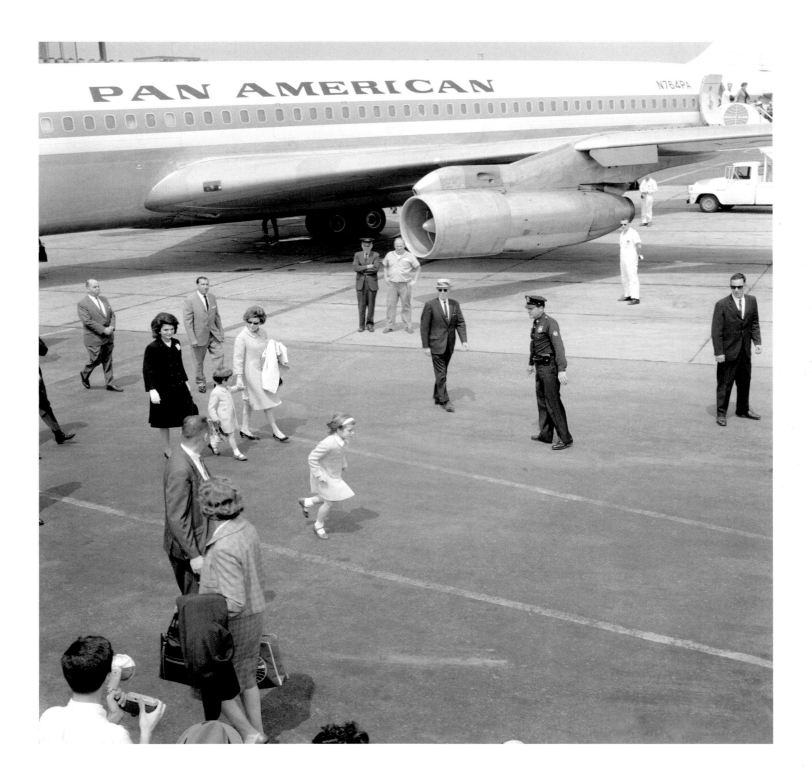

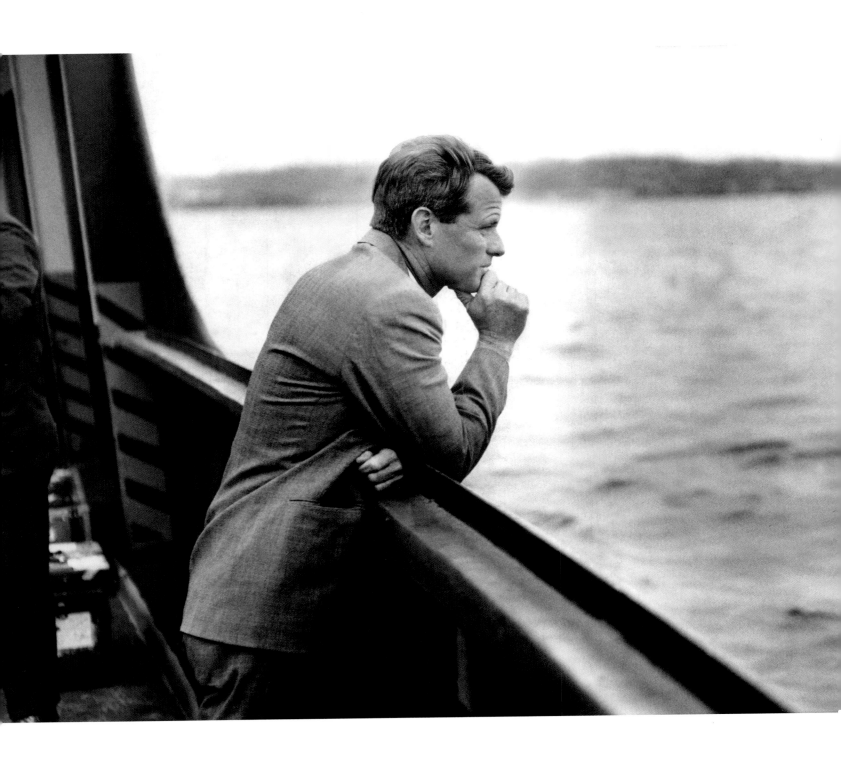

A contemplative Robert F. Kennedy leans on the railing of a ferry heading from Staten Island to Brooklyn on September 13, 1964. He spent that day campaigning for the U.S. Senate in various neighborhoods. On November 3, the former attorney general won the election against incumbent Republican Kenneth Keating, and people generally expected Kennedy to follow in his assassinated brother's footsteps and run for the White House.
JIM ROMANO

Going virtually unnoticed,
Jacqueline Kennedy rows
her children, Caroline and
John Jr., in a boat on Central
Park Lake, September 15,
1964. The *Daily News* pur-
chased this photograph from
boater Peter Rosenberg.
PETER ROSENBERG

Crowds make their way to various pavilions on April 22, 1964, opening day of the 1964–65 New York World's Fair, which was built on the site of the 1939 World's Fair at Flushing Meadow in Queens. About 90,000 people showed up—only about one-quarter the number attending opening day in 1939. The World's Fair featured eighty countries, two dozen states, and fifty corporations, and it attracted roughly 25 million visitors during each of the two six-month periods, from April to October, that it was open. Nevertheless, it ended up losing money. The site is now Flushing Meadow Park, where a few remnants from the fair—including the Unisphere, the Hall of Science, and the New York City Pavilion (now the Queens Museum)—are still intact.

ED GIORANDINO

Port Authority Patrolman Harold Krapels rides a self-propelled catwalk car in the Lincoln Tunnel, late August, 1960. The new device was intended to speed up traffic supervision in the tunnel.

ED PETERS

Referee Jimmy Devlin counts out Gabriel "Flash" Elorde on November 28, 1966, as lightweight champ Carlos Ortiz watches. The time: 2:01 of the fourteenth round. The Madison Square Garden bout was Ortiz's second fourteenth-round defeat of Elorde. With one brief break, Ortiz kept the title from 1962 to 1968.
WALTER KELLEHER

Opposite:
Gondolier charges into the lead in the first race at Aqueduct Race Track on May 1, 1968. The horse, ridden by jockey Mike Venezia, was declared the winner by half a length. The famous one-and-a-quarter-mile track, just northwest of Kennedy International Airport in Queens, opened in 1894— about 230 years after thoroughbred horse racing first came to the New York City area. By 1960, a year after completion of a major rebuilding, it was the leading betting track in the country, with a daily handle of $2.7 million. From 1963 to 1967, the Belmont Stakes, the final jewel in the Triple Crown, took place there. In 1917, however, off-track betting became legal, OTB parlors sprang up in most neighborhoods, and attendance at Aqueduct and other city tracks began to plummet.
GENE KAPPOCK

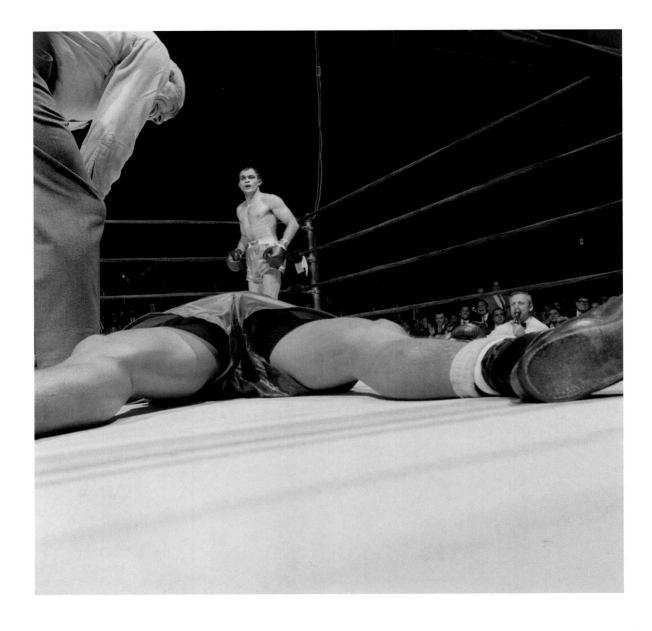

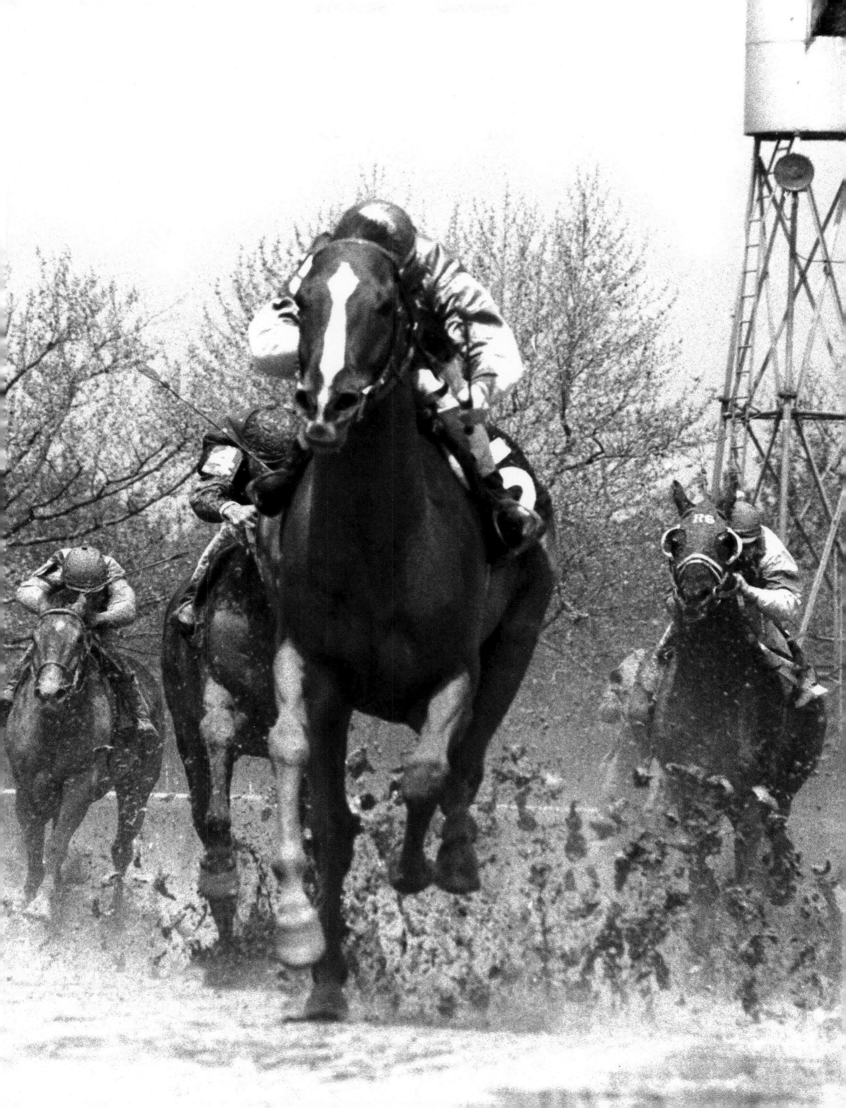

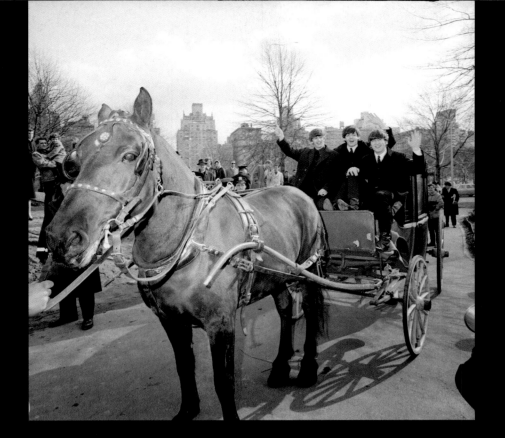

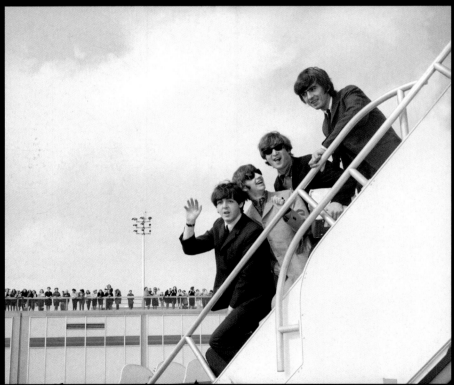

Top:
Three of the Fab Four—(left to right) Ringo Starr, Paul McCartney, and John Lennon—wave from a horse-drawn carriage in Central Park on February 9, 1964, the day after the Beatles' arrival in the United States for the first time. George Harrison was off resting a sore throat. The Beatles took to New York City right away—and much of America took to them as well, in a really big way.
FRANK HURLEY

Above:
Fans line the rooftops at Kennedy International Airport on September 21, 1964, for a last glimpse of the Beatles—(left to right) Paul McCartney, Ringo Starr, John Lennon, and George Harrison—as they fly home to England after their second American tour of the year.
DAN FARRELL

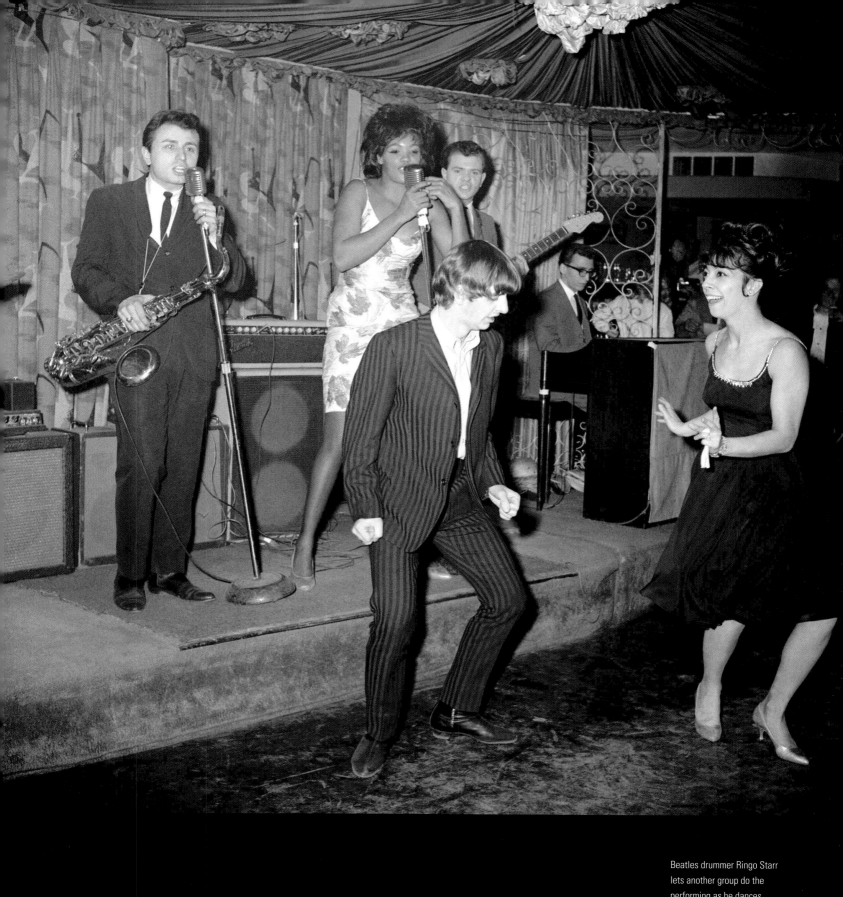

Beatles drummer Ringo Starr lets another group do the performing as he dances with Jeanie Dell, a singer at the Headline Club, a few days after the Beatles' phenomenal first appearance on *The Ed Sullivan Show*, on February 9, 1964—which was watched by an estimated 60 percent of American TV viewers.
KEN KOROTKIN

Police try to restrain a fan, Mary Smith, as she holds on to George Harrison during a Beatles concert at Forest Hills Stadium on August 28, 1964. The frenzied fans thrilled but sometimes terri-fied the Beatles during the group's twenty-three-city second tour of the United States. At this typical concert, they arrived by heli-copter, waited nearly two hours while the 16,000 screaming fans booed or ignored the opening acts, and then played thirty-three minutes of barely audible music before flying off.

DAN GODFREY

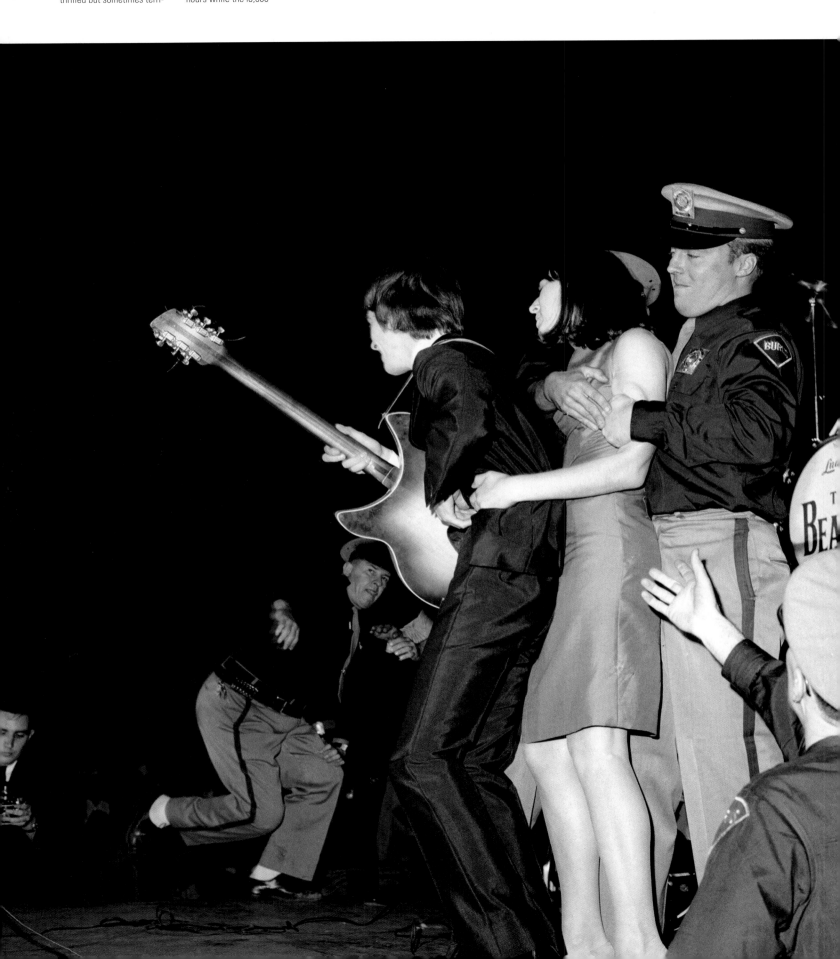

A police officer carries off a girl who ran onto the field during the Beatles concert at Shea Stadium on August 15, 1965.
DAN FARRELL

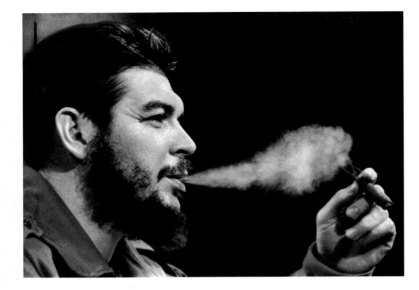

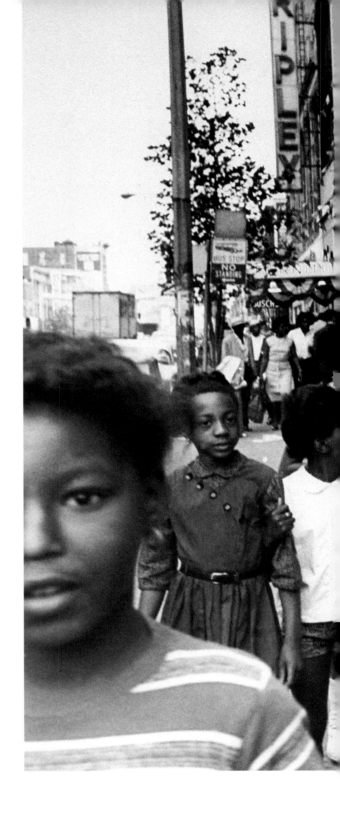

Ernesto "Che" Guevara, Cuba's minister of industry, smokes his cigar during an appearance on the interview program *Face the Nation*, December 13, 1964. Fidel Castro's right-hand man during the Cuban revolution, Guevara said he "hoped for harmonious relations with the United States but would accept no conditions set by this country." When he left the CBS Studios, at 524 West 57th Street, he had his driver make a U-turn to go past 150 anti-Castro demonstrators a second time.
DAN FARRELL

Right:
The Pied Piper of Harlem, Muhammad Ali, whistles a sweet tune as he nonchalantly strolls down a street in Harlem, mid-December, 1964. But he was now the heavyweight champion of the world, having beaten Sonny Liston on February 25. Many newspapers continued to refer to Ali as Cassius Clay, which he called his "slave name," but he had proclaimed his conversion to Islam and announced his new name (initially, Cassius X) the day after the title match.

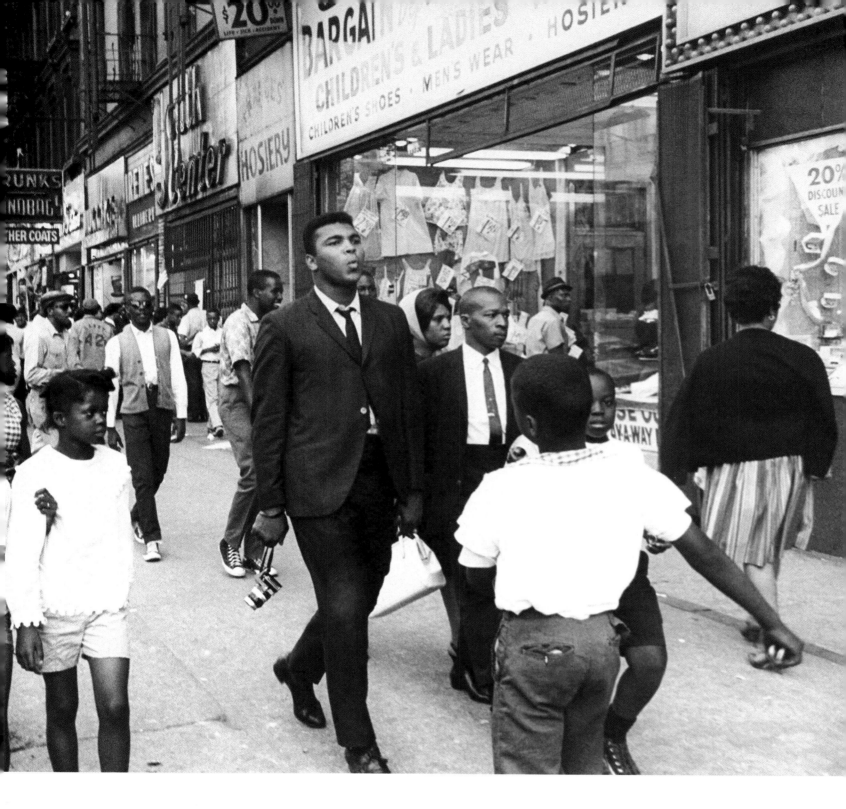

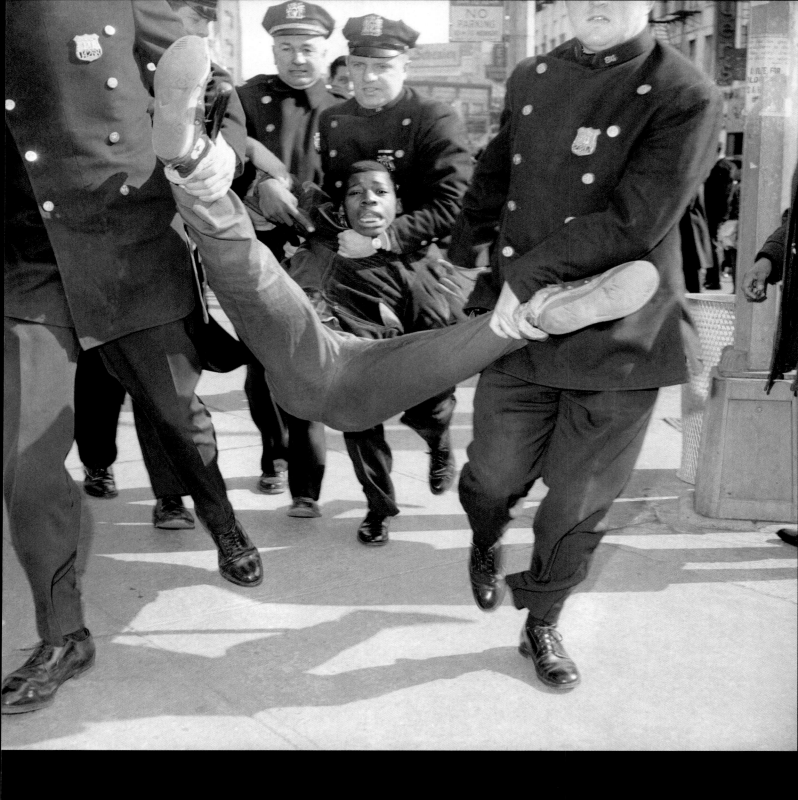

Police carry off one of the
teenagers who reportedly
"ran amok" in a nearby shop-

city schools. On March 7,
School Superintendent Calvin
Gross called for the transfer

migration to the suburbs.
That only increased racial
segregation of neighbor-

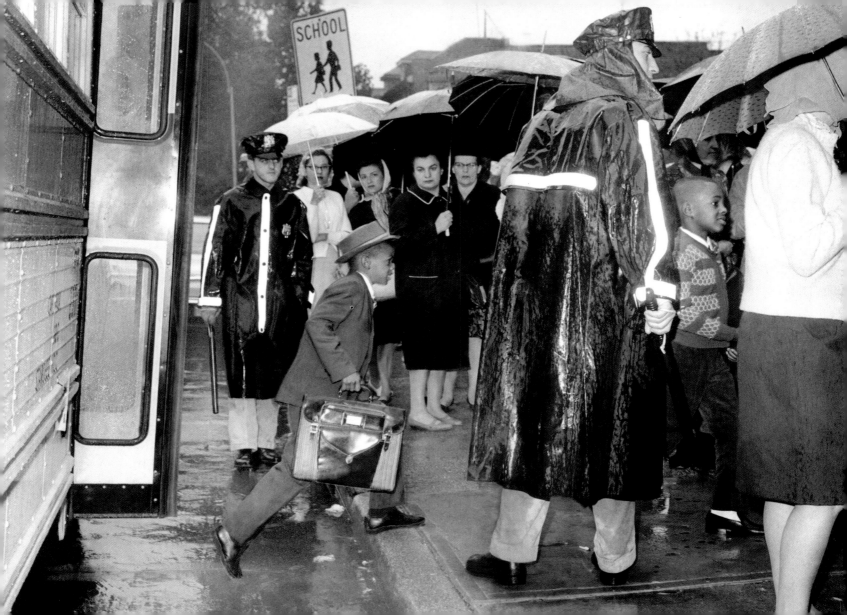

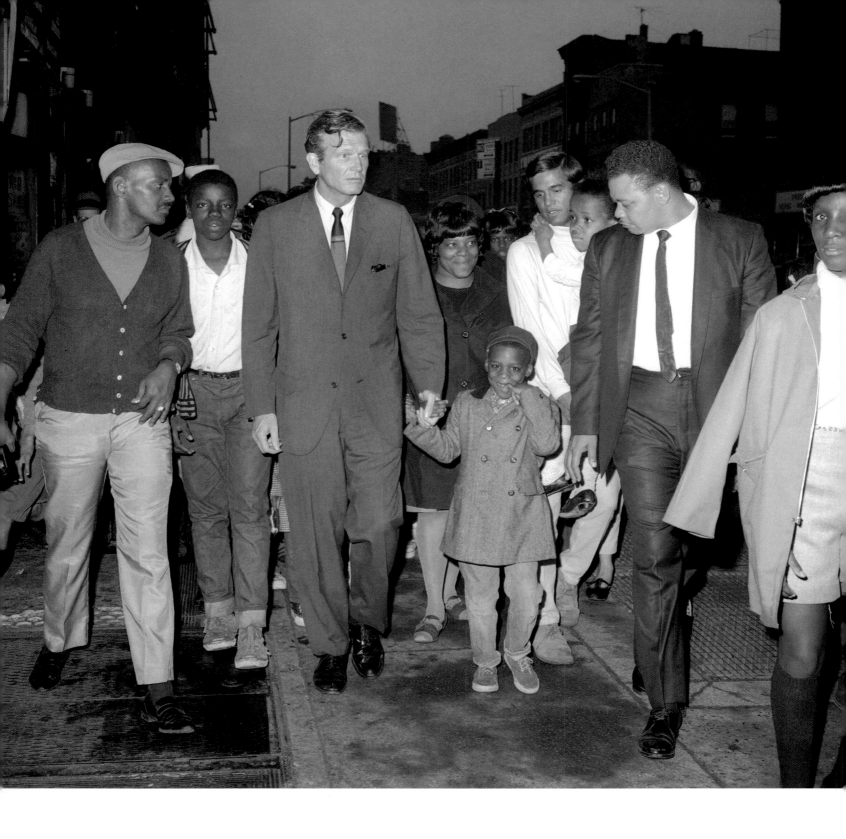

Left:

Mayor John Lindsay strolls through the Bedford-Stuyvesant section of Brooklyn on June 11, 1968, despite tightened security around City Hall after apparently serious death threats against him, barely a week after the assassination of Robert F. Kennedy in California. Lindsay was New York City's liberal mayor from 1966 to the end of 1973. By taking well-publicized walks like this one through inner-city neighborhoods, starting in the racially tense summer of 1967, he was widely credited with helping to keep New York calm when other American cities exploded in rioting after the assassination of the Reverend Martin Luther King Jr. on April 4, 1968.

Above:

The Reverend Adam Clayton Powell Jr. (right) engages in some "soul touching" with a well-wisher on July 20, 1968, while visiting the Abyssinian Baptist Church, 132 West 138th Street in Harlem—the largest, the oldest (founded 1808), and for decades the most influential black church in New York. Powell, the pastor of that church, was also a maverick Democratic member of Congress from 1945 to 1971, but the House of Representatives refused to seat him in 1967 on the grounds of conduct unbe-coming a member: he was accused of misuse of official funds and of contempt of court relating to a libel case. Powell easily won the next two special elections in his district but spent much of his time in self-exile in the Bahamas; he was finally seated again in 1969, though he was also fined and stripped of his seniority. The Supreme Court ruled in 1969 that the House had acted unconstitutionally against him. The following year, Powell finally lost a reelection bid, and he died in 1972.

MEL FINKELSTEIN

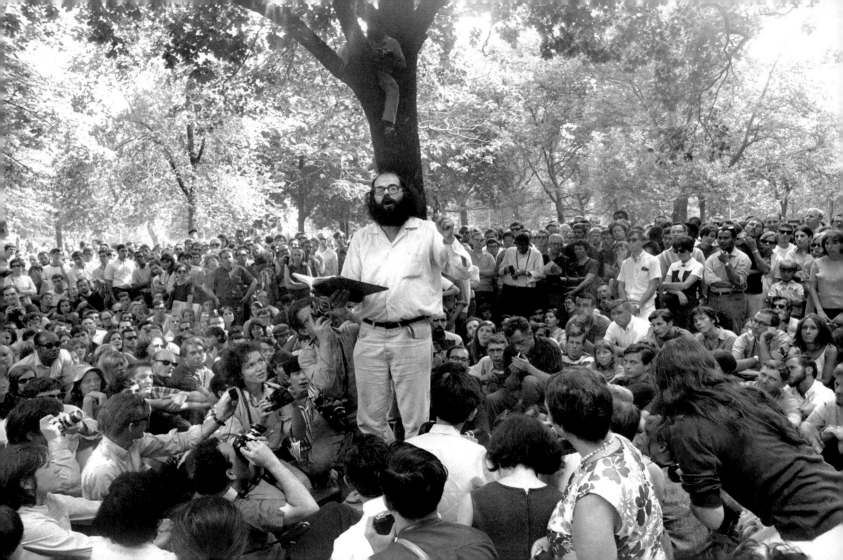

Pop artist and filmmaker Andy Warhol checks the lighting for *Beauty #2*, a picture featuring—and verbally dissecting—vulnerable underground movie star Edie Sedgwick (left). The photo was part of an August 6, 1965, feature about the downtown scene centered around underground movie makers Warhol, Jonas Mekas, and Stan Brakhage. Sedgwick, a cometlike cult figure of that moment, died as a result of a drug over-dose in late November, 1971.
JOHN PEODINCUK

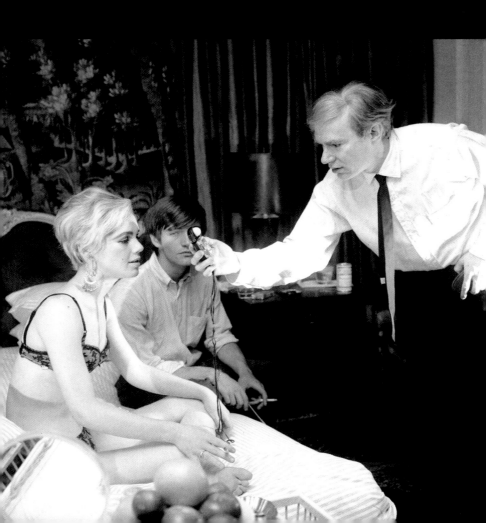

218 A Columbia University student responds violently to one of the students whose campus strike, to protest the Vietnam War and local disputes between the university and the surrounding community, has blocked his way to class. A series of protests at Columbia culminated in the takeover of several campus buildings beginning on April 23, 1968; the one-week standoff ended when the university administration called in the New York City police. At 2:30 A.M., in the largest police action on any campus up to that point in American history, about 1,000 police swept through the buildings and roughly removed the students and their supporters. More than 700 were arrested, and about 150 injuries were reported. The school year ended with suspended classes, student walkouts, and acrimony.
MEL FINKELSTEIN

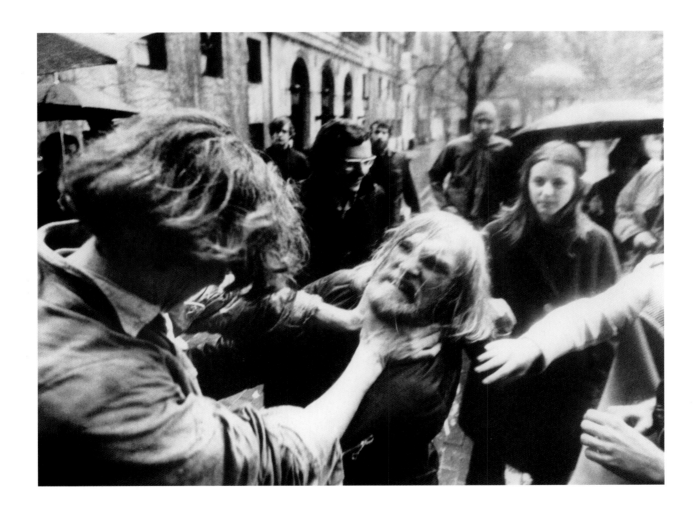

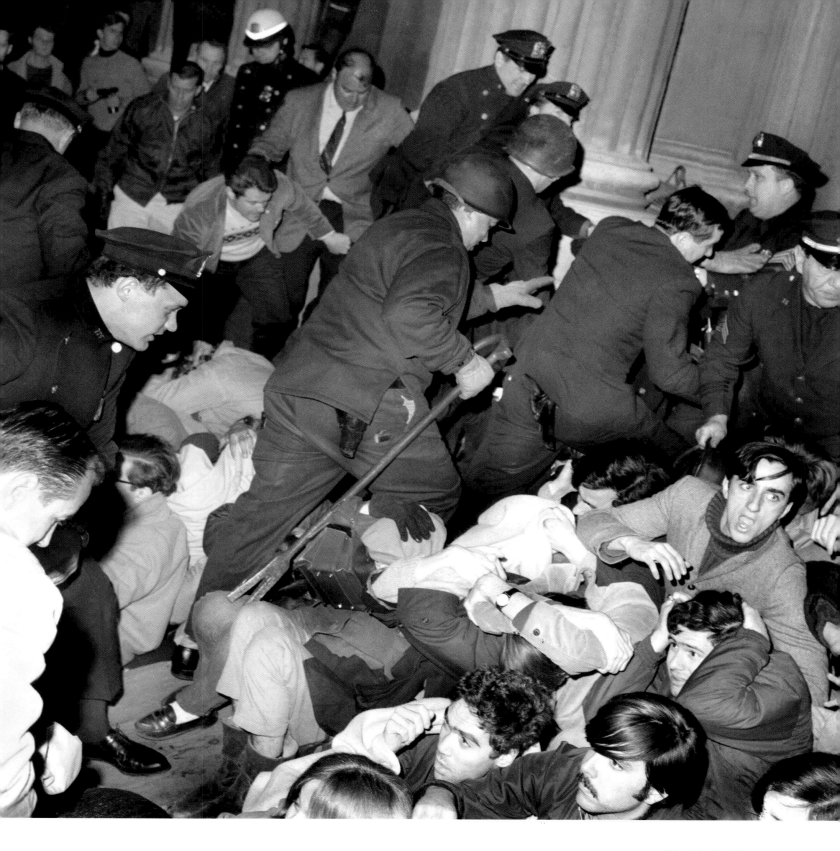

Helmeted police of the
Tactical Patrol Force
wade through sit-ins
blocking the entrance to
Columbia University's
Avery Hall, April 30, 1968.
CHARLES RUPPMAN

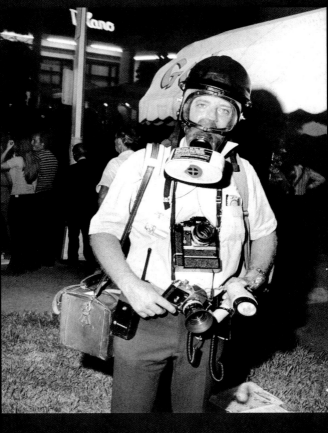

Photographer Keith Torrie
ready for pepper gas at the
Republican Convention in
Miami, August 1972.

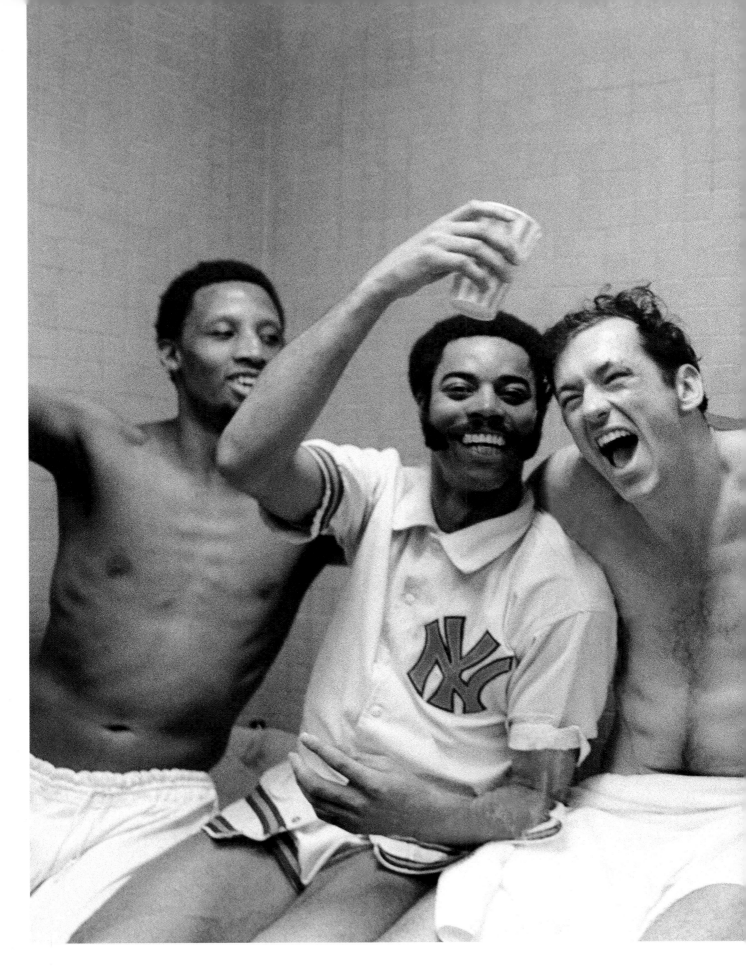

The New York Knicks' start-
ing five—(left to right) Dick
Barnett, Walt Frazier, Bill
Bradley, Dave DeBusschere,
and Willis Reed—rejoice in
the dressing room on April

20, 1970, after winning their
fifth playoff game against the
Milwaukee Bucks, by a lop-
sided score of 132–96, and
with it their first National
Basketball Association

Eastern Conference title
since 1953. The Knicks went
on to beat the Los Angeles
Lakers in the finals for their
first-ever NBA championship.

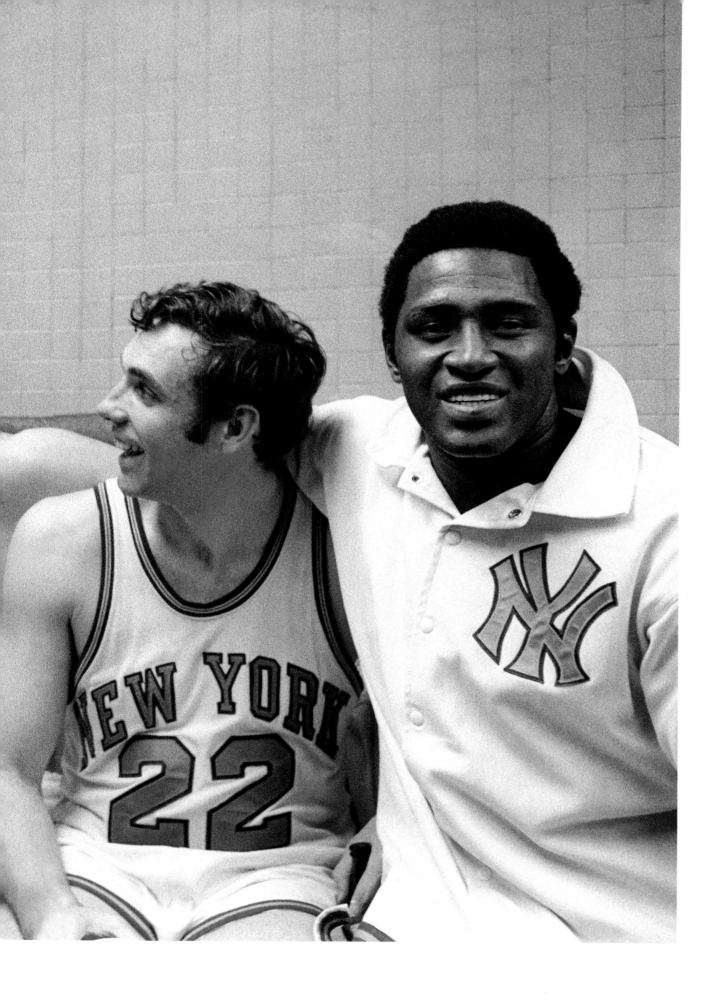

224 Duke Ellington strikes a pose for a fan taking his photograph during an out-door Jazzmobile concert in Harlem in mid-September, 1970. Born in Washington, D.C., the twenty-four-year-old Ellington moved to New York in 1923 and created a body of music that is deeply evocative of the city.
FRANK RUSSO

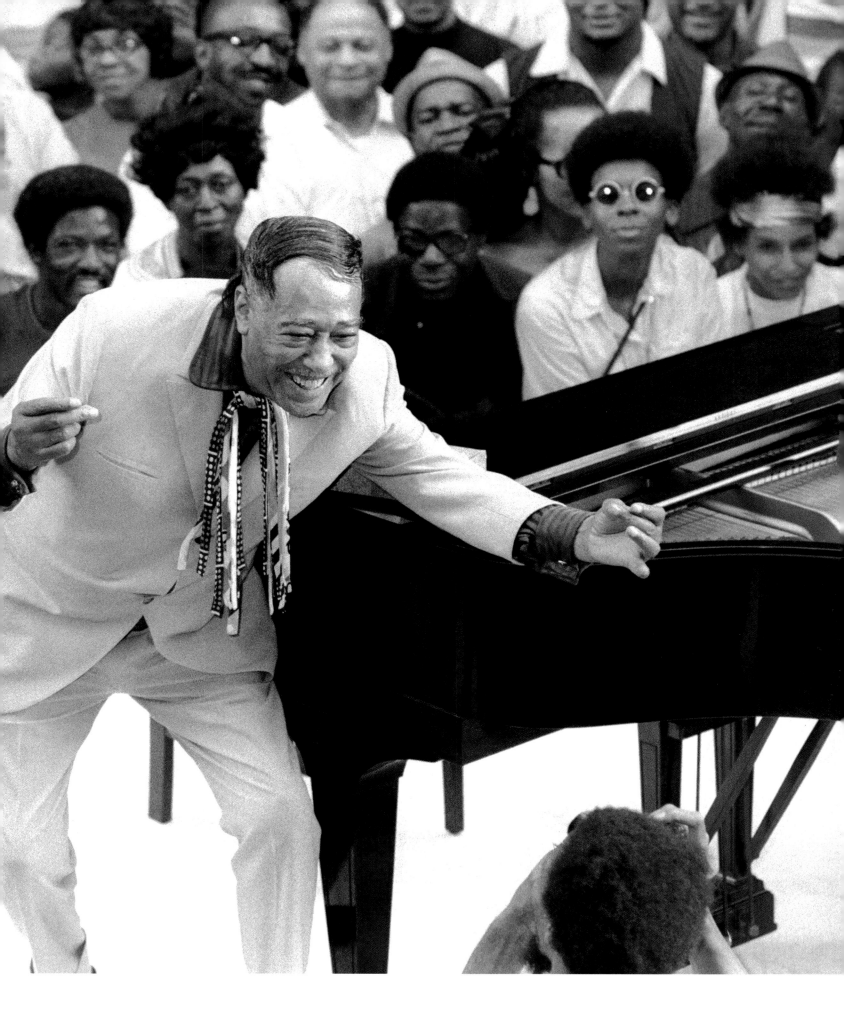

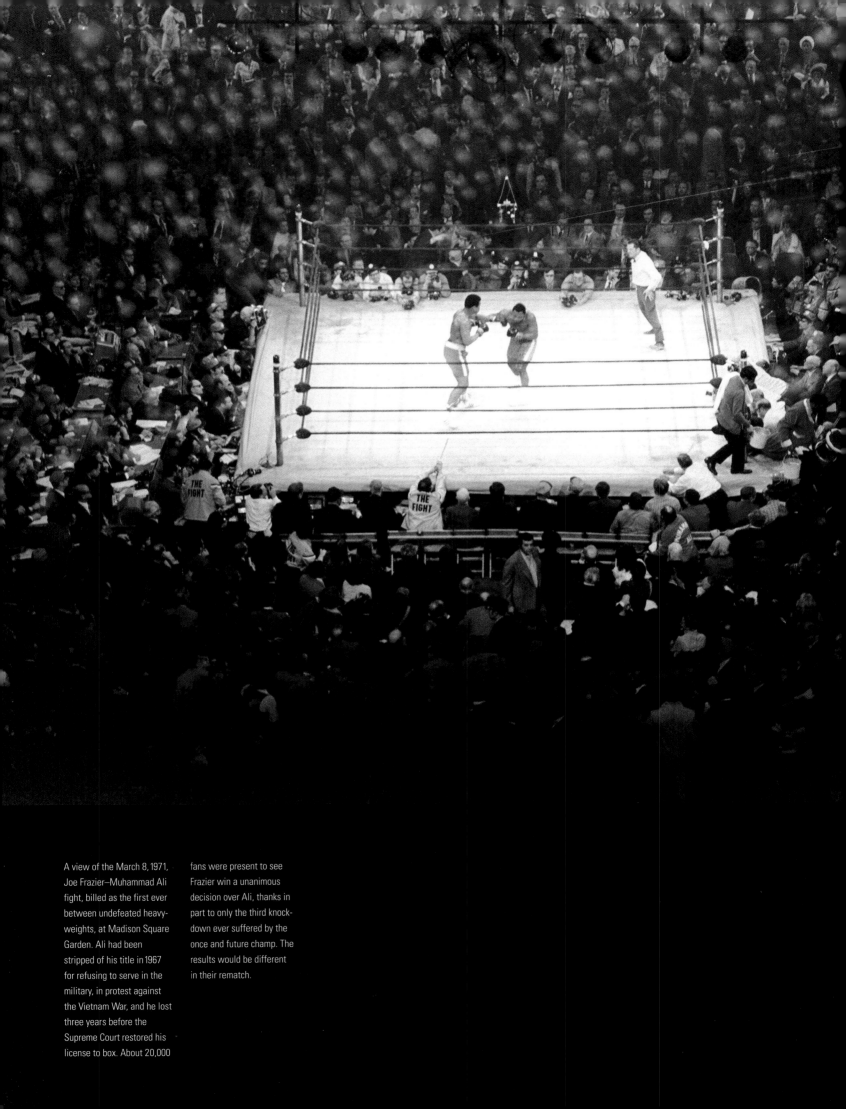

A view of the March 8, 1971, Joe Frazier–Muhammad Ali fight, billed as the first ever between undefeated heavyweights, at Madison Square Garden. Ali had been stripped of his title in 1967 for refusing to serve in the military, in protest against the Vietnam War, and he lost three years before the Supreme Court restored his license to box. About 20,000 fans were present to see Frazier win a unanimous decision over Ali, thanks in part to only the third knockdown ever suffered by the once and future champ. The results would be different in their rematch.

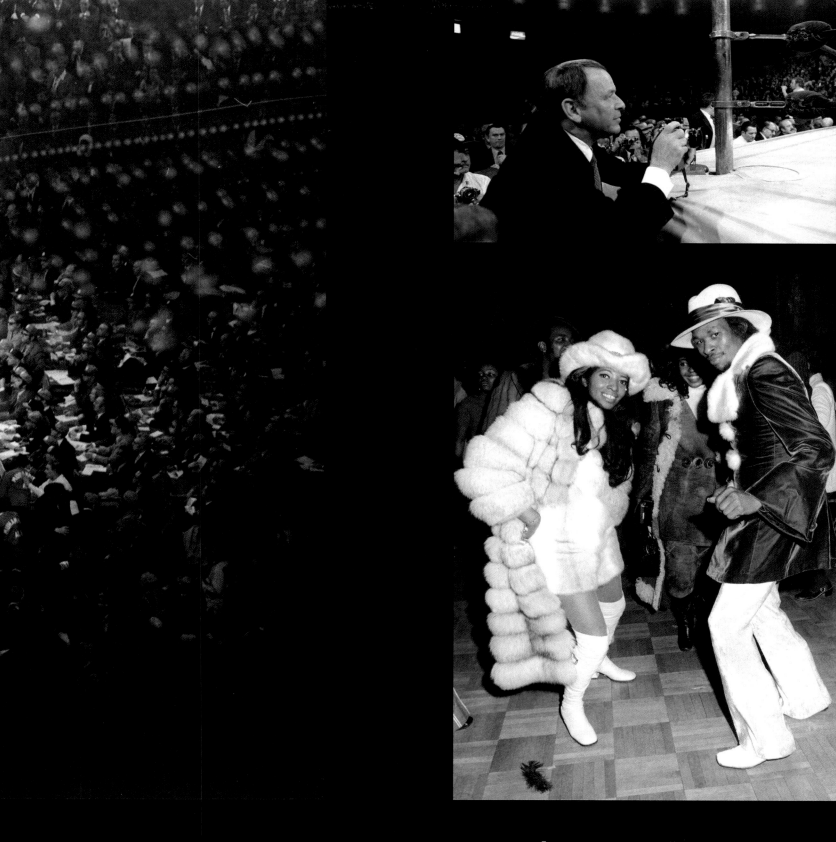

Top:
Ol' Blue Eyes turns the tables
on the press and picks up a
camera to shoot the fight.
DAN FARRELL

Above:
Boxing fans Betty Brown and
Sterling Godfrey, dressed for
the 1970s, enjoy a party at
the Americana Hotel after
the Frazier-Ali match.
KEN KOROTKIN

Below:
Mob boss Joseph Colombo is severely wounded at an Italian-American Civil Rights League rally in Columbus Circle on June 28, 1971. The hit was set up through gangsters in Harlem by the Gallo brothers, but it is believed that the assignment came from Carlo Gambino, the most powerful mob boss in the early 1970s. Colombo, was not a popular figure among his cohorts: by insisting on a public strategy of denying the existence of organized crime, to the point of creating the league to protest public identification of Italian-Americans with mobsterism, the onetime hit man only succeeded in bringing more attention to activities that the mob preferred be kept in darkness. Colombo remained in a coma for the next seven years, finally dying in 1978.
MEL FINKELSTEIN

Opposite:
The body of Sam Burns lies just a few feet from a police safety net on November 18, 1972—the culmination of a daylong tragedy. Burns fatally stabbed his partner in a fur business on West 29th Street in Manhattan, went home to Co-op City in the Bronx, spent about an hour on an adjacent roof at 2420 Hunter Avenue, and then plunged twenty-six floors to his death after yelling to police, "You think I'm not going to jump, but I'm going." Before jumping, the husband and father of a grown son told police about the murder but did not reveal a motive; apparently, it turned out, he had discovered that Jules Roth was replacing high-quality furs with inferior merchandise.
TOM CUNNINGHAM

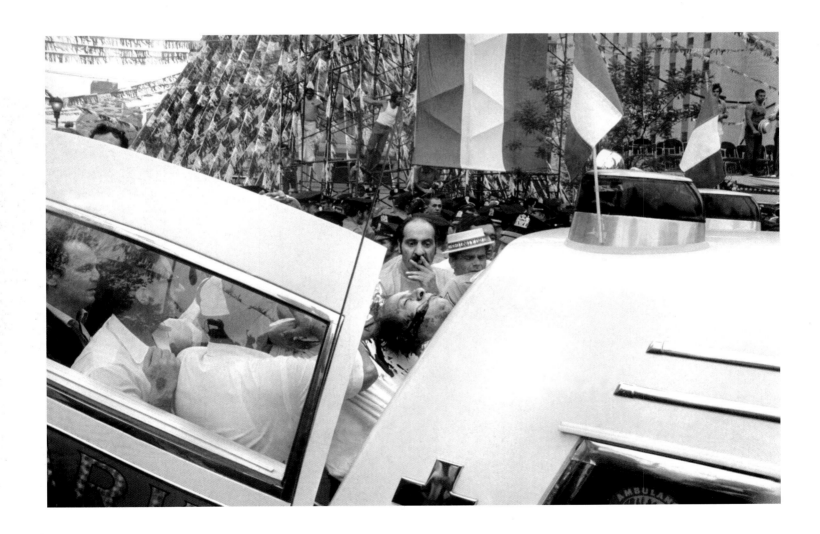

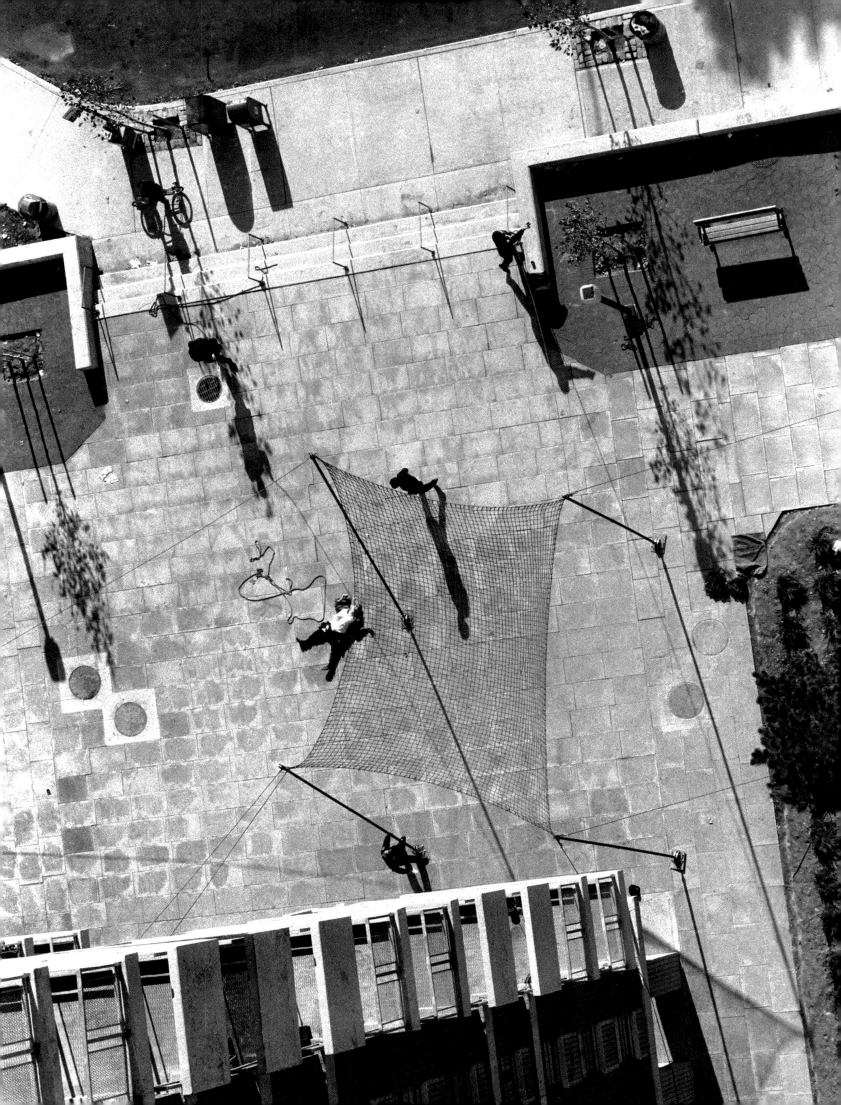

230 Charlie O'Connell of the San Francisco Bombers is knocked off his feet by Bill Groll of the New York Chiefs during roller derby's Whirl Championship at Shea Stadium on May 26, 1973. The Chiefs won, 27–26, and took the championship after defeating the Chicago Pioneers as well. O'Connell dominated roller derby for two decades as its highest-paid and reputedly meanest player. He had led the Chiefs to the world championship in 1972, his one year with that team before returning to the Bombers.

GENE KAPPOCK

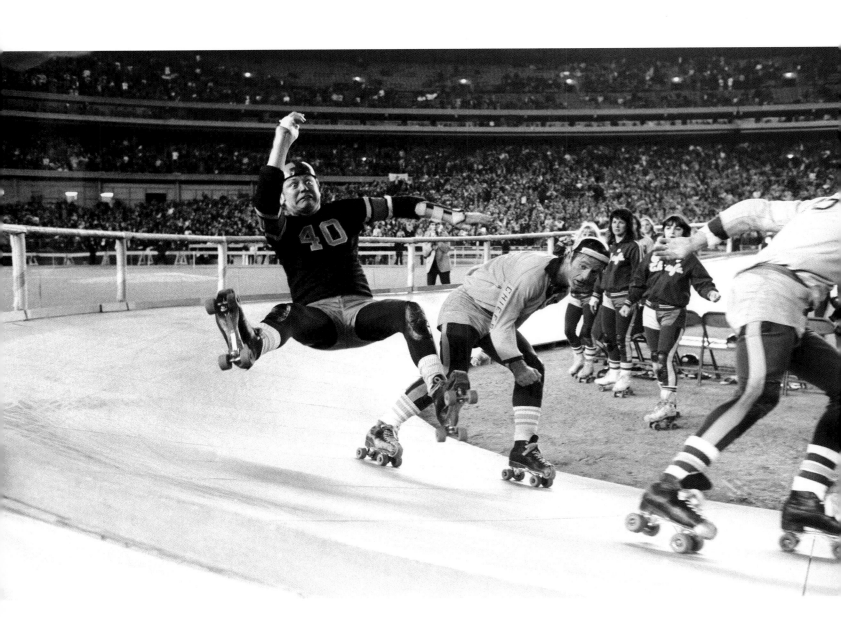

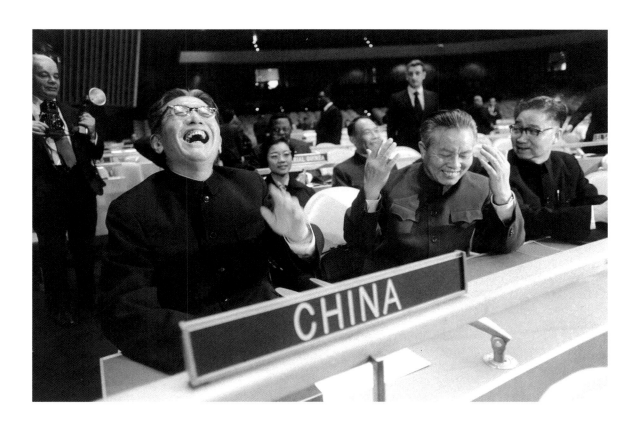

Delegates from the People's Republic of China enjoy the welcome to their new seats at the United Nations, November 15, 1971. At left is Deputy Foreign Minister Chiao Kuan-hua (left), head of the delegation; next to him is Huang Hua, permanent UN representative (and later the country's foreign minister). They were seated three weeks after the world body, despite U.S. opposition, expelled the anti-Communist government of the Republic of China (Taiwan). Communist China's return to the world stage, after two decades of isolation by the West, had begun in mid-July with a secret visit to Beijing by National Security Adviser Henry Kissinger. On February 21, 1972, Richard Nixon became the first American president to visit Communist China.
MEL FINKELSTEIN

Procession of altar boys
at the start of the Feast of
Saint Anthony of Padua on
Sullivan and West Houston
streets, June 13, 1973.

BILL STAHL

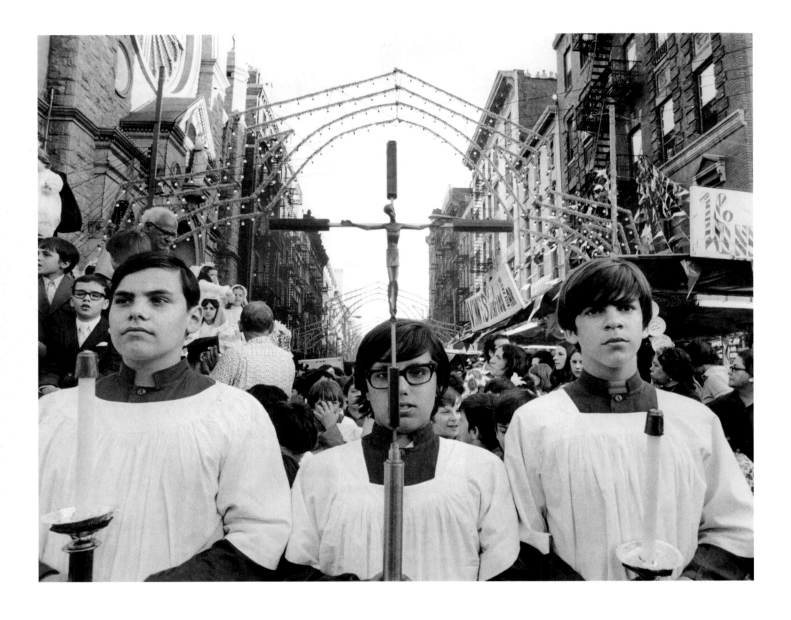

Four young women in fashion-
able hot pants walk along
White Plains Road in the
Bronx during the Promenade
Festival, late June, 1971.
TOM CUNNINGHAM

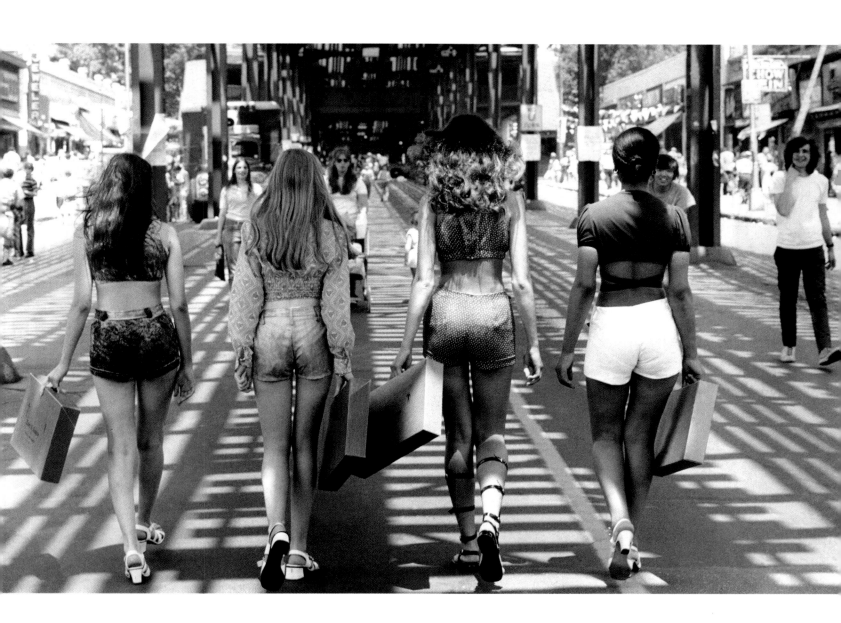

Passersby congratulate senatorial candidate Daniel Patrick Moynihan through the window of his campaign headquarters, at Sixth Avenue and West 43rd Street, on September 15, 1976, the day after his narrow victory in the 1976 Democratic primary. Moynihan—previously an adviser to Presidents Kennedy, Johnson, and Nixon, an author of influential 1960s studies of ethnicity and urban poverty, a professor at Harvard, and an ambassador to India and then to the United Nations—defeated Congresswoman Bella Abzug, the outspoken liberal, by just 9,000 votes. (City Council President Paul O'Dwyer and former attorney general Ramsey Clark also ran.) Moynihan easily defeated the conservative Republican incumbent, James Buckley, in November and ended up serving four terms as one of the leading Democrats in the Senate, before being succeeded in 2001 by former First Lady Hillary Rodham Clinton.

DAN FARRELL

Sidewalk superintendents keep an eye on the construction of a new skyscraper at Lafayette and Leonard streets in lower Manhattan, May 7, 1971. There was a real-estate boom then, so they had a lot of options.
GEORGE MATTSON

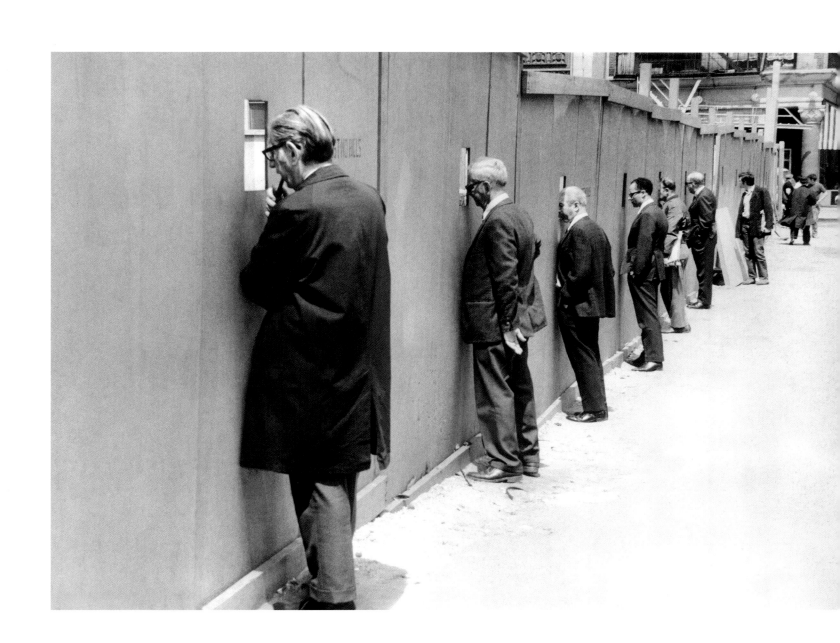

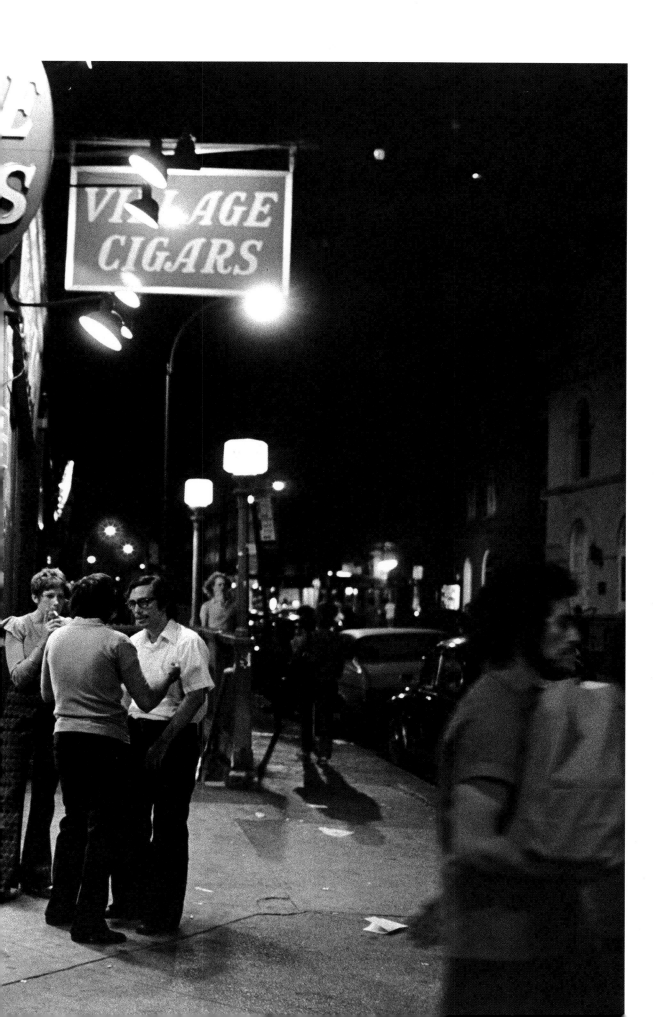

Officers Tim Byrne (left) and Carl Garritani work under- cover outside a store at Sheridan Square in the West Village, late August, 1973. Police increased their pres- ence in the neighborhood in response to two fatal stab- bings. One reason cited for the temporary increase in crime was a police cleanup of Central Park, which drove many drug users and other criminals downtown.
CHARLES RUPPMANN

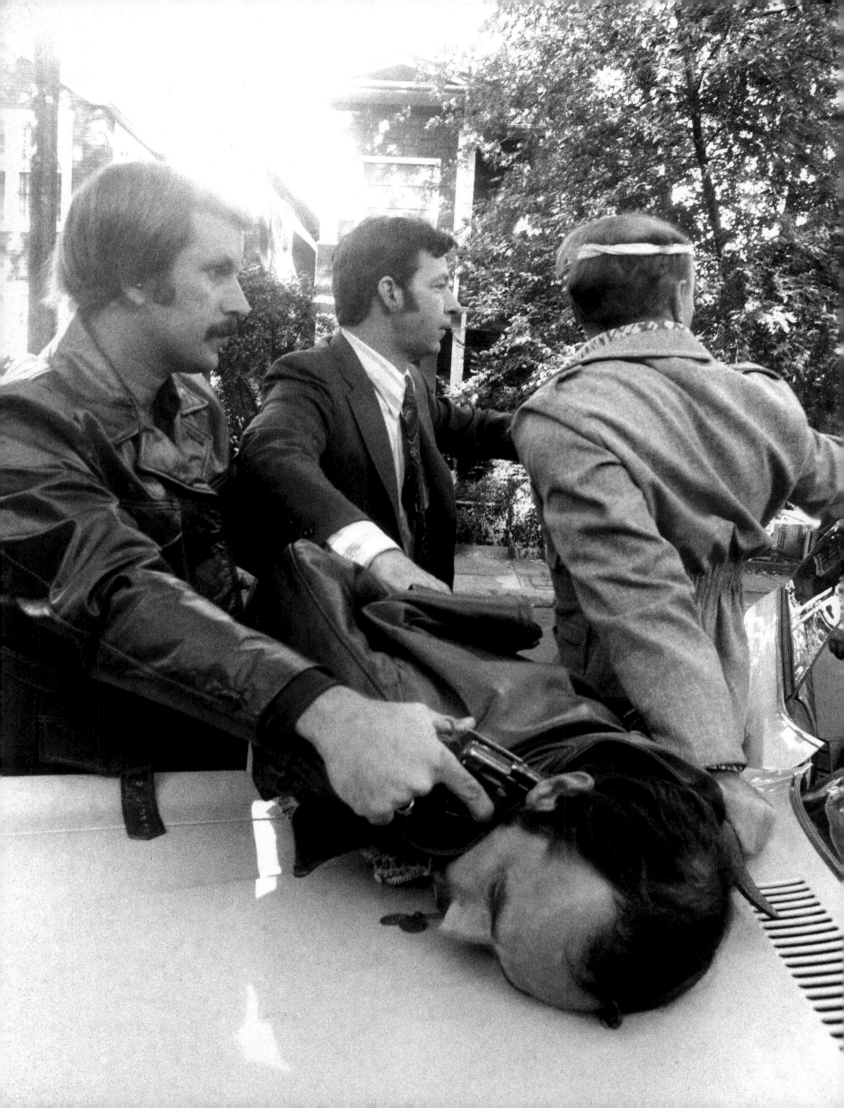

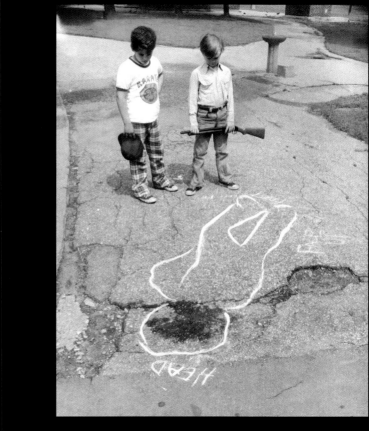

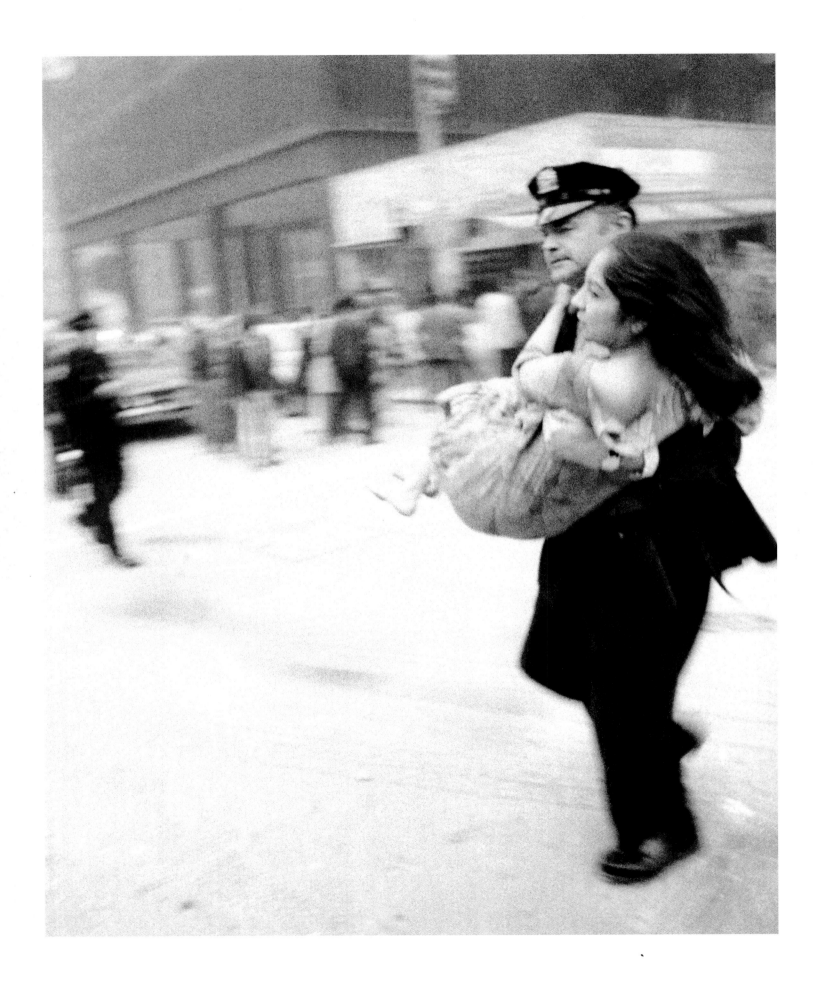

Opposite:

An officer carries a woman to safety from the Envoy Towers, a 180-unit building for diplomats and workers at the nearby United Nations, after a huge gas explosion in the adjacent commercial building on April 22, 1974. The blast, which occurred after an overpressurized water tank burst and ruptured a gas main it was placed too close to, blew off the entire west wall of the twenty-four-story former Graphic Arts Building at 305 East 45th Street just before 7 A.M. and heavily damaged the nineteen-story luxury apartment building at 300 East 46th Street, as well as nearby stores. Miraculously, no one was killed, though more than seventy people were injured; if it had happened an hour or two later, at the start of the workday, the death toll might have been staggering. **JAMES McGRATH**

Below:

Anthony Ricco, one of ten inmates who escaped together from Riker's Island in the East River on October 1, 1977, holds a gun to his wife's head six days later to keep more than fifty police officers at bay at 323 East 108th Street in East Harlem. A convicted rapist being held on a murder charge, Ricco drew a large crowd during the standoff, which ended peacefully after nine hours. He was sent to the prison psychiatric ward at Bellevue Hospital—where he and an accomplice made a daring escape on Christmas Day, using a hacksaw blade that his girlfriend smuggled in to him. Ricco was recaptured in Yonkers after a shootout and police chase of his stolen car, and in 1979 he was given a life sentence for the 1975 murder. **JIM HUGHES**

Truman Capote towels off after a relaxing whirlpool bath at his East Side gym in late March, 1978. He was keeping in shape while trying in vain to work on *Answered Prayers*, which remained unfinished at his death in 1984. Chapters from the massive novel, published in 1975 and 1976 in *Esquire* magazine, alienated many of his socially prominent friends and benefactors, who were all too thinly disguised amid the indiscreet text. Capote had previously earned critical acclaim for sensitively written novels and short stories and for *In Cold Blood*, his groundbreaking 1966 "nonfiction novel" about the murders of a Kansas family.
RICHARD CORKERY

Tennessee Williams enjoys a cocktail party in late November, 1976, to celebrate a television production of his play *Cat on a Hot Tin Roof* (starring Natalie Wood as Maggie the Cat). Like fellow southern writer Truman Capote, Williams explored taboo subjects such as homosexuality, battled inner demons, and lived hard. Williams, who died in 1983 in a freak accident at home, is generally considered one of the two or three greatest American playwrights, best known for two mid-1940s poetic dramas about memory, dreams, and disillusionment: *The Glass Menagerie* and *A Streetcar Named Desire*.
RICHARD CORKERY

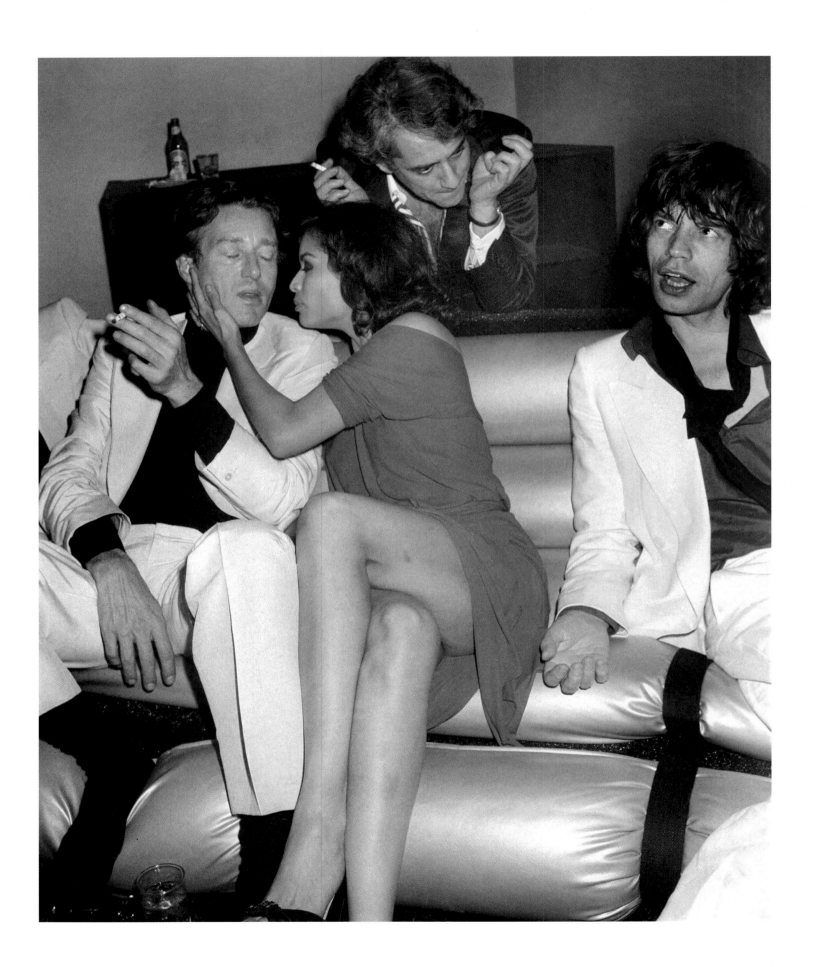

Opposite:

Former model Bianca Jagger comforts fashion designer Halston (left) as her husband at the time, Rolling Stones star Mick Jagger (right), looks on during her thirtieth birthday bash at Studio 54 in May 1977. People like Mick and Bianca (who later became a prominent advocate for refugees and other humanitarian causes) and Halston had no trouble getting into the trendiest nightclub of the period—and a frequent law-enforcement target, for its association with heavy cocaine use and allegations of ties to organized crime—but others were kept waiting beyond velvet ropes, desperately hoping for a signal that they, too, could be counted among the Beautiful People, at least for one night. **RICHARD CORKERY**

Below:

Singer-actress Liza Minnelli, a daughter of the legendary Judy Garland, dances with American Ballet Theatre star Mikhail Baryshnikov, who defected from the Soviet Union in 1974. The occasion was a birthday party for Minnelli's half sister, Lorna Luft, at New York, New York disco on November 21, 1977. **RICHARD CORKERY**

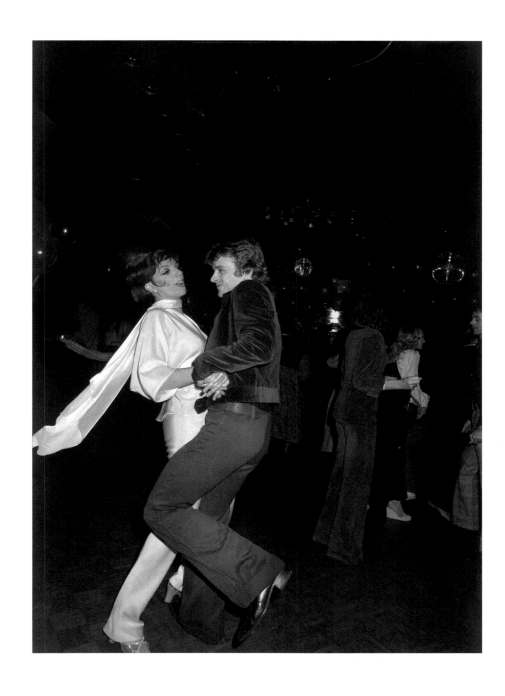

246 David Berkowitz, the serial killer who called himself Son of Sam, terrorized the city for a year beginning in the summer of 1976, killing six people and wounding seven others in random attacks. The media initially called the gunman the .44-Caliber Killer, but in letters he sent to the police and *Daily News* columnist Jimmy Breslin, he referred to himself as Son of Sam. Here, police examine the parked car on 211th Street in Bayside, Queens, in which Judith Placido and Sal Lupo, who had just left a Queens disco, were sitting before dawn on June 26, 1977, when the gunman wounded them before fleeing. (Both recovered, and the seventeen-year-old Placido later worked for a crime victims' rights organization.) **TOM MONASTER**

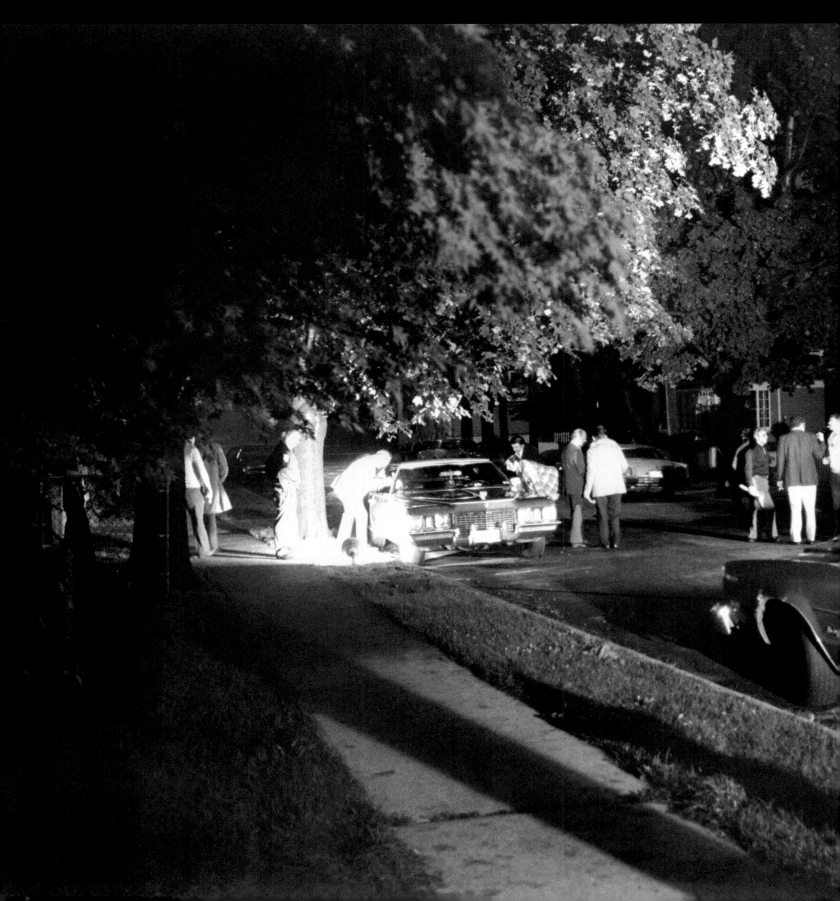

parked car at Gravesend Bay in Brooklyn two days after the first anniversary of the beginning of Berkowitz's spree, she died thirty-eight hours later. Her companion, Bobby Violante, also shot, survived. She was his last victim.
BILL TURNBULL

Bottom:
New York's long nightmare ended on August 10, 1977, when Berkowitz was apprehended and brought to police headquarters at 1 Police Plaza. He was caught when a witness noticed a parking ticket on the car that the gunman took off in after shooting his final victims. Police traced the ticket to the innocuous-looking postal worker, who explained that he was ordered to kill young women by Sam—a neighbor's dog. Berkowitz pleaded guilty and was sentenced to twenty-five years to life for each murder.
ALAN AARONSON

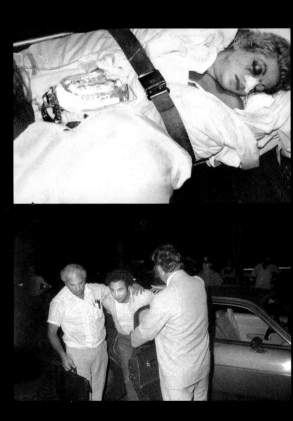

Below:
Fashion designer Calvin Klein has a tense wait in a telephone booth on 42nd Street at Fifth Avenue for a call from the kidnapper of his daughter Marci, eleven years old, on February 3, 1978. The bag under his arm contains $100,000 ransom. Marci was released later that day after being held for nine hours. A former baby-sitter, her half brother, and another man were later arrested, tried, and given long sentences.

THOMAS MONASTER

Opposite:
The bodies of big-time mobster Carmine Galante (at top, a cigar still in his mouth) and bodyguard Leonardo Coppolla lie on the outdoor patio of Joe and May's Restaurant at 205 Knickerbocker Avenue, in the Bushwick section of Brooklyn, on July 12, 1979. Chalk marks indicate the slugs, casings, and impact points in the gangland slayings. Galante, once an aide to Vito Genovese and then kingpin of the Bonanno family, became the most powerful Mafia boss after Carlo Gambino's death in 1976, but the other bosses of the Five Families agreed to have him rubbed out after he started a gang war in 1978.

FRANK CASTORAL

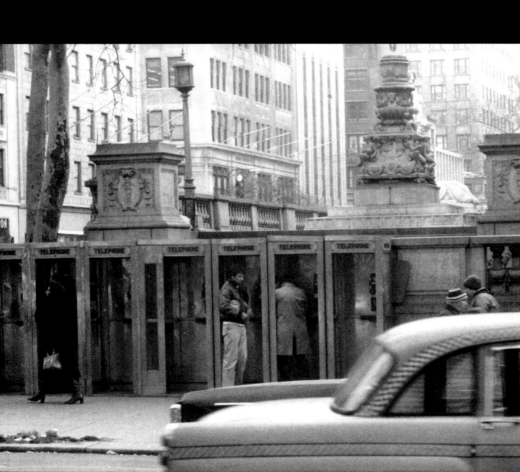

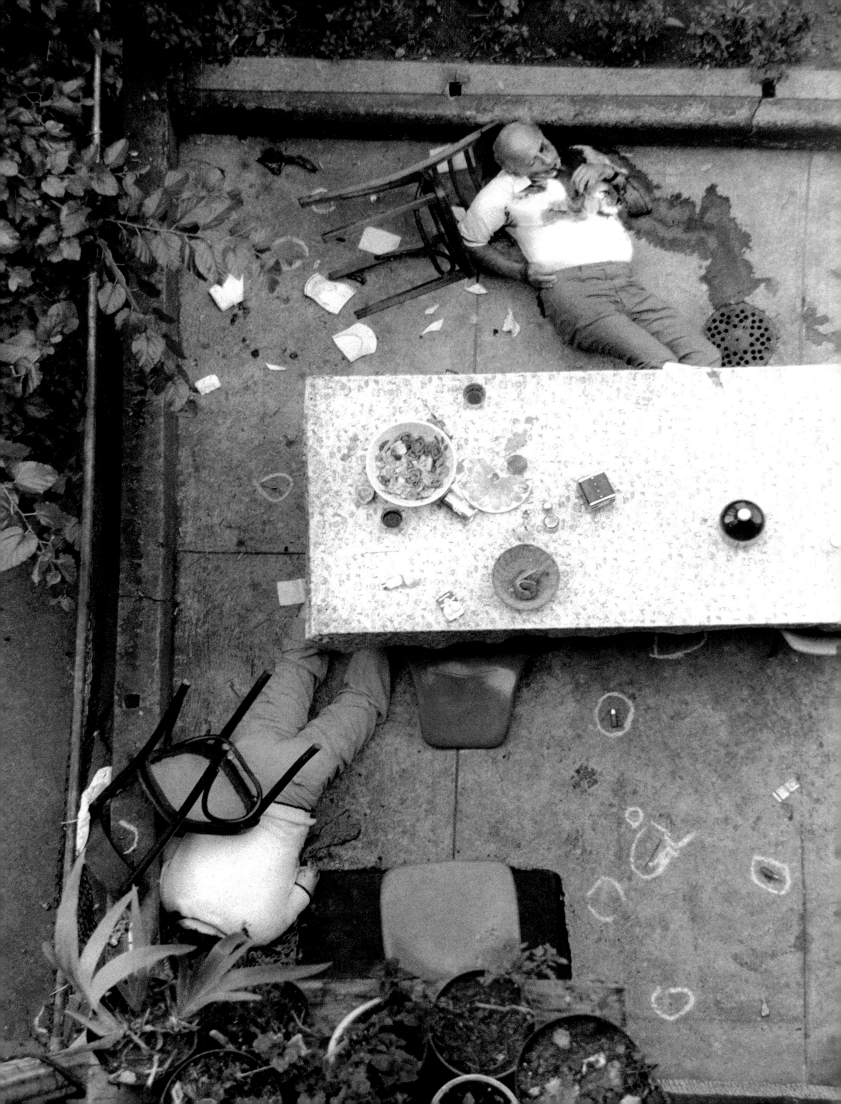

Yoko Ono and John Lennon put on a performance of her work of art called *Bag Piece*, November, 1979. Derived from performance art she began doing in the early 1960s, Bagism became a recurring theme for the couple, having to do with shedding perceptions based on outward appearance. It was also one of their theatrical means—like their honeymoon "bed-in"—of calling attention to their idealistic crusade for world peace. On December 8, 1980, the former Beatle was murdered outside the couple's Upper West Side apartment building, the Dakota.
THOMAS MONASTER

Youngsters in a vacant lot in Maspeth, Queens, in early May, 1977, show that it doesn't take much to put together a makeshift game of basketball. In New York City, as in urban areas around the country, basketball was gradually replacing baseball—and its street variant, stickball—as the favorite sport for kids to play. But they often had to play in rock-strewn places like this, because, as area residents complained at the time, many of the city's parks were in even worse shape, as a result of sharp cutbacks in maintenance.
JAMES MCGRATH

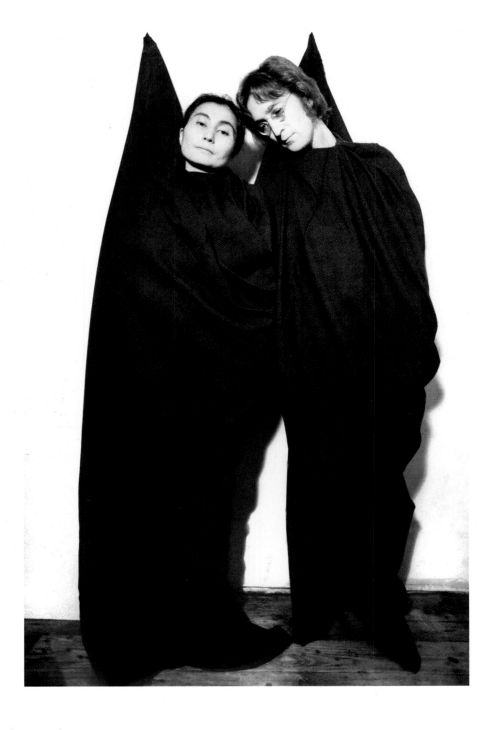

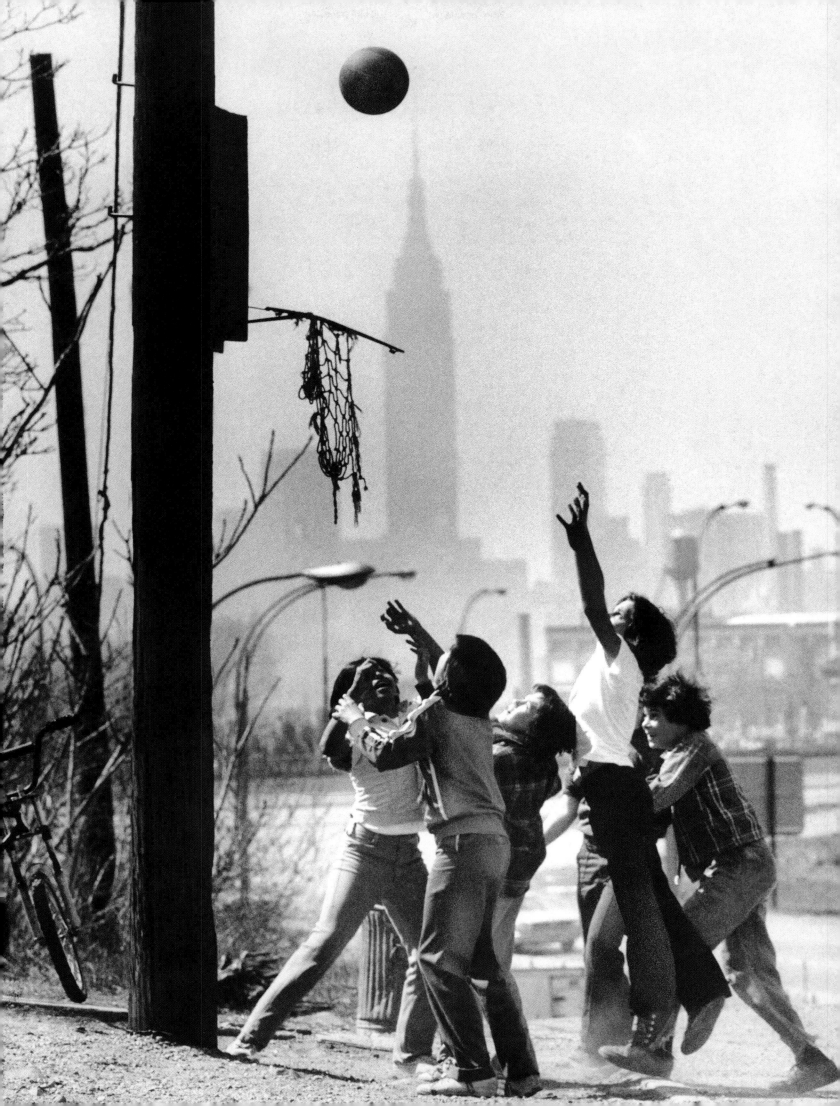

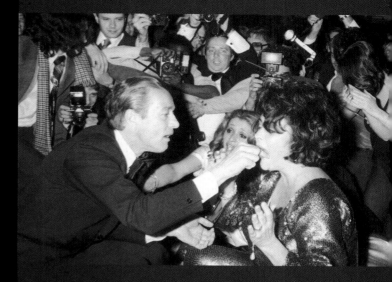

Richard Corkery pushes
through the throng of cele-
brants at Studio 54 to get a
shot of Halston feeding Liz
Taylor a slice of her birthday
cake in March 1978. **AP**

King Kong returns to the
Empire State Building in mid-
April, 1983, but this time the
famed giant ape is inflatable.
This eighty-four-foot-high,
3,000-pound creature, made
of vinyl-coated woven nylon
was a publicity stunt to cele-
brate the fiftieth anniversary
of Kong's debut in what
remains one of the best
monster movies ever made.
The makers spent a week
dealing with leaks and high
winds before they managed
to put it up on the night of
April 13 for a planned stay of
ten days. But this Kong didn't
have much better luck on his
last perch than the first one;
it remained fully inflated for
only one day before high
winds on April 15 put a
sixteen-foot rip in its right
shoulder—a fatal wound
for this kind of primate.
HARRY HAMBURG

Opposite:
A torrential downpour, with
winds gusting to fifty-five
miles per hour, pelts pop
singer Diana Ross during a
free outdoor concert in
Central Park, her "gift to
New York," on July 21, 1983.
The rain stopped the show
after only about forty-
minutes, but that couldn't
stop the former Motown
legend: Ross returned the
next night, drawing an esti-
mated 350,000 fans again.
RICHARD CORKERY

Overleaf:
Fire Engine 226 is frozen
in place after being soaked
all night long during the
wintertime battle to stop a
five-alarm fire in a vacant
landmark hotel in Brooklyn
Heights, February 1, 1980.
TOM MONASTER

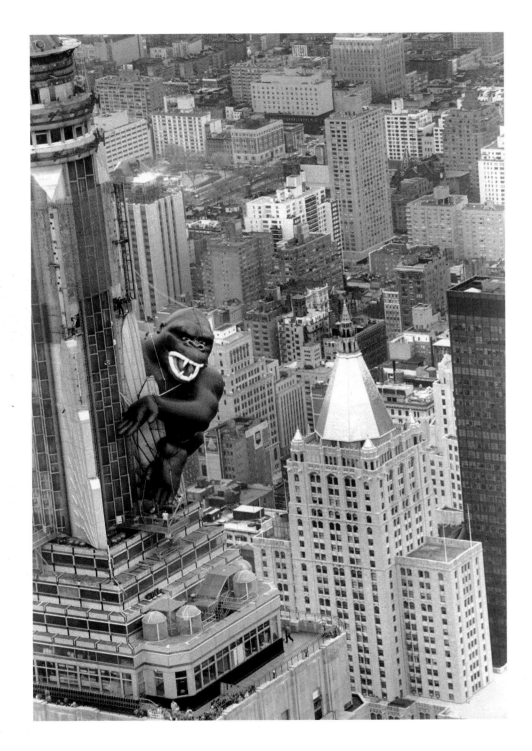

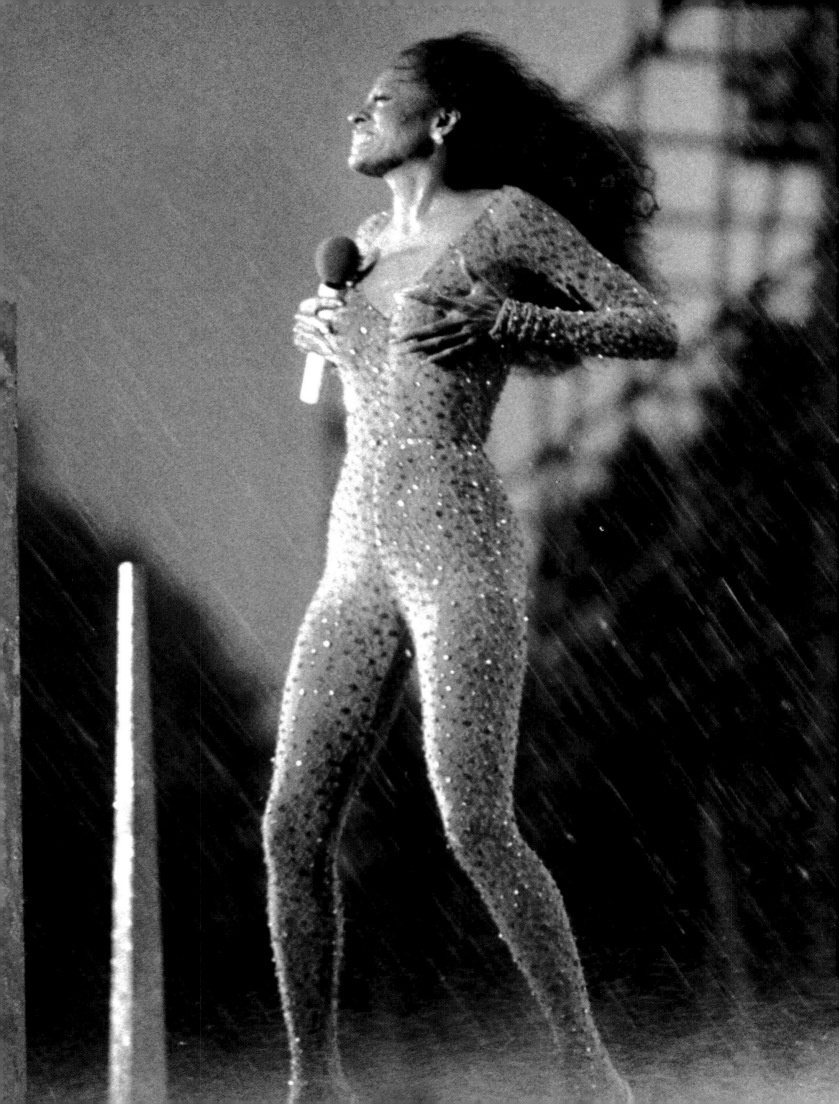

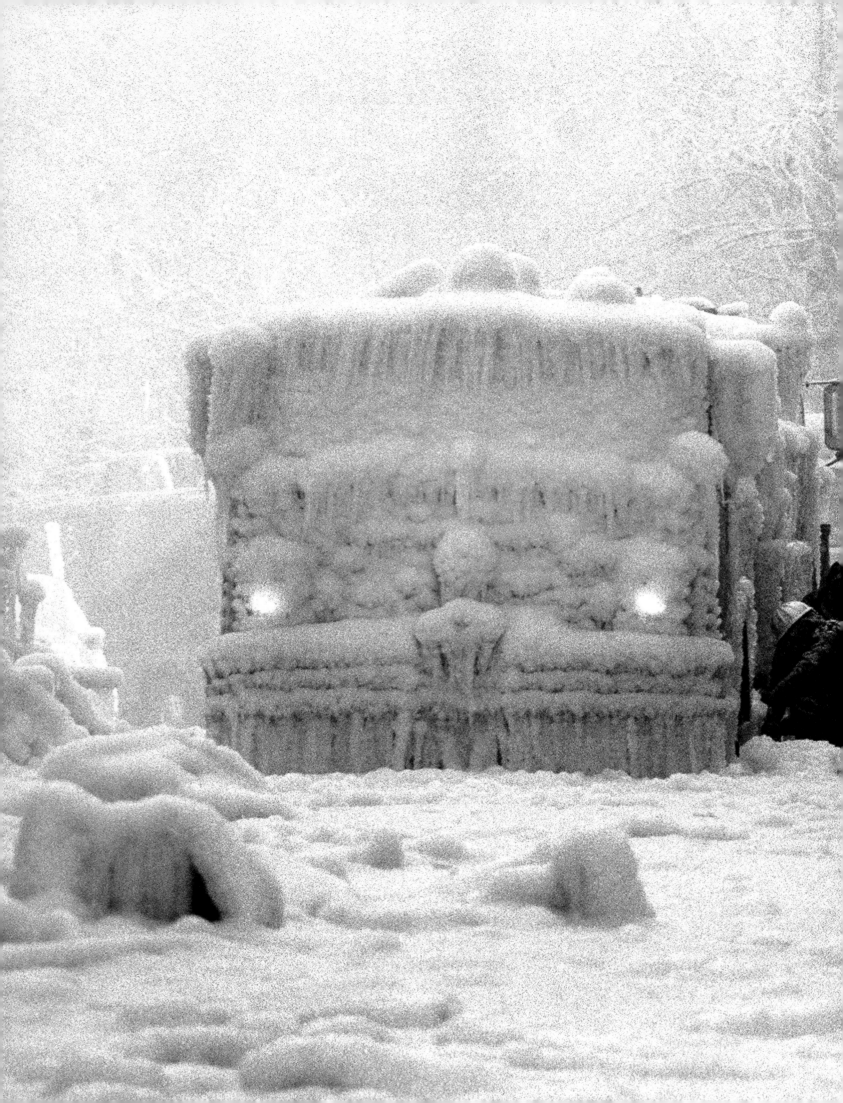

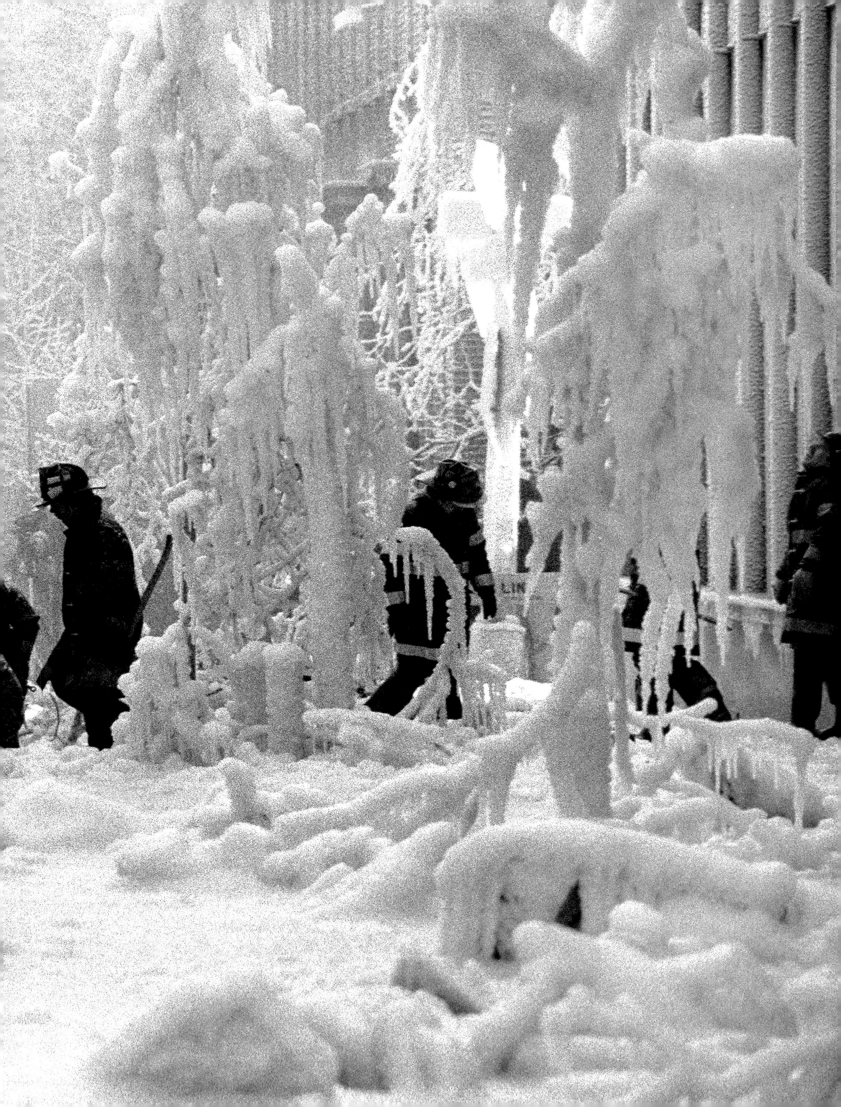

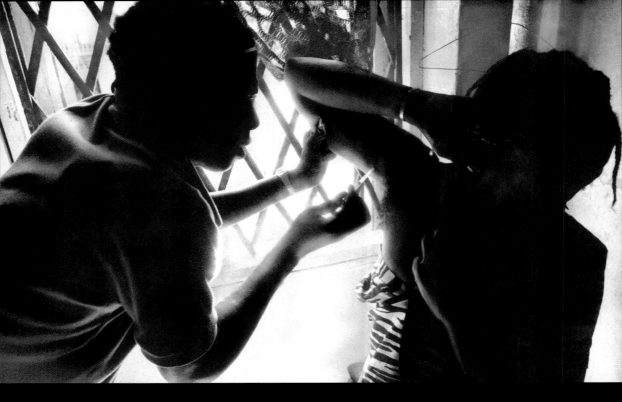

Above:

A professional "hitter" injects a drug addict with a speedball (a mixture of cocaine and usually heroin) for a small fee and part of the client's drugs, early August, 1984. New York City and then many other parts of the country were struck by an epidemic of hard drugs in the 1980s. Cocaine especially became the drug of choice in a variety of forms and among a wide range of users, from poor inner-city residents taking vials of "crack" to thrill-seeking celebrities and young urban professionals inhaling lines of powdered coke, often through large-denomination bills.
MEL FINKELSTEIN

Opposite:

Joseph Lawrence clings to a crucifix at his fourth-story window at 506 East Fifth Street in the East Village, mid-December, 1984. A fifty-year-old restaurant worker, Lawrence became despondent when he lost his job—unemployment remained high in many sectors despite the economic boom of the 1980s—and finally he began hurling flowerpots, garbage, candles, and other items out of the apartment. He also went out onto a fire escape and threatened to jump. After trying to reason with him for an hour and a half, some police distracted Lawrence while others rushed into the room and restrained him. He was taken to Bellevue Hospital for psychiatric evaluation.
MICHAEL LIPACK

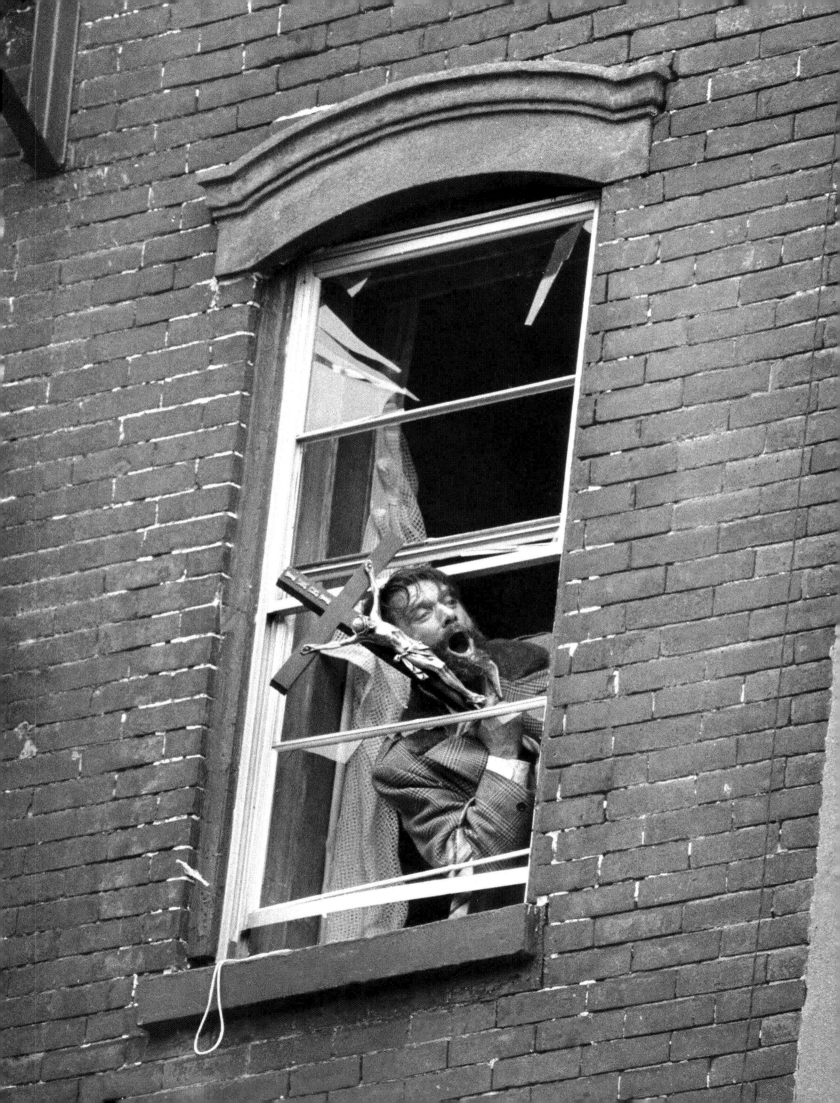

a capo of Mafia boss Paul Castellano and apparently about to be named his second-in-command, lies in the street after the gangland slaying of both men outside Sparks Steak House, 210 East 46th Street, at 5:30 P.M. on December 16, 1985. Castellano ran the Gambino family, the biggest Mafia group in the country, after Carlo Gambino's death in 1976, but now he was in the middle of one trial and facing more, federal prosecutors were trying to get him to turn on his colleagues, and the other mob bosses feared that the seventy-year-old Castellano might not be up to doing hard time in prison. After underboss Aniello Dellacroce died of cancer on December 2, his protégé— another Gambino capo named John Gotti—decided it was time to take care of both Castellano and the only other person in Gotti's way, Bilotti. The three hit men (with several backup shooters standing nearby, according to testimony much later by Gotti underboss turned informant Salvatore "Sammy the Bull" Gravano) pumped six bullets into each victim, then got away in a black limousine—and suddenly Gotti, the Dapper Don, became the nation's most powerful Mafia boss.
THOMAS MONASTER

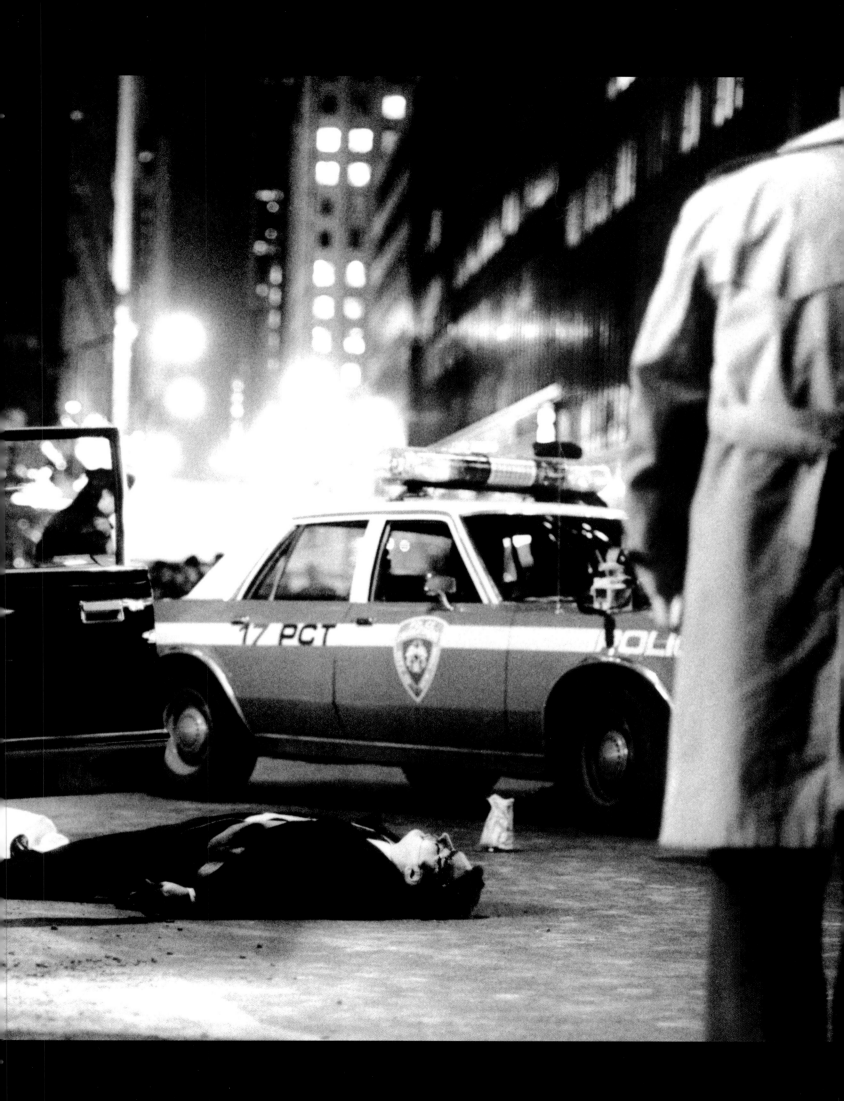

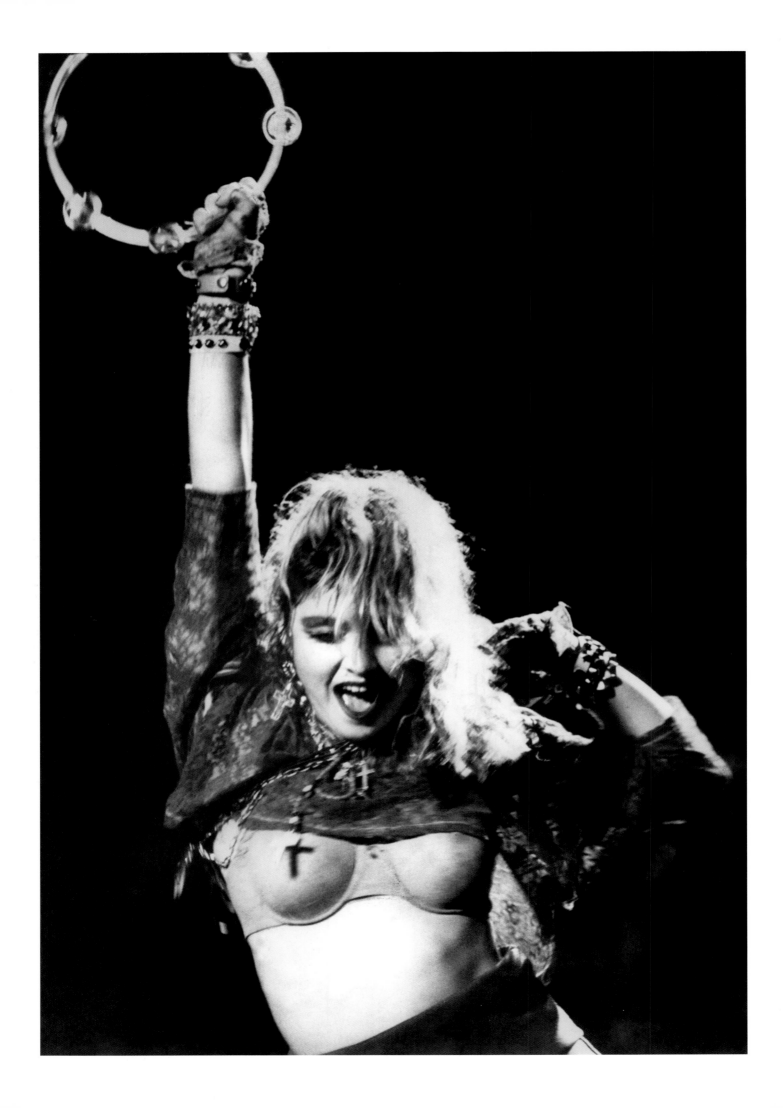

Opposite:
Madonna performs early hits such as "Like a Virgin" and "Material Girl" at Madison Square Garden and then attends a party for her, with about 5,000 people present, at the Palladium on June 11, 1985. Her theatrical live performances and the music videos shown on the increasingly popular cable channel MTV made her one of the decade's pop superstars.

JOHN ROCA

Left:
Caroline Kennedy, in a white organza silk Carolina Herrera gown decorated with shamrocks, signals photographers to shush as she enters Our Lady of Victory Church in Centerville, Massachusetts, for her wedding to Edwin A. Schlossberg on July 19, 1986. Senator Ted Kennedy gave her away, and the best man was John F. Kennedy Jr., at the very private ceremony, which was followed by a reception for 400 at the Kennedy family compound in Hyannis Port, about six miles away. No longer just the adorable young daughter of President John F. Kennedy (or a nineteen-year-old intern at the *Daily News*), Caroline Kennedy Schlossberg became an advocate of civil liberties and coauthor (with Ellen Alderman) of two books on the Bill of Rights and the right to privacy—as well as a mother of two little girls and a son named John.

JOHN ROCA

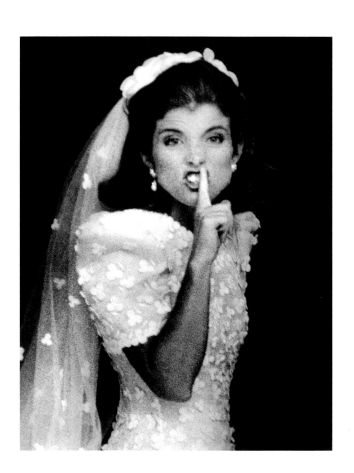

Nelson Pena, ten, takes a whack at a ball during a pickup game in a schoolyard on East Houston Street, late July, 1986. Behind Pena is a mural warning kids about the evils of crack, the deadly form of cocaine that became an urban plague in the mid-1980s.
KEITH TORRIE

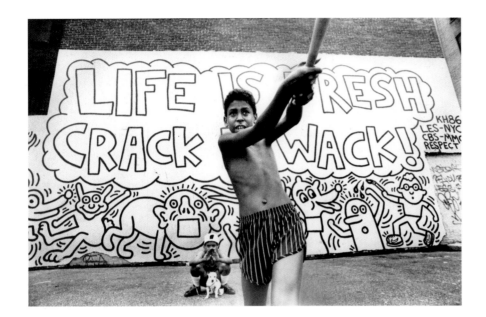

Detectives examine the crime scene in Central Park, behind the Metropolitan Museum of Art, where the body of eighteen-year-old Jennifer Levin was found after her strangulation in the predawn hours of August 26, 1986. Nineteen-year-old Robert Chambers, who had just met Levin that night in Dorrian's Red Hand (an Upper East Side bar popular with an upscale and sometimes underage clientele), initially claimed that she died accidentally while the two were engaged in "rough sex." In March 1988, during jury deliberations, he suddenly pleaded guilty to manslaughter and was given a five-to-fifteen-year sentence for what the media called the "preppie murder," because the killer and his victim had each attended a prestigious private school.

DAN GODFREY

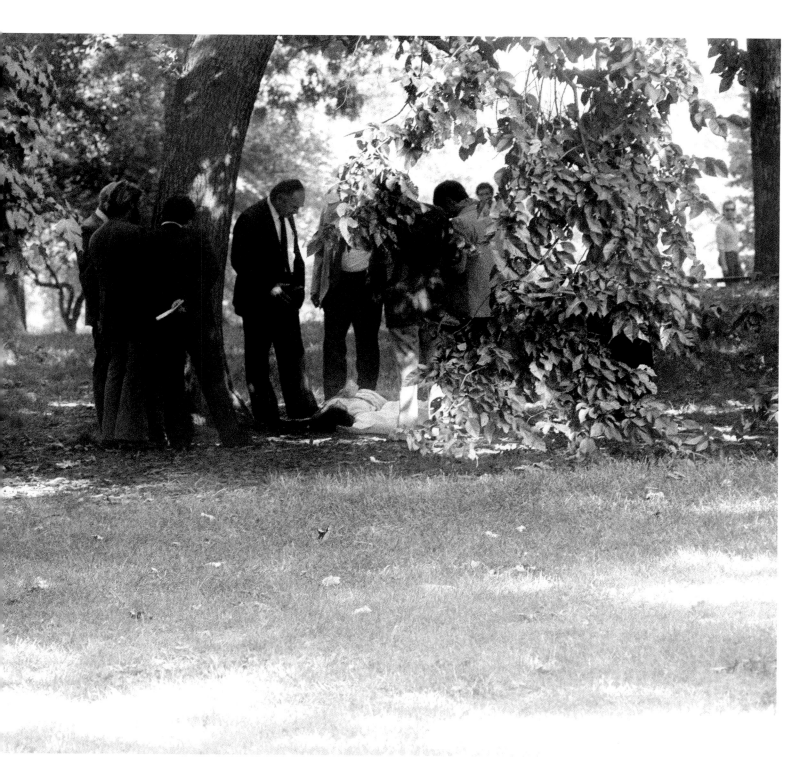

Upon the roof of a building on East 39th Street, models (left to right) Michelle Mayfield, Feline Terrell, Regine Vavasseur, and Eileen Baker get an early start on their tans during the first day of Memorial Day weekend, 1984.
ROBERT ROSAMILIO

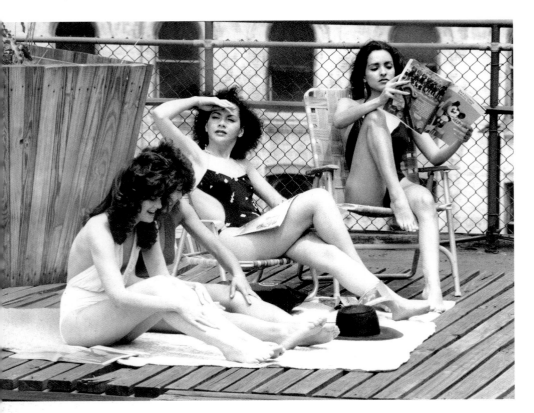

Right:
Jesse Orosco, the star closer and a postseason hero for the New York Mets, celebrates as Marty Barrett strikes out on a 2–2 fastball up and away, giving the Mets an 8–5 win over the Boston Red Sox in the seventh game of the World Series, October 27, 1986. That made the Mets the world champs for the first time since 1969. Orosco himself had three wins in the National League Championship Series and saved the fourth and seventh games of the Series. The triumph was short-lived, however, for both player and team: Orosco had a poor 1987 season and then was traded to the Los Angeles Dodgers, and the Mets did not get into a World Series again until they lost to the Yankees in 2000.
JOHN ROCA

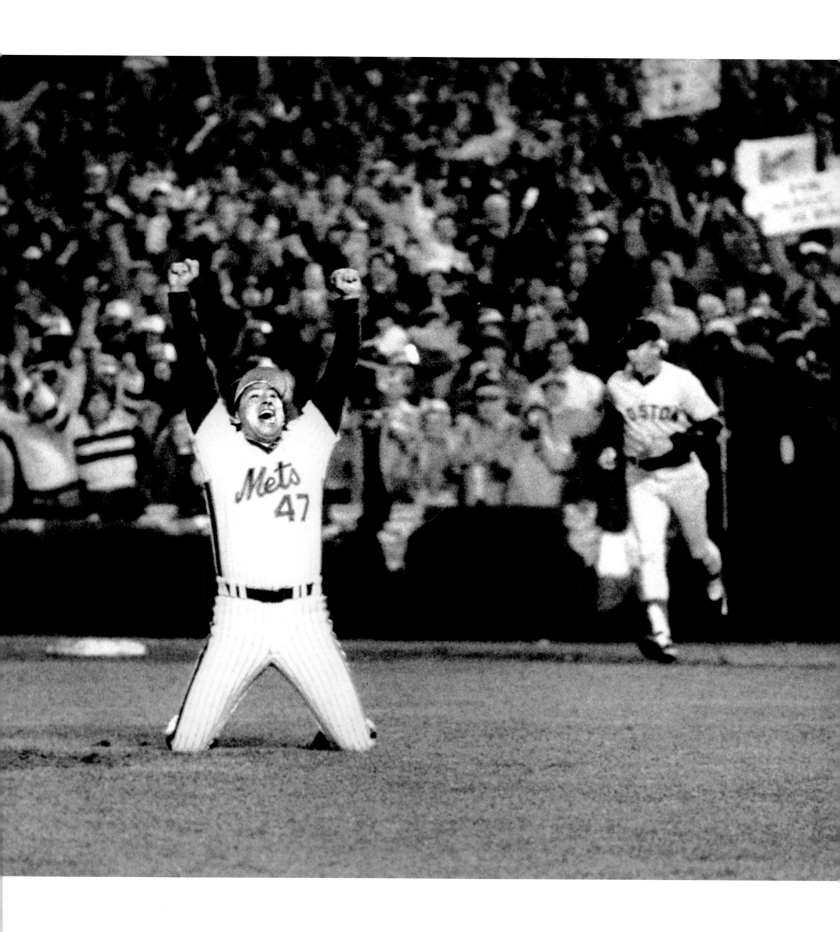

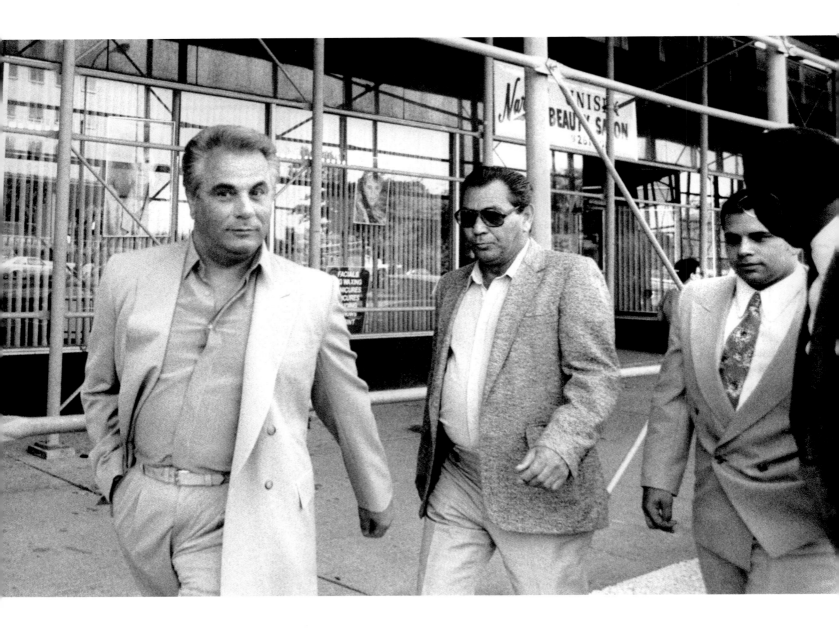

John Gotti (left) leaves Queens Criminal Court with his son, John Jr. (second from right), on June 5, 1987, after the latter's acquittal on a charge of assaulting an off-duty police officer in a restaurant brawl in 1985 (even though the officer identified the younger Gotti as being one of his assailants). The fashionably dressed Dapper Don became head of the Gambino crime family in 1985, after the murder of Paul Castellano, but elements in the media portrayed him as a roguish, almost amiable celebrity—aided, in part, by three straight acquittals in the late 1980s on assault and racketeering charges. He seemed untouchable—until he was convicted in 1992 and given a life sentence, a watershed change in the fortunes of the Mafia. **JOHN PEDIN**

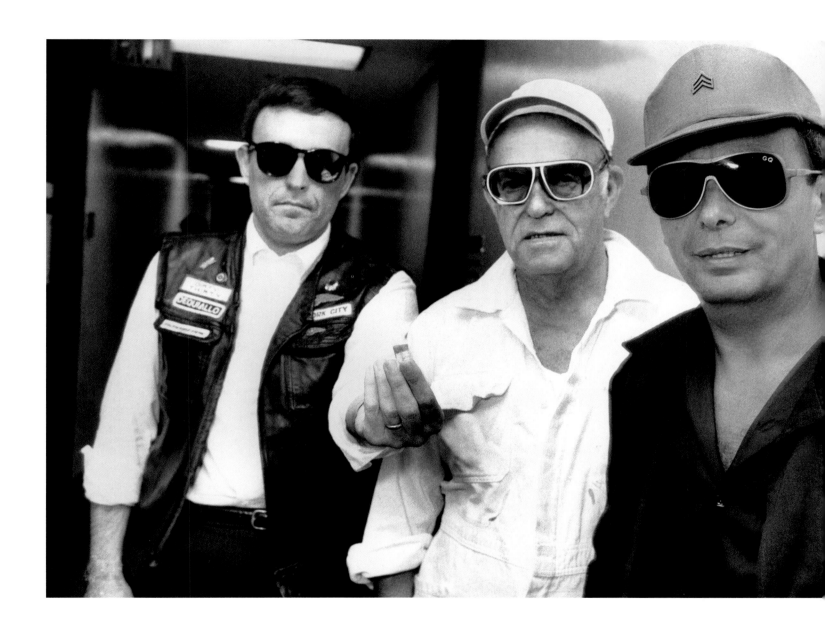

Behind the sunglasses and the grungy clothes, that's (left to right) U.S. Attorney Rudolph Giuliani, U.S. Parole Commission chairman Benjamin Bear, and Senator Alfonse D'Amato with vials of crack they easily purchased on West 160th Street, around Broadway and Amsterdam Avenue, during their undercover excursion into the drug-infested Washington Heights section of Manhattan, July 9, 1986. Seven years later, Giuliani rode his reputation as a crime fighter all the way to City Hall, where he began his two terms as an uncompromising anti-crime mayor. **MISHA ERWITT**

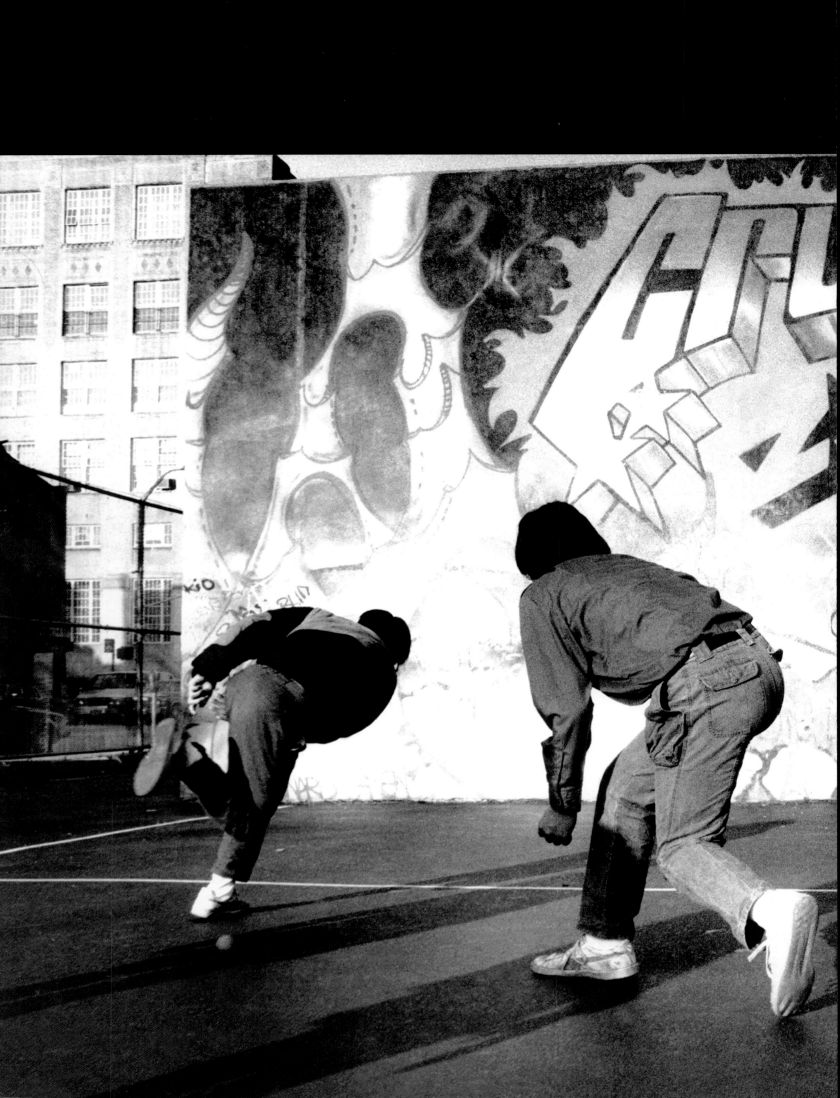

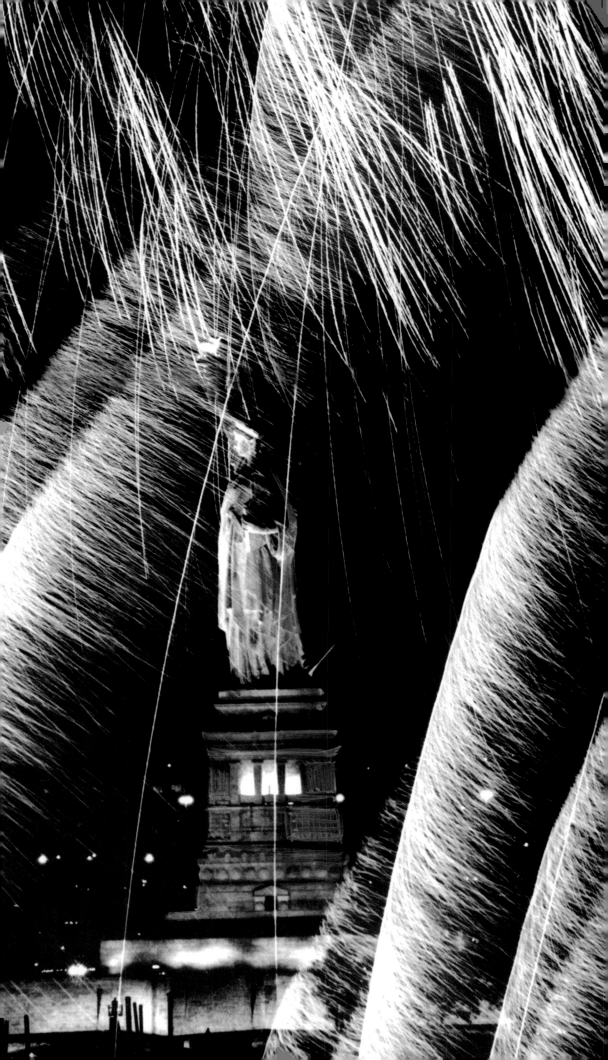

Opposite:
Fireworks explode around the Statue of Liberty during the Liberty Weekend party, July 3–6, 1986, to mark the statue's centennial year as a beacon of hope and welcome to people from all over the world. After two years of restoration, the scaffolding around the statue was removed and President Ronald Reagan lit the torch again.
ROBERT ROSAMILIO

Below:
Dr. Joyce Wallace (left) gets together with yet another prostitute in mid-February, 1988—but with good cause. During the 1980s she roamed city streets in her medical van to test prostitutes and their clients for the AIDS virus and counsel them; in fact, she even paid street-walkers the going rate of $20 for their time. Dr. Wallace fought for the state Testing Confidentiality Act, passed in 1988, and two years later the state awarded her Foundation for Research on Sexually Transmitted Diseases a quarter-million-dollar grant. In 1994, however-er, she ran into unyielding "not in my backyard," or NIMBY, resistance from neighbors when she sought to convert her West 12th Street town house into a rehabilitation residence for former prostitutes.
NICOLE BENGIVENO

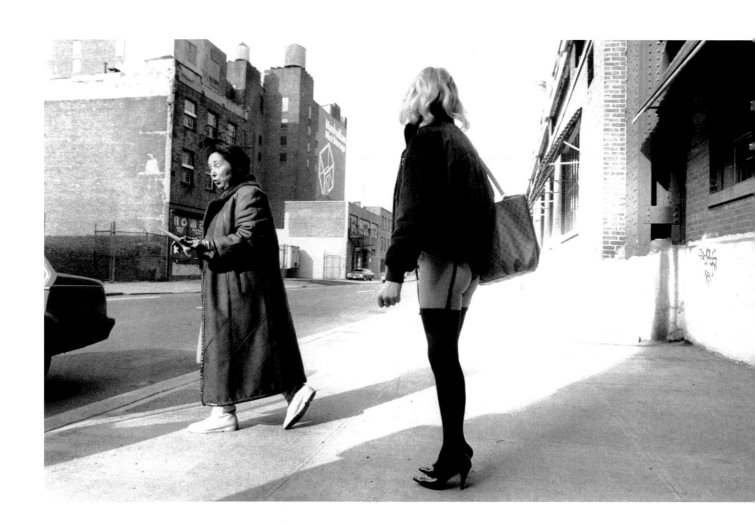

Edward Pitt makes a face for photographers after the sixteen-year-old's arrest for a wilding incident in Central Park on October 31, 1989. The headline was "Horroween"—all over the city, groups of youths took trick-or-treating to a grim new level as they rampaged through numerous supermarkets, department stores, restaurants, and other businesses while robbing, beating, or slashing several passersby. At least sixty-seven people were arrested on charges of robbery, assault, and other acts of mayhem. Such incidents of "wilding" soured Central Park's reputation during the 1980s and early 1990s.
CARMINE DONOFRIO

Jack Nicholson enjoys the spotlight at Sardi's for the New York Film Critics Awards, January 24, 1988. The irrepressible Nicholson had reason to grin: he won the award as Best Actor for two roles, in *Ironweed* and *The Witches of Eastwick*. Awards, or at least nomina- tions, were already common- place for him. By the 1990s, he was probably one of the few celebrities (Michael Jordan is another) who could be clearly referred to, at least in many settings, by just a very ordinary first name. **RICHARD CORKERY**

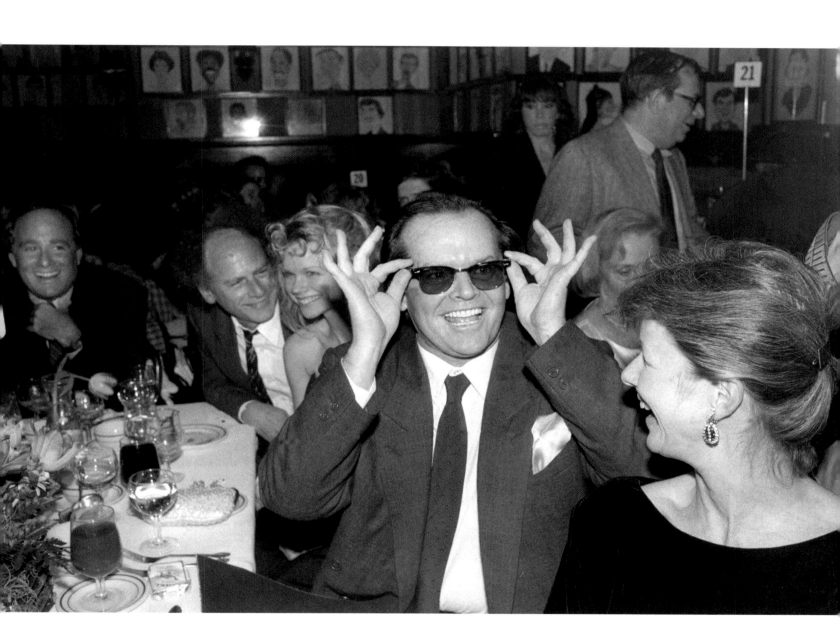

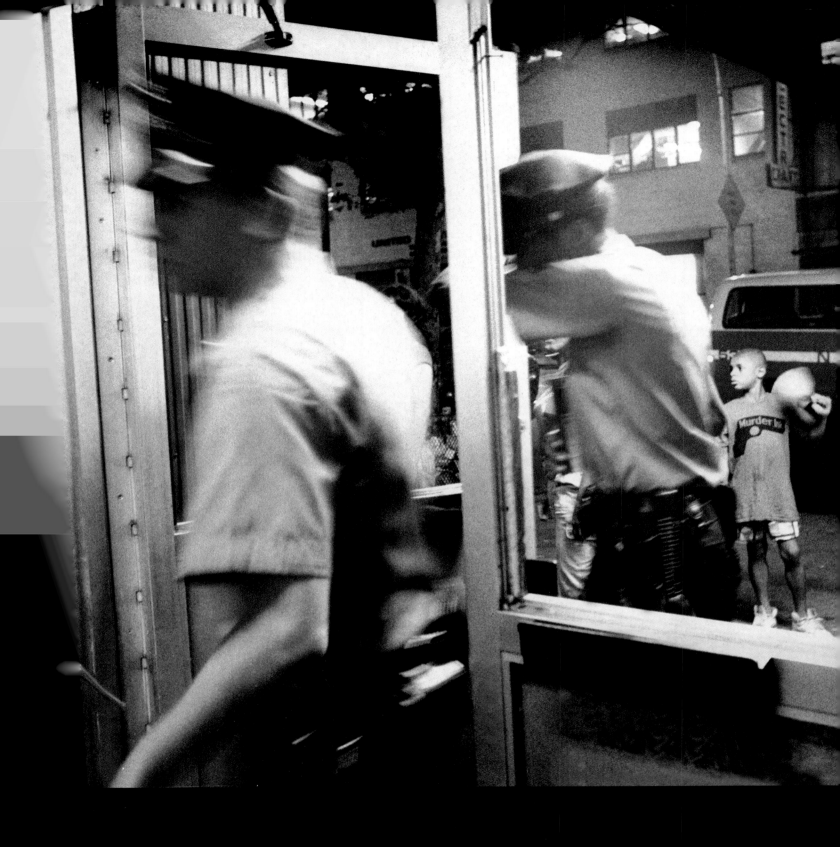

...h into the Hotel ...351 West 42nd ...arly September, ...ommon occurrence ...rious welfare ...h the *Daily News* ...called the "shame ...following a series ...rrors. More than ...were placed in ...ne-story wel...

fare hotel, one of sixty-three in New York City, where the city paid up to $3,100 per month to house the homeless in vermin-infested rooms among drug dealers, muggers, prostitutes, and rapists. The Holland, which police called the hub of crack cocaine activity in the Times Square area, had been cited

for 2,600 building and safety code violations; however, the owner, alleged international swindler Rajendra Sethia, and his brother-in-law, hotel manager Ranjit Ghura, repeatedly defied court orders to clean up the place, while pocketing millions of dollars in profits. They finally declared bankruptcy in 1988

and the Holland was closed. Even the aftermath was ugly: the city purchased the building for $13 million to be a shelter for 500 people, but it gave up after spending another $12 million on renovations, and it sold the place to a nonprofit group for $2 plus a loan of $10 million.

NICOLE BENGIVENO

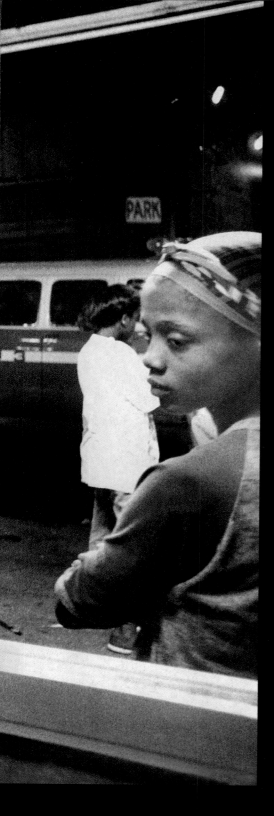

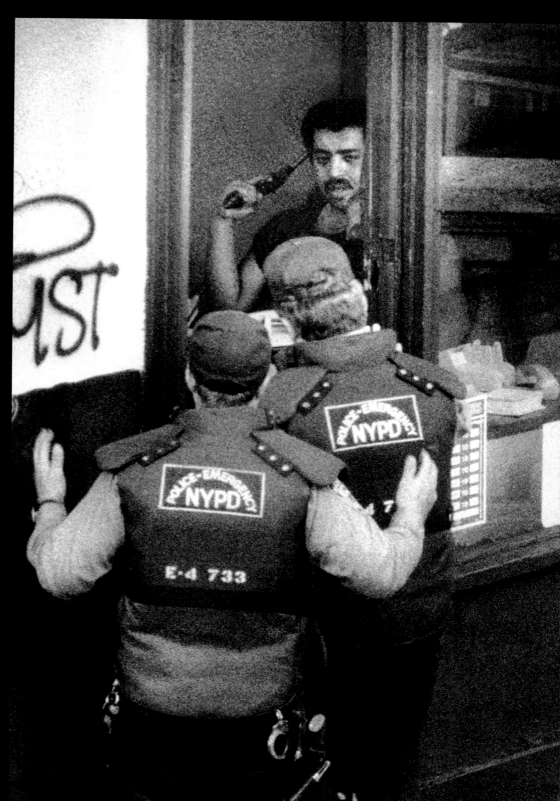

Charles Betancourt holds a gun to his head as police negotiators try to persuade him to surrender at the U.S. Army recruiting station at Fordham Road and the Grand Concourse in the Bronx on October 5, 1988. He finally did so after a four-hour standoff, releasing his hostage, Sergeant William Rizzara, unharmed. The twenty-eight-year-old Betancourt went to the recruiting station and inquired about enlisting, but when he was asked if he had a high-school diploma, he pulled out the gun instead. After the hostage situation ended, he was taken to Bellevue Hospital for psychiatric evaluation. **DAVID HANDSCHUH**

Below:

José Ramos sits outside his cell in the AIDS ward at Riker's Island, late October, 1987. What began at the start of the decade as a mysterious and deadly condition that predominantly seemed to affect male homosexuals had become a full-scale epidemic by the late 1980s, especially among intravenous drug users as well as gay men. The nature of the groups most affected resulted in widespread virulent prejudice, callous neglect, and slow headway in finding treatments. Many young people on the bottom rungs of the social ladder—such as inmates—never had a chance.

MONICA ALMEIDA

Opposite:

John F. Kennedy Jr. waits for the subway on his first day as assistant district attorney, August 21, 1989. Although he was accompanied by a mob of reporters as well as two bodyguards on his trek to work, the city's most glamorous figure and, until 1996, most eligible bachelor tried to live like an ordinary New Yorker as much as possible: hanging out in Central Park, walking his dog, bicycling around town. Before long he had turned his attention not to political office, as was generally expected of the chief heir to the Kennedy mystique, but to the more lighthearted look at politics of his magazine creation, *George*. But once again, a Kennedy did not live long enough to "comb grey hair"; the small plane he was piloting to a family wedding went down—with his wife, Carolyn Bessette Kennedy, and her sister, Lauren Bessette, also on board—off Martha's Vineyard, Massachusetts, on July 16, 1999. He was thirty-eight years old.

WILLIAM LAFORCE

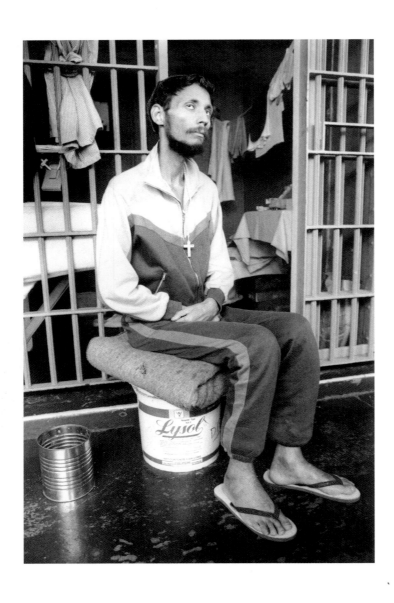

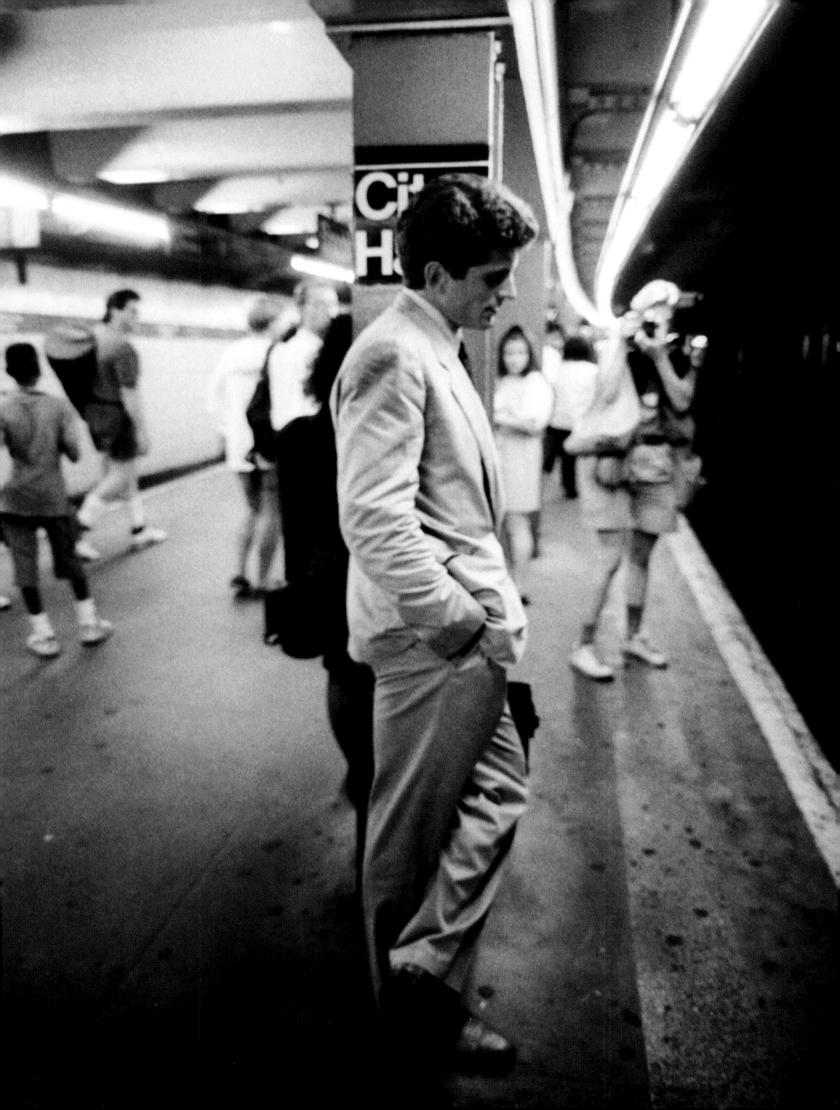

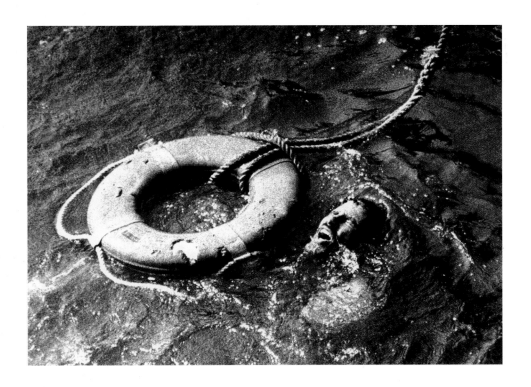

Above:
An unidentified man struggles for air after jumping from the bridge at West 225th Street into the Harlem River on September 8, 1989. Police from Harbor Launch 18 rescued him.
DAVID HANDSCHUH

Right:
The Reverend Al Sharpton is arrested during a demonstration at LaGuardia Airport against racism, late January, 1987. The outspoken civil rights activist—the first African-American to run for the New York State Senate, in 1978—gained prominence in the wake of the Howard Beach incident on December 20, 1986, when young whites attacked three black men who had stopped at night in that white neighborhood in southern Queens. Sharpton's persistent protests, sometimes intemperate comments, and flamboyant self-promotion over the years brought the former "Wonder Boy Preacher" (who is said to have begun preaching at the age of four and was ordained at ten) widespread support in the African-American community.
JOHN ROCA

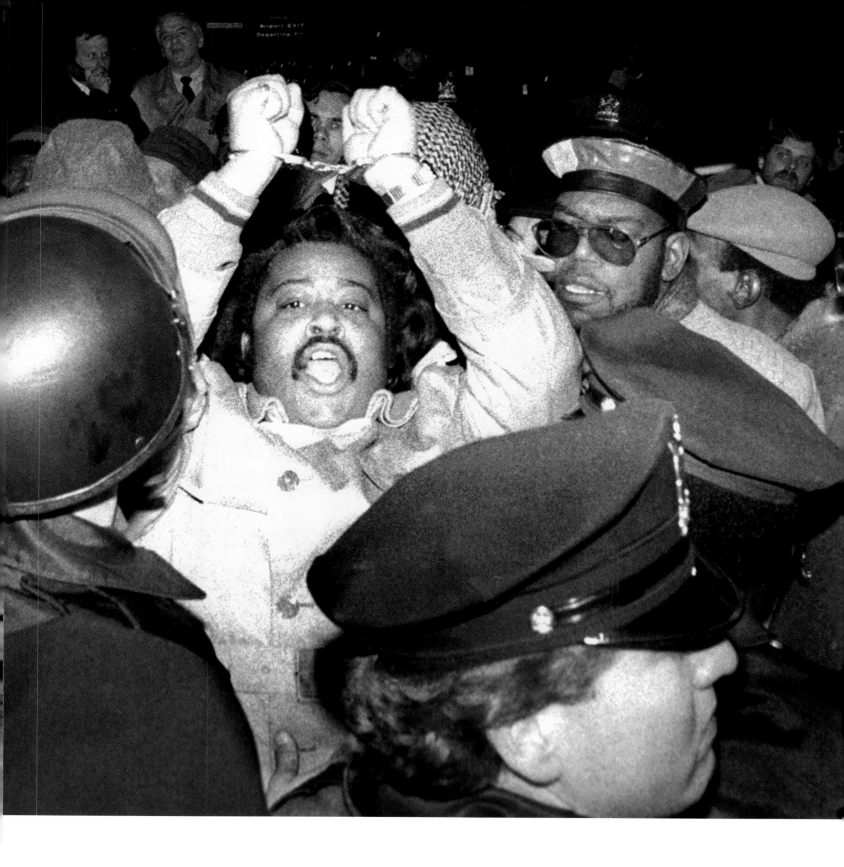

THE NINETIES

Photography in the digital age: Misha Erwitt does a double take, shooting a self-portrait with a digital camera from a video screen in the windows of B&H Photo, New York.
MISHA ERWITT

A Hasidic Jew watches a
car burning during the third
night of rioting in the Crown
Heights section of Brooklyn,
in August, 1991. Long-
standing friction between
the Lubavitch and African-
American communities exist-
ing side by side in Crown
Heights exploded after a car
driven by one of the mem-
bers of the ultra-Orthodox
group struck and killed
seven-year-old Gavin Cato
and injured his young cousin.
Police agreed it was an
accident, but as angry
protest quickly flared into
violence, a teenager in the
crowd fatally stabbed Yankel
Rosenbaum, a twenty-nine-
year-old Hasidic scholar
from Australia. (Much later,
Lemerick Nelson Jr. was
arrested and, after one
acquittal, eventually tried
and convicted in federal
court.) Others set fires as
terrified Jewish residents
sought help from the authori-
ties, but police waited it out
in hopes of not inflaming the
situation further. Many Jews
likened the extensive rioting
to the officially sanctioned
anti-Semitic pogroms in
Russia a century earlier, and
their decision not to vote
again for Mayor David
Dinkins, an African-American
whom they saw as timid
about confronting his own
people, was widely consid-
ered a major factor in the
mayor's defeat by Republican
challenger Rudolph Giuliani
in the 1993 election.
JOHN ROCA

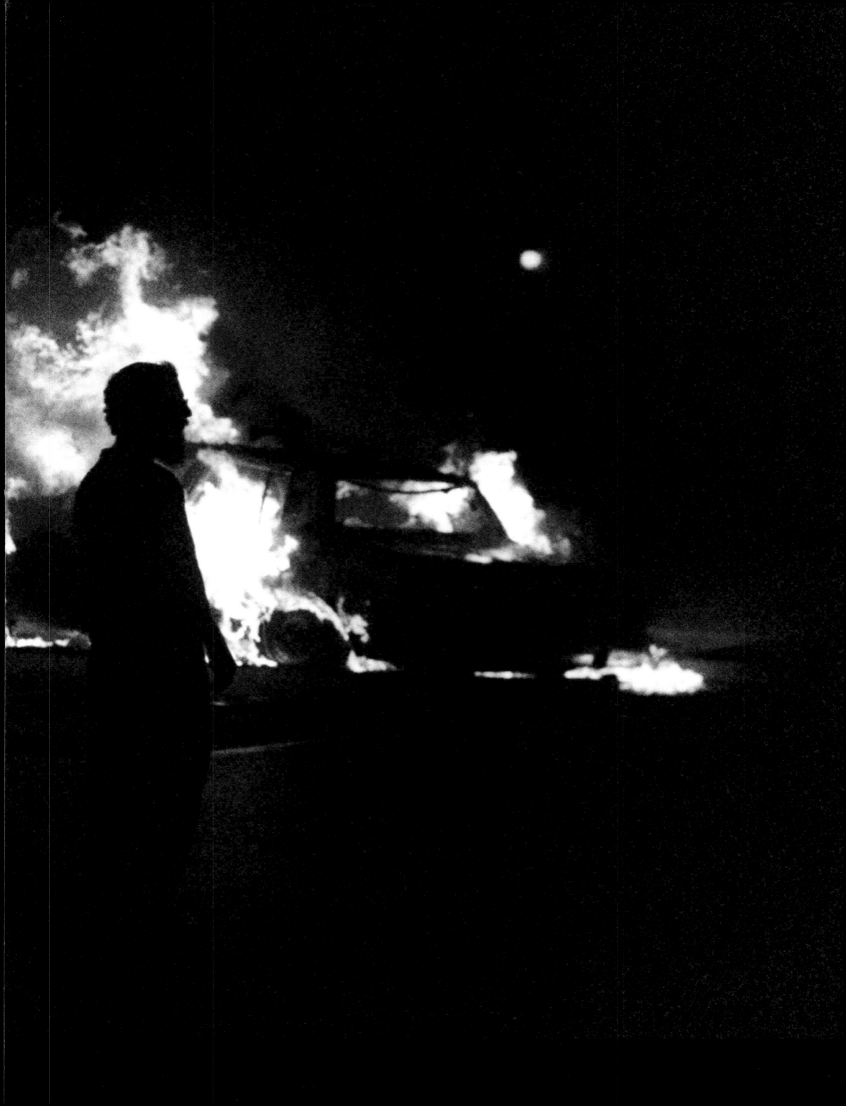

A distraught woman is helped from the scene of the World Trade Center bombing on February 26, 1993. When Islamic militants set off explosives in a rental truck driven into an underground parking garage in one of the Twin Towers, the blast killed six people, injured more than 1,000 (mostly from smoke inhalation during the evacuation), and caused perhaps $500 million in damage. It could have been much worse, however: the terrorists, unaware of the building's structural strengths, had hoped to topple one of the 110-story buildings, the tallest man-made structures in New York City and a symbol of American financial power, into the other while 50,000 people were inside the complex. Thanks in part to traced fragments of the blown-up truck, terrorist mastermind Ramzi Yousef (seized two years later in Pakistan), inspirational leader Sheik Omar Abdel Rahman, and several followers were eventually arrested, convicted, and given long prison sentences.

KEN MURRAY

Opposite:
Police officers rescue a would-be suicide atop Grand Central Station on July 3, 1990. The unidentified teenage girl was taken to Bellevue Hospital for observation.

DAVID HANDSCHUH

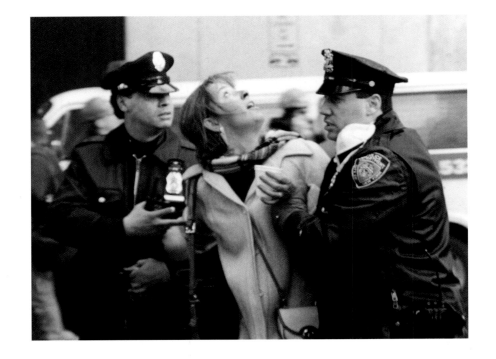

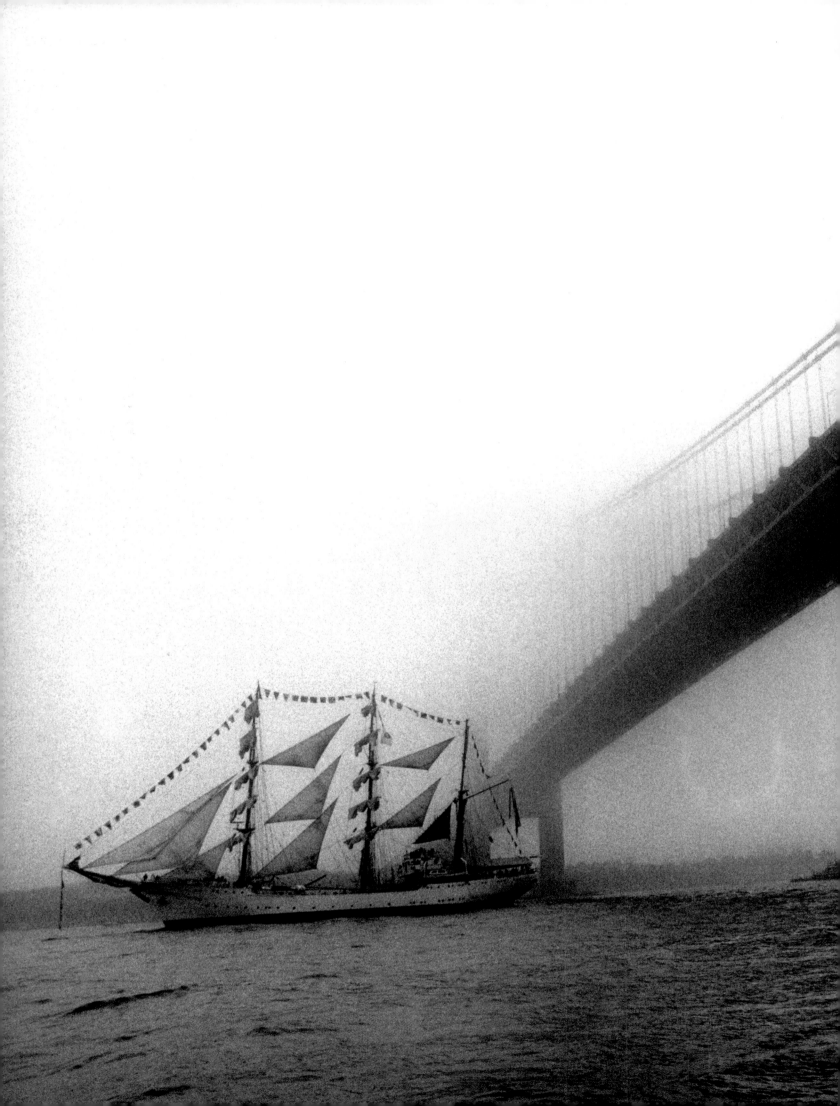

Left:

The good news for this unlucky man is that he was successfully freed after being stuck upside down for seven hours in an air shaft at 114 West 125th Street on February 4, 1990. The bad news is that he was charged with attempted burglary.

DAVID HANDSCHUH

Right:

Detectives examine the bodies of three reputed members of the Vietnamese street gang Born to Kill, who were found murdered in a downtown Manhattan parking lot in the early-morning hours of October 15, 1990. Considered the most violent Vietnamese gang in the United States, Born to Kill was most active from 1989 to 1991, taking part in robberies, extortion, and murder as well as turf wars, especially against a Queens-based Chinese gang called the Green Dragons. Four Chinese were later charged with these murders. A concerted law-enforcement effort against Born to Kill culminated in several arrests, and its founder and leader, David Thai, was given a life sentence in October 1992.

JACK SMITH

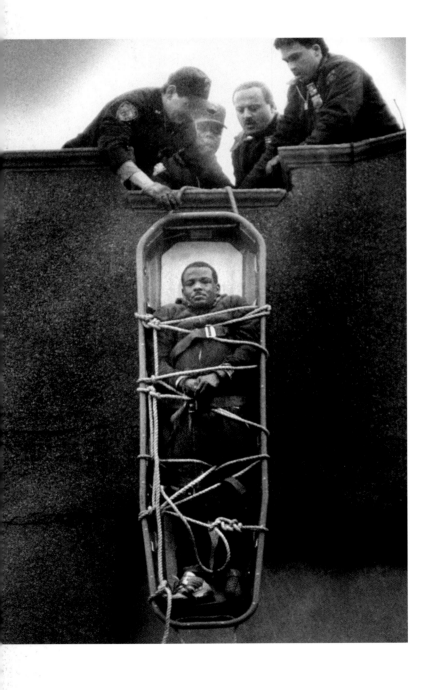

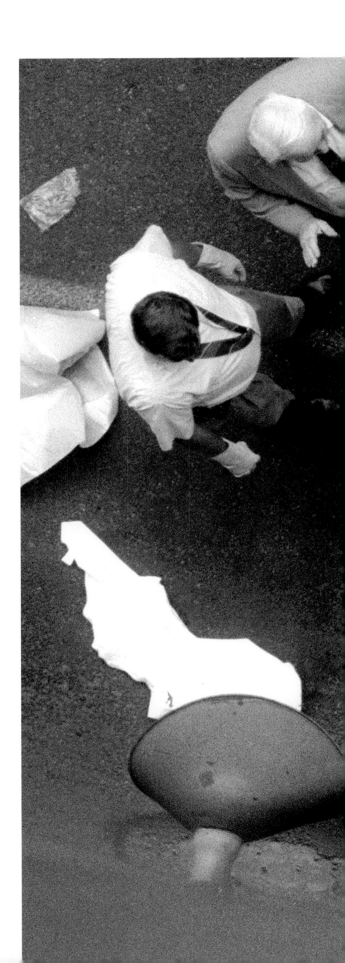

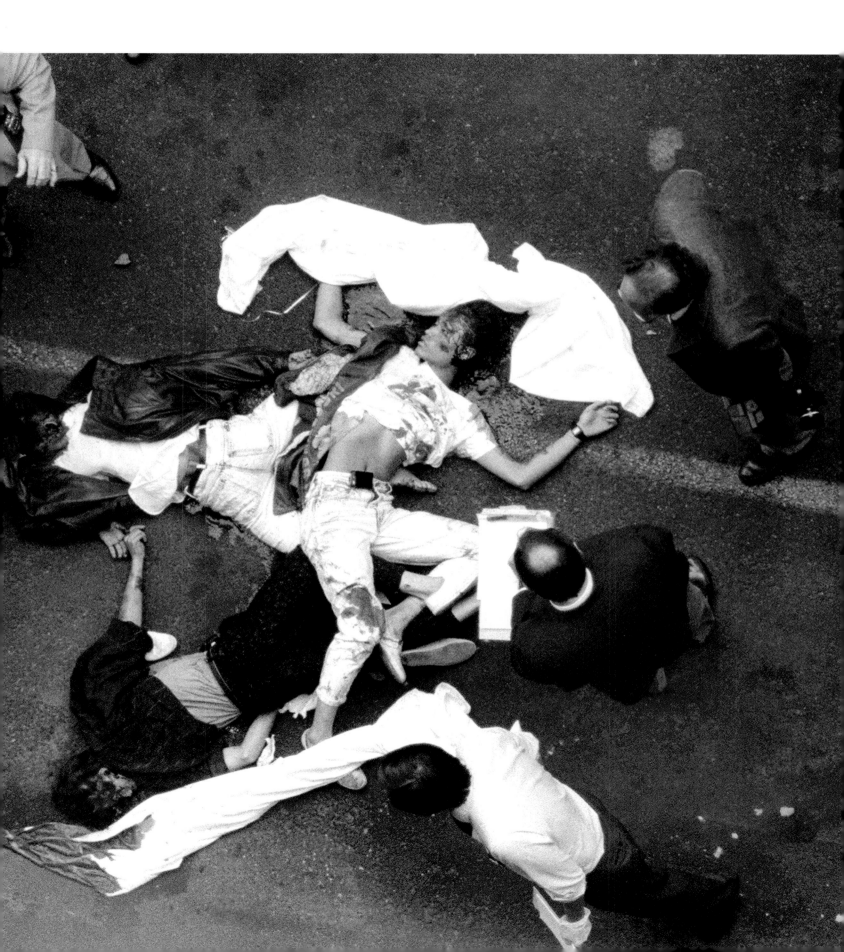

Actor Johnny Depp and supermodel Kate Moss, his girlfriend of the moment, sit together at the thirty-eighth birthday party thrown by Depp for fellow iconoclastic actor Mickey Rourke at Metronome in late September, 1994. About 3,000 people showed up at the club. The highly paid Moss gained fame—and drew criticism—for the anorexic look that she and other models cultivated, and made voguish among adolescent female admirers. Many of those same girls decorated their bedroom walls with posters of Depp, who at this point (just a week after getting in the news for trashing his hotel room) had barely begun a very eclectic, critically acclaimed career in largely out-of-the-mainstream films such as *Edward Scissorhands* and *What's Eating Gilbert Grape*. **RICHARD CORKERY**

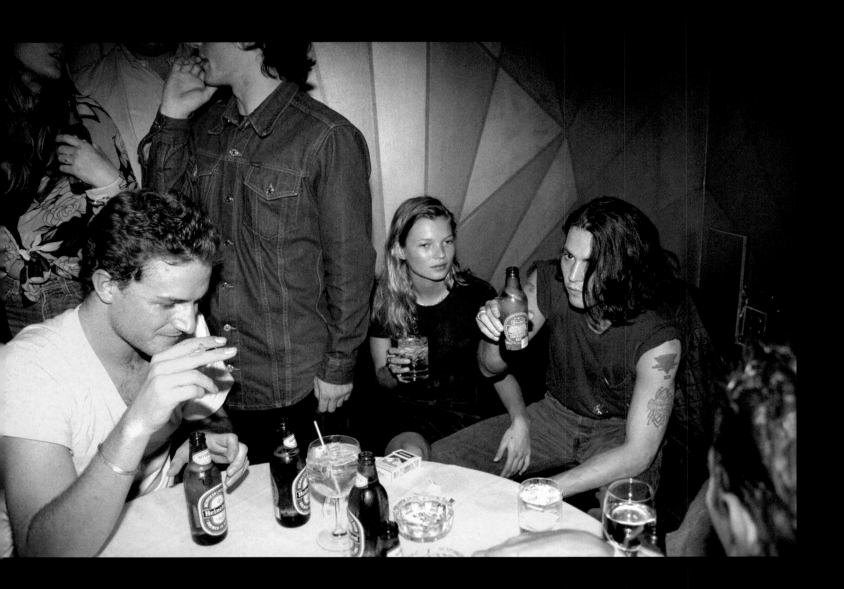

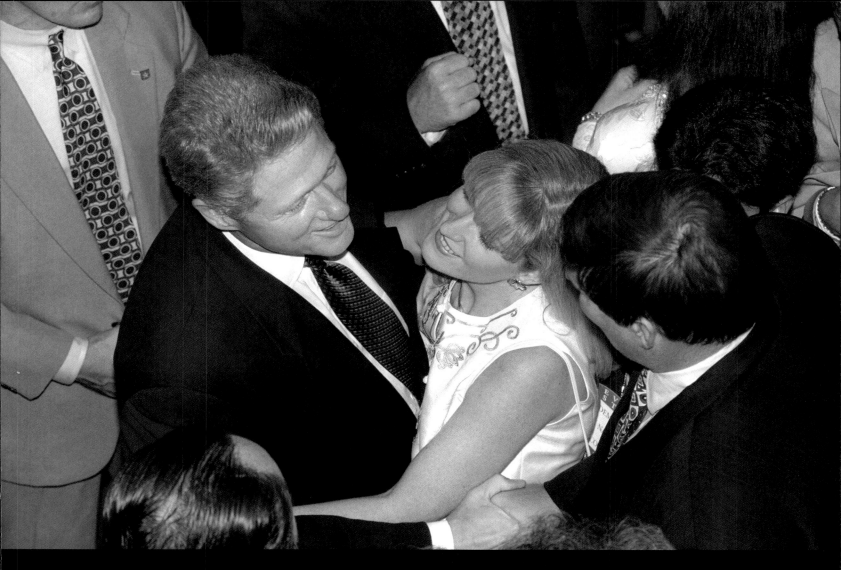

President Bill Clinton greets admirers after a reelection-year fund-raising speech at the Waldorf-Astoria Hotel on June 24, 1996. Then he rushed off to another event at the Plaza. In all, he raised $3 million for the Democratic Party that night. New Yorkers ended up giving Clinton nearly twice as many votes as Republican Bob Dole (who was also campaigning in the city that day)—and nearly double Clinton's 1992 margin of 1.1 million votes over President George Bush. New Yorkers' love affair with the Clintons continued in 2000, when Hillary Rodham Clinton easily defeated her Republican opponent, New York–born Congressman Rick Lazio, and became the first wife of a sitting president to be elected to the U.S. Senate.

ANDREW SAVULICH

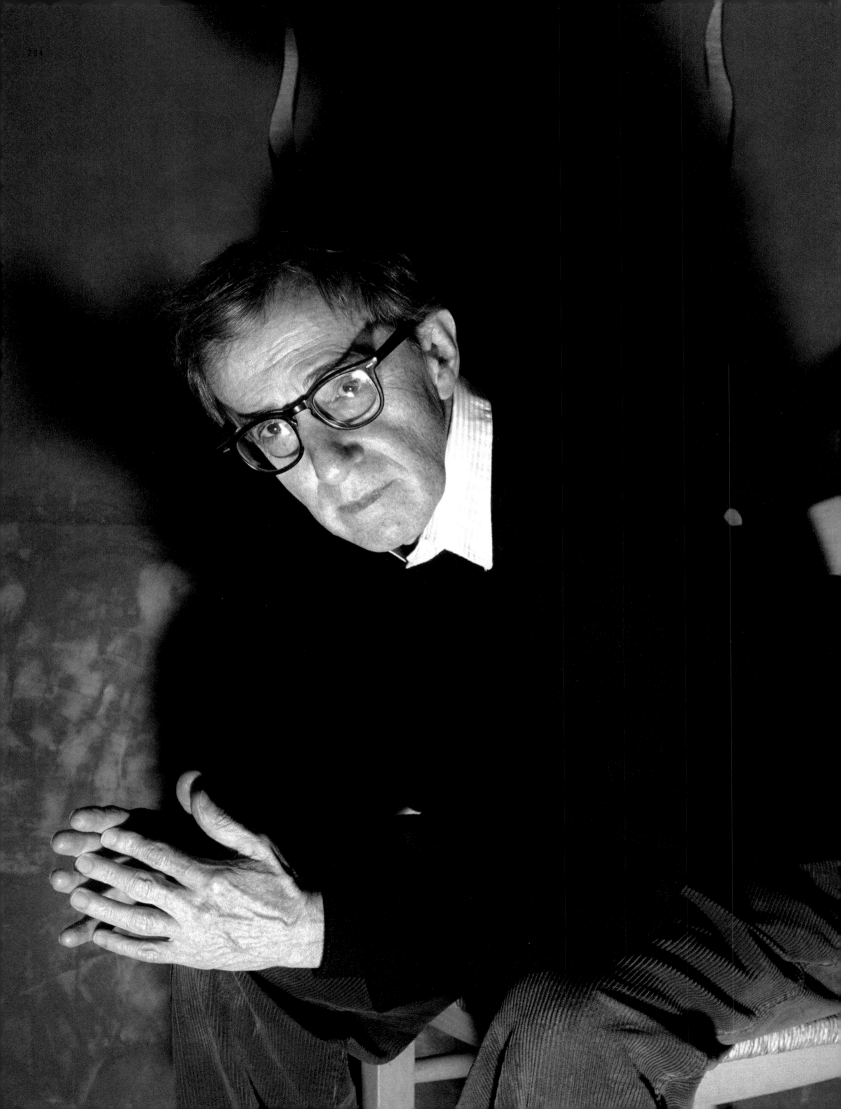

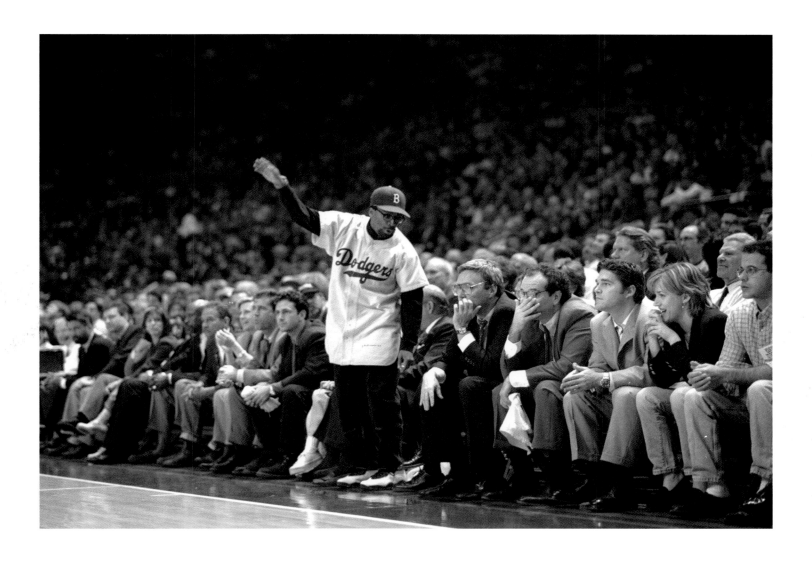

Opposite:

Woody Allen, the quintessen-
tial New Yorker—born
Allen Stewart Konigsberg in
Brooklyn; New York Uni-
versity dropout; creator of
films that have basically
defined the New York
sensibility for the rest of
the nation—photographed
in late September, 1997.
HOWARD SIMMONS

Above:

Fervent New York Knicks fan
Spike Lee—the noted film-
maker, who sharply depicts
black urban life when the
basketball team is not play-
ing—presides from his usual
courtside station during the
second game of a playoff
series against the Indiana
Pacers, at Madison Square
Garden on May 9, 1995.
Throughout the game, Lee
used choking gestures
to taunt the Pacers' Reggie
Miller, who had single-
handedly demolished the
Knicks in the last eighteen
seconds of the first game
and then insulted the New
York team. This time the
Knicks won, 96–77, but they
couldn't make it to the finals
as they had in 1994.
GERALD HERBERT

Right fielder Paul O'Neill tops the Yankee pileup at the end of game six of the 1996 World Series, on October 26. The 3–2 win over the Atlanta Braves gave the Yankees their twenty-third world championship—and their first since 1978. Their traditional ticker-tape parade, to be repeated three more times in the next four years, followed three days later.

LINDA CATAFFO

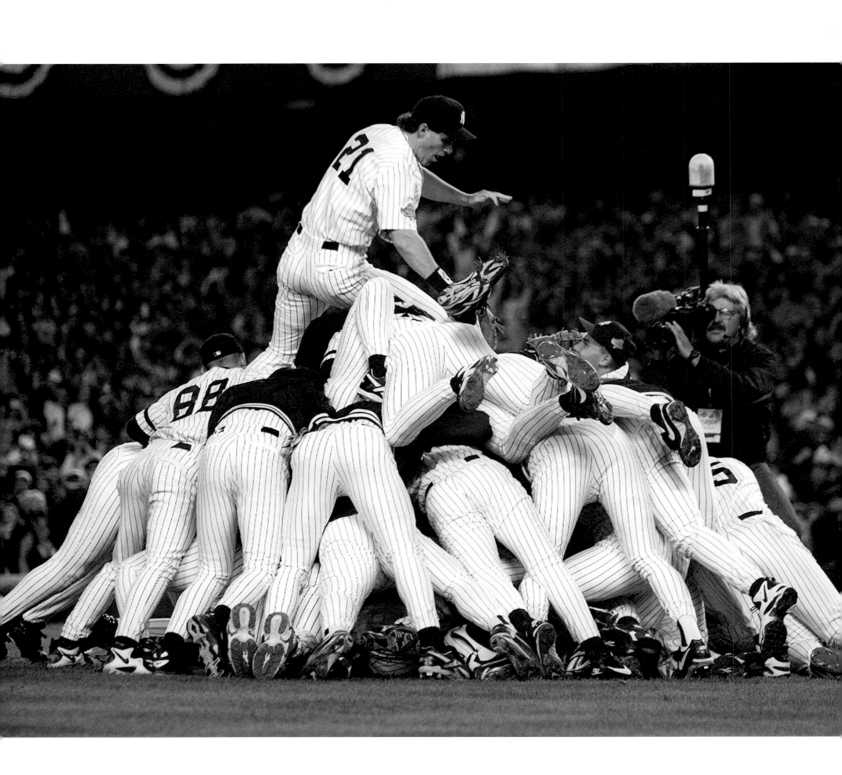

It looks like a ride at an amusement park, but it's just three guys hanging out inside the Unisphere, built for the 1964-65 World's Fair, during their lunch hour in Flushing Meadow Park, March 1998. The stainless steel sphere, 120 feet in diameter, is the largest model of the Earth ever constructed. Although it became a kind of unofficial symbol of the borough of Queens, few would argue that the Unisphere has proven to be a less than ideal monument for a public park.
WILLIE ANDERSON

An infant is baptized at Our
Lady of Refuge Church,
2020 Foster Avenue,
Brooklyn, early April, 1997.
EVY MAGES

A longtime tradition in New York (and just about every-where else): girl-watching along Broadway on a hot summer day in late July, 1998, when the thermome-ter hit ninety-three degrees.
COREY SIPKIN

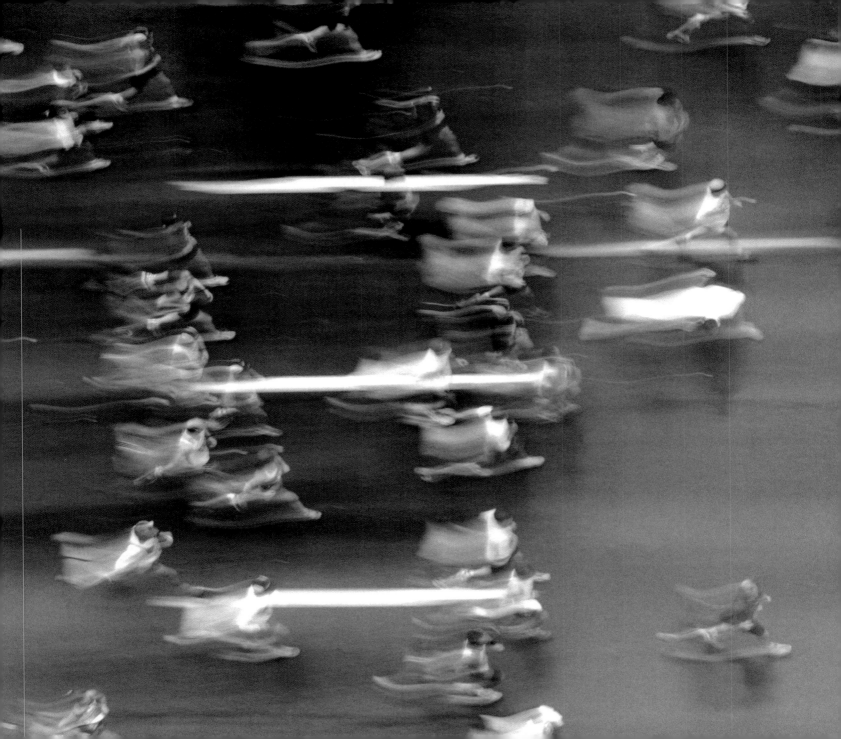

Left:
A few of the runners in the New York Marathon go by in a rain-soaked blur on November 2, 1997. John Kagwe of Kenya won in two hours, eight minutes, and twelve seconds, only eleven seconds short of the record. The fastest woman was Franziska Rochat-Moser of Switzerland, in two hours, twenty-eight minutes, and forty-three seconds. Organized footraces in New York City date back to the 1830s (with some lasting six days and covering 400 miles), but the modern 26-mile, 385-yard event in the city began in 1970, thanks to Fred Lebow (now deceased) and his New York Road Runners Club. The race has grown from little more than 100 participants running within Central Park to about 30,000, from all over the world and including a contingent of disabled athletes in specially designed wheelchairs, traversing the five boroughs in anywhere from two to several dozen hours. An estimated two million or more spectators line the route, from the Staten Island side of the Verrazano-Narrows Bridge to Central Park, to provide the runners with refreshment and encouragement.
SUSAN WATTS

Below:
Stray dogs—apparently five males lovingly following a female—stroll along the Bruckner Expressway in the Bronx during morning rush hour on November 22, 1996. The strays caused at least one three-car accident as they wandered south in the northbound lanes of the Bruckner, then headed onto the Major Deegan Expressway before moving to local streets. They covered about four miles before police tranquilized and collared four of them in a lot near University Avenue, about two hours after the adventure began.
SUSAN WATTS

Overleaf:
After midnight: a slice of life on the boardwalk in Coney Island, early summer, 1997.
JON NASO

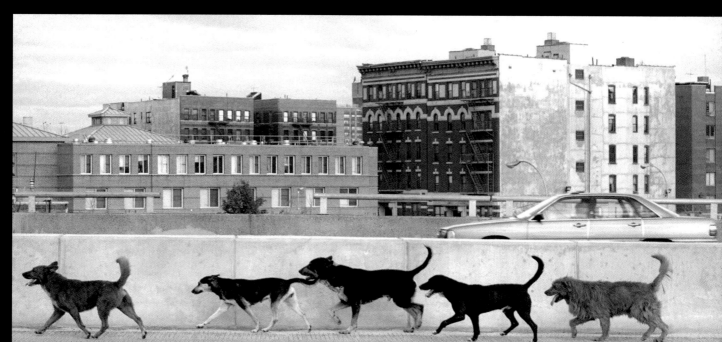

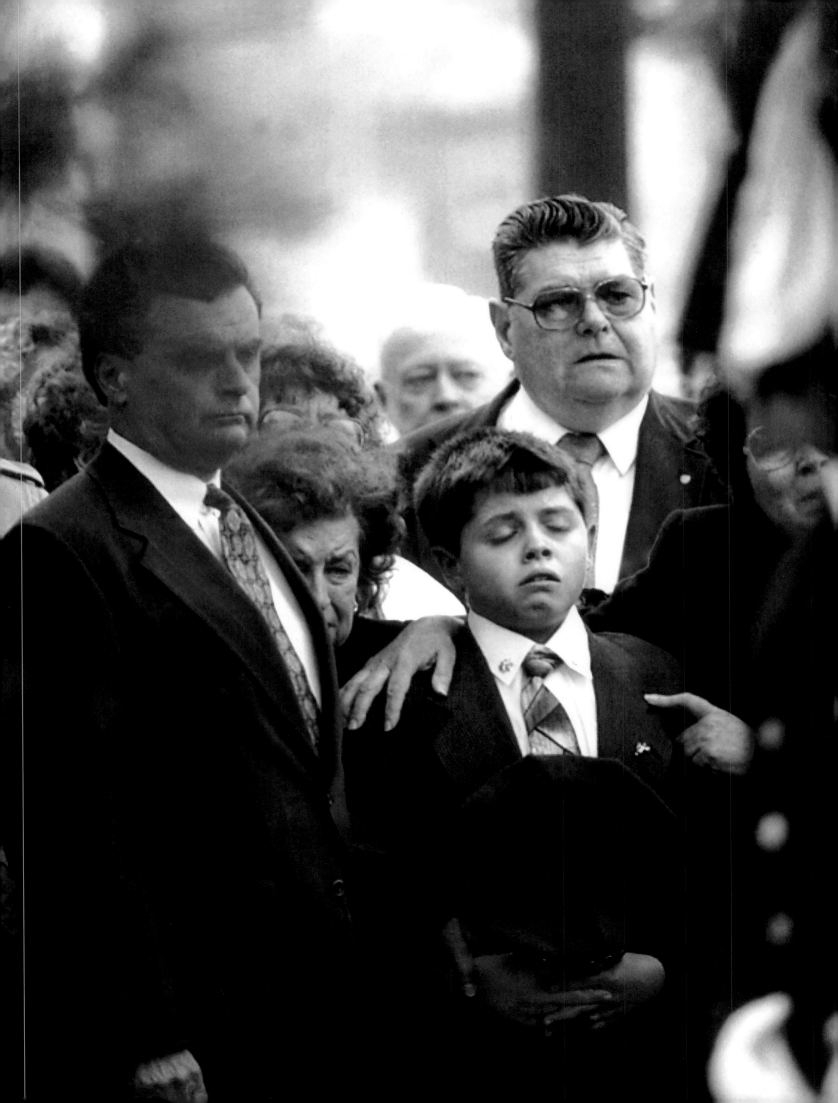

Opposite:

Thirteen-year-old John Fahy Jr. holds his father's police cap as he enters St. Thomas More Church, in the Breezy Point section of Queens, on April 29, 1996, while bagpipers play "Amazing Grace." Young Fahy and his nine-year-old sister, Meaghan, had been rescued from a second-floor balcony after fire broke out in their home four days earlier, but their father, Deputy Inspector John Fahy, and six-year-old brother, James, both died in the blaze. And only two months earlier, cancer had taken the youngsters' mother, police Captain Margaret Fahy, at age forty-six. (The couple had been the first to be promoted to captain on the same day, and at least a dozen other family members were also on the force.) About 1,000 mourners filled the church, and Mayor Rudolph Giuliani expressed their feelings: "Too much loss, too much sorrow."

BILL TURNBULL

Below:

Comforted by her family, Rajiah Sultana, thirty-nine, awaits a liver transplant in Bellevue Hospital, December 1998. America's oldest public hospital, and its largest city hospital, Bellevue is particularly famous for its emergency ward, which receives 89,000 visits each year.

MIKE ALBANS

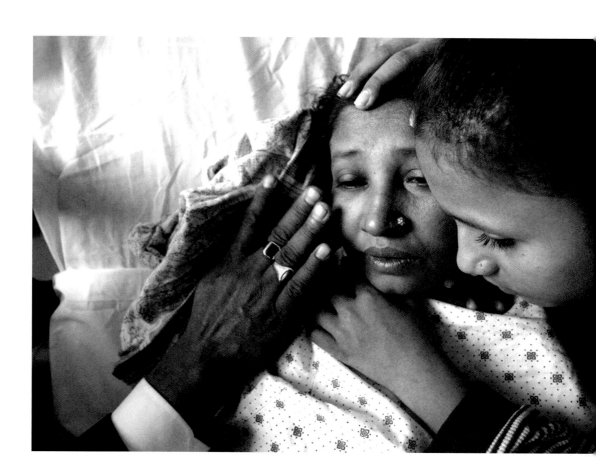

Left:

As the November temperature drops down into the low thirties, a group of New York's homeless huddle in the lee of church doors, 1998. At the end of the millennium, homelessness continued to be a chronic problem in New York City, which gained an unenviable reputation as the homeless capital of North America in the 1970s and 1980s. The waiting list for public housing had 130,000 families, and on a typical night, shelters took in nearly 5,000 families and 7,000 single people. The sight of people camping out in doorways or in cardboard shelters was still all too familiar.
CLARENCE DAVIS

Right:

Prostitute Gloria Colon reacts emotionally after shooting up in the Bronx, mid-July, 1997.
SUSAN WATTS

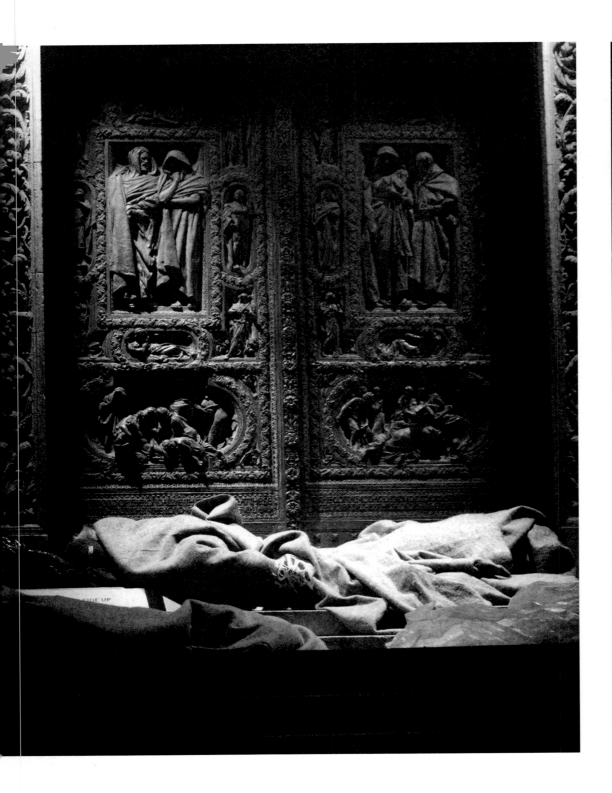

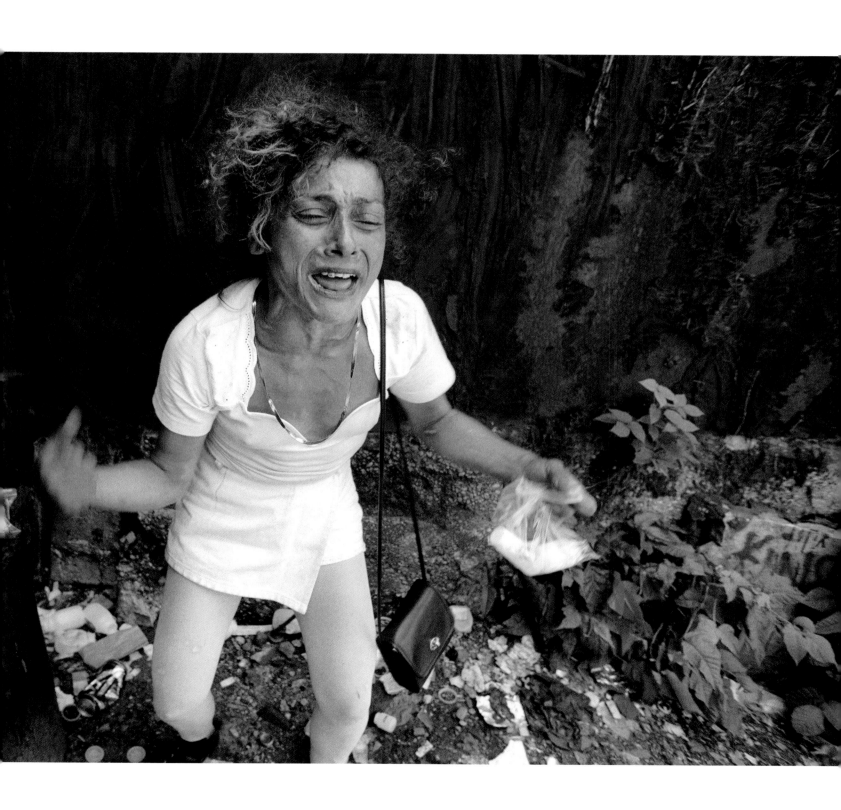

Below:

Sixteen-year-old Alicia Mai (left) and her friend Pierre Vallejo, fourteen, play in the sand on the beach at Coney Island, mid-May, 1999, under the dangling feet of someone sitting on the boardwalk railing.

EVY MAGES

Opposite:

A stately transvestite strides past a police officer during a rainy Gay and Lesbian Pride Parade down Fifth Avenue, from 52nd Street, and then west to Christopher Street in the Village, on June 30, 1996. Another marcher was Mayor Rudolph Giuliani. Such open-ness, and governmental partic-ipation, was a far cry from the mostly underground nature of life for homosexuals in New York City until 1969, when decades of police raids and harassment culminated in an unexpected outbreak of vio-lence after a typical raid at the Stonewall Inn on Christopher Street. Several gay-rights organizations were created, and bias incidents by police, area residents, and visitors to New York began to decline.

MISHA ERWITT

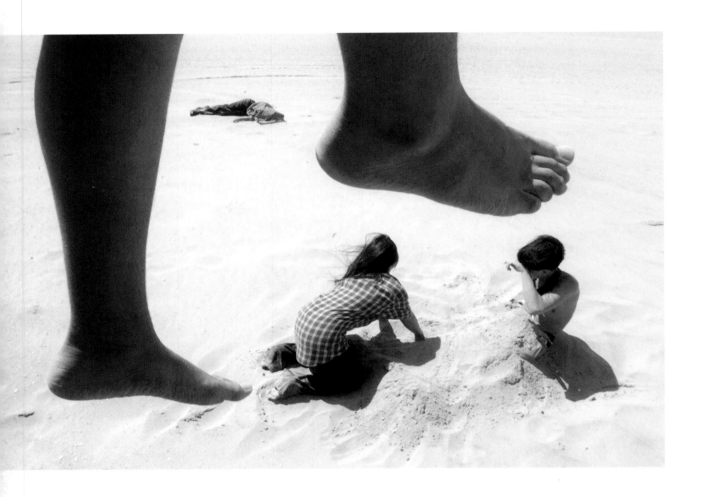

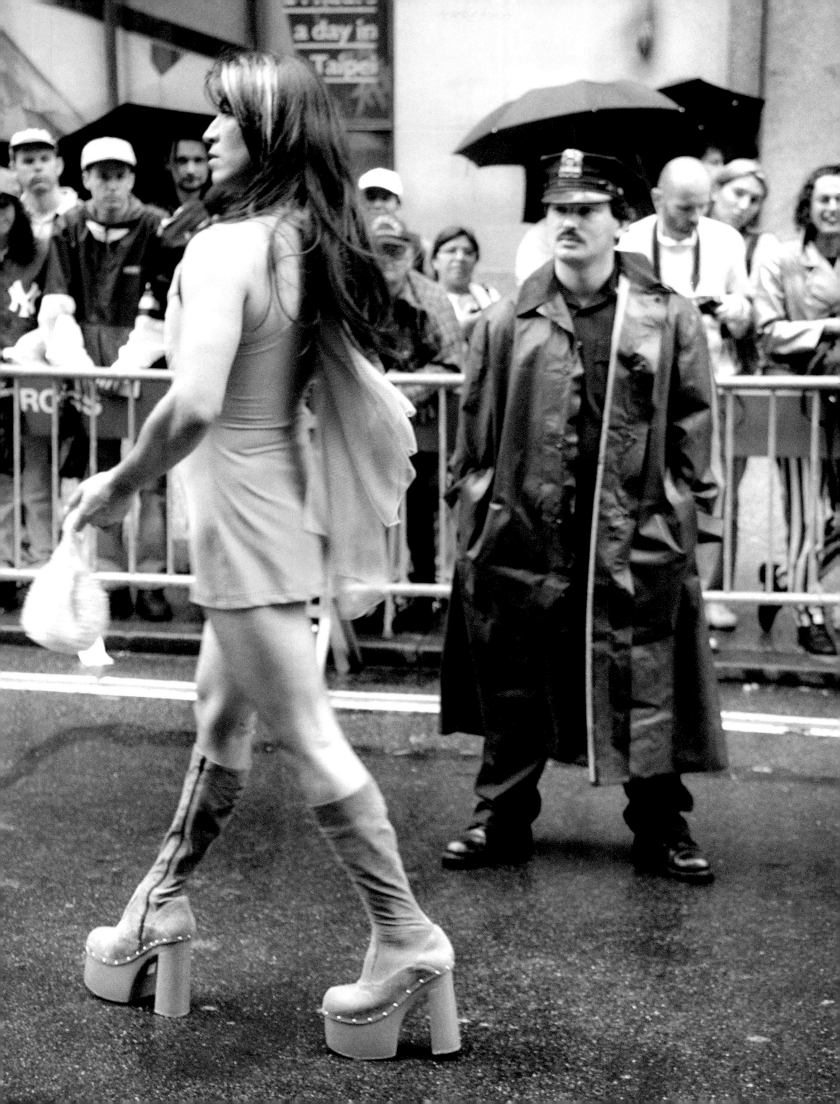

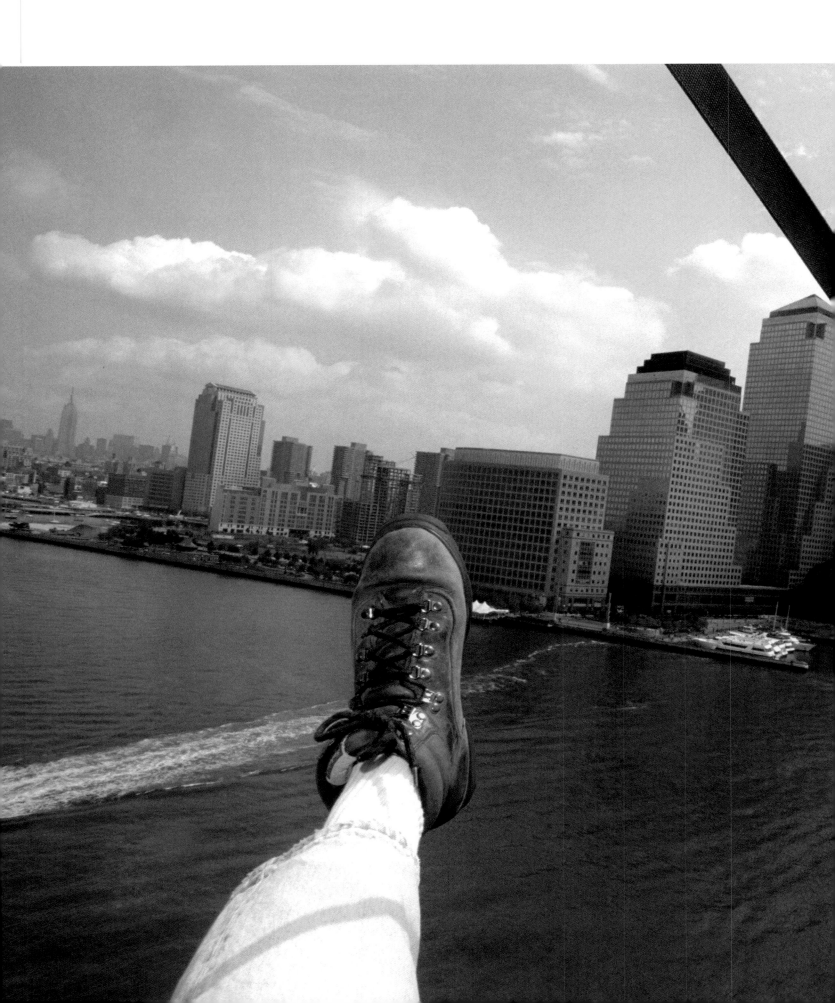

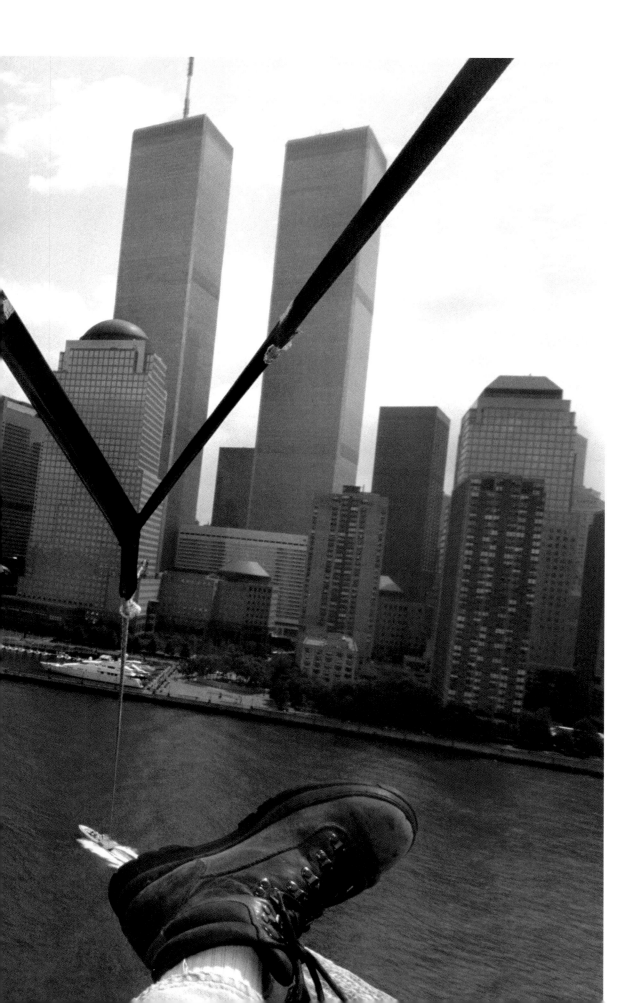

Self-portrait with cityscape:
Daily News photographer
Mike Albans goes parasail-
ing over the Hudson River
near Lower Manhattan.
MIKE ALBANS

312 Elaborately decorated, this youngster at Kingston Avenue and St. John's Place in Brooklyn shines with pride and joy as she takes part in the Children's Carnival on August 30, 1997, part of a five-day festival culminating on Labor Day with the thirtieth annual West Indian American Day Carnival Parade, along Eastern Parkway and Prospect Park. Every year, about two million people enjoy the festivities, the last of the city's great summertime parties. **SUSAN WATTS**

Sean "Puffy" Combs and Jennifer Lopez (right) were still an item when she was photographed with fashion designer Donatella Versace at a party he threw for the magazine *Notorious* at the club Limelight in mid-April, 1999. The romance between the rap impresario and the Bronx-born pop star seemed to have cooled after they were both arrested following a shooting at the Club New York eight months later. No charges were lodged against Lopez, but Combs was eventually indicted for gun possession and bribery. Her career took off like a rocket; he lay low preparing for his trial, which began in January 2001. The jury found him innocent of all charges. **RICHARD CORKERY**

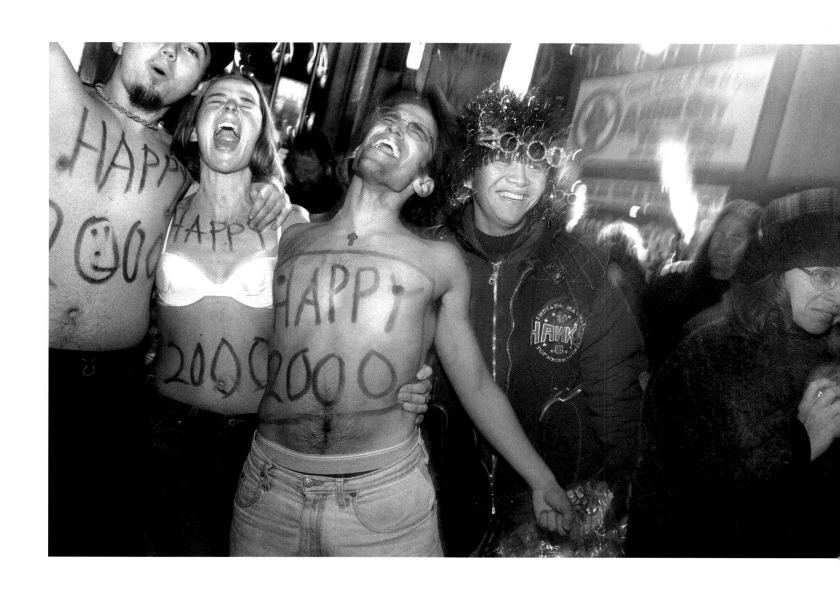

Opposite:
Not *all* old soldiers just fade away: a spectator honors the participants in the annual Veterans' Day Parade down Fifth Avenue, November 11, 1999. The tradition, stemming from Armistice Day, which marked the end of World War I, is fading away, however, and the 5,000 veterans participating in the 1999 parade outnumbered the onlookers.
BUDD WILLIAMS

Above:
Exuberant celebrants at Times Square join in the worldwide party of the millennium. Up to two million people jammed Times Square—perhaps its largest crowd ever, with the sole exception of V-J Day on August 14, 1945—so early that police closed off the entire twenty-six-square-block area to new arrivals five hours before a brand-new, sparkling version of the traditional big apple fell at the stroke of midnight.
LINDA ROSIER

"Their collective work is a well-rounded coverage of life and death and despair in a great city twenty-four hours a day." With these words, for the first time in Pulitzer Prize history, the trustees of Columbia University in 1956 awarded the coveted prize not to a single photographer, but to the entire staff of twenty-six *Daily News* photographers for "consistently excellent news picture coverage." They continued, noting "any one of the forty-two photos entered could be admired in any exhibit or salon." This tribute is one that could be ascribed to the *News's* photographers in any given year. The tradition of excellence begun in 1919 continues into the next century. It was, and is, photos that move the paper—not only as good news, but also as great photography.

Today, the photographers' voices mingle with the other voices of the street, their contribution to the daily story of life in the metropolis as powerful as that of the writers. Their task is no less daunting than in the days of risking life and limb in open planes or burning ships to "make the picture." Photographers still climb bridges, brave mobs, and prowl crime scenes—although they are barricaded on our side of the police tape, without the privilege of close collaboration with the city's caretakers that was enjoyed by their forebears, so evident in the earlier pictures. It is their job to see the city fresh, and get beyond the "grip and grin" of sound-bite media. They are one of us, and it is with their eyes that we see up close the humanity of the city.

The *Daily News's* editorial use of picture spreads and large pictures to tell a story revolutionized American journalism (it was rumored that the *News* was required reading in the editorial offices of Henry Luce's fledgling *Time Magazine).* The photographers became adept not just at getting the picture, but also at taking the picture—honing their craft with experimentation until their technique became seamless. One story relates how Charles Hoff, one of the first photographers to use synchronized flash, left the rest of the picture press literally in the dark. They had caught on fast, carefully watching the movement of his shutter finger, timing their moment of exposure to his own, and piggybacking off his light. But the fiercely competitive Hoff faked the click, listened as they all spent their shots, and then proceeded to illuminate the scene for an exclusive.

The history of the *News* is also the history of innovation in photographic technology, placing the paper ahead of the learning curve, with the photographers constantly revising and inventing new equipment, even the cameras they used. Lou Walker's invention of the Big Bertha—the first telephoto lens—brought the action at home plate to every reader. It was *Daily News* photographers who had Madison Square Garden fitted with strobes so that the night fights could be captured without blur. The result was pictures with incredible depth, graphic impact, and of course, a ringside view. In the mid-thirties Harry Warnecke suggested that color might be worth looking into, and he began producing one color picture each week on the cover of the Sunday Rotogravure section. Warneke designed a special camera to accommodate three plates, one for each color. He also supervised the News Photo Studio, which took up a whole floor in the 42nd Street building. The studio had great cachet in entertainment circles, and the archive abounds with pictures of celebrities. Everyone from Franklin Roosevelt to Elizabeth Taylor posed for what became known as the Three and One Studio.

The *News* was the first paper to use aerial photography and owned their own planes. By the fifties, the staff numbered sixty-three, with ten radio cars, two planes, four darkrooms, and a brigade of cycle couriers to insure that no story was missed.

Few entered the ranks as fully formed photographers. The camera culture at the *News* was similar to an apprenticeship. A young man (the news hired its first female, Evelyn Straus, during World War II, when many of the men were overseas) started out as a copyboy, then went out into the street as a courier, then became a studio or darkroom assistant, and finally graduated back to the street as a shooter. The veteran shooters acted as mentors to the youngsters. Dan Farrell recalls it as being exciting: "For twenty-one dollars a week you got to run film and go to all the ballgames." It was a rather complete education, for the photographer was thus trained to be streetwise, quick on his feet, and thoroughly knowledgeable of what his camera and darkroom could do. This is evident in looking at the negatives, where one can see that many of the great images were "made" in only one or two frames.

In keeping with its history of technological innovation the *Daily News* recently made photographic history again by becoming the first metropolitan paper to digitize every image appearing in the paper. Digital cameras capture images that are in essence a series of numbers. With wireless technology, images are transmitted back to the picture desk, edited on the AGT system on computer, and sent to prepress—all within minutes of an event. Gone is the reliance on radio cars, couriers, cycles, boats, planes, trains, and the kindness of strangers in getting the film back to the darkroom by press time. And gone is the lament of a missed deadline because a photographer was stuck in traffic.

There are over six million images in the *News'*s archive—it is by far the most comprehensive photographic history of the great city extant. This book, only the tip of the iceberg, is an introduction into a treasure trove of images wrought by some of the best photographers of the last century. It is by design not a history of New York, but a tribute to the unique vision of men and women who spend their time recording its history. The variety of photographic styles is as varied as its subject matter. These exposures reveal the skill and versatility of those that made them. Each photographer is well versed in shooting sports, fashion, studio, crime, whatever the assignment of the day calls for. This precedent was set from the first days of the *News,* and although there are photographers that cover certain beats, they are all expected to change course now and then. Frank Hurley could shoot presidents as well as double plays. Charles Hoff recorded crime scenes as well as a knockouts in the ring.

In making this book, we sought to show the images in all of their original beauty, as the photographer originally witnessed the scene, scanning from negatives wherever possible. In some cases where the negatives were old and damaged, prints were used. Some of the original prints retain marks applied by retouchers and intended to enhance reproduction on the early presses. Rather than viewing this as a flaw, we choose to include those images, as some of them are much too good to hide away because of scars. We also gave photographer credit wherever possible, but many did not bear a credit, especially in the early years, when it was the paper's policy to employ the credit "News Photo."

Photography itself recreates the act of seeing: light striking an image travels through a lens, reacts on a surface, is transmitted to the brain, and is often stored in memory. Like a multitude of visions, these images are stored away in the vast memory bank that is the *News* archive. Like memories, they are in turn heartbreaking, beautiful, disturbing, terrifying, sometimes fun, and always worth the recollection.

INDEX OF NAMES

SHAWN O'SULLIVAN / ACKNOWLEDGMENTS

A book, like a newspaper has many makers, each contributing their talents to the whole. This book owes thanks to many. Thanks to Eric Meskauskas, Director of Photography at the *News,* for inspiration and encouragement. To Mike Lipack, onetime streetwise *News* Photographer, now Deputy Director of Photography. To Dolores Morrison, Assistant Director of Photography, without whom this book would not have made production, and her staff: Lee Sprecace Clark, Raymond Cruz, Sarah Feinsmith, Klaus Guglberger, Ann Marie Linden, Vincent Panzarino, Rita Robinson, Laura Stempien, Angela Troisi, and Lloyd Villas. To Gardy Delatour, my right hand on the job. To Nikhil Rele, Director of Photography for Technology. To James Wellford, the editor who began the monumental task of organizing the digital archive. To Faigi Rosenthal, Head Librarian of the *News,* and Bill Gallo, a bit of *News* history himself. To Pete Hamill, whose perspective on the *News's* place in the history of photojournalism creates an insightful and lively backdrop to the pictures. To my editor at Abrams, Eric Himmel, whose love of photography and the City of New York were invaluable in the shaping of this book. Finally, thanks to my family—who have listened to talk of "the book" for years. Now they will get to hold it in their hands.